BLICK MEAD

best wishes,
David Jacques x

STUDIES IN THE BRITISH MESOLITHIC AND NEOLITHIC

Volume 1

Series Editors
David Jacques and Graeme Davis

PETER LANG
Oxford • Bern • Berlin • Bruxelles • New York • Wien

BLICK MEAD

Exploring the 'First Place' in the Stonehenge Landscape

David Jacques, Tom Phillips and Tom Lyons

Edited by David Jacques

PETER LANG
Oxford • Bern • Berlin • Bruxelles • New York • Wien

Bibliographic information published by Die Deutsche Nationalbibliothek.
Die Deutsche Nationalbibliothek lists this publication in the Deutsche
National-bibliografie; detailed bibliographic data is available on the
Internet at http://dnb.d-nb.de.

A catalogue record for this book is available from the British Library.

Library of Congress Control Number: 2017957165

Front cover: photograph courtesy of Andy Rhind-Tutt.
Back cover: Dury and Andrews map of the Stonehenge area, 1773, courtesy of Wiltshire and Swindon History Centre.

Cover design by Peter Lang Ltd.

ISSN 2297-1068
ISBN 978-1-78707-096-7 (print) • ISBN 978-1-78707-477-4 (ePDF)
ISBN 978-1-78707-478-1 (ePub) • ISBN 978-1-78707-479-8 (mobi)

© Peter Lang AG 2018

Published by Peter Lang Ltd, International Academic Publishers,
52 St Giles, Oxford, OX1 3LU, United Kingdom
oxford@peterlang.com, www.peterlang.com

David Jacques, Tom Phillips and Tom Lyons have asserted their right under the Copyright, Designs and Patents Act, 1988, to be identified as Authors of this Work.

All rights reserved.
All parts of this publication are protected by copyright.
Any utilisation outside the strict limits of the copyright law, without the
permission of the publisher, is forbidden and liable to prosecution.
This applies in particular to reproductions, translations, microfilming,
and storage and processing in electronic retrieval systems.

This publication has been peer reviewed.

Printed in Germany

Contents

List of Contributors	vii
List of Figures	ix
List of Tables	xiii

DAVID JACQUES, TOM PHILLIPS AND TOM LYONS
Preface — xv

Summary — xvii

Acknowledgements — xix

CHAPTER 1
Introduction: Landscape History and Project Methodology — 1

CHAPTER 2
Fieldwork Results: The Archaeological Narrative — 17

CHAPTER 3
Environmental Setting: Geoarchaeological Investigations and Environmental Analysis — 35

CHAPTER 4
The Lithic Material — 67

CHAPTER 5
Aurochs Hunters: The Large Animal Bones from Blick Mead — 127

CHAPTER 6
Smaller Vertebrates from the Mesolithic Site of Blick Mead — 153

CHAPTER 7
Discussion — 159

APPENDICES — 171

Appendix A: Fieldwork — 173

Appendix B: Ecofacts — 193

Appendix C: Miscellaneous Artefacts 199

Appendix D: Supporting Data for Lithostratigraphy, Isotope Analysis
 and Radiocarbon Dating 203

AFTERWORDS
Tony Legge and the Blick Mead Project 215

Community: The Contribution of Volunteers from Amesbury to the Blick Mead Project 217

Bibliography 221

Index 235

Contributors

Principal authors	David Jacques	School of Humanities, University of Buckingham
	Tom Phillips	Oxford Archaeology East
	Tom Lyons	
Editor	David Jacques	School of Humanities, University of Buckingham
Editorial consultant	Victoria Ridgeway	Pre-Construct Archaeology
Geoarchaeological and environmental analyses	D. S. Young	Quaternary Scientific (QUEST), University of Reading
	C. P. Green	Quaternary Scientific (QUEST), University of Reading
	N. P. Branch	Quaternary Scientific (QUEST), University of Reading
	S. A. Elias	Royal Holloway
	C. Bateson	University of Reading
	C. R. Batchelor	Quaternary Scientific (QUEST), University of Reading
	Tom Maltas	Sheffield University
Lithics	Barry Bishop	School of Humanities, University of Buckingham
Use wear analysis	Randolph Donahue	School of Archaeological Sciences, University of Bradford
	Keith Bradbury	School of Humanities, University of Buckingham,
XRF analysis	Peter Webb	Open University
Analysis of algae	David M. John	Department of Life Sciences, Natural History Museum, London
Large animal bones	Bryony Rogers	Department of Archaeology, Durham University
	Kurt Gron	Department of Archaeology, Durham University
	Janet Montgomery	Department of Archaeology, Durham University
	Darren R. Gröcke	Department of Archaeology, Durham University
	Peter Rowley-Conwy	Department of Archaeology, Durham University
Fragmentary skeletal material (ZooMS)	Sophy Charlton	Natural History Museum, London

Small vertebrates	Simon A. Parfitt	Institute of Archaeology, University College London
Geophysical survey	Eamonn Baldwin	Ludwig Boltzmann Institute and Stonehenge Hidden Landscapes Project
	David Sabin	Archaeological Surveys Ltd
	Kerry Donaldson	Archaeological Surveys Ltd
Copper alloy knife	Lorraine Mepham	Wessex Archaeology
	Andrew Lawson	Wessex Archaeology
Iron Age pottery	Lorraine Mepham	Wessex Archaeology
Anglo-Saxon disc brooch	Jörn Schuster	Wessex Archaeology

Figures

Figure 1.1	General site location: Blick Mead in its wider landscape setting	2
Figure 1.2	Vespasian's Camp and Blick Mead, featuring sites where there have been interventions and excavations	2
Figure 1.3	Blick Mead Trench Location Plan, showing location of trenches mentioned in text	3
Figure 1.4	The natural geology in the vicinity of Blick Mead	3
Figure 1.5	Flitcroft Survey of Little Southam Field, Wall's Field (and Vespasian's Camp) and Woolson Hill, Amesbury, 1726	5
Figure 1.6	Charles Bridgeman's plans for landscaping Vespasian's Camp and Amesbury Abbey, c. 1738	5
Figure 1.7	Dury and Andrews' map of Amesbury parish, 1773	6
Figure 1.8	Antrobus Estate survey of Amesbury Abbey lands, 1824	7
Figure 1.9	Mike Clarke's drawing of Vespasian's Camp and Blick Mead, 2005	8
Figure 1.10	Ordnance Survey map of Vespasian's Camp area, 1901	9
Figure 1.11	A moment of discovery: Tom Phillips discovers a worked flint in a boggy Trench 19	10
Figure 1.12	Working on the sieves at Blick Mead	11
Figure 1.13	David Jacques and Malcom Guilfoyle-Pink being interviewed by the BBC's *Horizon* programme in Trench 24	13
Figure 2.1	Trench 19 plan, showing division of layer [59] into 1 m × 1 m squares	18
Figure 2.2	North-east facing section through deposits in Trench 19	20
Figure 2.3	Section through deposits in Trench 19	21
Figure 2.4	South-west facing section, Trench 22	21
Figure 2.5	North-west facing section, Trench 22	22
Figure 2.6	Trench 22 during excavation, looking east	23
Figure 2.7	Mesolithic tool types retrieved from Trenches 19–23	24
Figure 2.8	Trench 23 plan	25
Figure 2.9	South facing section, Trench 23	25
Figure 2.10	Trench 23 during excavation, looking north	26
Figure 2.11	East facing section, Trench 23	27
Figure 2.12	Trench 24 plan at the end of the 2015 season of excavations	29
Figure 2.13	Trench 24, looking east, towards the low-lying wet areas of Blick Mead	30
Figure 2.14	Tree-throw hollow [111], Trench 24	30
Figure 3.1	Location of Blick Mead (Site 1) and Site 2	36
Figure 3.2	Location of the boreholes at Blick Mead (Site 1)	38
Figure 3.3	Surface of the Gravel	41
Figure 3.4	Surface of the Sand	42
Figure 3.5	Peat thickness	43
Figure 3.6	Surface of the Peat	44
Figure 3.7	Surface of the Alluvium	45
Figure 3.8	Made Ground thickness	46
Figure 3.9	Results of the pollen analysis of borehole BH25 (Site 1)	57
Figure 3.10	Results of the pollen analysis of borehole S2BH2 (Site 2)	58

Figure 3.11	Borehole data	62
Figure 3.12	North-west to south-east borehole transect, from low to high ground	62
Figure 3.13	South-west to north-east transect across low-lying ground	63
Figure 4.1	Distribution of struck flint in the Basal Clay Horizon of Trench 19	71
Figure 4.2	Distribution of unworked burnt flint in the Basal Clay Horizon of Trench 19	72
Figure 4.3	Selection of large flakes and cores from Trench 19	76
Figure 4.4	Flint cores	86
Figure 4.5	Flint cores	87
Figure 4.6	Flint cores	88
Figure 4.7	Arrowhead and blades	90
Figure 4.8	Shape and size distribution of all complete edge retouched flakes and blades	93
Figure 4.9	Size distribution of all seventy microliths	97
Figure 4.10	Microliths	98
Figure 4.11	Microliths	99
Figure 4.12	Possible microlith made from slate	101
Figure 4.13	Selection of Later Mesolithic microliths	103
Figure 4.14	Retouched implements	105
Figure 4.15	Transverse Axe/Adze	108
Figure 4.16	Transverse Axe/Adze	109
Figure 4.17	Transverse Axe/Adze	110
Figure 4.18	Four views of the sandstone slab	111
Figure 4.19	Map showing the outline of Blick Mead, nearby seasonally flowing springs and watercourses and the spring-fed pool that flows into the River Avon	123
Figure 4.20	Colour change of the *Hildenbrandia rivularis* crust on flint taking place after drying	124
Figure 5.1	Distribution of bone fragments in Layer [59]	129
Figure 5.2	Butchery traces on aurochs bones from Blick Mead	131
Figure 5.3	Measurements of the Blick Mead aurochs astragali compared to those from Star Carr and Denmark	132
Figure 5.4	Measurements of the red deer astragalus and scapula from Blick Mead compared with those from Star Carr	133
Figure 5.5	The Blick Mead animal bone frequencies compared to those from other Mesolithic sites	136
Figure 5.6	The aurochs lower M3s sampled incrementally	140
Figure 5.7	Oxygen isotope values from the Blick Mead aurochs teeth compared to the results from the Irthlingborough specimen.	141
Figure 5.8	Carbon isotope values from the Blick Mead aurochs teeth compared to the results from the Irthlingborough specimen	142
Figure 5.9	Comparison between the Blick Mead carbonate percentages and the oxygen and carbon values	143
Figure 6.1	Histograms comparing upper incisor anterior-posterior diameter for modern harvest mouse, wood mouse, yellow-necked mouse with the Mesolithic sample from Blick Mead	157
Figure 7.1	Ripple-flaked arrowheads from Blick Mead and Marden Henge	167
Figure 7.2	Blick Mead from the air	169

Figures

Appendix A

Figure A1	Site location with GPR survey area outlined	182
Figure A2	Topographic surface model with GPR survey area outline and radargram profiles	182
Figure A3	Selected radargrams (transect profiles) with features marked	183
Figure A4	Amplitude time-slices	184
Figure A5	Amplitude time-slices	185
Figure A6	Geo-rectified time-slice	186
Figure A7	Feature of potential interest: Interpretation from time-slice data	186
Figure A8	Greyscale plot of processed magnetometry data	190
Figure A9	Abstraction and interpretation of magnetometry anomalies	191
Figure A10	Greyscale plots of raw and processed resistance data	191
Figure A11	Abstraction of interpretation of resistivity anomalies	192

Appendix B

Figure B1	Trench 19, context [92]: Weight of residues	198

Afterwords

Figure AW1	Gilly Clarke, Mike Clarke and Barry Bishop at Blick Mead. The terrace, and the future site of Trench 24, is in the background	217
Figure AW2	Amesbury Midwinter Solstice Lantern Parade to Blick Mead	218
Figure AW3	Looking north over Trench 24 towards the end of the latest excavations. The chalk mound of the tree throw is clearly visible. L–R: John Gibbens, Mick Smith, David Jacques, Lance Russum, Vicky Ridgeway, Barry Bishop and Tom Lyons, with volunteers from Amesbury History Centre and elsewhere looking on	220

Tables

Table 2.1	Radiocarbon dates from Blick Mead (including borehole samples, see Chapter 3)	31
Table 3.1	Borehole attributes	39
Table 3.2	Results of the macrofossil assessment of bulk samples	53
Table 3.3	Results of the macrofossil assessment of samples from borehole BH25	54
Table 3.4	Results of the waterlogged plant macrofossil (seeds) analysis of borehole BH25	54
Table 3.5	Results of the insect analysis of selected samples from Trenches 19 and 22	55
Table 3.6	The contents of the processed sample from tree-throw hollow [111]	66
Table 4.1	Quantification of struck flint and unworked burnt flint at Blick Mead	68
Table 4.2	Quantification of struck flint and unworked burnt flint by context from Trench 19	69
Table 4.3	Vertical distribution of struck flint and unworked burnt flint in square [77] of the Basal Clay Horizon in Trench 19	70
Table 4.4	Quantification of struck flint and unworked burnt flint by context from Trench 22	73
Table 4.5	Quantification of struck flint and unworked burnt flint by context from Trench 23	74
Table 4.6	Quantification and distribution of unworked burnt flint by context, shown in stratigraphic order	75
Table 4.7	Quantification of struck flint	79
Table 4.8	Core striking platforms	84
Table 4.9	Quantification of retouched and other implements	91
Table 4.10	Shape and edge morphology of edge retouched flakes and blades	92
Table 4.11	Micro-burin forms	94
Table 4.12	Classification of identifiable microliths	96
Table 4.13	Quantification of lithic material from Trench 24	115
Table 5.1	The animal bones from Blick Mead	146
Table 5.2	Skeletal distribution of the aurochs and red deer bones	146
Table 5.3	Measurements from bones at Blick Mead	147
Table 5.4	Skeletal distribution of the elk, roe deer and wild boar from Blick Mead	148
Table 5.5	Results of Sr-87/Sr-86 analysis of the Blick Mead teeth	149
Table 5.6	The bulk collagen results from aurochs bone samples from Blick Mead	149
Table 5.7	ZooMS identifications of samples	151
Table 6.1	Summary of taphonomic alterations of small vertebrates from the Mesolithic horizon	156

Appendix B

Table B1	Smaller vertebrates from sieved samples	194
Table B2	Measurements of insectivore and rodent teeth from the Mesolithic horizon	196
Table B3	Summary statistics of measurements (in mm) of *Clethrionomys glareolus* molars from the Mesolithic horizon	197
Table B4	Blick Mead, Trench 19, context [92]: Weight of residues from wet-sieved bulk samples from the 1993 season	197
Table B5	Blick Mead, Trench 19, context [92]: Sediment inclusions from the samples sieved during the 2013 season	198

Appendix D

Table D1	Lithostratigraphic description of borehole <BH2>	203
Table D2	Lithostratigraphic description of borehole <BH3>	203
Table D3	Lithostratigraphic description of borehole <BH4>	203
Table D4	Lithostratigraphic description of borehole <BH5>	204
Table D5	Lithostratigraphic description of borehole <BH6>	204
Table D6	Lithostratigraphic description of borehole <BH7>	204
Table D7	Lithostratigraphic description of borehole <BH8>	205
Table D8	Lithostratigraphic description of borehole <BH9>	205
Table D9	Lithostratigraphic description of borehole <BH10>	205
Table D10	Lithostratigraphic description of borehole <BH11>	206
Table D11	Lithostratigraphic description of borehole <BH12>	206
Table D12	Lithostratigraphic description of borehole <BH13>	206
Table D13	Lithostratigraphic description of borehole <BH14>	207
Table D14	Lithostratigraphic description of borehole <BH15>	207
Table D15	Lithostratigraphic description of borehole <BH16>	207
Table D16	Lithostratigraphic description of borehole <BH17>	208
Table D17	Lithostratigraphic description of borehole <BH18>	208
Table D18	Lithostratigraphic description of borehole <BH19>	209
Table D19	Lithostratigraphic description of borehole <BH20>	209
Table D20	Lithostratigraphic description of borehole <BH21>	209
Table D21	Lithostratigraphic description of borehole <BH22>	210
Table D22	Lithostratigraphic description of borehole <BH23>	211
Table D23	Lithostratigraphic description of borehole <BH24>	211
Table D24	Lithostratigraphic description of borehole <BH25>	211
Table D25	Lithostratigraphic description of borehole <S2BH1>	212
Table D26	Lithostratigraphic description of borehole <S2BH2>	212
Table D27	$\delta^{18}O$ determinations from the aurochs teeth at Blick Mead. BM 421, Mesial lobe	213
Table D28	$\delta^{18}O$ determinations from the aurochs teeth at Blick Mead: BM 421, Middle lobe	214
Table D29	$\delta^{18}O$ determinations from the aurochs teeth at Blick Mead: BM 422, Middle lobe	214

Preface

The Stonehenge World Heritage Site is one of the most famous prehistoric places in the world, but much about its origins and the choice of its location remains a mystery. Although recent archaeological investigations have revealed stunning new details of Neolithic and Early Bronze Age monuments in its vicinity (Bowden *et al.* 2015, 136), little attention has been paid to establishing the area's 'back story'. The Neolithic settlement of Durrington Walls has been identified as the place where the community lived who conducted the main stage of construction at Stonehenge (Stage 2: when the sarsen circle and trilithons were erected. Craig *et al.* 2015, 1098), but until recently no residential and activity sites pre-dating the Late Neolithic period had been identified within the area of the World Heritage Site. This was set to change with Blick Mead.

This book attempts to set out how, why and what Blick Mead has changed. The ways the site was discovered, the challenges it has presented and how some of them were overcome are detailed in Chapter 1 ('Landscape History and Project Methodology'); Chapter 2 ('Fieldwork Results: The Archaeological Narrative') presents the results of the fieldwork; analysis of the site's setting and its vegetational history is provided in Chapter 3 ('Environmental Setting'); Chapter 4 presents the evidence for flintworking; Chapters 5 and 6, the evidence for large and small fauna; and the results and the questions they have provoked are pondered in Chapter 7. A series of Appendices provide additional and supplementary data.

The book also tries to capture how the project has evolved from 2005, as that has a bearing on why and how the archaeology has been found. For the first six years it was run on £500 to £1,000 per annum, financed by the Open University and the Amesbury community and volunteers. This just about paid for one long weekend dig per year. Our excavations, partly out of necessity, have allowed people of talent, whatever their age or background, to be involved from the beginning and that has affected our methodology and made us think hard about the sort of dynamics needed on site to bring out the best in the people working there.

To date the project has created much interest and this volume seeks to satisfy some of the curiosity the project has generated. It is to be hoped that the investigations will continue for many years to come. As this book goes to press, in early 2018, Professor Tony Brown is leading an analysis of aDNA, seDNA and pollen from Trench 24, and excavations will continue. As such the contents of this volume form an interim statement on the findings up to 2015 so far, focusing on archaeological research up to 2013, but referencing more recent findings, analyses of which are still ongoing. This enables us to consolidate our evidence, share the results of our research to date, and allowing a time for reflection while we focus on planning the research to come and the ways in which we would like the project to evolve.

David Jacques, Tom Phillips and Tom Lyons

Summary

Excavations at Blick Mead and its adjacent terrace have revealed substantial Mesolithic deposits and provide evidence for the people who built the first monuments on the Stonehenge knoll and the first Mesolithic residential and activity area to be discovered within the Stonehenge World Heritage Site. A radiocarbon date sequence from the latter brings the transition from Mesolithic to Neolithic culture in the area into question for the first time. Further finds hint at Blick Mead being part of the wider Stonehenge ceremonial ritual complex in the Late Neolithic.

The radiocarbon sequence is accompanied by multiproxy isotopic analysis, using carbon, oxygen and nitrogen isotopic values to explore the diet and mobility of some of the animals that occupied this landscape. The use of emerging analytical techniques (ZooMS) to identify small and otherwise unrecognisable zooarchaeological remains from Blick Mead using Mass Spectrometry has contributed to the development of this discipline, which we hope will be of benefit to future prehistoric studies.

The discoveries at Blick Mead potentially transform our understanding of the pre-Stonehenge landscape and the establishment of its later ritual character. This book details the landscape history of the Blick Mead site and the discoveries made during the excavations and post-excavation work, and concludes with a review of the site and its wider significance to the Stonehenge World Heritage Site.

Acknowledgements

The amount of collaboration, forward planning, charm, mental arithmetic, creativity, flexibility and iron will involved in keeping the Blick Mead Project running since 2005 has only been possible because it has been greatly supported by a wide range of kind and able people. We are extremely grateful that the landowners of Amesbury Abbey, the Cornelius-Reid family, in particular David and Naomi Cornelius-Reid, continue to enable us to work at Blick Mead and support us so wholeheartedly. Similarly, we wish to warmly thank the landowners of Vespasian's Camp, Sir Edward and Lady Antrobus for their keen interest in the project and for so generously allowing us access to the Camp since 2005. We also wish to extend our thanks to the many Amesbury residents and volunteers from other places who, along with our excellent university students, have worked so hard before, during and after the excavations. Between 2009 and 2012, our work was only possible with the logistical support provided by Amesbury Town Council, Wiltshire Unitary Authority, QinetiQ (Boscombe Down), particular volunteers and English Heritage. It is difficult to express in words the depth of our gratitude to these people and institutions. We are thrilled that the University of Buckingham is providing the resources to take our work to a new level.

Cllr Fred Westmoreland's daily commitment to the project ensured that our funding continued over the critical 2009–2012 period and beyond through his establishment of the Amesbury Archaeology Fund. Logistical help came from local employer QinetiQ, ably coordinated by Pete Kinge. Andy Rhind Tutt's insightful persistence on Amesbury's and our behalf has led, among other things, to the creation of Amesbury Museum and Heritage Trust which has greatly supported our work since 2012. Amesbury History Centre was formed during the time of the project and is ably chaired by local resident Gemma Allerton, who recently studied for an MA at the University of Buckingham (and obtained a Distinction). We look forward to it becoming Amesbury Museum in due course, to showcase the history of Amesbury as well as the rich involvement of many of its inhabitants in the project's discoveries. Blick Mead has arguably shown how important it is to involve local 'outsiders' and how they could be seen as potentially key 'insiders'.

Like Blanche Dubois in *A Streetcar Named Desire*, the project has at times relied on the kindness of strangers. Melinda Covington, now very much not a stranger, has wired crucial donations from Charlotte, North Carolina, USA, since 2015 and as a result has helped to date and analyse the discoveries in Trench 24. Work on site as well as radiocarbon dating has been part funded by generous contributions from volunteers: Simon Banton (Amesbury); Jo and Del Derrick (Amesbury); John and Sarah Gibbens (Wisbech); the Hewitt family (Allington); John and Kerry Holmes (Reydon); Chris Kenward (Amesbury); Emily, Craig and Sue Levick (Bletchley); Beth and Bob Jacques (Warlingham); the Rhind-Tutt family (Allington); Mick and Chris Smith (Soham); the Westmoreland family (Amesbury); and Mr and Mrs Curry, Miss Lepper, Commander Parker and other friends from Amesbury Abbey. We thank them for this and their many other contributions on and off site. Supportive institutions and bodies like the BBC, the Stonehenge Hidden Landscapes Project, Polk State College (Lakeland, Florida, USA), RS Spiller Ltd (Amesbury) and our families have also provided much needed and appreciated logistical support and skills and we thank them warmly for it.

The work at Blick Mead has inspired and motivated a lot of bright people. They have got involved because they have seen a value in it, not because they have been told to, with the result being very much a team success. We are very grateful for the personal involvement therein with Eamonn Baldwin, Nick Branch, Mark Bowden, Tony Brown, Dave Field, Vince Gaffney, Chris Green, David John, Tony Legge, Phil McMahon, Dave McOmish, Janet Montgomery, Simon Parfitt, Mike Parker-Pearson and Peter Rowley-Conwy. Peter Rowley-Conwy's regular words of encouragement, inspiration and challenge have been especially helpful and appreciated, along with Tony Brown and David

John's perspicacity, skills and enthusiasm. We are also very grateful for the interest and perceptions of Alistair Barclay, Richard Bradley, Claire Couant, Chantal Conneller, Tim Darvill, Randolph Donahue, John Drew, Brian Edwards, Roy Froom, Saffi Grey, Malcolm Guilefoyle-Pink, Sue Haynes, Rosalind and Jonathan Higham, Carly Hilts, Peter Hoare, Nick James, Jim Leary, Judy John, Robert Jones, Clare King, Sarah Lakin-Hall, Lorraine Mepham, Richard Mills, Clare Moggridge, Jon Phelan, Laurie Poulson, Julian Richards, Martin Ricketts, Jörn Schuster, Robyn Veal, Peter Webb, Matt Westmoreland, Josh White and Caroline Wickham-Jones, many of whom have visited the site and/or worked on its artefacts and dynamics. Tony Legge's gift of brilliantly designed bespoke sieves, made just before his death, speak of his keen support. Tony was a constant source of advice and kindness and his grandson Tom Maltas continues the family presence on site.

It should not go without saying that this publication would not have been possible without the involvement of those who have contributed to this volume. The authors have been exceptionally fortunate to have Vicky Ridgeway as editorial consultant for this book and Graeme Davis as indexer. Vicky has given us essential support, experienced advice and encouragement throughout the making of it. We are also grateful for her brilliant archaeological skills on site and her warmth in general. Graeme Davis's good offices brought the project to the University of Buckingham – just one of a number of rare and crucial acts of friendship and kindness which have resulted in this book and so much more for Blick Mead. Great thanks go to the team at Peter Lang at Oxford, too, who have been ever helpful and patient. Thanks, too, to the Wiltshire Records Office for their promptness, interest and effort in going the extra mile to retrieve documents. Bryony Rogers, Kurt Gron, Janet Montgomery, Darren R. Gröcke and Peter Rowley-Conwy would all like to thank the University of Buckingham Amesbury Abbey, the Antrobus Estate and Mike Clarke for allowing the opportunity to study this remarkable assemblage, as well as the Blick Mead team for providing Bryony Rogers and Peter Rowley-Conwy with opportunities to visit the site and answering numerous questions regarding the excavation process and the stratigraphy. The University of Buckingham is also thanked for providing the funding for both the isotopic analyses of the teeth and the radiocarbon dates, and for the data set to enable Sophy Charlton's ZooMS results. The Durham University team also wish to thank Umberto Albarella for acting as external referee, site custodian Mike Clarke for help with taking the water samples, Vicky Garlick and Dr Tina Jakob for the X-rays of Fragment {1119}, Jeff Veitch for his superb photographs and Jim Burton for preparation and analysis of the strontium samples. Sophy Charlton wishes to thank Nick Overton and Frido Welker for their comments on her manuscript and NERC for funding her research at Blick Mead (Ref.NE/K500987/1). Simon Parfitt wishes to thank The Calleva Foundation for supporting his research on the Blick Mead bulk samples, Peter Hoare and Andy Rhind-Tutt for their help on site and Glenys Salter for her assistance in the laboratory.

Above all, the Blick Mead Project exists because of the personal interest of the site custodian Mike Clarke, greatly respected by all for his knowledge of Vespasian's Camp and Blick Mead. This book is dedicated with great appreciation and affection to him and his family.

CHAPTER 1

Introduction: Landscape History and Project Methodology

– David Jacques

> The first time I ever visited Vespasian's Camp as it was to me; an Amesbury girl born and bred, it took my breath away. How, I wondered, could I have lived here for almost forty years and never clapped eyes on this little miracle? My first visit was just about trying to make life a little easier for David and his team. My employer's Corporate Responsibility Committee asked me to do what I could to help and the sum of my usefulness that first weekend was a plentiful supply of hot tea and coffee, biscuits, a 4 × 4 and bringing along willing hands.
>
> Over the last eight years I've spent countless hours come rain or shine, kneeling, leaning and bent double over pits and sieves. Away from the site I've had my fair share of curries and a few wines with everyone too. I have come to love the place, the people, the contagious enthusiasm the place injects in all who visit, even the odd bit of chest-puffing rivalry and in-house politics. It's reunited me with the people of my past metaphorically and quite literally in some cases.
>
> —JULIE BROMILOW, third-generation Amesbury resident

Evidence for Mesolithic activity in the Stonehenge landscape is both rare and neglected and limited largely to the publication of discrete assemblages of material found as by-products of other projects (Leivers and Moore 2008), or summaries of find spots in the area (Darvill 2005, 62–67; Lawson 2006, 26–36). As a result, analysis of Mesolithic activity in and around the Stonehenge World Heritage Site is overdue. The discovery of a nationally important Mesolithic site at Blick Mead, in the north-east corner of Vespasian's Camp, Amesbury, Wiltshire (NGR SU146417), c. 2.3 km east of Stonehenge, provides new insights into Mesolithic and Early Neolithic society in this part of Wiltshire and in Britain more generally. This locale shows many of the characteristics of a periodically occupied 'persistent place' (Barton *et al.* 1995, 81–82; Griffiths 2014). Visited over a period of over 4,000 years, recent excavations have provided evidence of the communities who built the first monuments at Stonehenge between the 9th and 7th millennia BC, and for Mesolithic use of the place continuing into the late 5th millennium BC and the dawn of the Early Neolithic. The six radiocarbon dates of the 5th millennium BC are the only such dates recovered from the Stonehenge landscape and fill a crucial gap in the occupational sequence for the Stonehenge area at this time as 'Nowhere in the sequence is the Atlantic (Late Mesolithic) represented' (Allen 1995, 55 and 471). A further radiocarbon date from the 4th millennium BC, and the find of an arrowhead of a type associated with late 3rd millennium BC Neolithic ritual sites in Wessex (Bishop, this volume), suggest that the site was remembered into the Neolithic and may have been valued as part of the wider Stonehenge ritual landscape c. 2500 BC.

Seventeen radiocarbon dates from Blick Mead, twelve from the wet areas of the site and five from the adjacent terrace, present the longest Mesolithic sequence of dates of any Mesolithic site in Britain (Table 2.1). This aspect provokes a series of questions about the extent of Mesolithic activity in the vicinity before the creation of the Stonehenge ritual landscape. Of particular interest is whether Neolithic monuments reflect earlier activity at Blick Mead and in its surroundings.

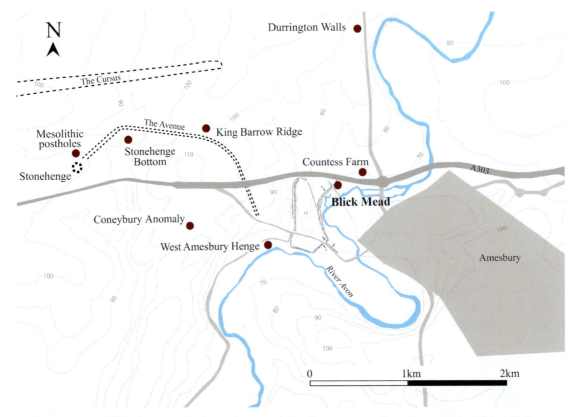

Figure 1.1: General site location: Blick Mead in its wider landscape setting. Illustration courtesy of Tom Phillips.

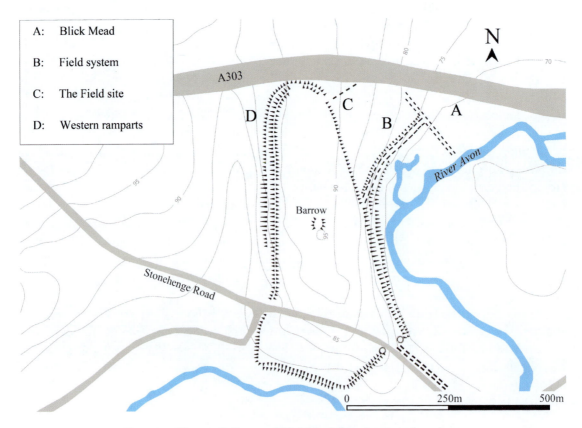

Figure 1.2: Vespasian's Camp and Blick Mead, featuring sites where there have been interventions and excavations. Illustration courtesy of Tom Phillips.

Introduction: Landscape History and Project Methodology

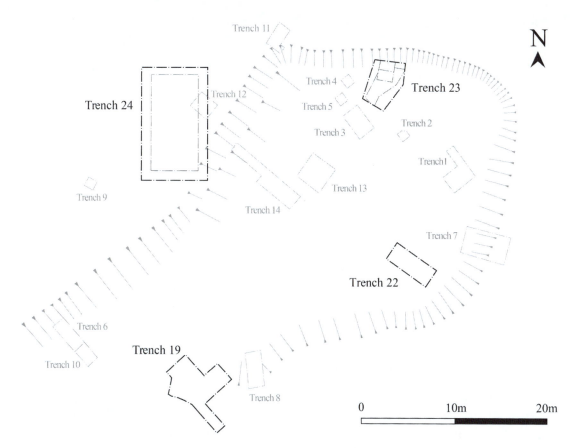

Figure 1.3: Blick Mead Trench Location Plan, showing location of trenches mentioned in text. Illustration courtesy of Tom Phillips.

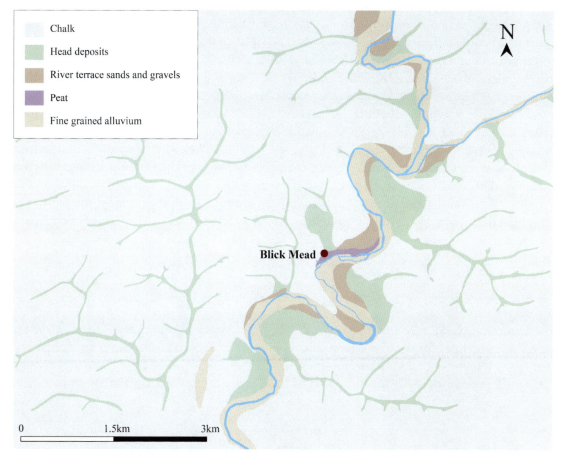

Figure 1.4: The natural geology in the vicinity of Blick Mead. Illustration courtesy of Vicky Ridgeway and Cate Davies.

Previous research and the landscape history of Vespasian's Camp

Vespasian's Camp, so called by antiquarian William Camden (there is no connection with the Roman Emperor; Camden 1610, Wiltshire 10), is an impressive Iron Age promontory fort situated on a chalk spur rising to a height of 102 m above OD on Salisbury Plain close to Amesbury. The spur was surrounded by important sites and monuments throughout prehistory and is intervisible with the Stonehenge Avenue, West Amesbury Henge, Coneybury, Ridge King Barrow Ridge, the River Avon and Durrington Walls (Figure 1.2). The place might have been expected to have had significance for the Plain's early inhabitants on the strength of its location alone. The substantial Iron Age ramparts enclose 16 ha, although it is widely assumed that the Camp's archaeology was destroyed by the Marquis of Queensberry's landscaping of the area between 1725 and 1778 (Hunter Mann 1999, 39–51) and by modern building work (Lindford 1995). Between 1999 and 2003 however, an examination of eighteenth-century maps and estate records of the site and nearby farms revealed that the north-east part of the site had been largely unaffected by the landscaping (Jacques and Phillips 2014). Recent surveys of the extent of the landscaping at the Camp confirm that interpretation and reflect how complicated the evidence is (Haynes 2013; Bowden 2017).

Previous archaeological investigation at Vespasian's Camp

There are no recorded excavations at Vespasian's Camp before the nineteenth century, though its barrows were dug into by antiquarians during the Queensberrys' period by 1770 (RCHME 1979, 22). The Antrobus family took ownership of the Camp in 1824 and permitted two small excavations there up to 2005. In 1964 Early Iron Age pottery was discovered within the western ramparts (RHCME 1979, 20) and two episodes of rampart construction, one around 500 BC and another around 400 BC, were revealed in 1987 (Hunter-Mann 1999, 50) (see Figure 1.2). The family's reluctance to allow excavations on their land has a long history, with the disfiguring of various earthworks on their estate in the past being a factor, along with a profound desire to protect and conserve the landscape (Sir Edward Antrobus, Lady Rosalind Antrobus, pers. comm.).The family's long term attitude has meant that, amongst others, Charles Darwin, Flinders-Petrie, Lane Fox (later General Pitt-Rivers) and the Wiltshire Archaeological Society had fieldwork requests refused at Stonehenge, which the Estate owned until 1915 (Chippingdale 2012, 161). In 1979 the Cornelius-Reid family purchased Amesbury Abbey and later Blick Mead from the Antrobus Estate. They also have a strong commitment to protecting the privacy and tranquillity of the landscape. Until the Blick Mead Project they had refused all requests to excavate on their land. Amesbury Abbey, Vespasian's Camp and Blick Mead have thus remained blind spots for archaeological enquiry for close to 200 years in an area world famous for its archaeology. This has meant that long standing assumptions about the extent of the eighteenth-century landscaping of Vespasian's Camp, and by extension Blick Mead, have remained unchallenged until recently.

Vespasian's Camp and the extent of the eighteenth-century landscaping design

The Duke and Duchess of Queensberry inherited the Abbey Estate in 1725. Their first estate survey, the Flitcroft Survey of 1726 (Figure 1.5), shows that the main area within the ramparts of Vespasian's Camp required for landscaping, 'Wall's Field', was not owned by the estate, with five of the eight farmed strips under the ownership of the Reverend Hayward, a major landowner in the

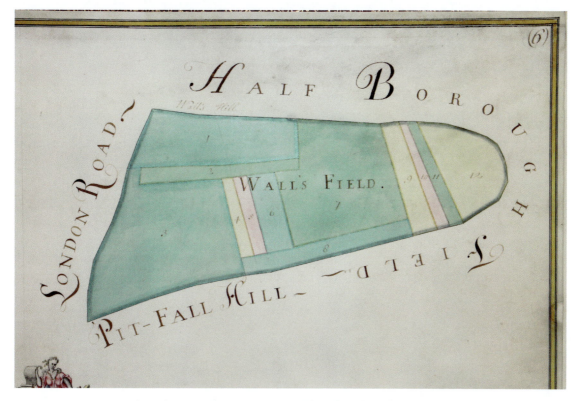

Figure 1.5: Flitcroft Survey of Little Southam Field, Wall's Field (and Vespasian's Camp) and Woolson Hill, Amesbury, 1726.

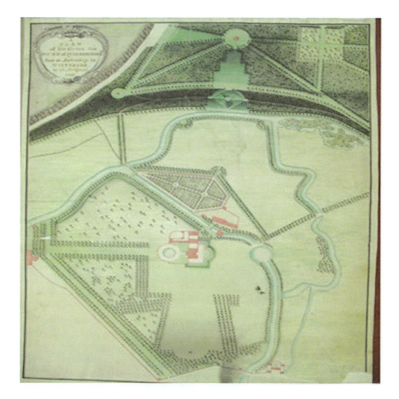

Figure 1.6: Charles Bridgeman's plans for landscaping Vespasian's Camp and Amesbury Abbey, c. 1738. Illustration courtesy of the Bodleian Library.

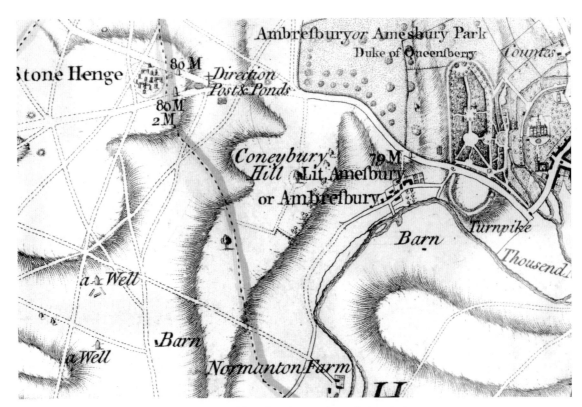

Figure 1.7: Dury and Andrews' map of Amesbury parish, 1773.

area (WRO 944/2; Figure 1.5). Wall's Field was purchased by the Queensberry Estate in 1735 (WRO 283/176; Murray (ed.). 1824, 109), but the estate survey of 1741 indicates it was still unenclosed, with twenty-five of its twenty-seven acres being rented out for open field cultivation (WRO 283/6 4). The area is recorded as being fully enclosed in the 1742 estate survey, but strips two and six continued to be farmed by separate freeholders. Separate negotiations would have been required with them for the landscaping plans in this key area for the design to be realised. Seventeen years after the Queensberrys first inherited the estate, four years after Charles Bridgeman's designs showed them fully landscaped (Bodleian Library, MS Gough Drawings a3* folio 32; Figure 1.6), the landscaping of these crucial parcels of land had not even begun.

The piecemeal process of the land acquisition is also evident in the purchasing of Half Borough Field which ran up to the ramparts from the north-west. Half Borough was part of the Reverend Hayward's estate at West Amesbury and by the 1741 survey only fourteen of a possible thirty-three acres of it were owned by the Queensberrys. The tree lined avenue running from the Abbey mansion to Vespasian's Camp and on to the parklands to the north-west is described as a 'new walk' in the survey (WRO 283/6). It may have been a visual reminder of where the boundaries were between Half Borough Field and the Abbey Estate land.

Hayward is recorded as selling 'A Piece of Enclos'd pasture called the sling near Countess Farm' in 1741 (*ibid.*) which is likely to have adjoined Half Borough Field. Later called 'The Slang next to Countess Farm' in the 1771 estate survey (WRO 944/3), the names 'Sling' or 'Slang' are topographical field names which originated in the West Country that described a narrow strip of land beside water and/or a long strip of land connecting larger divisions of ground (Dolan 1998, 215). Both meanings fit with the shape and position of the terrace, which the 1824 estate map explicitly names 'The Sling'. It is shown as immediately adjacent to Blick Mead, as named (WRO 283/219), to the west. Its association with Countess Farm rather than Vespasian's Camp in the 1771 survey points to it being outside of the landscaped area.

Introduction: Landscape History and Project Methodology

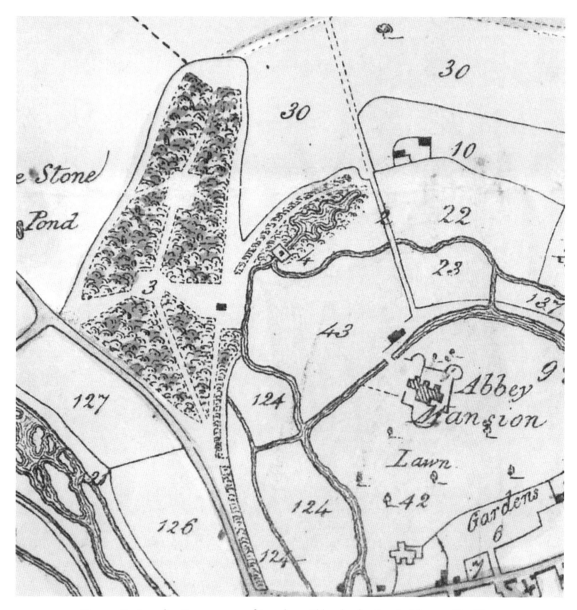

Figure 1.8: Antrobus Estate survey of Amesbury Abbey lands, 1824. '10' denotes The Sling. Blick Mead is in the land parcel denoted '22'.

In 2011 the terrace 'Sling' area was interpreted by English Heritage senior investigators Mark Bowden, Dave Field and Dave McComish as likely to have been part of a large lynchet. It had been an area of interest for the Blick Mead Project since its inception in 2005, but in 2014 this identification encouraged us to choose it as a target for ground-penetrating radar by the Stonehenge Hidden Landscapes Project after that was supportively offered to the project free of charge. Subsequent investigations in 2014 and 2015 were to demonstrate that a late 5th millennium BC Mesolithic residential and activity area lay beneath the lynchet and colluvium (see below).

The name and place 'Blick Mead' is first recorded in 1796 in Queensberry Estate records entitled 'Parts of the park let to Ingrams and Waters' (WRO 776/1122). These show that Blick Mead was leased to tenant 'farmer' Waters. Letters by Christopher Ingram, tenant farmer at Countess Farm, to the Queensberrys' solicitor John Hodding, demonstrate that he and Waters got on well and had shared concerns about the limited resources their areas of land had (WRO *ibid.*). They, along with other estate documents, show that Countess Farm and Blick Mead were places of work and not landscaped, as has been assumed. The Dury and Andrews' map of 1773 (WANHS 1952) also indicates that there was no landscaping in this area (Figure 1.7).

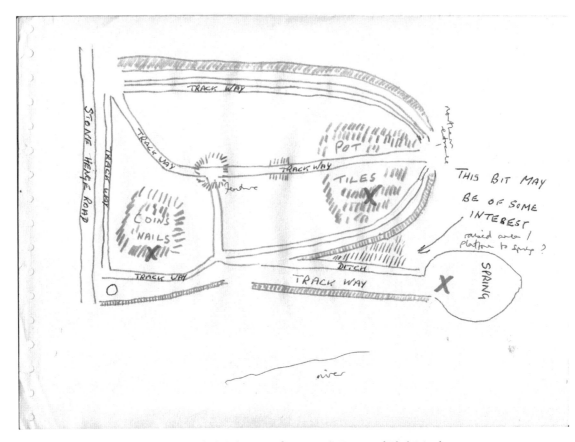

Figure 1.9: Mike Clarke's drawing of Vespasian's Camp and Blick Mead, 2005.

Dury and Andrews' map gives no indication of a spring in the Countess Farm and Blick Mead areas. However, Christopher Ingram's letters to John Hodding between 1788 and 1797 contain two references to 'a pond' which was used by the estate's dairy cattle. Ingram's correspondence relays concerns about the effect of new field boundaries, likely to be as a result of enclosure, on this important water source – 'If it was only the pond for watering your cattle … (the new field boundaries) will make such confusion there' (WRO *ibid.*). In another letter Ingram explains to Hodding that there are not enough water resources on the farm to accommodate an extra dairyman – 'I have looked over your pond … but no plaise for dairyman unless going to a considerable expense. In first place there is not a drop of water to be had, unless some of your neighbours which is verry against Dairying' (WRO *ibid.*).

Evidence from Trench 14 also suggests that there was a pond at Blick Mead abutting the terrace (see Appendix A). Some nineteenth- and twentieth-century Ordnance Survey maps of the area depict a small pond feature with field boundaries converging around it (e.g. 01 County Series 1st edition 1st revision 1:2500 1901; Figure 1.10). This is one of the areas which still has standing water in most winter months as a result of pooling of spring water (Mike Clarke, pers. comm.). Evidence of extensive post-medieval cobbling and chalk surfaces are present in many trenches in the northern and western areas of the site (Trenches 1, 2, 4, 5 and 14–11; Appendix A). The 1824 estate map records a yard with some buildings on the Sling and it is possible that these surfaces were laid to accommodate cattle so they could get access to water without churning up Blick Mead (Figure 1.8).

Introduction: Landscape History and Project Methodology

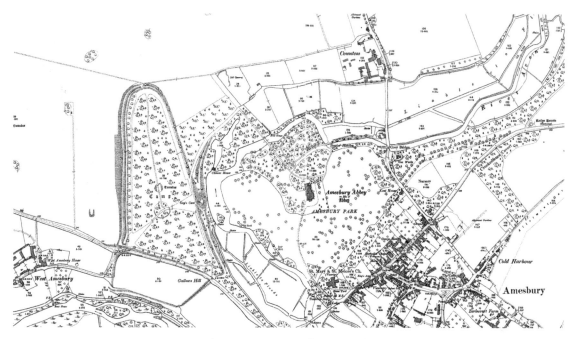

Figure 1.10: Ordnance Survey map of Vespasian's Camp area, 1901.

Locating the excavation areas

On the basis of the results of the investigations into the estate records, a letter was written to Sir Edward Antrobus in 2005 suggesting a meeting. Sir Edward responded by arranging one between his site custodian Mike Clarke and the author at Vespasian's Camp.

Mike's Clarke's long-term personal interest and sensitivity to landscape features in the Camp have been pivotal to the project from the beginning and it was his astute knowledge, garnered over decades of working at the site, which confirmed and greatly added to the efficacy of the review of the estate records. During the meeting, which was largely held at Blick Mead, he passed on his drawing of Vespasian's Camp (Figure 1.9). A spring and area that may be of some interest is labelled by Mike in the bottom left of the picture, and the author's handwriting points out the terrace (the Sling) immediately to the west of it. It was partly on the basis that there was a shared area of interest that Mike gave the team permission to work at the site.

The aims and methodology of the project have evolved over the course of the project. It was apparent that the landscaping was less intrusive than had been previously assumed at Blick Mead, which fell outside the area covered by the Scheduled Monument, so areas within it were targeted for excavation. We were particularly interested to examine the spring area as such accessible water sources are relatively rare on Salisbury Plain. Investigations in the Stonehenge landscape have tended to focus on the monuments therein, but our main focus was on a place which potentially provided a key resource for people and animals in the past.

Within the wet areas of Blick Mead small trenches were opened to determine the depth of deposits, identify any features and to recover artefacts and ecofacts. The trenches were located to provide an even spread across the wet area of the spring and included some on the dry area of the terrace.

Mesolithic material was first found in Trench 19, which began as a 3 m × 3 m hand-excavated trench in 2010. During initial excavation Mesolithic flints were retrieved from a dark brown sticky silt, measuring 0.2 m thick, approximately 1 m below ground level (see results in Chapter 2 below).

Conditions were very wet and the flints were extracted almost from below the water table (Figure 1.11). The scale and significance of the deposits within Trench 19 soon became clear and so from October 2012, four excavation days after they were first encountered, all spoil from layer [59] in Trench 19 and subsequently also from the Mesolithic deposits in Trenches 22 and 23 were sieved through four custom made sieving machines with both 2 mm and 5 mm mesh.

Between 2005 and 2010 the project was restricted to one weekend of fieldwork per year at the site due to landowner concerns about public access and the need for our work to be as un-intrusive as possible. This greatly reduced our scope to access funding. Over that period test pits revealed that the Blick Mead 'basin's' northern, eastern and southern sides contained dumped material and Made Ground, largely as a result of the widening of the A303 in the late 1960s. They also indicated that the site had a long history of use in part because of its proximity to an accessible supply of water (Phillips and Lyons, this volume, and Appendix A).

Project methodologies

For the first six years, the project fieldwork was undertaken and financed as a part of an Open University student training weekend exercise which involved local volunteers from Amesbury; between 2005 and 2008 the project was financed on a grant of £500 per year. Since 2009 this funding has been supplemented by Amesbury Town Council, who awarded an annual grant of £1,000 in recognition of the way the project had involved the town, whether it be through local volunteers taking part in the excavation weekends, the project's outreach to local schools and other community groups and businesses, or through the way the media presented the town (see Allerton, Afterwords, this volume). These sums, plus donations from volunteers, paid for one long fieldwork weekend per year between 2005 and 2010. Sixteen days in total were spent in the field from 2005 to 2011.

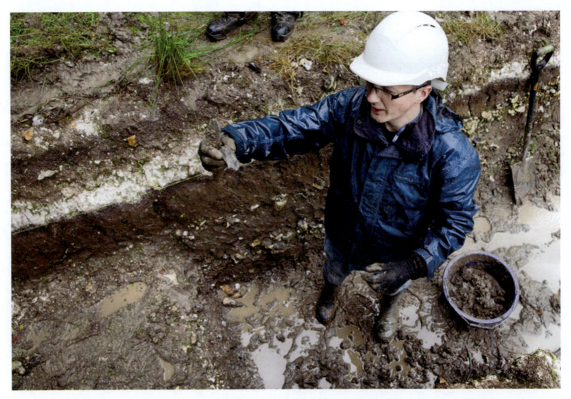

Figure 1.11: A moment of discovery: Tom Phillips discovers a worked flint in a boggy Trench 19. Photograph courtesy of Tom Lyons.

In 2013, funding increased significantly as a result of the University of Buckingham's adoption of the project. As a result, longer fieldwork seasons were possible and, between 2005 and 2016, seventy-two days of archaeological excavation have taken place.

Since 2010 the project team on site has been made up of about twenty people at any one time. As well as the principal authors and volunteers, the work on site has involved subject area specialists including Eamonn Baldwin (GPR and Stonehenge Hidden Landscapes Project), Barry Bishop (Lithics, University of Buckingham), Nick Branch (Environmental Science, Reading University), Tony Brown (Physical Geography, University of Southampton), Sophy Charlton (ZoomS, Natural History Museum), Chris Green (Environmental Science, Reading University), Nick James (Landscape History, University of Cambridge), David John (Algal Biogeography, Natural History Museum), Vicky Ridgeway (PCA), Peter Rowley-Conwy (Faunal Remains, Durham University), Bryony Rogers (Faunal Remains, Durham University). The following have visited the site, often during the excavations, and given advice: Martin Bell (Reading University), Mark Bowden (Historic England), Richard Bradley (Reading University), Chantal Conneller (University of Manchester), Tim Darvill (University of Bournemouth), Dave Field (ex Historic England), Roy Froom, Vince Gaffney (University of Bradford and Stonehenge Hidden Landscapes Project), Clare King (Wiltshire County Council Archaeology Department), Jonathan Last (Historic England), Bernhard Maier (University of Tubingnen), Dave McOmish (Historic England), Phil McMahon (Historic England), Lorraine Mepham (Wessex Archaeology), Wolfgang Neubauer (Ludwig Boltzmann Institute, Austria), Mike Parker-Pearson (University College London and Stonehenge Riverside Project) Josh Pollard (University of Southampton and Stonehenge Riverside Project), Melanie Pommery-Killinger (Wiltshire County Council Archaeology Department), Julian Richards (Archaemedia), Nick Snashall (National Trust), Kate Welham (University of Bournemouth and Stonehenge Riverside Project) and Caroline Wickham-Jones.

One consequence of such tight financial and time constraints was that there was more time for desk-top research and discussion before targets were selected for excavation. Another was that there

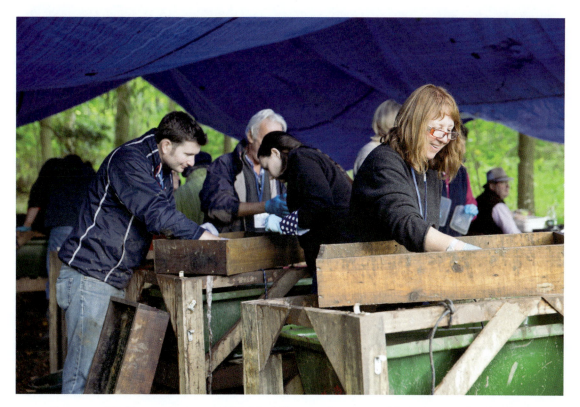

Figure 1.12: Working on the sieves at Blick Mead. Photograph courtesy of the University of Buckingham.

were more opportunities for local volunteers and institutions in Amesbury to get involved (Allerton, Afterwords, this volume). In 2010 the donation of high-power water pumps from local company QinetiQ (Boscombe Down) enabled the team to excavate below the c. 0.6 m water line in the spring for the first time. Since 2012, bespoke sieves designed by Tony Legge, made by local residents and donated to the project by the town have enabled 100% sieving of all material excavated in trenches 19, 22 and 23 as well as all the features found in Trench 24.

The radiocarbon dating sequence for the site has often been funded by volunteer contributions. In terms of research outcomes, the initiative has led to a uniquely detailed sequence of dates for the British Mesolithic (see Table 2.1).

One of the most distinctive and encouraged aspects of our work at Blick Mead is that local and other volunteers become absorbed by different aspects of the project and have different interactions with the past. The discovery of the magenta-coloured flint phenomena, for example, was by a volunteer who picked up a tiny piece of unworked flint in the pool at the end of the springline at Vespasian's Camp which she thought was an interesting shape and put it in her pocket to show one of the specialists. When she retrieved it later it had begun to turn bright pink. This phenomenon may not have been found without the particular volunteer dynamic the site has (Vince Gaffney, pers comm.). It was ultimately to lead to the involvement of algae specialist David John of the Natural History Museum (Chapter 4, this volume).

The meaningful contributions and involvement of local volunteers to the excavations mean a great deal to the residents of Amesbury. Media interest in Blick Mead has been of great importance to Amesbury and has been encouraged by all the local stakeholders. BBC programmes such as *Flying Archaeologist* (<http://www.bbc.co.uk/programmes/p017h423>), for example, have prominently featured the town's involvement in the discoveries, and international publications such as the New York Times have foregrounded volunteer contributions (Chang 2015, D2). Overall, the media coverage of Blick Mead has cast the town and the excavations in a positive light and enabled Amesbury to get ownership over at least some of its internationally famous past.

A series of quotations from site volunteers, interspersed throughout this volume at the beginning of each chapter, give unique insight into what Blick Mead has meant for volunteers from Amesbury and beyond and highlight the significance of these excavations for all of those who have been involved with the project. Through the involvement of volunteers of different talents, backgrounds and abilities, the team at Blick Mead has become more aware that the past is seen differently by different communities and that it has different values for them. This has been seen as a strength as it provides a different set of voices with which to cross reference our approach and data set. Mick Smith's remarks (see Chapter 6) illustrate that some volunteers offer transferable, but not exactly the same, methodological approaches which are of benefit to the archaeology. At a site like Blick Mead the archaeologists are not able to set their own agenda; it has to be negotiated through a variety of local stakeholders. This arguably makes for a more nuanced research plan which foregrounds good communication skills. The benefits of this approach to the town are best exemplified by Amesbury Town Council's decision to build a new museum in Amesbury, the first the town has ever had, to house its local archaeological finds. Local people were given the chance to vote on whether they wanted the museum as there had to be an increase in the local Community Charge to pay for it. Over 90% of the townsfolk voted in favour of this increase (Allerton, Afterwords, this volume).

Project leadership

As someone who has suffered with a congenital spinal problem since my youth I am aware that I am an 'incomplete leader' in a trench. Bearing in mind the various complexities the project has thrown

Introduction: Landscape History and Project Methodology

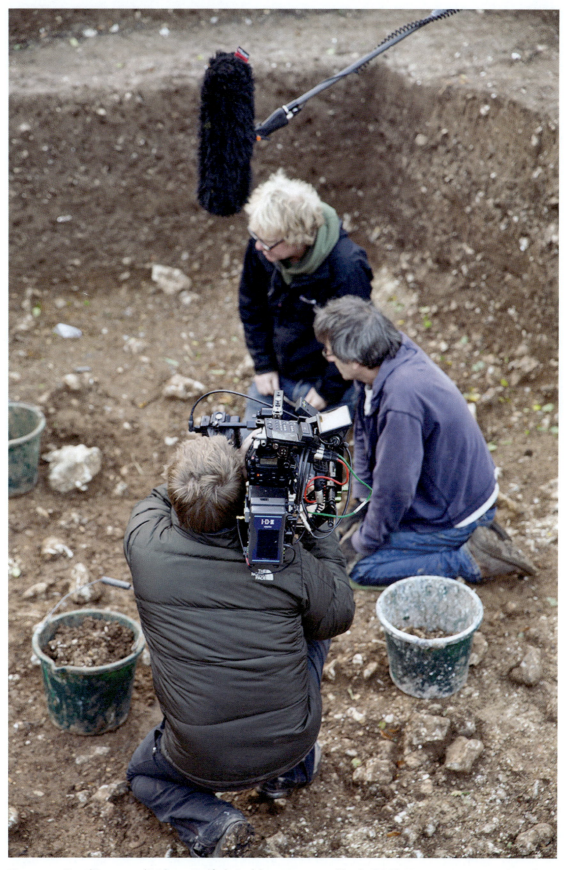

Figure 1.13: David Jacques and Malcom Guilfoyle-Pink being interviewed by the BBC's *Horizon* programme in Trench 24. Photograph courtesy of the University of Buckingham.

up since 2005 I also lack some skills in other areas. The project has taken the approach of seeing an incomplete leader as something not to be feared; that indeed it is better to think about what people do best and create conditions under which others can lead different aspects of the project and distribute leadership accordingly. This model has reduced hierarchy on site and has evolved to a point where people at all levels in the project feel able to assume a greater responsibility. At Blick Mead this has created some simple but effective rubrics.

(1) Everyone working on site is encouraged to use their wider perspectives and abilities to consider other possibilities when faced with interpretive problems.
(2) People are encouraged to reveal their ignorance of some situations, mistakes and lack of capability in a particular context. Our experience has been that this helps establish trust and ensures that people feel secure enough to admit mistakes, or that things are not going well.
(3) 'Amicability', a methodological concept developed Agile Software Development (Cockburn 2005), is encouraged. The term, essentially meaning the willingness to listen with goodwill, has resulted in the team on site being more comfortable in exchanging information quickly. This should not be confused with politeness, as that can mean that people simply cover disagreements passively so don't sufficiently detect or deal with problems. At Blick Mead people can be competitive with each other (see Julie Bromilow's comments above), but as a rule this is not taken personally. We have found that once amicability and trust are established a useful and productive working dynamic tends to emerge.
(4) We have found that (3) is easier to establish if the numbers on site are capped at 20. People are more likely to interact with one another, volunteer and specialist alike, and come to know each other sooner. The communication that comes from background hearing and along lines of sight on site really only works with small teams of this size in our experience as the feedback loops are smaller. In our experience people are unlikely to self-organise if the group is much bigger. Both landowners and Mike Clarke prefer the daily site team to be small sized too. Being a research-led excavation which is sensitive to landowner concerns we are in a good position to cap our team size.
(5) We have found that a recurring problem with many archaeological methodologies is that they do not provide a sufficient focus on small rules or the effects of individuals with strong personalities. These are issues that can affect the success of a project design and such aspects need to be accounted for. A clear emphasis on (3) is important to mitigate this.
(6) As archaeologists, it is a professional duty to engage with a range of communities and mediate their involvement.

In short, excavations at Blick Mead are characterised by having (i) dedicated, (ii) experienced people who (iii) are within earshot of each other, (iv) have easy access to site specialists and are used to (v) providing tested results regularly. This sounds simple and obvious, but in our experience such a framework is not present on every excavation.

This report

This report presents the results of fieldwork at Blick Mead between 2005 and 2016, and the subsequent analyses of the recovered finds assemblages. The report focuses in detail on archaeological research up to 2013, covering the excavation of Trenches 1 to 23 and borehole survey of the Blick Mead area. It also references more recent findings, specifically those in Trench 24, analyses of which are still ongoing, as indeed is excavation. The intention is to consolidate and disseminate the results of research to

date. Given the interim nature of this work, the perceived importance of Blick Mead and the interest it has generated, the approach taken to publication is thorough and inclusive.

Numerous other reports, both archive and published, support and complement this work. These include a detailed archive report on the findings up to 2013 (Jacques and Phillips 2014), numerous project designs, as well as published articles (Hilts 2017; Jacques *et al.* 2017; Jacques *et al.* 2014, Jacques and Phillips 2014; James 2012; Jacques *et al.* 2010) contributions to books (Jacques *et al.* in press 2018; Jacques 2017) and online articles (Jacques 2015; Rogers *et al.* 2015).

This Chapter set out to present the landscape history of the site and to provide a methodology for the project. Chapter 2 presents the methodologies and results of the fieldwork in those trenches which produced evidence of prehistoric occupation, specifically Trenches 19, 22, 23 and 24 (to date). Full descriptions of the archaeological sequence in other trenches investigated are given in Appendix A1. Analysis of the site's setting and its vegetational history is provided in Chapter 3 (Environmental Setting). This details work undertaken by QUEST (Quaternary Scientific, Reading) on boreholes and bulk samples. A short interim statement on plant remains from a tree-throw in Trench 24, by Tom Maltas, University of Sheffield, concludes the chapter, bringing the fieldwork up to date. Chapter 4 presents the evidence for flintworking; data from Trenches 19, 22 and 23 have been fully catalogued and are reported on in detail. An interim statement on the findings from Trench 24 is included for completeness. The chapter concludes with reports on microwear analysis to examine evidence for tool use, portable XRF analysis to attempt to establish the provenance of a possible slate artefact and a consideration of the causes and implications of the phenomenon of crimson colouration on flints from a nearby pool. Chapter 5 considers the evidence for large animals, through identifiable bone fragments and includes sections on the isotopic analysis of the teeth of large herbivores (aurochs). It concludes with a report on fragmentary skeletal material. Through the application of a newly developed biomolecular technique, Zooarchaeology by Mass Spectrometry, it has been possible to identify bone fragments, too small to be identifiable macroscopically, to species. The small invertebrate remains found are discussed in Chapter 6. Finally, the results and the questions they have provoked are pondered in Chapter 7. A series of Appendices provide additional data and supporting documentation.

CHAPTER 2

Fieldwork Results: The Archaeological Narrative

> A key memory, from 2010, is of taking a mattock to what was just about to become Trench 19. The layers of chalk backfill from the A303 and the horseshoes that soon appeared did not prepare us for the extraordinary finds that would emerge over the following years. The site at Blick Mead subsequently became, for us, one of pilgrimage, shared with fellow-travellers from all backgrounds and occupations. We had, together, been drawn to an exceptional and unspoiled place to be inspired by the enthusiasm, vision and expertise of the project team. All of them wore their knowledge lightly and encouraged us to have a role to play.
>
> — KERRY AND JOHN HOLMES, volunteers, Reydon, Suffolk

This chapter presents the results of excavation in those trenches which produced significant prehistoric remains. In only four trenches of the 24 excavated, were *in-situ* prehistoric (Mesolithic) horizons reached. This volume focuses on the excavations in three of those trenches, which lay within the lower lying, spring, or wet area of Blick Mead (Trenches 19, 22 and 23). The archaeological results of excavations in a fourth trench (in Trench 24), at a higher level on a natural terrace overlooking the spring, have been included here. This comprises the most recent three seasons' excavations, analyses into the artefactual and ecofactual assemblages from Trench 24 are ongoing and it is important to note that any interpretations offered here are preliminary and may be subject to amendment or change. Nevertheless, the results are presented here as it is felt that this enables the natural topography of the site to be better understood and brings interim reporting on the fieldwork up to date.

Descriptions of all other trenches excavated are included as an appendix to this volume (Appendix A1). A full report detailing the circumstances and results of the excavations to 2013 has been produced and is held with the archive (Jacques and Phillips 2014). A peer reviewed report on the findings in Trench 24 up to 2016 is in press (Jacques *et al.* 2018).

Fieldwork methodology and results
– Tom Phillips, Tom Lyons and David Jacques

In total, twenty-four trenches have been excavated, twenty-three of them in the waterlogged areas at Blick Mead, ranging from 1 m × 1 m pits, to the largest trenches which measured 6 m × 3 m (Trench 19), 5 m × 2 m (Trench 22), 5 m × 3 m (Trench 23) and 12 m × 7 m (Trench 24, the terrace trench). Trenches 19 and 23 were dug to a minimum of 0.6 m depth and revealed well-sealed and waterlogged deposits. Trench 22 was also dug to 0.6 m depth, but the Mesolithic deposits there were disturbed by probable medieval/post-medieval ditch digging in the area (see below). Trench 19 yielded a nationally important assemblage of Mesolithic faunal remains and lithics (Rogers *et al.*; Bishop; this volume). In the terrace area, Trench 24 was located immediately to the north-west of the waterlogged area. Excavations here revealed a Mesolithic residential and activity area dated by a tight sequence of radio-carbon dates to the late 5th millennium BC. The following provides detailed excavation methodologies and descriptions of the four trenches with significant Mesolithic archaeology. Further descriptions of the other trenches and finds dating to later periods can be found in Appendix A1.

All deposits within each trench have been recorded using pro-forma context sheets, section drawings (drawn at 1:10 or 1:20), trench plans (drawn at 1:20 or 1:50) and photographs (both digital and film SLR). Several volunteers have metal detected the majority of trenches and spoil heaps. Deposits were recorded using a single context recording system, in which each individual event (deposit, fill or cut) identified on site, was assigned a unique number, presented here in square brackets, thus [95]. In some cases (particularly the excavation of flint-rich layer within Trench 19, the layer was subdivided spatially (into 1 m × 1 m squares) for the purposes of analysing finds distributions; in this case each individual square was assigned its own unique context number, which formed part of the layer (see individual methodologies below).

Excavation methodologies

The following section outlines employed during the excavation of each of the trenches reported on here.

TRENCH 19

Mesolithic material was first found in Trench 19, which began as a 3 m × 3 m hand-excavated trench, in 2010. It was originally opened on the advice of site custodian Mike Clarke who had noticed that the area was damp in high summer (normally a time when the water table is at its lowest). During initial excavation Mesolithic flints were retrieved from a dark brown sticky silt, measuring 0.2 m thick, approximately 1 m below ground level. Conditions were very wet and the flints were extracted almost from below the water table. The scale and significance of the deposits within Trench 19 became clear by 2011, four working days after first encountering it. From 2012 all spoil from this

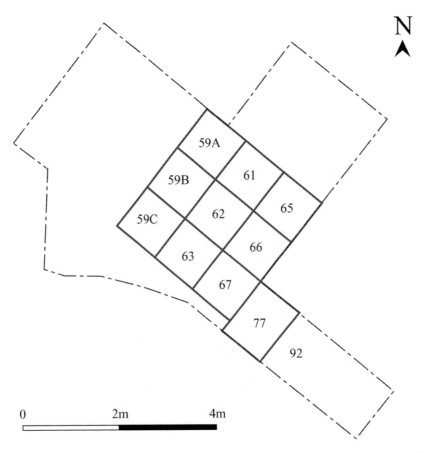

Figure 2.1: Trench 19 plan, showing division of layer [59] into 1 m × 1 m squares. Illustration courtesy of Tom Phillips.

deposit (layer [59]) was sieved through four custom made sieving machines with 2 mm and 5 mm meshes. Subsequently, the trench was extended to 6 m × 3 m by 2013, with a further 1 m × 3.5 m extension to the east also in 2013 as this area had the densest concentration of flint. Layer [59] sat below the water table, which varies depending on the time of year, but is on average c. 0.5 m below ground level. The high water table hampered excavation, especially before 2011 when the project was not able to resource a powerful enough water pump, as has the heavy viscous quality of the sediment. The layer was assigned an overall context number, but in addition, individual context numbers were given to each 1 m × 1 m grid square excavated in order to enable the spatial distribution of finds to be analysed. the viscous nature of deposits in the trench combined with the wet conditions, rendered three-dimensional recording of individual findspots impractical. In order to elucidate the stratigraphic position of the lithic material *within* the BCH, one of the 1 m × 1 m squares, context [77], was excavated in five horizontal spits (Table 4.1), numbered successively in this report [77.1] to [77.5], [77.1] being the highest.

Trench 22 was located in the north-east of the spring, close to Trenches 1/20 and 7. It was originally opened to investigate the nature and succession of natural geological stratigraphy at the base of the existing slope. It measured 5 m × 2 m and was hand excavated to a depth of 1.34 m.

Located at the far north end of Blick Mead and c. 5 m from the A303, Trench 23 measured 5 m × 3 m and was hand excavated at its deepest point to a depth of 1.4 m below modern ground level (a 1 m² test pit against the northern baulk). It was originally opened to investigate whether any natural geology was present at the base of the existing slope.

The results of excavation in Trench 24 will form the subject of future reporting. Much material remains to be analysed and any statements presented here are, of necessity, provisional. Nevertheless, it is felt that it would be useful to present the archaeological sequence for this trench here.

In 2014 investigations were extended to evaluate any relationship between the Mesolithic deposits in the wet areas of Blick Mead and the adjacent higher terrace to the north-west. Trench 24 was positioned on a slight downward slope from north-west to south-east. This had been known by its Middle English names the 'Sling' or 'Slang' in the late eighteenth century. Prior to excavation a ground-penetrating radar survey of the terrace area by the 'Stonehenge Hidden Landscapes Project' team had revealed an ovoid feature about 1.8 m below the ground surface (Baldwin, this volume, Appendix A3)

Fieldwork results

TRENCH 19

The earliest recorded layer in the sequence [78] was a pale green sandy silt at least 0.3 m thick, with the upper horizon c. 1 m below ground level. No finds were recovered, although the deposit was not extensively sampled. Layer [78] was sealed by Mesolithic horizon [59], a viscous dark brown silty clay 0.2 m thick, which extended uniformly across the trench without any obvious gradient. This layer was divided horizontally into 1 m squares so that the distribution of finds could be examined more closely (contexts [59], [61], [62], [63], [65], [66], [67], [76] and [77]; Figure 2.1). The last excavated m² within layer [59] context [77] was also divided horizontally into 5 cm spits as a cautious method of recording finds distribution. Unfortunately, as with the other trenches in the wet areas, the viscous nature of the silty clay soil, combined with the high density of struck flints, made three-dimensional recording of finds impractical.

This layer has yielded 11,727 pieces of Mesolithic worked flint reflecting the entire process of tool production. The tools themselves indicate a wide variety of tasks being undertaken close to the site across the radiocarbon date range and with a wide range of retouch types. An exceptionally large amount of burnt flint indicates nearby hearths and possibly large fires (Bishop, this volume, Chapter 4).

In addition to the lithics, an important assemblage of 2,058 large vertebrate animal bones was recovered from layer [59]. Durham University has examined the bones and, of the 236 bones identified to species, 57% were found to be from aurochs (*Bos primigenius*) (Rogers *et al.*, this volume, Chapter 5).

A ZooMS's analysis of twenty unidentified fragments of bone provides an even higher percentage (Charlton, this volume, Chapter 5).

The fauna from Trench 19 have yielded nine radiocarbon dates across a 2,900-year period in the Mesolithic (see Table 2.1). The earliest date (7596–7542 cal BC, 8542±27 BP; SUERC 42525) indicates activity contemporary with the monumental post structures in the Stonehenge car park (8500–6600 cal BC; Vatcher and Vatcher 1973) and the most recent is of 5th millennium BC date (4846–4695 cal BC, 5900 ± 35 BP; SUERC 37208).

Layer [59] was sealed by layer [58], a sediment with similar composition to [59], but with one intriguing difference. Although this deposit did not include the same large quantity of finds as [59] it did incorporate frequent fragmentary unworked flint nodules that appear to have been either consolidated by people or by some natural process. The recovered finds assemblage included struck flints in a more chipped condition than those in that layer including Neolithic and Bronze Age pieces (Bishop, this volume, Chapter 4). This is suggestive of the wet area continuing as a focal point of some sort through successive periods.

TRENCH 22

The earliest recorded deposit in Trench 22, was layer [96], a light greyish/greenish brown sandy silt with occasional gravel inclusions, measuring at least 0.42 m thick. This was the closest equivalent to layer [78] in Trench 19 and layer [93] in Trench 23. Layer [78] was sealed by layer [91], a greyish

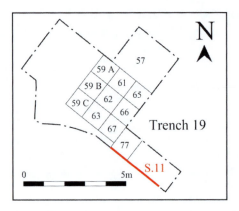

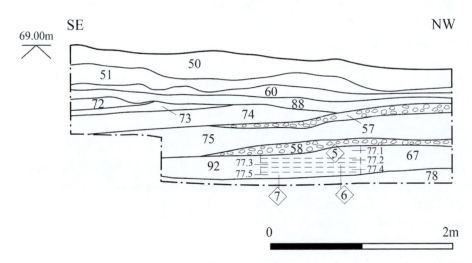

Figure 2.2: North-east facing section through deposits in Trench 19. Illustration courtesy of Tom Phillips.

Figure 2.3: Section through deposits in Trench 19 (scale 1 m). Photograph courtesy of Tom Lyons.

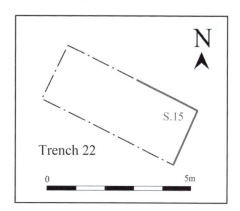

Section 15

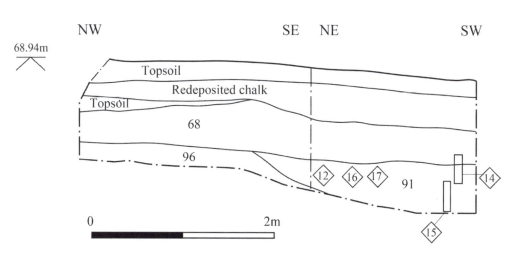

Figure 2.4: South-west facing section, Trench 22. Illustration courtesy of Tom Phillips.

blue silty clay visible in the south-east corner of the trench (Figures 2.4–2.6), measuring 0.48 m thick. It contained a large and dense concentration of both struck flint (3,454 pieces) and burnt flint (841 pieces, 5,533 g), along with animal bone. It contained few inclusions. Some large flint nodules were recovered from the base of layer [91] which displayed few signs of erosion/attrition indicating

Section 14

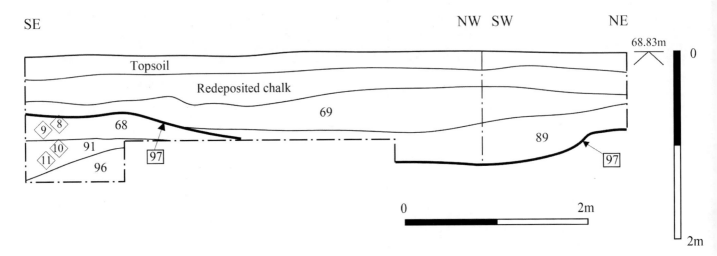

Figure 2.5: North-west facing section, Trench 22. Illustration courtesy of Tom Phillips.

that they had not travelled far out of chalk bedrock (Barry Bishop, pers. comm.). A fragment of aurochs femur from layer [91] was radiocarbon dated to 5289–5048 cal. BC (SUERC-51969; 95% confidence; 6198 ± 32 BP).

Layer [91] was sealed by layer [68], a viscous mid-grey clay measuring 0.44 m thick, which yielded 338 struck flints, burnt flint (ninety-six fragments, 1305 g) and animal bone. Layer [68] was then truncated by the cut of linear feature [97], interpreted as a medieval/post-medieval drainage ditch. The ditch was orientated north-west to south-east, meaning it was encountered obliquely in section 14 (Figure 2.11) and in the base of the trench (Figure 2.10). The ditch measured 1.04 m wide and 0.58 m thick although its full dimensions were not exposed within the trench.

Layer [91] and overlying [68] were observed to be alluvial deposits belonging to an ancient course of the Avon which had been deposited under very low energy conditions (Tony Brown, pers. comm.). Riverine sands/gravels [96] which sloped down towards the eastern end of Trench 22 and extended further east are likely to have formed the edge of this putative ancient Avon. The underlying gravel deposits still carried water and essentially acted as a sealed aquifer, beneath the clays and silts as seen in the eastern end of the trench (*ibid.*). Trench 22 had inadvertently been positioned across the edge of this ancient river course where underlying water carried through gravel could well up where the overlying clay silts layer [91] were relatively thin. Tony Brown stated that this fitted entirely with Mike Clarke's observation that the eastern end of Trench 22 was the location of the greatest pooling of water from below. Furthermore, he posited that the springline located to the south is likely to be part of the same phenomenon: water being released from underlying gravels at the margins of a palaeochannel where sealing clays/silts are relatively thin. If this is the case, the upswellings of groundwater observed at Blick Mead do not originate from a classic chalk spring.

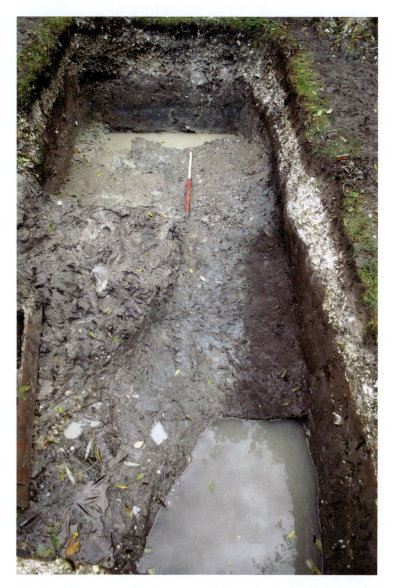

Figure 2.6: Trench 22 during excavation, looking east (scale 1 m). Photograph courtesy of Tom Lyons.

Ditch [97] contained two fills [89] and [69], both of which comprised very dark brown peat with some silt. The lower fill [89] contained fragments of wooden stakes similar in nature to the medieval and post-medieval ones recovered and dated from Trench 6 (Appendix A1) although they were not *in situ*. Fragments of unworked wood, struck flint (382 pieces) and burnt flint (121 pieces, 1,216 g) were also recovered. Fill [69], a dark brown peat deposit measuring 0.2 m thick, contained fewer inclusions of struck flint (180 pieces) and burnt flint (eighty-nine pieces, 1,421 g). It also contained a fragment of iron, thought to be post-medieval in date.

The assemblages of struck flint from both the clay layers [91] and [68] and the peat deposits are indistinguishable from each other and closely comparable to the material from that of layer [59] in Trench 19 (Bishop, this volume, Chapter 4). They are blade-based and date to the Mesolithic. Intrusive pieces from later industries were very rare, though the material from the peat was clearly residual.

Ditch [97] was sealed by redeposited natural chalk (deriving from road construction dumping), measuring 0.1 m in thickness. Modern topsoil up to 0.15 m thick completed the sequence. That fill [68] directly underlay redeposited modern chalk – spread around inconsistently – makes it probable that 1960s activity relating to the A303 widening immediately to the north involved removal of original soil sequences by heavy machinery. This would account for the fact that modern material sits atop ancient deposits with no deposits relating to intervening historic periods.

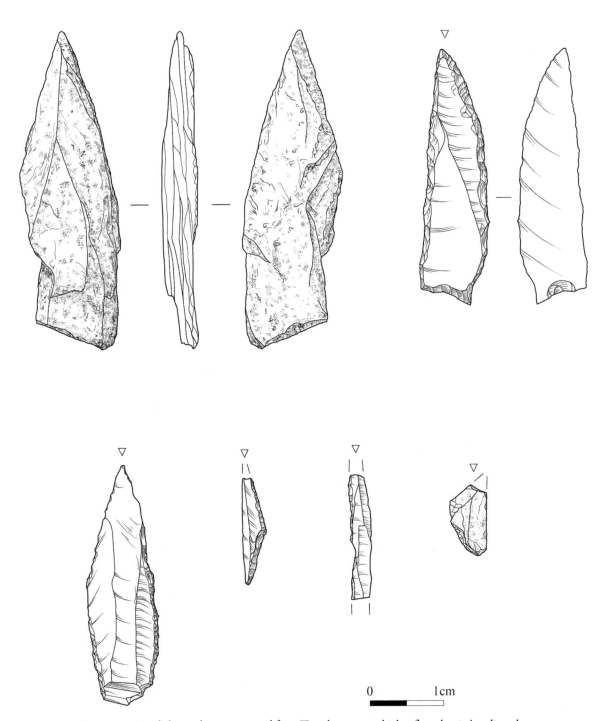

Figure 2.7: Mesolithic tool types retrieved from Trenches 19–23 which reflect the site's radiocarbon date range. Illustration courtesy of Cate Davies.

TRENCH 23

The earliest recoded deposit was layer [93], a light blueish green sandy clay measuring at least 0.6 m thick. Layer [93] had the appearance of a riverine silt, roughly equivalent to layer [78] in Trench 19. It was devoid of any obvious inclusions. Layer [93] was sealed by layer [90], a greenish grey silty clay measuring 0.2 m thick (Figures 2.8–2.10). Layer [90] contained inclusions of struck flint (519 pieces), burnt flint (ninety-two pieces, 598 g) and animal bone. A fragment of aurochs bone from layer [90] was radiocarbon dated to 6698–6531 cal. BC (SUERC-51968; 95% confidence; 7808 ± 33 BP).

Fieldwork Results: The Archaeological Narrative

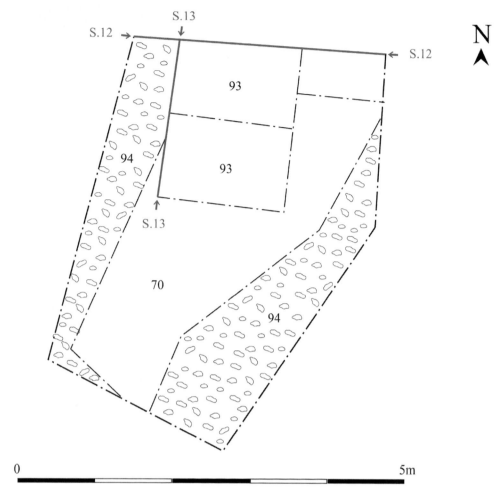

Figure 2.8: Trench 23 plan.

Section 12

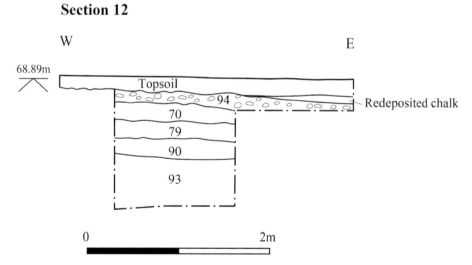

Figure 2.9: South facing section, Trench 23. Illustration courtesy of Tom Phillips.

Layer [90] was sealed in turn by layer [79], a dark grey clayey silt measuring 0.22 m thick. Layer [79] produced a substantial assemblage of Mesolithic struck flint (2,129 pieces from 2 m^2) and burnt flint (396 pieces, 4,154 g). The struck flint was once again indistinguishable to that from layer [59] in Trench 19 and the assemblages in Trench 22. It was sealed by layer [70], a grey clay

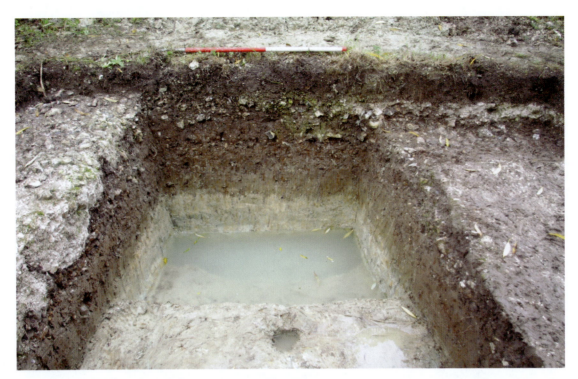

Figure 2.10: Trench 23 during excavation, looking north (scale 1 m). Photograph courtesy of Tom Lyons.

measuring 0.24 m thick, with inclusions of unworked flint and a smaller number of struck flints (159 pieces). Much of it is comparable to the Mesolithic flintwork, but there are also a small number of later prehistoric struck flints, including a possible transverse arrowhead of Later Neolithic date (Bishop, this volume). Overlying layer [70] was a metalled flint cobbled surface [94], also recorded in trenches to the south and west, the nearest being Trenches 2 and 11, and interpreted as being of post-medieval date. The metalled surface was 0.12 m thick and was sealed by a thin lens of re-deposited chalk natural (road construction dumping). Modern topsoil measuring 0.12 m thick completed the sequence.

TRENCH 24

Trench 24 was positioned on a slight downward slope from north-west to south-east. On excavation, an ovoid feature revealed by GPR survey (Baldwin, this volume, Appendix A3) was found not to be structural, although the GPR had located elements of landform related to some of the features discovered. At the base of the trench solifluced chalk bedrock was encountered at 1.6 m below the ground level. Three sondages were excavated along the south, east and west facing baulks through a layer of loess [107], which was uniform throughout and contained some charcoal. A radiocarbon date from oak charcoal in this deposit yielded a date of 4340–42323 cal BC (95% probability, SUERC 66820; 5412 ± 30 BP; see Table 2.1).

The loess layer [107] was truncated by a series of features in the base of the trench; a large tree throw [111], a smaller, more sub-circular, tree throw [105] and two putative post-holes [109] and [115]. Principal amongst these was tree throw [111], curvilinear in plan, measuring up to 2.9 m in diameter and 0.56 m deep. The shape was formed by a large tree falling in the direction of the wet areas to the south-east and pulling a large amount of earth with it, leaving a large raised mound of chalk in the centre. This was at least partially redeposited and provided a complex infilling sequence. In the base of the throw were two sub circular features [214] and [216], which on excavation had the appearance of root holes. Each feature contained two struck flints and up to ten pieces of burnt flint.

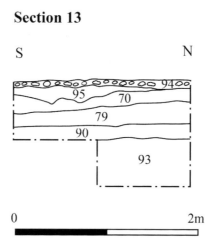

Figure 2.11: East facing section, Trench 23. Illustration courtesy of Tom Phillips.

All the fills of the tree throw [111] were excavated in terms of north-east, north-west and north segments, with each context recorded in plan. The lower fills [212]–[218] contained unworked flint, struck flint (ninety-five pieces, including two microliths) and burnt flint (twenty-five pieces). The upper fill represented redeposited natural material which characteristically infills a hollow created after a tree fall (Evans and Pollard 1999, 249–25). On the north-western side of the cut was a compact layer of unworked flint nodules [116] which had the appearance of being a deliberately laid revetted edge, suggesting that the profile of this substantial natural feature may have been modified. Charcoal from oak underneath this surface to the north-west of the cut [212] and from the lower fill itself [218] returned dates of 4236–4041 Cal BC (probability 95%; SUERC 66822; 5298 ± 30 BP) and 4234–4045 Cal BC (probability 95%; SUERC 66823; 5302 ± 29 BP) respectively (Table 2.1). Numerous large cobbles were found clustered around the profile of the tree throw. A 0.4 m high upright piece of patinated tabular flint was also discovered embedded within loess [107] close to tree throw [105] in the north-west of the trench.

The fill of the central tree throw [111] ([110]=[210]) comprised a dark-brown clayey silt measuring up to 0.3 m thick and produced 808 pieces of struck flint in mostly good or sharp condition and over 3 kg of unworked burnt flint. A small amount of worked burnt flint, two pieces of aurochs tooth enamel and some charcoal fragments were also recovered. The majority of the assemblage represented *in-situ* knapping or material left shortly after manufacture, with its contextual integrity underscored by the presence of at least three sequentially fitting blades (Bishop, this volume, Chapter 4). The worked flint assemblage included all stages in the reduction sequence, including primary core dressing and preparation waste, extensively reduced cores, potentially useable flakes and blades. The assemblage contained twenty microliths or microlith fragments of scalene triangle and rod type. Other retouched pieces included two truncated blades, a piercer, a blade-like flake with a small notch and a number of flakes and blades with light retouch. The majority of the microliths were especially tiny, even by Later Mesolithic standards, with the smallest scalene measuring only 8 mm × 3 mm × 1 mm and the majority of rods, which were nearly all broken, measuring just 1–2 mm in width. Such a diminutive size 'suggests a degree of integrity that may have been associated or produced by the same person or group' (Bishop 2018, in press). A flotation sample from [210] (north-east segment) may have yielded the first evidence for plant exploitation over the whole site (Maltas, Chapter 3, this volume).

A large rounded sarsen cobble was found near the top of the chalk mound that formed the raised centre of the tree-throw hollow weighing 2.1 kg. It has a smooth, water-worn surface and may have been brought from the river; the prominent position in which it was found suggests it could have been placed. Visible abrasion along one edge indicates its use as a pounding tool, perhaps for tenderising meat, pulverising bones or processing nuts (Caroline Wickham-Jones, pers. comm.).

This artefact potentially adds to the finds of 'exotic' stone material previously found at Blick Mead (see Chapter 7, Discussion, this volume).

A second tree throw [105] was located in the western half of the trench, approximately 1.4 m north-west of tree throw [111]. It was irregular in plan and measured up to 1.6 m wide and 0.16 m deep with gently sloping sides and an undulating, irregular base. Its lower fill contained forty-three pieces of struck flint with just under one-third comprising macro-debitage (>15 mm). Within this assemblage was a minimally worked complete elongated nodule suggestive of a rough out for a tranchet axe comparable to those used to make some of the finished axes found in trenches located into the wetter, lower lying areas of Blick Mead (e.g. Jacques and Phillips 2014, fig. 5). Charcoal from this fill returned a radiocarbon date of 7960–7716 cal BC (95% probability; SUERC 66824; 8775 ± 29 BP) connecting activity here to the time of the construction of Post B on the Stonehenge knoll. The upper fill was a dark brown clayey silt. It was located only within the western part of the tree throw. It contained an exceptionally large quantity of intensively and uniformly burnt flint, which had not been burnt *in situ*, amounting to over 14 kg, along with some charcoal.

To the east a smaller feature [115] was thought to be a posthole integral to tree throw [105]. It was sub-circular in plan, measuring 0.39 m wide and 0.22 m deep. It contained a single fill which comprised a mid- to dark brown clayey silt with occasional inclusions of charcoal and a small quantity of unworked burnt flint and twelve struck pieces, including a fragment of a narrow obliquely truncated point of Later Mesolithic date. Charcoal unidentified to species from the fill returned a radiocarbon date of 4336–4246 cal BC (95% probability; SUERC 56919; 5424 ± twenty-five years BP). To the north of the tree throw was a small posthole or stakehole [109], which was circular in plan, measuring 0.19 m wide and 0.1 m deep with a concave profile.

Above tree throw [111] was hollow [206], a shallow scoop-like feature, which appeared to truncate the western edge of infilled throw [111] and was clearly later. It was sub-circular in plan with a concave base. Its single fill contained seventy pieces of struck flint including a number of blades, relatively wide and thick flakes, and two cores. Much of the flint work was quite fresh and more typical of Later Neolithic industries (Bishop, this volume). A radiocarbon date obtained from hazel/alder in the upper part of [210] close to the colluvium returned a date of 3636–3507 cal BC (95% probability; SUERC 66281; 4748 ± 29 BP), thus providing the first Neolithic date and context for Blick Mead. There was no evidence for Neolithic material culture in any of the Mesolithic features.

In the south-east corner of the trench a sondage revealed the edge of a palaeochannel where the present spring sits and water lain chalk. A potential link between the wet and the residential and activity area was thus indicated in this area. Layers [217], [219] and [224] represented layers of alluvium sitting within the top of the channel. The features were sealed by a series of thick, homogenous cultivation soils or layers of colluvium, which formed the remaining sequence in Trench 24 and in total measured up to 1.6 m deep. The colluvial layers contained significant quantities of struck flint and unworked burnt flint. Much of this is likely to have been displaced from the Mesolithic horizons but a sizeable amount of the struck flint indicates later prehistoric activity in the vicinity.

The above features were sealed by a series of thick, homogenous cultivation soils or layers of colluvium, which formed the remaining sequence in Trench 24 and in total measured up to 1.4 m deep. These layers contained significant quantities of struck flint and unworked burnt flint which may have been displaced from the Mesolithic horizons, and included later prehistoric pieces indicative of nearby Late Neolithic and Early Bronze Age activity. In particular, layer [204], the interface between the colluvium and relict soils, excavated in 1 m squares, produced 908 pieces of struck flint and nearly 2 kg of burnt flint. This mixed assemblage included two scalene triangles, a rod-like microlith and a 'stemmed' or 'tanged' micro-tranchet microlith, the latter being of special interest as it is an uncommon type that has been associated with late 5th millennium BC industries. Later flintwork was recorded too, including a ripple-flaked oblique arrowhead type dating to the Late Neolithic. These types of arrowhead are rare, with southern British examples coming from Later Neolithic Henge enclosures, including near-by at Durrington Walls, Woodhenge and from one of the ditches of the Stonehenge

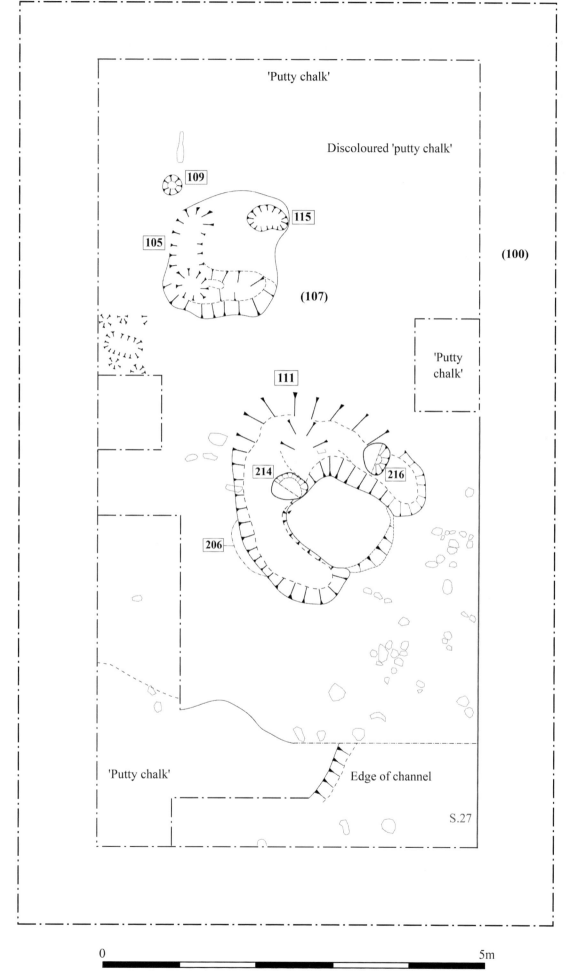

Figure 2.12: Trench 24 plan at the end of the 2015 season of excavations. Illustration courtesy of Tom Phillips.

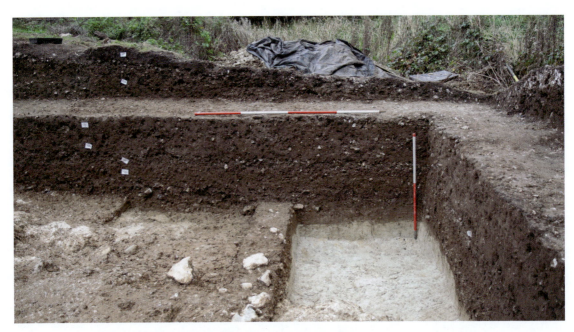

Figure 2.13: Trench 24, looking east, towards the low-lying wet areas of Blick Mead.
Photograph courtesy of Tom Lyons.

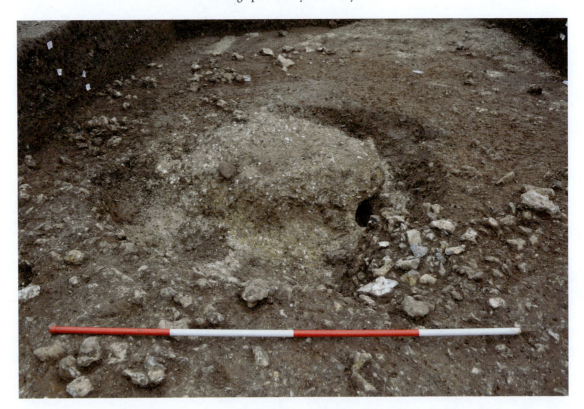

Figure 2.14: Tree-throw hollow [111], Trench 24. Note worked sarsen tool on crest of the chalk mound.
Photograph courtesy of Tom Lyons.

Avenue at West Amesbury Henge. The Blick Mead example has the tip and stem missing, but is otherwise in good condition and characteristically very finely worked. Other possible later prehistoric pieces include a globular multi-platformed core and a small quantity of relatively large and thick flakes. Many of these are also in good condition emphasising that, although from colluvial deposits, the activity they were associated with was close by (Bishop, this volume, Chapter 4).

Table 2.1: Radiocarbon dates from Blick Mead (including borehole samples, see Chapter 3)

Trench	Context no./depth (m OD)	Feature/Context type	Material	Lab no.	Radiocarbon age BP	Cal BC (68%)	Cal BC (95%)
24	[221]	Tree throw [105], lower fill	Wood charcoal	SUERC-66824	8775 ±29	7937–7751	7960–7716
19	[67]	Layer [59]	Bovine tooth	SUERC-42525	8542 ± 27	7593–7569	7596–7542
23	[90]	Layer [90]	Aurochs	SUERC-51968	7808 ± 33	6657–6600	6698–6531
19	[65]	Layer [59]	Aurochs	SUERC-33649	7355 ± 30	6330–6100	6360–6080
19	[92]	Layer [59]	Red deer	SUERC-51973	7294 ± 34	6214–6106	6226–6074
19	[59c]	Layer [59]	Aurochs	SUERC-60917	6881±33	5793–5723	5845–5686
19	[64]	Layer [59]	Wild pig	SUERC-42341	6396 ± 26	5464–5325	5469–5320
22	[91]	Layer [91]	Aurochs	SUERC-51969	6198 ± 32	5216–5073	5289–5048
19	[77.1]	Layer [59]	Aurochs	SUERC-47248	6114 ± 28	5199–4992	5208–4948
19	[76]	Layer [59]	Aurochs	SUERC-46224	6018 ± 31	4947–4848	4998–4810
19	[77.5]	Layer [59]	Red deer	SUERC-51972	6009 ± 28	4939–4848	4989–4808
19	[67]	Layer [59]	Aurochs	SUERC-37208	5900 ± 35	4798–4722	4846–4695
19	[77.4]	Layer [59]	Aurochs	SUERC-51971	5881 ± 26	4781–4722	4826–4702
24	[107]	Layer – loess	Oak charcoal	SUERC-66820	5412±30	4327–4259	4340–4183
24	[114]	Posthole [115]	Charcoal	SUERC-56919	5424 ± 25	–	4336–4246
24	[212W]	Tree throw [111], lower fill	Oak charcoal	SUERC-66822	5298 ± 30	4227–4051	4236–4041
24	[218]	Tree throw [111], lower fill	Oak charcoal	SUERC-66823	5302 ± 29	4227–4054	4234–4045
24	[210]	Tree throw [111], main fill	Alder/hazel	SUERC-66821	4748 ± 29	3632–3520	3636–3381
S2BH2	67.01–66.97	Not applicable	Charcoal; Maloideae	SUERC-58195	3847 ± 29	2401–2210	2455–2205
BH25	66.13–66.10	Bulk peat	Humic Acid	SUERC-52882	3012 ± 28	–	1385–1130
BH25	66.13–66.10	Bulk peat	Humin	SUERC-52878	2956 ± 28	1214–1125	1260–1055

In total 5,513 pieces of struck flint and 36.3 kg of intensively fired burnt flint were retrieved from Trench 24, which was stepped, with dimensions of 12 m × 7 m on the surface reducing to 10 m × 5 m at the base. The results from the trench suggest Mesolithic activity was intensive in this part of the terrace in the late 5th millennium BC, and in ways that potentially enhance the significance of what has been found in the wet areas at Blick Mead.

Synopsis of results

In only four of the trenches investigated were prehistoric horizons reached. Three of these (Trenches 19, 22 and 23), which were situated in the low-lying 'wet' areas of Blick Mead, produced broadly consistent results. Whilst it is not possible to directly equate deposits across the three trenches, broad correlations can be made. The earliest deposits excavated archaeologically have been variously described as pale blue, grey, green to greenish brown soft sandy silts and gravels. These can be equated to Unit L1 Sand and gravel of the Lower Gravel Surface as identified in boreholes (Young *et al.*, this volume, Chapter 3 below). The borehole survey, which trace these deposits across a broad area, demonstrated a remarkably consistent level across the upper surface of this horizon, at 66.03 m OD. These layers represent deposition of sediment by water in a relatively fast flowing environment, and are most probably Late Glacial in date.

Overlying these sands and gravels were clayey, alluvial deposits, between 0.2 and 0.44 m thick, which would have been deposited in a low-energy environment. These layers equate to Unit L2 lower alluvium, as identified by Young *et al.* (this volume, Chapter 3), or the basal clay horizon (BCH) described by Bishop (this volume, Chapter 4). Lithostratigraphic analyses suggest that these layers were deposited in either standing or very slow-moving water, subject to infrequent flooding. It is these layers which provided the highest concentrations of finds (particularly lithics and animal bone) which appeared to represent *in-situ* deposition of material into a wet environment, during the Mesolithic. These layers were overlain by peat, further alluvium and Made Ground (Young *et al.*'s Unit L3, L4, and L5, this volume, Chapter 3), the lower levels of which contained Mesolithic flintwork in a more abraded condition along with a Neolithic component, which attests to continued visitation of the site, albeit on a less intense scale.

Trench 24, excavated on higher ground overlooking the floodplain, identified sand and gravel overlain by fine grained sand. Borehole evidence has demonstrated that these deposits (Units H1 and H2) can be traced across a broad area and range in height from an upper level of 67.73 to a lowest height of 66.54 (see Young *et al.*, this volume, Chapter 3 for detailed modelling). These deposits thus appear to represent an area of higher sands and gravels, scoured by the later (but probably Late Glacial) actions which resulted in the deposition of the low-lying sands and gravels encountered in Trenches 19, 22 and 23. In the Early Holocene this location, as now, would have occupied a slightly elevated position on a terrace overlooking the wetter environment to the east and south.

Analysis of these deposits, and in particular the finds recovered from them, are ongoing. The flintwork from the 2016 excavations has not yet been fully assessed. Nevertheless, some tentative statements can be made. The identification of two tree throw hollows which formed the focus of Mesolithic flint working, with *in-situ* knapping debris indicative of all stages in the reduction sequence, suggests a temporary camp or homebase, with the tree throw hollow 111 area plausibly used as the basis for shelter. A later hollow contained an assemblage of lithics which again is indicative of continuing visiting of the site into the Neolithic.

Temporality

An important consideration when accounting for the high density of finds and the long-term use of the site is to understand how the data translate in terms of the frequency, timing and duration

of visits. Conneller *et al.* (2012, 1017) argue that '... repeated settlement disguises different occupation signatures ...', and at Star Carr, North Yorkshire interval dating of macro and micro charcoal in pollen profiles has been used to gauge how often the site was visited over the span of its use (Mellars and Dark 1998, 210–211). Successive layers of debris from the Early Mesolithic house at Howick in Northumberland indicate regular if not continuous occupation (Waddington *et al.* 2003, 11). At Blick Mead water action and possible trampling – probably minor disturbances in the overall stratigraphic sequence – may have caused spreading and mixing of the Mesolithic material making calculations of the length and frequency of visits difficult.

Similar stratigraphy and dating complexities can be found at the Early Mesolithic site at Faraday Road, Newbury, west of Thatcham, (Ellis *et al.* 2003, 107–135). The Mesolithic occupation horizon there was 0.15 m thick and lay 0.3 m below the modern ground level. Two radiocarbon dates, both from the same 1 m × 1 m test pit, were c. 1,000 years apart. The excavators extrapolated from these results that each episode of activity may have been minimal and short lived, though repeated. As the Faraday Road excavations are complete the excavators were better placed to cast a summative judgement (Ellis *et al.* 2003, 107–135) than is the case with the incomplete Blick Mead investigations. Elucidating the precise post-depositional processes that the artefactual material went through after initial discard remains a research priority. A more detailed analysis of the organic components similar to studies the York group are undertaking at Star Carr may provide some answers as to how consistent the burial conditions were over time (Tony Brown will be leading seDNA, aDNA and pollen analysis of samples from Blick Mead in 2018).

CHAPTER 3

Environmental Setting: Geoarchaeological Investigations and Environmental Analysis

– D. S. Young, C. P. Green, N. P. Branch, S. A. Elias, C. Bateson and C. R. Batchelor

> Being part of the Blick Mead Project has been life-changing for me. I am thirty years old, and now a classical studies postgraduate student and local museum volunteer. My parents are also involved and we thoroughly enjoy it. My work on the sieves in the company of environmental and other specialists, as well as fellow volunteers, has taught me many new skills and I have learned to view things from a different, more confident perspective.
>
> — EMILY LEVICK, volunteer, Bletchley

Geoarchaeological context

The site of archaeological investigation (see Figure 3.1) is a small area on the alluvial floodplain of the Salisbury Avon where the river makes a broad meander loop to the west around the town of Amesbury. The site is on the right bank (north side) of the river on the northern limb of the meander loop, about 150 m from the present main channel of the Avon and close to the boundary between the alluvial floodplain and the valley-side. This boundary is marked by a conspicuous break of slope immediately to the north-west of the site of archaeological investigation.

Mapping by the British Geological Survey (BGS) (1:63,360 Sheet 298 Salisbury; <http://www.bgs.ac.uk> 2013) shows the site close to the boundary separating 'Alluvium' in the centre of the valley floor, from 'Head 1 – Gravel' on its northern edge. The site is also just downstream from the point where a dry valley with a north–south alignment is confluent with the valley of the Avon. The floor of the dry valley is mapped by BGS as 'Head – Clay, Silt, Sand and Gravel'. The bedrock beneath the site is the Upper Chalk, represented by the Seaford Chalk Formation.

Ordnance Survey mapping (e.g. 1:25,000 Provisional Edition 1958 Sheet SU14) shows a water course skirting the edge of the floodplain to the north-west of the archaeological site with lateral water courses directed broadly southward towards the main channel of the Avon. One of these lateral channels originates within the area of interest and skirts the south-west edge of the site. These water courses are most likely to have been channels associated with a now defunct system of water-meadows. The archaeological investigation of the site (Jacques and Phillips 2013) has revealed some evidence of late medieval or post-medieval water management directly associated with features which probably represent traces of such artificial water courses (this volume, Appendix A).

Understanding the relief of the natural ground surface at and immediately around the archaeological site is complicated not only by traces of former water management on the floodplain, but also by the close proximity of substantial earth-moving activity. Close to the south-west edge of the site, an artificial causeway is present supporting a broad tree-lined walk that forms part of the eighteenth-century landscaping scheme; and to the south-east of the site, there is an extensive low fan-shaped mound of spoil, put in place during reconfiguration of the A303 Trunk Road that passes close to the north-east edge of the site. The formation of both these features has involved the burial of the natural ground surface and the borehole investigation described

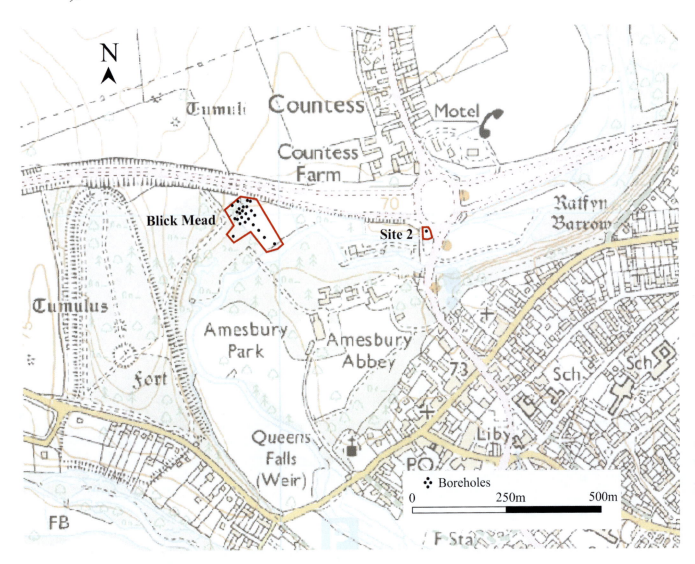

Figure 3.1: Location of Blick Mead (Site 1) and Site 2. Contains Ordnance Survey data © Crown copyright and database right [2014].

here has shown that Made Ground was completely absent in only two boreholes (BH14 and BH21) of the twenty-three boreholes put down. Where the Made Ground is absent the ground surface was at, respectively 68.68 m OD and 68.89 m OD. Elsewhere, in nine boreholes (BH1, BH5, BH6, BH8, BH12, BH13, BH15, BH22, BH23) the base of the Made Ground is close to 68.5 m OD (68.22–68.57 m OD) and this seems likely to be the level of the undisturbed natural ground surface. In boreholes passing through the thickest part of the spoil from the A303 roadworks (BH7, BH9, BH20) compaction of the underlying natural sediment has occurred and the base of the Made Ground is lower, between 68.02 and 67.81 m OD. In the remaining boreholes (BH3, BH4, BH10, BH11, BH16) the Made Ground extends down to lower levels which may reflect the infilling of pre-existing depressions either natural or artificial (channels/ditches) in the alluvial surface.

Subsequent to the borehole survey at the archaeological site (Site 1), the investigation was extended to a site (Site 2) lying about 0.45 km upstream on the floodplain of the River Avon (in the grounds of Avon House) where British Geological Survey (BGS) archive boreholes indicated the presence of a thick (up to 2.44 m) peat unit.

Aims and objectives

A programme of fieldwork incorporating a borehole survey, deposit modelling and environmental archaeological analysis was conducted at the site between 2014 and 2015. The specific research questions related to this work were as follows:

(1) What was the natural environment like during the period of occupation of the site?
(2) Is there any evidence for modification of the environment during the occupation of the site?
(3) How did the environment change during the periods of occupation, and following abandonment of the site?
(4) Can the insect record provide any indications of variations in the past climate?
(5) What is the nature of the sediments that have accumulated on the surrounding floodplain, and can these tell us anything about the sedimentary history of the site itself?
(6) Do sediments accumulated on the surrounding floodplain have good palaeoenvironmental potential for reconstructing the environmental history of the site and its environs?

In order to address these questions, a multiproxy approach was employed, including the following techniques:

(1) *Geoarchaeological borehole survey and deposit modelling* – to investigate the sediments in the area of the site and the surrounding floodplain, and to provide a record of the sedimentary history and palaeoenvironmental potential of these sediments.
(2) *Plant macrofossil analysis (charred and waterlogged seeds/wood)* – to enable reconstruction of the vegetation history, as well as to provide an indication of diet and economy on the site (e.g. food transport, diet).
(3) *Insect analysis* – To provide information on the vegetation history of the site, anthropogenic environments and palaeoclimatic reconstructions.
(4) *Pollen analysis* – To enable reconstruction of the past vegetation of the site and its environs, and the influence of human activity upon it.

Methods

Geoarchaeological borehole survey

In all, twenty-seven boreholes were put down at and near the site (Table 3.1). A grid of boreholes (BH1 to BH25) spaced at approximately 10–20 m intervals was put down in the area of the archaeological trenches, with one transect (BH16 to BH19) extending across the floodplain towards the modern course of the Salisbury Avon (Figure 3.2). Two boreholes (BH2 and BH24) were put down to the west of the site where the ground surface rises up from the floodplain, on a feature interpreted as a lynchet and later revealed to be a Late Mesolithic residential and activity area. Borehole BH25 was put down c. 30 m to the south of the archaeological trenches, to the south of the artificial causeway.

Two further boreholes were put down from the floodplain surface about 0.45 km upstream from the archaeological site (in the grounds of Avon House) to investigate peat recorded in British Geological Survey (BGS) archive boreholes (Site 2 of the present investigation).

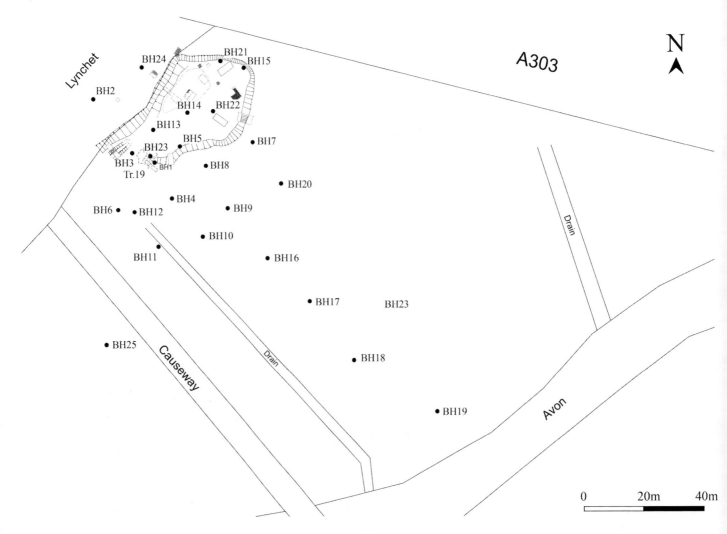

Figure 3.2: Location of the boreholes at Blick Mead (Site 1), showing the approximate location of the archaeological trenches (Site 2 not shown), with hachures indicating the lower area of site. All boreholes shown (with the exception of BH2 and BH24) were used in the deposit models.

The spatial position of the boreholes at the archaeological site was recorded using a Leica GS09 differential GPS (DGPS). Due to poor satellite and mobile data signals in the area of the site, the OD heights for each borehole were calculated using a dumpy level and staff, with a backsight to borehole BH2, where the DGPS provided an OD height accurate to within 5 cm. It was not possible to gain a backsight to any of the boreholes from the position of BH25, due to dense vegetation in this area; the OD height for this borehole is therefore based on Lidar data (provided for research purposes by Geomatics Group/Environment Agency) and the observed position of the borehole.

LITHOSTRATIGRAPHIC DESCRIPTIONS

The borehole core samples were recovered with an Eijkelkamp window sampler and gouge set using an Atlas Copco TT two-stroke percussion engine. Nine continuous, undisturbed core samples were retained for laboratory examination and sub-sampling from boreholes BH13, BH14, BH18, BH21, BH22, BH23 and BH25 at Site 1 and boreholes S2BH1 and S2BH2 from Site 2. The lithostratigraphy of the remaining boreholes was recorded in the field. Borehole BH1 was not put down to the full depth of the sequence, and is thus not included in the deposit model.

Table 3.1: Borehole attributes

BH	Easting	Northing	Elevation (m OD)
BH1	414897.9	142010.4	69.00
BH2	414877.5	142031	70.83
BH3	414890.2	142013.6	68.68
BH4	414903.4	141999	69.13
BH5	414906.1	142015.7	68.86
BH6	414885.9	141995.4	68.72
BH7	414930.5	142016.9	70.04
BH8	414914.8	142009.3	69.48
BH9	414921.8	141995.6	69.52
BH10	414913.8	141986.4	69.29
BH11	414898.9	141983.3	68.60
BH12	414891	141994.6	68.86
BH13	414897.4	142021.1	69.01
BH14	414908.6	142026.5	68.78
BH15	414927.4	142040.7	68.82
BH16	414935.4	141979.5	69.34
BH17	414949.3	141965.6	69.10
BH18	414964	141946.6	68.61
BH19	414991.2	141930.1	68.37
BH20	414939.9	142003.8	69.94
BH21	414919.7	142043.1	68.89
BH22	414917.2	142026.9	68.83
BH23	414896.3	142012.7	68.73
BH24	414893.9	142041.2	70.64
BH25	414881.2	141951.8	68.75*
S2BH1/S2BH2	415367	141958	69.30*

*based on Lidar data and field observations

The lithostratigraphy of all boreholes was described using standard procedures for recording unconsolidated sediment and organic sediments, noting the physical properties (colour), composition (gravel, sand, clay, silt and organic matter) and inclusions (e.g. artefacts) (Tröels-Smith 1955). The procedure involved: (1) cleaning the samples with a spatula or scalpel blade and distilled water to remove surface contaminants; (2) recording the physical properties, most notably colour using a Munsell Soil Colour Chart; (3) recording the composition; gravel (*grana glareosa*; Gg), fine sand (*grana arenosa*; Ga), silt (*argilla granosa*; Ag) and clay (*argilla steatoides*); (4) recording the degree of peat humification and (5) recording the unit boundaries (e.g. sharp or diffuse). The results are displayed in Appendix D1: Tables D1–D25.

DEPOSIT MODELLING

The reconstruction of the sedimentary architecture beneath the Blick Mead basin was undertaken using records from the twenty-three geoarchaeological boreholes that lie on the floodplain (i.e. not including boreholes BH2 and BH24, located off the floodplain on a Late Mesolithic surface, nor

the Site 2 boreholes). Modelling was undertaken using RockWorks v14 software. The term 'deposit modelling' describes any method used to depict the sub-surface arrangement of geological deposits, but particularly the use of computer programmes to create contoured maps or three-dimensional representations of contacts between stratigraphic units. The first requirement is to classify the recorded borehole sequences into uniformly identifiable stratigraphic units. For the purposes of the deposit modelling exercise five stratigraphic units were recognised: (1) Gravel, (2) Sand, (3) Alluvium, (4) Peat, (5) Made Ground (mainly spoil associated with the A303 roadworks). The results of the deposit modelling are displayed in Figures 3.3 to 3.4.

How effectively RockWorks portrays the relief features of stratigraphic contacts or the thickness of sediment bodies depends on the number of data points (boreholes) per unit area, and the extent to which these points are evenly distributed across the area of interest. At Blick Mead boreholes were distributed every 10 to 20 m within the core area of boreholes; but were not distributed evenly south of the raised causeway in the area of borehole BH25 or to the east of the transect that extends away from the site.

In some cases, because of the 'smoothing' effect of the modelling procedure the modelled levels of stratigraphic contacts may differ slightly from the levels recorded in borehole logs. In addition, it should be noted that how effectively RockWorks portrays the relief features of stratigraphic contacts or the thickness of sediment bodies depends on the number of data points (boreholes) per unit area, and the extent to which these points are evenly distributed across the area of interest. The portrayal is also affected by the significance assigned to these data points, in terms of the extent of the area around the point to which the data are deemed to apply. This can be predetermined for each data set, and in the present case was restricted to a 'maximum distance filter' of 15% of the modelled area, except for the models of the less ubiquitous peat, for which a value of 10% was used.

Archaeological samples

During the excavations undertaken in 2013 column and bulk samples were recovered from specific archaeological features and contexts from Trenches 19 and 22, for laboratory based investigations.

PLANT MACROFOSSIL ANALYSIS

A total of eight bulk samples from the Mesolithic horizons in the archaeological trenches above were selected for the analysis of plant macrofossil remains. A volume of 1 litre of sediment from each sample was processed by wet sieving using 1 mm and 300 micron mesh sizes in order to recover charred and waterlogged macrofossil remains (seeds and wood). The wet sieved fractions (>300 μm and >1 mm) from each of the samples were sorted for the remains selected for analysis, and notes regarding sample contents were made. In some instances, the quantities of remains were insufficient for analysis. The wet sieved residues were sorted under a stereozoom microscope at 7–45× magnification. These remains were sorted into broad taxonomic groups, and stored in glass vials for subsequent identification through comparison with reference material in the University of Reading reference collection and reference atlases (Anderberg 1994, Berggren 1969, 1981, Cappers *et al.* 2006, Jacomet 2006, NIAB 2004). Nomenclature follows Stace (2005) and habitat information is given with reference to Stace (2005).

INSECT ANALYSIS

Four of the larger bulk samples, three from Trench 19 (context [77]) and one from Trench 22 (context layer [91]) were selected and processed for insect analysis. These contexts were chosen because [77] in Trench 19 contained numerous and relatively well-preserved Mesolithic dated fauna

Environmental Setting: Geoarchaeological Investigations and Environmental Analysis

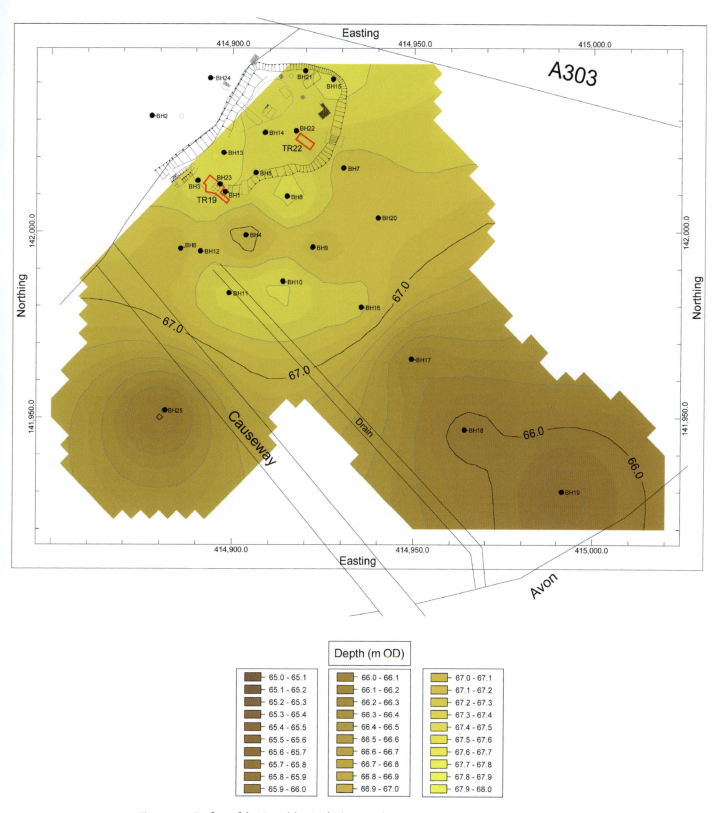

Figure 3.3: Surface of the Gravel (m OD), showing the 67 m OD contour that approximately separates the northern and southern terraces.

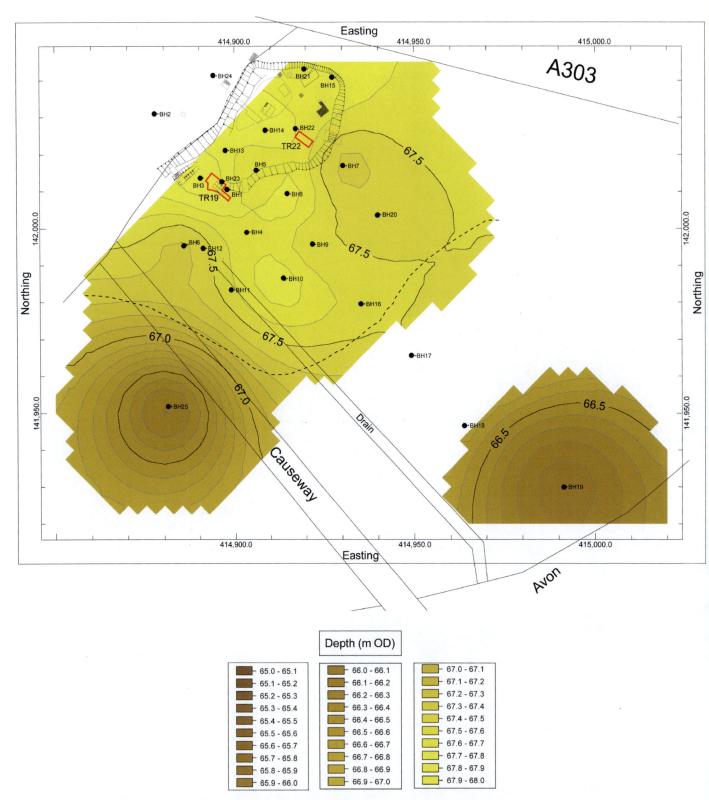

Figure 3.4: Surface of the Sand (m OD), showing (as a dashed line) the 67 m OD gravel surface contour.

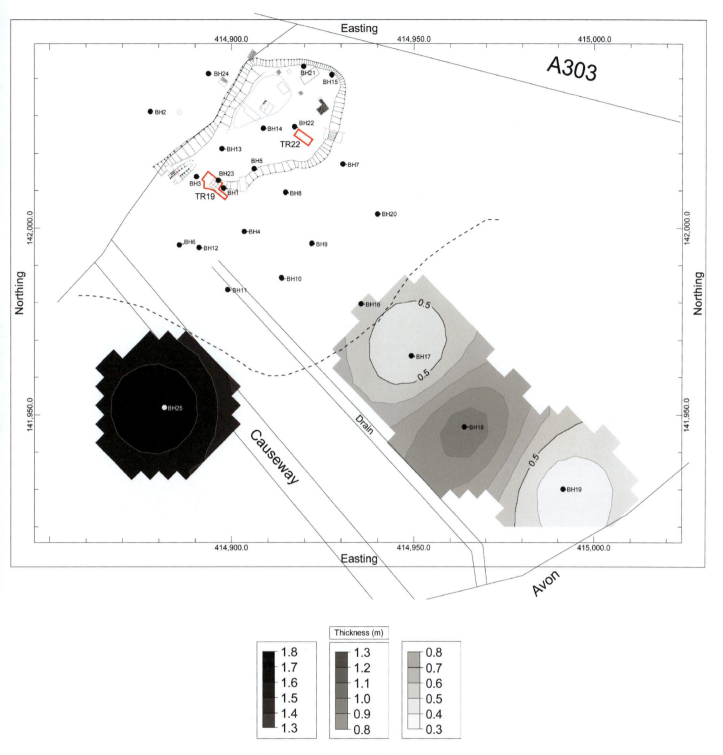

Figure 3.5: Peat thickness (m), showing (as a dashed line) the 67 m OD gravel surface contour.

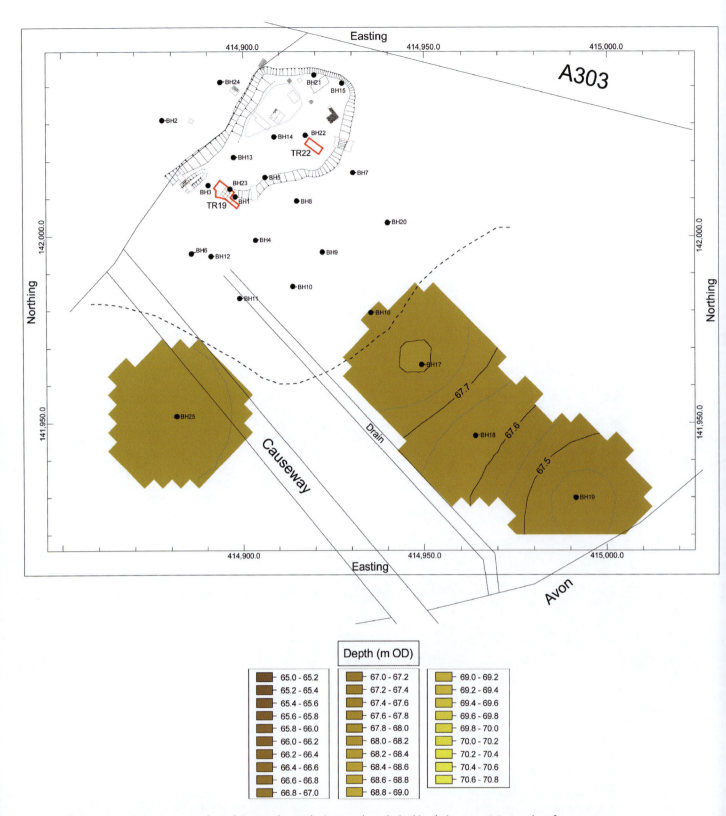

Figure 3.6: Surface of the Peat (m OD), showing (as a dashed line) the 67 m OD gravel surface contour.

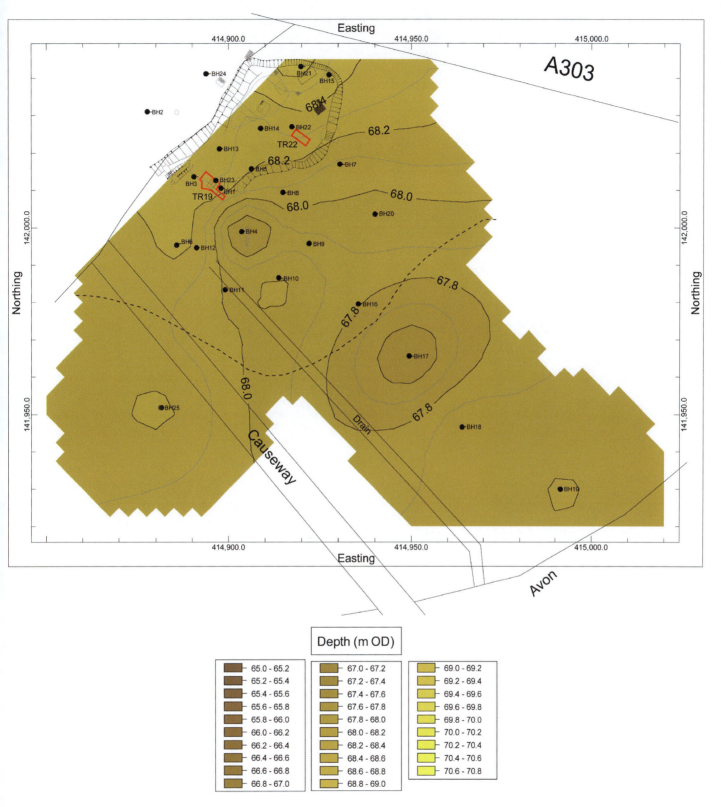

Figure 3.7: Surface of the Alluvium (m OD), showing (as a dashed line) the 67 m OD gravel surface contour.

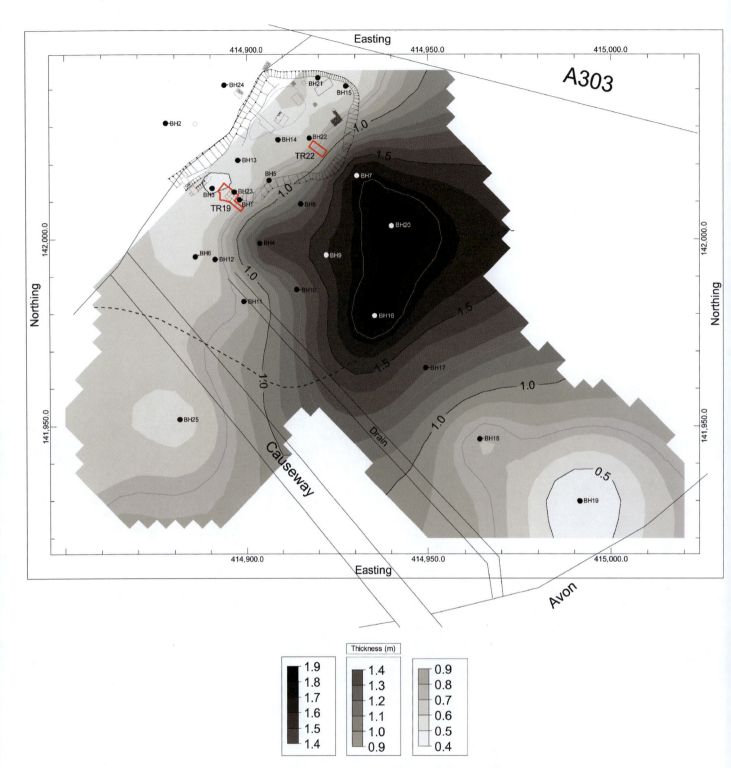

Figure 3.8: Made Ground thickness (m), showing (as a dashed line) the 67 m OD gravel surface contour.

and [91] in Trench 22 had returned a Mesolithic radiocarbon date from oxygenated conditions. Samples were processed by paraffin flotation following the methodology of Atkinson *et al.* (1987), as follows:

(1) Wash the bulk samples through a 5 mm mesh using hot water to remove larger wood fragments
(2) Wash remaining fraction onto a 300 micron mesh
(3) Wash twice with hot water to remove the fine fraction, and two cold water washes to remove the possibility of a thermal gradient forming during the subsequent flotation
(4) Drain well and mix with paraffin in a large bowl for 5 minutes
(5) Decant excess paraffin back into the stock bottle through an 80 micron mesh
(6) Add cold water to the organic fraction, mixing thoroughly
(7) Leave to stand for 15 minutes
(8) Decant the oil overlying the bulk material onto a 300 micron mesh and wash gently with detergent and hot water
(9) Rinse with distilled water, dehydrate in 95% ethanol, and transfer to a sealed container for storage in 95% ethanol
(10) Save remaining bulk material for further extraction of other fossil material. Flots were scanned using a low power binocular microscope (×10) to record the insect material, and to note principal beetle (Coleoptera) and bug (Hemiptera) taxa.

Boreholes BH25 and S2BH2

POLLEN ANALYSIS

Following the results of an initial assessment of samples from the archaeological trenches, it was found that pollen preservation was poor; the pollen analysis was therefore focused on the sequences retained within boreholes BH25 and S2BH2, where the thickest peat sequences were recorded. A total of eleven sub-samples were extracted from borehole BH25 and nine from borehole S2BH2 for analysis of the pollen content. The pollen was extracted as follows:

(1) Sampling a standard volume of sediment (1 ml)
(2) Deflocculation of the sample in 1% Sodium pyrophosphate
(3) Addition of two *Lycopodium clavatum* (club moss) spike tablets
(4) Sieving of the sample to remove coarse mineral and organic fractions (>125 μ)
(5) Acetolysis
(6) Removal of finer minerogenic fraction using Sodium polytungstate (specific gravity of 2.0 g/cm^3)
(7) Mounting of the sample in glycerol jelly

Each stage of the procedure was preceded and followed by thorough sample cleaning in filtered distilled water. Pollen grains and spores were identified using the Reading University pollen type collection and the following sources of keys and photographs: Moore *et al.* (1991); Reille (1992). Plant nomenclature follows the Flora Europaea as summarised in Stace (2005).

Prepared slides were examined under a Leica bi-focal high-powered microscope at ×400 magnification. Any pollen encountered was identified, recorded and counted until a count over 150 grains TLP (total land pollen) was obtained. In order to determine microcharcoal concentrations the spikes of exotic clubmoss (*Lycopodium clavatum*) were counted alongside charred and carbonised plant remains of size >25 μm, until the *Lycopodium* count reached 150 grains. The formula: ((# *Lycopodium*

spores added) / (# *Lycopodium* spores counted)) × (# microcharcoal counted) was applied to calculate microcharcoal concentrations using Tilia 2.0.2 software.

PLANT MACROFOSSIL ANALYSIS

In the process of attempting to extract plant macrofossils for radiocarbon dating from the top and base of the peat in borehole BH25, nine small bulk samples were extracted for the recovery of macrofossil remains. These samples were focused on the top (67.85– 67.50 m OD) and base (66.19–66.13 m OD) of the peat only. The sediment from each sample was processed by wet sieving using 1 mm and 300 micron mesh sizes in order to recover charred and waterlogged macrofossil remains (seeds and wood). The wet sieved fractions (>300 μm and >1 mm) from each of the samples were sorted for the remains selected for analysis, and notes regarding sample contents were made. The wet sieved residues were sorted under a stereozoom microscope at 7–45× magnification. These remains were sorted into broad taxonomic groups, and stored in glass vials for identification through comparison with reference material in the University of Reading reference collection and reference atlases (Anderberg 1994, Berggren 1969, 1981, Cappers *et al.* 2006, Jacomet 2006, NIAB 2004). Nomenclature follows Stace (2005) and habitat information is given with reference to Stace (2005).

RADIOCARBON DATING

Due to the absence of plant macrofossils suitable for radiocarbon dating at the top and base of the peat horizon in borehole BH25, humin and humic acid fractions of a bulk peat sample (18 g) from the base of this horizon were radiocarbon dated. At Site 2, a fragment of charred Maloideae (e.g. Crataegus spp. Pyrus sp., Malus sp.) from near the base of the peat was radiocarbon dated. The samples were submitted to the Scottish Universities Environmental Research Centre (SUERC), East Kilbride radiocarbon dating facility. The results are presented in Table 2.1.

Results and interpretation of the lithostratigraphic descriptions, deposit modelling and radiocarbon dating

In order to describe fully the stratigraphic sequences recorded in the boreholes, nine stratigraphic units/sub-units were recognised and are described in the following paragraphs. They form two separate sediment sequences, representing two distinct stages in the development of the floodplain and floodplain deposits of the River Avon. Detailed lithostratigraphic descriptions are presented in Appendix D1. A discussion section draws the results together into a coherent whole.

Gravel and sand was encountered underlying all the fine-grained sediment sequences that were recorded in the boreholes. The gravel was largely of fine to medium size, consisting almost entirely of sub-angular flint and well-rounded chalk. The gravel matrix and the sand bodies associated with the gravel were composed of quartz sand, sand-size chalk and sufficient glauconite to give much of the sediment a greenish hue, often speckled white with grains of chalk. The surface contours of the gravel indicate the presence of two distinct levels separated by about 1.35 m. The upper level (Higher Gravel Surface) underlies the northern part of the archaeological site, and forms the basis of the sediment sequence from which the Mesolithic lithics and faunal assemblage has been recovered. The lower level (Lower Gravel Surface) underlies the southern part of the site, and is also recognised at Site 2. In all the deposit models, the 67 m OD contour of the gravel surface is displayed in order to illustrate the spatial arrangement of the two distinct sediment sequences underlying the site. They are described separately in the following paragraphs.

Higher Gravel Surface
Unit H4: Made Ground
Unit H3: Alluvium
Sub-unit: H3a Mesolithic horizon
Unit H2: Sand
Unit H1: Sand & Gravel

Lower Gravel Surface
Unit L5: Made Ground
Unit L4: Upper Alluvium
Unit L3: Peat
Unit L2: Lower Alluvium
Unit L1: Sand & Gravel

(The arrangement of the units here is indicative only and does not indicate age relationships.)

Higher gravel surface

This gravel surface was recorded in nineteen of the boreholes with a height range of the surface mainly between 67.73 and 67.16 m OD, with lower levels in three boreholes (BH6, BH7, BH9) down to 66.54 m OD in BH9. The gravel surface (Figure 3.3) appears to slope up very gently towards the north, but there is a low rise centred on Borehole BH10, elongated from east to west from Boreholes BH11 in the west to Borehole BH16 in the east. Immediately to the north of this low swell is a shallow depression centred on Borehole BH4, possibly also having an east–west alignment extending from Boreholes BH6 and BH12 in the west to Borehole BH9 in the east. These inequalities may represent evidence of a low relief pattern of bars and channels on the surface of the gravel.

UNIT H2: SAND

Immediately overlying the Sand and Gravel forming the Higher Gravel Surface was a unit of sand. This was recorded in thirteen of the boreholes, and across most of the Higher Gravel Surface with the exception of an area defined by Boreholes BH3, BH4, BH11 and BH12 and the probable exception of Borehole BH14. This unit was generally a greyish well-sorted clayey silty sand either stoneless or with widely scattered clasts of sub-angular flint, but in places the unit in this position was a silty clay, and in a few places was a silty fine to medium sand. The recorded thickness of this unit ranged from 0.09 to 0.7 m (Mean 0.31 m). However, the transition from this unit to the overlying unit was in some places very gradual and in such cases it was difficult to identify a precise boundary and in consequence these thickness values and the surface contours of the sand unit (Figure 3.4) should be regarded as provisional. This unit immediately underlies the horizon rich in Mesolithic fauna and lithics.

UNIT H3: ALLUVIUM

In most of the boreholes in the northern part of the archaeological site, this unit immediately overlies the Sand (Unit H2). Only in Boreholes BH4, BH11 and BH12 and possibly BH14 was it recorded resting directly on the underlying Sand and Gravel (Unit H1). Where there was no superficial layer of Made Ground (Boreholes BH14 and BH21) the Alluvium formed the ground surface. In these boreholes it was a very wet, weakly consolidated, dark brown passing down to olive brown, poorly sorted gritty sandy silty clay with scattered clasts of sub-angular flint and chalk. Pedological features were common, including active root systems and common worm granules. Remains of Mollusca were also present in the form of broken shell. In Boreholes BH14 and BH21 this unit was respectively 1.45 m and 1.55 m thick. In Borehole BH14 a piece of burnt flint was present at a depth of c. 1.0 m below the ground surface.

Where a superficial layer of Made Ground was present, the Alluvium immediately below the base of the Made Ground was a grey, greyish brown or dark brown organic sandy silty clay with scattered clasts of sub-angular flint and less commonly chalk. Beneath the Made Ground, the

Alluvium was much more compact and thinner (Mean 0.56 m) than the Alluvium in Boreholes BH14 and BH21. The compaction of this unit where it underlies Made Ground no doubt reflects compression by the repeated passage of heavy plant during the introduction and grading of the spoil from the A303 roadworks. However, in many of the boreholes the unit retained evidence of pedological processes, including mottling, worm granules and root and plant remains. Remains of mollusc shell were also present in this unit in some boreholes. In two of the boreholes (BH13 and BH23) pieces of burnt flint were recorded, respectively at 0.62–0.73 m and 0.57–0.69 m below the base of the Made Ground.

In six of the boreholes, (BH1, BH5, BH7, BH8, BH15, BH22) it was possible to distinguish a sub-unit (Sub-unit H3a) immediately overlying the sand of Unit H2 which could be tentatively equated with the layer rich in Mesolithic flint-work recorded in the archaeological excavations. This sub-unit formed the lowest part of the Alluvium and therefore immediately overlay the sand of Unit H2. In the other thirteen boreholes it was not possible to recognise a separate sub-unit at this level but in three of them burnt flint (BH13, BH23) or possible flint debitage (BH9) was present immediately above the sand of Unit H2.

In six of the remaining boreholes (BH3, BH4, BH11, BH12, BH14, BH16) the sand unit H2 is missing. In four of these boreholes (BH3, BH4, BH11, BH16) and in BH10 the base of the Made Ground is below the likely level of the natural ground surface, probably indicating the presence of a hollow in the alluvial surface prior to the placement of the Made Ground. It seems possible that these borehole records represent evidence of ground disturbance leading to the removal of part or all of the sequence of sediments overlying the sand and gravel of Unit H1. It is perhaps significant that almost all of the boreholes displaying these characteristics lie either close to the floodplain edge or adjacent to the NW-SE artificial causeway forming the SW boundary of the archaeological site. In both these locations there is cartographic evidence (e.g. OS 1:25,000 Provisional Sheet SU14 1958) indicating the former presence of water courses, most probably associated with a system of water-meadows.

The surface of the Alluvium (Figure 3.7) slopes up to the north-north-west, towards the edge of the alluvial floodplain. However, the relief pattern on the surface of the underlying Sand & Gravel is still recognisable, with a slight swell centred on Borehole BH10 and a slight depression to the north of the swell, centred on Borehole BH4.

It seems likely that the Alluvium comprises a mixture of water-laid fine-grained sediment introduced by the floodwaters of the River Avon, and colluvial material including clasts of flint and chalk derived by downslope movement of superficial material from the valley side. It is also obvious that the surface of the floodplain here, and hence the character of the alluvium, has been affected by a history of land-use interventions, including water management and the creation of areas paved with flint nodules, as reported from several archaeological trenches both on the alluvial surface and on the adjoining valley side (Appendix A1).

Lower gravel surface

UNIT L1: SAND AND GRAVEL

The gravel underlying the Lower Gravel Surface was indistinguishable in terms of composition and appearance from the gravel underlying the Higher Gravel Surface. It was not possible to determine whether the gravel surface represents an erosional bench cut into the gravel that underlies the Higher Gravel Surface, or was the product of a separate cut-and-fill episode. There is a slight depression in the surface of the gravel centred on Borehole BH17, which might represent the position of a former channel or floodplain pond located close to the boundary between the Lower and Higher Gravel Surfaces.

UNIT L2: LOWER ALLUVIUM

This unit was recorded in Boreholes BH17 and BH19 and in boreholes S2BH1 and S2BH2 immediately overlying the Sand & Gravel (Unit L1). It consisted of grey clayey silt with scattered clasts of sub-angular flint, traces of detrital plant material, scattered mollusc remains and possible tufa debris.

UNIT L3: PEAT

At Site 1, focused on the main areas of excavation at Blick Mead, peat was present in all the sediment sequences overlying the low-level gravel surface in the southern part of the archaeological site (Figures 3.5 and 3.6). In Boreholes BH18 and BH25, the peat rested directly on the Sand & Gravel of Unit L1. In Boreholes BH17 and BH19 it rested in the Lower Alluvium (Unit L2). In Boreholes BH 17, BH19 and BH25, the peat was present as a single bed, respectively 0.37 m, 0.32 m and 1.78 m thick. In Borehole BH18 the peat formed three beds separated by thin beds of peaty silt. The total thickness of the peat and intercalated silt was 1.72 m. The height range of the peat surface was between 67.42 (Borehole BH19) and 67.88 m (Borehole BH25) (Mean 67.68, remarkably close to the level of the gravel surface in the northern part of the site – Mean 67.38). In Borehole BH25 a piece of burnt flint was present in the peat at a depth of 1.64 m below the peat surface. A radiocarbon date of 1385 to 1130 cal BC (95% probability; SUERC 528823012 ± 28 BP) was obtained from the base of the peat in borehole BH25.

At Site 2 (Avon House; Figure 1.1) peat was recorded in both boreholes. In borehole S2BH1 it was present as a single thin (0.1 m) unit, and in borehole S2BH2 as two units separated by a thin (0.08 m) silty organic sub-unit which incorporated charcoal and burnt flint. In neither borehole was the peat as thick as peat units recorded in three nearby BGS archive boreholes (SU14SE44, SU14SE45, SU14SE46). In these boreholes peat was recorded at the ground surface at levels close to 68.8 m OD and extended down respectively to 1.98 m, 2.44 m and 2.13 m bgs and rested directly on gravel at levels close to 66.5 m OD. A radiocarbon date of 2455–2205 cal BC (95% probability; SUERC 58195; 3837 ± 29 BP) was obtained from charcoal near the base of the peat in borehole S2BH2.

UNIT L4: UPPER ALLUVIUM

In Borehole BH17 the peat was directly overlain by the Made Ground, but in Boreholes BH18, BH19 and BH25 and in boreholes S2BH1 and S2BH2 the peat was overlain by a unit of predominantly mineral sediment, equivalent to part of the Alluvium (Unit H3) recorded in the sediment sequence overlying the Higher Gravel Surface. In Boreholes BH18 and BH25 this sediment was stoneless, but in Borehole BH19 and in boreholes S2BH1 and S2BH2 scattered flint clasts were present. Root and detrital plant remains and Mollusc remains were also present and in Borehole BH18 worm granules were recorded.

Made Ground

UNITS H4 AND L5

These units form part of the same body of blocky chalk rubble originating from the A303 roadworks. A thin dark brown soil overlies the rubble and was probably introduced as part of the landscaping following the completion of the roadworks. In several boreholes (BH4, BH8, BH9, BH10, BH17, BH18, BH20) the chalk rubble was separated into two sub-units by a dark brown horizon comprising slightly sandy organic silty clay and having the appearance of topsoil. Similar sequences were noted in the upper part of sections exposed in the archaeological trenches.

Results and interpretation of the plant macrofossil analysis

A one-litre volume of sediment was sub-sampled from each of the eight bulk samples from the archaeological trenches for the recovery of macrofossil remains. These samples were initially assessed for their macrofossil remains, including waterlogged and charred plant macrofossils, insects, bone and Mollusca (Table 3.2). In the process of attempting to extract plant macrofossils for radiocarbon dating from the top and base of the peat in borehole BH25, an additional nine small bulk samples were extracted for the recovery of macrofossil remains (Table 3.3). These samples were focused on the top (67.85 to 67.50 m OD) and base (66.19 to 66.13 m OD) of the peat only.

Archaeological samples

The results of the initial assessment of the archaeological samples from Trenches 19 and 22 indicated that insect fragments were present in low quantities in one sample from Trench 19 (sample <5>, context [77.1]) and three samples from Trench 22 (<9> [68], <11> layer [91] and <12> layer [91]). In all cases the insects were too poorly preserved, and present in too low concentrations for full analysis.

Fragments of bone were recorded in low quantities in one sample from Trench 19 (<5> (77.1)) and two samples from Trench 22 (<11> layer [91] and <12> layer [91]). Mollusca were recorded in two samples from Trench 22 (<8> [68] and <11> layer [91]). The Mollusca remains in sample <11> layer [91] were too poorly preserved for full analysis, and the specimen in sample <8> [68] is likely to represent a modern (burrowing) specimen.

Charcoal fragments were recorded in low to moderate quantities in all eight samples. In all cases however the assemblage of identifiable fragments (>2 mm on all axes) was too small to warrant full analysis.

Borehole BH25

Of the nine small bulk samples assessed from borehole BH25, three contained low quantities of insects which were preserved as fragments (67.85 to 67.83, 66.17 to 66.15 and 66.15 to 66.13 m OD). Again, these assemblages were too poorly preserved to warrant full analysis. Two samples (66.19 to 66.17 and 66.17 to 66.15 m OD) contained low quantities of waterlogged wood, whilst four (67.83 to 67.81, 66.19 to 66.17, 66.17 to 66.15 and 66.15 to 66.13 m OD) contained low quantities of unidentifiable (<2 mm diameter) charcoal.

Six of the nine samples contained low quantities of waterlogged seeds (Table 3.2), comprising herbaceous and aquatic taxa including *Rumex/Polygonum* sp. (dock/sorrel/knotweed), *Carex* sp. (sedge), *Ranunculus* cf. *repens* (creeping buttercup), *Bidens* sp. (bur-marigold) and *Ranunculus* cf. *fluitans* (river water crowfoot). Although limited, the assemblage is consistent with a damp environment dominated by herbaceous and aquatic taxa as might be expected on the margins of a stream, river or pond. The limited concentration of remains prevents any further interpretation of this assemblage, and it should be noted that the samples are limited to the top and base of the peat horizon only.

Results and interpretation of the insect analysis

Four of the larger bulk samples, three from Trench 19 (context [77]) and one from Trench 22 (layer [91]), were selected and processed for insect analysis. As identified during the rapid assessment described above, the insect assemblages were limited in all four samples and thus a full interpretation

Table 3.2: Results of the macrofossil assessment of bulk samples from the archaeological trenches.

Trench number	Sample number	Context number	Volume processed (l)	Fraction	Charred					Waterlogged		Mollusca		Bone			
					Charcoal (>4 mm)	Charcoal (2–4 mm)	Charcoal (<2 mm)	Seeds	Chaff	Wood	Seeds	Whole	Fragments	Large	Small	Fragments	Insects (fragments)
19	<5>	(77.1)	1.0	>300 μm	-	-	2	-	-	-	-	-	-	-	-	-	1
				>1 mm	1	2	-	-	-	-	-	-	-	-	-	2	-
19	<6>	(77.3)	1.0	>300 μm	-	-	2	-	-	-	-	-	-	-	-	-	-
				>1 mm	1	3	-	-	-	-	-	-	-	-	-	-	-
19	<7>	(77.5)	1.0	>300 μm	-	-	2	-	-	-	-	-	-	-	-	-	-
				>1 mm	1	2	-	-	-	-	-	-	-	-	-	-	-
22	<12>	(91)	1.0	>300 μm	-	-	2	-	-	-	-	-	-	-	-	-	1
				>1 mm	-	1	-	-	-	-	-	-	-	-	-	1	-
22	<8>	(68)	1.0	>300 μm	-	-	3	-	-	-	-	-	-	-	-	-	-
				>1 mm	-	2	-	-	-	-	-	1(m)	-	-	-	-	-
22	<9>	(68)	1.0	>300 μm	-	-	2	-	-	-	-	-	-	-	-	-	1
				>1 mm	-	2	-	-	-	-	-	-	-	-	-	-	-
22	<10>	(91)	1.0	>300 μm	-	-	2	-	-	-	-	-	-	-	-	-	-
				>1 mm	-	2	-	-	-	-	-	-	-	-	-	-	-
22	<11>	(91)	1.0	>300 μm	-	-	4	-	-	-	-	-	-	-	-	-	1
				>1 mm	-	2	-	-	-	-	-	-	1	-	-	2	-

Key: 0 = Estimated Minimum Number of Specimens (MNS) = 0; 1 = 1 to 25; 2 = 26 to 50; 3 = 51 to 75; 4 = 76 to 100; 5 = 101+.
(m) = potentially modern

(for example Mutual Climatic Range (MCR) analysis) was not possible. The insect assemblages are described below and in Table 3.5.

Trench 19

Sample <5>, from layer [77.1] was the richest of the four samples analysed, containing ten identified taxa. This sample included the predaceous diving beetle *Agabus* and the water scavenger beetles *Helophorus brevipalpis* and *Laccobius minutus*. *Agabus* species typically inhabit ponds and lakes. *H. brevipalpis* is typically found in temporary ponds, but it is also found in slow running water. *L. minutus* is likewise found in ponds, ditches and streams. According to Koch (1989) it prefers cold, acid, vegetation-rich waters. This assemblage contained the rove beetle *Tachyporus nitidulus*, a species found in damp grass and moss tussocks. Most species of the rove beetle genus *Olophrum* are also found in this type of habitat. The seed weevil *Protapion apricans* feeds exclusively on the meadow plant, red clover (*Trifolium pratense*). The leaf beetle *Altica* is also a typical member of the meadow insect community. Finally, the ant *Myrmica schencki* is an upland species that lives in relatively dry habitats in open areas and forests. Taken together, this fauna indicates the presence of a small, vegetation-choked

Table 3.3: Results of the macrofossil assessment of samples from borehole BH25.

Depth (m bgs)	Depth (m OD)	Volume processed (ml)	Fraction	Charred					Waterlogged		Mollusca		Bone			
				Charcoal (>4 mm)	Charcoal (2–4 mm)	Charcoal (<2 mm)	Seeds	Chaff	Wood	Seeds	Whole	Fragments	Large	Small	Fragments	Insects (fragments)
0.90 to 0.92	67.85 to 67.83	<10	>300 μm	-	-	-	-	-	-	1	-	-	-	-	-	1
0.92 to 0.94	67.83 to 67.81	<10	>300 μm	-	-	1	-	-	-	-	-	-	-	-	-	-
0.94 to 0.96	67.81 to 67.79	<10	>300 μm	-	-	-	-	-	-	-	-	-	-	-	-	-
1.10 to 1.15	67.65 to 67.60	25	>300 μm	-	-	-	-	-	-	1	-	-	-	-	-	-
1.15 to 1.20	67.60 to 67.55	30	>300 μm	-	-	-	-	-	-	1	-	-	-	-	-	-
1.20 to 1.25	67.55 to 67.50	25	>300 μm	-	-	-	-	-	-	1	-	-	-	-	-	-
2.56 to 2.58	66.19 to 66.17	10	>300 μm	-	-	1	-	-	1	-	-	-	-	-	-	-
2.58 to 2.60	66.17 to 66.15	20	>300 μm	-	-	1	-	-	1	1	-	-	-	-	-	1
2.60 to 2.62	66.15 to 66.13	20	>300 μm	-	-	1	-	-	-	1	-	-	-	-	-	1

Key: 0 = Estimated Minimum Number of Specimens (MNS) = 0; 1 = 1 to 25; 2 = 26 to 50; 3 = 51 to 75; 4 = 76 to 100; 5 = 101+.
(m) = potentially modern

Table 3.4: Results of the waterlogged plant macrofossil (seeds) analysis of borehole BH25.

Depth (m bgs)	Depth (m OD)	Waterlogged seeds		
		Latin name	Common name	Number
0.90 to 0.92	67.85 to 67.83	-	-	-
0.92 to 0.94	67.83 to 67.81	*Ranunculus* cf. *fluitans*	river water crowfoot	1
0.94 to 0.96	67.81 to 67.79	-	-	-
1.10 to 1.15	67.65 to 67.60	*Ranunculus* cf. *repens* *Rumex/Polygonum* sp. *Ranunculus* cf. *fluitans* *Carex* sp.	creeping buttercup dock/sorrel/knotweed river water crowfoot sedge	1 2 4 2
1.15 to 1.20	67.60 to 67.55	*Ranunculus* cf. *fluitans*	river water crowfoot	1
1.20 to 1.25	67.55 to 67.50	*Ranunculus* cf. *fluitans*	river water crowfoot	3
2.56 to 2.58	67.50 to 66.17	-	-	-
2.58 to 2.60	66.17 to 66.15	*Ranunculus* cf. *repens* *Ranunculus* cf. *fluitans*	Creeping buttercup river water crowfoot	1 1
2.60 to 2.62	66.15 to 66.13	*Ranunculus* cf. *repens* *Rumex/Polygonum* sp. *Ranunculus* cf. *fluitans* *Bidens* sp.	creeping buttercup dock/sorrel/knotweed river water crowfoot e.g. bur-marigold	1 2 1 2

Table 3.5: Results of the insect analysis of selected samples from Trenches 19 and 22.

Taxon	Trench 19			Trench 22
	<5> (77.1)	<6> (77.3)	<7> (77.5)	<12> layer [91]
DYTISCIDAE (predaceous diving beetles)				
Agabus sp.	1	-	1	-
HYDROPHILIDAE (Water scavenger beetles)				
Ochthebius minimus (F.)	-	1	-	-
Laccobius minutus (F.)	1	-	-	-
Enochrus sp.	-	1	-	-
Helophorus brevipalpis Bedel	1	-	-	-
STAPHYLINIDAE (rove beetles)				
Lathrobium sp.	1	1	-	-
Tachyporus nitidulus (F.)	1	-	-	-
CHRYSOMELIDAE (leaf beetles)				
Altica sp.	1	-	-	-
APIONIDAE (seed weevils)				
Protapion apricans Herbst	1	-	-	-
CURCULIONIDAE (weevils)				
Genus et sp. indet.	-	-	-	1
HYMENOPTERA – FORMICIDAE (Ants)				
Myrmica schencki Emery	1	-	-	-

pond or bog with moss or grass tussocks on the margins, situated in a landscape that includes nearby herbaceous meadows.

Sample <6> from layer [77.3] yielded only three insect taxa: the water scavenger beetles *Enochrus* and *Ochthebius minimus*, and the rove beetle *Lathrobium*. Most species of *Enochrus* live in swamps, bogs, and ponds with rich vegetation. *Ochthebius minimus* lives in both slow-flowing and standing water, typically in mud banked, vegetation-rich ponds. Most species of the rove beetle *Lathrobium* live in damp tussocks in bogs and other damp localities. Taken together, this fauna suggests the presence of a small, vegetation-choked pond or bog.

Sample <7> from layer [77.5] sample yielded only the predaceous diving beetle *Agabus*, indicative of ponds and lakes.

Trench 22

Sample <12> from layer [91] yielded only a broken fragment of weevil elytron that was not possible to identify to the generic level. Weevils are a very large family of exclusively plant-feeding insects

Results and interpretation of the pollen analysis

The results of the pollen analysis of boreholes BH25 (Site 1) and S2BH2 (Site 2) are shown in Figures 3.9 and 3.10, with the local pollen assemblage zones and their interpretation summarised below.

Radiocarbon determinations provide some dating for these sequences, which extend from 1385–1130 cal BC (3335–3080 cal BP; SUERC-52882) at the base of the sequence in BH25 and before

2455–2205 cal BC (4405–4155 cal BP; SUERC-58195) in S2BH2. Both sequences are assumed to extend to the present. No attempts have been made here to correlate or compare the sequences at each site, which are presented here independently.

Borehole BH25 (Site 1)

LPAZ-A 66.34–66.13 M OD CYPERACEAE-POACEAE-LACTUCEAE

Zone *LPAZ-A* is characterised by high values of herbaceous taxa and low counts of tree and shrub taxa (Figure 3.9: Zone A). *Pinus* (pine) and *Corylus* type (e.g. hazel) are present, though counts do not exceed 5%. Cyperaceae (sedge family) dominates with values of 35%, rising to 50%. Poaceae (grass family) maintains values between 35% and 20%. Lactuceae (dandelion family) (15% maximum), *Aster* type (e.g. goldilocks) (8%), *Chenopodium* type (e.g. fat hen) (7%) and *Plantago lanceolata* (ribwort plantain) (<10%) achieve peaks within this zone. Aquatic and spore taxa include *Equisetum* (horsetail) (2%), *Dryopteris* (wood fern) (<2%) and *Sphagnum* (moss) (2%).

LPAZ-B 67.41–66.34 M OD CYPERACEAE-POACEAE-LACTUCEAE

Zone LPAZ-B is characterised by continued dominance of herbaceous taxa, and an increase in species diversity (Figure 3.9: Zone B). *Pinus* (<5%), *Betula* (birch) (<2%) and *Alnus* (alder) (<1%) are present in low values, along with *Corylus* (<2%), *Ligustrum* (privet) (<2%) and *Juniperus* (juniper) (maximum 3%). Cyperaceae dominates, achieving values of 60% at the base of zone, dropping to 30% at 67.02 m OD. Poaceae rises from 20% to achieve maximum values of 40%. Lactuceae (10%) and *Aster* type (4%) maintain low values throughout the zone. *Sinapis* (e.g. white mustard) (5%), *Chrysosplenium* (golden saxifrage) (1%), and *Cirsium* (thistle) (<1%) are present. Cereal pollen, including *Hordeum* (barley) (1%) and cf. *Avena/Triticum* (oat/wheat) (<1%) are present, along with *Plantago lanceolata* (3%). Aquatic and spore taxa include *Equisetum* (maximum 8%), *Dryopteris* type (maximum 7%) and *Polypodium* (polypody) type (2%).

LPAZ-C 67.82–67.41 M OD CYPERACEAE-POACEAE-SINAPIS

Zone LPAZ-C is characterised by a complete absence of tree taxa and continued dominance of herbaceous taxa (Figure 3.9: Zone A). The shrub taxa *Corylus* (<1%), *Juniperus* (<2%), and *Ligustrum* (<1%) are present. Cyperaceae dominates achieving maximum values of >65%, and maintaining high values throughout the zone. A decline in Poaceae (25%) is mirrored by a rise in *Sinapis* (maximum 17%). Lactuceae (8%) maintains low values throughout zone, whilst *Aster* type (3%), *Chenopodium* type (3%) and *Plantago lanceolata* (2%) are present. Aquatics and spore taxa include *Dryopteris* (maximum 6%) and *Polypodium* type (maximum 5%), both achieving peaks in this zone.

INTERPRETATION

The pollen assemblages throughout borehole BH25 are dominated by herbaceous taxa (predominantly sedges and grasses), with low concentrations of aquatic taxa and ferns/mosses. Tree and shrub taxa are limited to very low concentrations. The three zones are therefore indicative of open conditions on both the wetland (floodplain) and dryland surfaces, with only subtle changes in their assemblages over time. Alder is likely to have been growing on the floodplain in isolated stands, perhaps along with hazel and birch. Pine, ash, elm and hazel may also have been growing on the surrounding dryland,

Environmental Setting: Geoarchaeological Investigations and Environmental Analysis

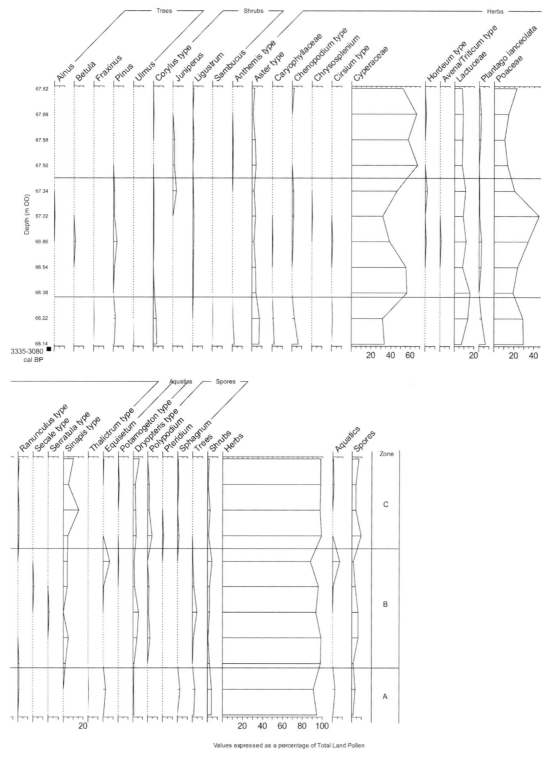

Figure 3.9: Results of the pollen analysis of borehole BH25 (Site 1).

but most likely only in isolated areas or at a distance from the site. The presence of ribwort plantain, fat hen and white mustard may be indicative of ground disturbance associated with human activity throughout zones LPAZ-A to LPAZ-C, whilst barley and wheat/oat in zones LPAZ-B and LPAZ-C provide evidence for cereal cultivation not far from the site.

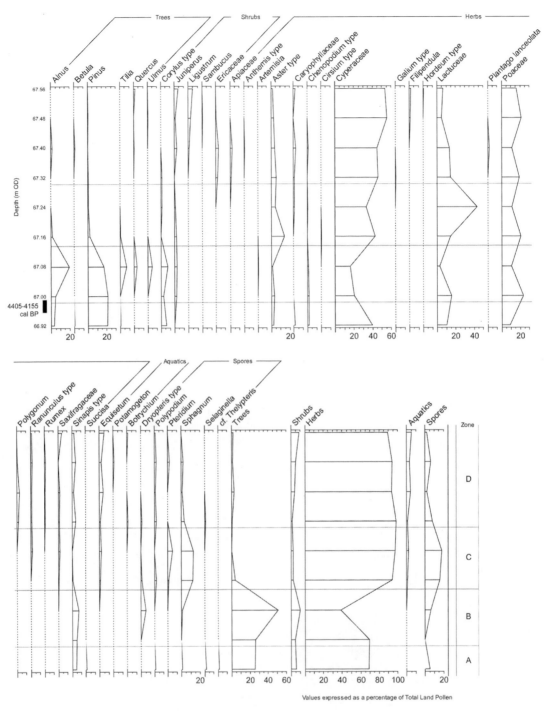

Figure 3.10: Results of the pollen analysis of borehole S2BH2 (Site 2).

Borehole S2BH2 (Site 2)

LPAZ-A 66.97–66.91 M OD PINUS-CORYLUS-CYPERACEAE

Zone LPAZ-A is characterised by the presence of tree and shrub taxa and dominance of herbaceous taxa (Figure 3.10: Zone A). *Pinus* (maximum 20%), *Alnus* (5%) and *Tilia* (lime) (2%) are present, with *Pinus* achieving maximum values in this zone. *Corylus* achieves maximum values of 8%, with

the presence of *Juniperus* (1%). Cyperaceae (maximum 40%, minimum 25%), Lactuceae (15%), and Poaceae (minimum 10%, maximum 15%) are also present, along with *Aster* type (2%), *Sinapis* (5%), *Chenopodium* type (1%) and *Succisa* (devil's bit) (1%). Aquatic and spore taxa include *Selaginella* (e.g. spikemoss) (2%), *Polypodium* (1%) and cf. *Thelypteris* (maiden fern) (1%).

LPAZ-B 67.13–66.97 M OD PINUS-ALNUS-CYPERACEAE

Zone LPAZ-B is characterised by an increase and peak in tree taxa, with low counts of shrub taxa and high counts of herbaceous taxa; along with increased species diversity (Figure 3.10: Zone B). *Pinus* decreases throughout zone to a value of 10%. *Alnus* (20%), *Tilia* (8%), *Quercus* (oak) (4%) and *Ulmus* (elm) (6%) achieve peaks in this zone. *Corylus* (10%) and *Juniperus* (4%) maintain values throughout the zone. *Aster* type (maximum 10%, minimum 3%), Cyperaceae (20%) and Lactuceae (maximum 15%, minimum 2%) are present. Poaceae (maximum 22%, minimum 10%) and *Sinapis* (8%) achieve peak values in this zone. Aquatic and spore taxa include *Dryopteris*, which achieves maximum values of 6%, and a rise in *Sphagnum* (8%).

LPAZ-C 67.30–67.13 M OD ASTER TYPE-CYPERACEAE-LACTUCEAE

Zone LPAZ-C is characterised by a decline in tree taxa and dominance of herbaceous taxa (Figure 3.10: Zone C). *Pinus* (<2%), *Alnus* (<1%) and *Tilia* (1%) are present. *Corylus* (2%) and *Juniperus* (2%) maintain low counts throughout the zone, whilst Cyperaceae (40%) and Poaceae (20%) maintain high values throughout the zone. *Aster* type (15%) and Lactuceae (40%) achieve maximum values in this zone. Caryophyllaceae (pink family) (1%) is present, along with, *Ranunculus* (e.g. creeping buttercup) (2%), and Saxifragaceae (e.g. saxifrages) (2%). Aquatic and spore taxa include *Sphagnum* (achieving a peak of 13% and maintaining values throughout the zone), *Pteridium* (bracken) (maximum 6%), and *Equisetum* (2%).

LPAZ-D 67.56–67.30 M OD CYPERACEAE-POACEAE-LACTUCEAE

Zone LPAZ-D is characterised by a slight increase in shrub taxa values, and dominance of herbaceous taxa (Figure 3.10: Zone D). *Alnus*, *Betula*, *Quercus*, *Ulmus* and *Pinus* are present (all <2%). An increase in *Juniperus* (maximum 4%) and *Ligustrum* (maximum 5%) is recorded towards the top of the zone. Cyperaceae peaks (55%), with sedge taxa dominant throughout the zone. Poaceae (20%), Lactuceae (10%), *Aster* type (4%) *Ranunculus* (2%) and *Sinapis* (5%) maintain low to moderate values throughout the zone. Ericaceae (heath) (4%), *Polygonum* (e.g. knotweed) (4%), *Rumex* (dock/sorrel) (2%), Apiaceae (carrot family) (4%) and Saxifragaceae (5%) achieve peak values. Cereal pollen is present (*Hordeum*, 1%), along with *Plantago lanceolata* (2%). Aquatic and spore taxa present include *Equisetum* (maximum 5%), with low counts of *Polypodium* (2%), *Pteridium* (2%) and *Sphagnum* (2%).

INTERPRETATION

Zones LPAZ-A and LPAZ-B are dominated by sedges and grasses along with moderate values of tree and shrub taxa. Alder is likely to have been growing on a damp, relatively open wetland surface, perhaps with hazel, whilst pine, oak and elm are likely to have been growing in a relatively open dryland woodland. The transition to LPAZ-C sees an increase in dominance by sedges, with grasses, mosses and ferns also common. Tree and shrub taxa are rare in zones LPAZ-C and LPAZ-D, indicative of a transition to very open conditions on both the wetland and dryland. The relatively high concentrations of *Sphagnum* moss in zone LPAZ-C may be indicative of wetter conditions on the floodplain surface during this zone.

The presence of fat hen, ribwort plantain and white mustard in zone LPAZ-D may be indicative of disturbance associated with human activity, whilst the presence of barley at the top of the zone provides evidence for cereal cultivation not far from the site.

Discussion

A programme of fieldwork (incorporating a borehole survey), deposit modelling and environmental archaeological analysis was conducted at the Blick Mead site (Site 1) and on the floodplain of the River Avon c. 0.45 km upstream from Blick Mead (Site 2). The aim was to address a set of specific research questions outlined above (see Aims and Objectives, this Chapter) and discussed in detail below (see Conclusions, this Chapter). However, preliminary investigation of the pollen assemblages in column samples extracted from the archaeological trenches in the spring basin revealed very poor pollen preservation and in the bulk samples from the trenches, the preservation of plant macrofossils and insect remains was very limited. Research questions relating to the Mesolithic occupation of the site are therefore addressed below, based largely on the results of the lithostratigraphic investigation and geoarchaeological deposit modelling. Analysis of the peat sequences in boreholes BH25 and S2BH2 provides evidence of palaeoenvironmental conditions at the site during the Late Neolithic and Bronze Age.

The site of the archaeological excavations lies on the alluvial floodplain of the Salisbury Avon. It is underlain by Sand & Gravel which forms two remarkably uniform levels (see Figure 3.11); a higher level beneath the northern part of the site with a mean elevation of 67.38 m OD (the Higher Gravel Surface) and a lower level beneath the southern part of the site with a mean elevation of 66.03 m OD (the Lower Gravel Surface), which is also represented upstream at Site 2 at a closely similar level. The higher level has a relief amplitude of less than a metre, rising slightly towards the floodplain edge and displaying a subdued relief that might represent evidence of minor bars and channels on the gravel surface. The gravel is probably of Late Devensian age. It is not possible to determine on the basis of the available evidence whether the gravel underlying the Lower Gravel Surface represents an erosional bench cut into the gravel that underlies the Higher Gravel Surface, or whether it represents evidence of a later cut-and-fill episode. In either case, it is unlikely that this bench was formed later than the Early Holocene.

Overlying the Sand and Gravel in both the northern and southern parts of the site are sequences of fine-grained and more or less organic sediments, representing deposition during the Holocene.

Higher Gravel Surface

In the northern part of the archaeological site at the base of the sequence in most places is a unit of sand, probably nowhere more than 0.5 m thick. The sediment of this unit is undoubtedly water-laid.

Overlying the sand across the whole of the Higher Gravel Surface is a unit (Unit H3) which has been termed in this report the Alluvium. Sub-unit H3a is separately recognisable in some of the boreholes as a silty unit forming the lowest part of the Alluvium (Unit H3). This is the layer that contains the great bulk of the Mesolithic assemblage. The areas displaying the highest densities of Mesolithic material identified in the archaeological investigation are situated where the underlying gravel surface, and hence the mantle of Sand (Unit H2), rise slightly towards the edge of the alluvial floodplain. They are also just to the north of the shallow E-W depression recognised on the gravel surface and tentatively identified as a former channel.

The silty layer containing Mesolithic artefacts seems most likely to have been deposited from either standing or very slow-moving water. Considering the distance from the main channel of the

Avon, the small thickness of the Sub-unit H3a and the long period of time represented by the included datable remains, flooding was probably very infrequent. There is nothing in the sediment record to indicate the presence of an active subsidiary channel of the Avon.

The palaeoenvironmental evidence for the Mesolithic is very limited. Few seeds or insects were recovered from the four bulk samples assessed from the archaeological contexts. No seeds were found in the samples from Trench 22 (contexts layer [91] and [68]). No seeds were recovered from Trench 19 (context (77) but the insect assemblages do include taxa indicative of bodies of water (including ponds, streams or ditches) in the area of the site, with moss or grass tussocks on the margins, situated in a landscape that included nearby herbaceous meadows.

Considering the long period of time during which the site appears to have attracted Mesolithic activity, there is a lack of evidence for ground disturbance, for example, by trampling, and no obvious evidence for soil formation in the sediments.

As a whole, the Alluvium (Unit H3) probably comprises a mixture of fine-grained alluvial sediment and colluvial material derived by downslope movement from the adjacent valley side. The true nature of this unit and its lateral continuity are difficult to determine in detail because it has suffered disturbance, either as a result of floodplain management or as a result of burial beneath large amounts of Made Ground associated either with historic landscaping of the parkland which the site adjoins or with the reconfiguration of the nearby A303 Trunk Road. It is significant that only two of the twenty-three cores recovered from the alluvial floodplain during the present investigation recorded no superficial unit of Made Ground. Other evidence of disturbance was noted during earlier archaeological investigations in the form of medieval and post-medieval timbers found on the eastern and western edges of the investigated area, possibly associated with water management structures, and areas of flint nodule paving.

Lower Gravel Surface

In the southern part of the archaeological site (Site 1) and at Site 2, overlying the Lower Gravel Surface, peat was present in all six boreholes, either resting directly on the Sand & Gravel (Unit L1) or on a silty alluvium (Lower Alluvium – Unit L2) that overlies the Sand & Gravel (see Figure 3.11). The palaeoenvironmental evidence from the peat is consistent with the dating of the onset of peat formation to a period from the Late Neolithic into the Bronze Age.

A deposit generally similar to the Alluvium (Unit H3) and probably an extension of part of it, was recorded overlying the peat in the four boreholes at Site 1. A similar deposit overlay the peat in the boreholes at Site 2. Even with the benefit of radiocarbon dates for the onset of peat formation within the sediment sequence overlying the Lower Gravel Surface, it is impossible to be sure of the exact chronological relationship between that sequence and the sediment sequence overlying the Higher Gravel Surface.

Palaeoenvironmental evidence from the peat

The combined results of the palaeobotanical analysis of the peat (seeds and pollen) are indicative of relatively open environments on both the wetland (floodplain) and dryland surfaces, at the latest from the Late Neolithic (2455–2205 cal BC; SUERC-58195) onwards. The wetland environment was damp, dominated by sedges, grasses and aquatic taxa, perhaps forming sedge fen and meadow-type communities on the margins of a body of water. Grassland dominated the dryland, with only sporadic occurrences of tree and shrub taxa (including pine, oak, ash, elm and hazel), forming a suitable habitat for animal grazing. The palaeoenvironmental evidence for a more open landscape at this time is consistent with investigations in the area of Durrington Walls and West Amesbury by French *et al.*

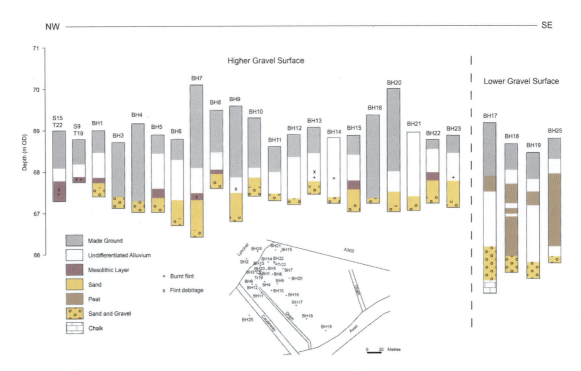

Figure 3.11: Borehole data from the Blick Mead basin, showing the higher and lower Gravel surfaces and the stratigraphic position of the Mesolithic horizons recorded in Trenches 19 and 22 (also shown). The Mesolithic layer is also shown where identified in the boreholes, along with burnt flint and flint debitage.

(2012), where a transition to a more open landscape was recorded during the Late Neolithic, with evidence for woodland clearance, disturbed ground taxa and cereals from c. 2900 cal BC onwards. Along with major soil and vegetation changes on the dryland, an expanding, wet floodplain dominated by alder and sedges was also demonstrated at this time (French *et al.* 2012). As recorded in the sequence from Site 2, where values of up to 20% were recorded during the Late Neolithic, pine was recorded

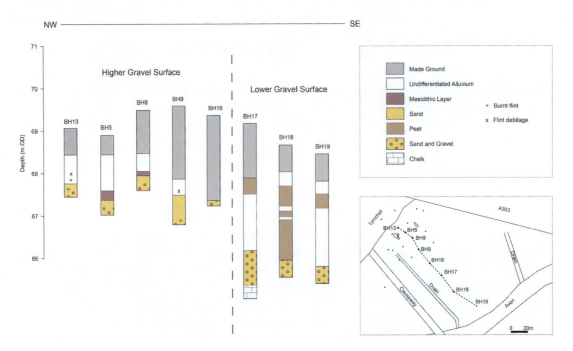

Figure 3.12: North-west to south-east borehole transect, from low to high ground.

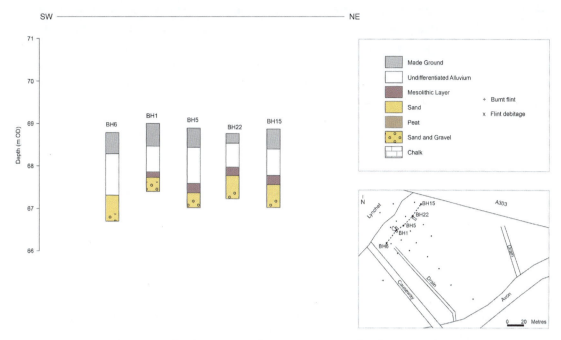

Figure 3.13: South-west to north-east transect across low-lying ground.

as a lingering component of the assemblages throughout the Neolithic period, perhaps significant as a resource for monument building (French *et al.* 2012).

Cereal pollen from both boreholes provides evidence of cultivation in the latter part of the sequences (at the latest from the Late Bronze Age onwards), but there are indications of disturbed ground and weed taxa at least from the Middle Bronze Age onwards (e.g. sorrel, thistles and ribwort plantain). Palaeoenvironmental investigations at Wilsford Shaft provided evidence for a scarcity of tree taxa, and localised pastoral and arable land (Bell 1989: 128) during the Late Bronze Age, whilst in the Durrington Walls/West Amesbury investigations a fully open landscape dominated by grassland and arable land was recorded from the Late Bronze Age/Early Iron Age onwards (French *et al.* 2012).

Conclusion

This investigation has established that within the area of interest two separate elements of the Holocene valley floor relief are present, represented by two well-defined gravel benches referred to here as the Higher Gravel Surface and the Lower Gravel Surface, underlying two separate sequences of fine-grained and more or less organic Holocene deposits. From the sedimentological and stratigraphic point of view, these deposits and their arrangement are all typical of alluvial sequences widely represented in the floodplains of rivers in southern England. The sediment sequence overlying the Higher Gravel Surface at Blick Mead includes Mesolithic flintwork and associated faunal remains which have been dated to between 7596 and 4695 cal BC (see Table 2.1). This area lies on the alluvial floodplain but very close to its edge where the valley side rises from a well-marked break of slope. The condition of the flintwork and the associated organic remains recovered from the wetland area suggests that foci of Mesolithic lay in the vicinity of the flint scatter, as the archaeological material had experienced little movement or redistribution since its original deposition. This is particularly demonstrated by

the sharp and unabraded nature of the recovered flintwork. The recent excavations in Trench 24 have provided evidence for at least one such focus. The sediment sequence overlying the Lower Gravel Surface relates in part at least to a period from the Late Neolithic into the Bronze Age.

In the context of this broad framework, it is now possible to review the specific research questions set out at the beginning of these analyses with a view to establishing in particular the setting and significance of the Mesolithic archaeological material.

What was the natural environment like during the period of occupation of the site?

The site lay within part of the floodplain of the River Avon, close to the valley side and probably marshy. There is insufficient palaeoenvironmental evidence to draw any detailed conclusions about the natural vegetation.

Is there any evidence for modification of the environment during the occupation of the site?

The radiocarbon dates associated with the Mesolithic archaeological material in the waterlogged areas span a period of some 3,000 years, but the material is contained in a thin layer of sediment which is essentially uniform and seems therefore to indicate a very stable environment during the period of Mesolithic occupation.

How did the environment change during the periods of occupation, and following abandonment of the site?

As noted above the environment seems not to have changed during the period of Mesolithic occupation. Subsequent natural deposition across the site did not lead to significant disturbance of the Mesolithic horizon, even when changes to environmental conditions developed nearby resulted in the accumulation of a substantial bed of peat. Ongoing intermittent human occupation of the site has affected the sediment sequence, possibly as a result of trampling; through the creation of various depressions that have been cut more or less deeply into the natural sediments and subsequently infilled with later deposits; and by compaction of the natural sediments beneath varying thicknesses of Made Ground.

Can the insect record provide any indications of variations in the past climate?

The insect record is too sparse to provide any indication of Holocene climatic change.

What is the nature of the sediments that have accumulated on the surrounding floodplain, and can these tell us anything about the sedimentary history of the site itself?

The most significant finding in connection with the sediments on the surrounding floodplain is the recognition of a substantial post-Mesolithic (Late Neolithic–Bronze Age) peat accumulation occupying a gravel bench at a lower level than the gravel underlying the archaeological site and between the archaeological site and the River Avon. This finding supports the view that the archaeological site has been protected from river activity for most of its history by its elevation above the more active parts of the floodplain. Hence the thin accumulation of alluvial material in which the Mesolithic remains occur, and the limited thickness and partly colluvial origin of the sediments that overlie the Mesolithic layer.

Do sediments accumulated on the surrounding floodplain have good palaeoenvironmental potential for reconstructing the environmental history of the site and its environs?

The discovery of post-Mesolithic (Late Neolithic–Bronze Age) organic sediment sequences on the floodplain has provided insights into environmental conditions during the period represented, and

suggests the possibility that a fuller understanding of the entire Holocene history of the floodplain can be achieved through further investigation of these sediments and their relationship to the sediments containing Mesolithic archaeology. Any account of the site needs to recognise the evidence for changing conditions on the floodplain during the Holocene and the effect that those conditions will have had on the site in terms of sediment deposition, and surface water and groundwater behaviour.

Charred plant remains from a tree throw in Trench 24, Blick Mead
– *Tom Maltas*

This report describes charred plant remains recovered from the centre of a tree throw (Cut [111], fill [210]NE), dated to c. 4236–4041 Cal B.C., in Trench 24, Blick Mead (see Chapter 2, Figure 2.12).

Methods

A sample containing 15 litres of sediment was processed by flotation at the Department of Archaeology, University of Sheffield. The subsequent residues were sorted in their entirety for artefactual and bio-archaeological material. As charcoal remains were highly fragmented, only those larger than 5 mm were collected. Charred plant remains were identified by comparison with modern reference material and published literature (Hather 1993). All identifications were verified by Catherine Longford, University of Sheffield.

Results

A list of the sample contents is provided in Table 2.1. Of note was the presence of two microliths, one unfinished, alongside six fragments of charred plant material. Two of the latter were diagnostic to species level, identified as part of a hazelnut shell (*Corylus avellana* L.) and, more tentatively, a root tuber of lesser celandine (cf. *Ficaria verna* HUDS). The four remaining fragments were non-diagnostic pieces of parenchymous tissue internal to plant roots and tubers (Hather 1993, vii).

Discussion

Ecology and exploitation of identified taxa

CORYLUS AVELLANA

Hazel is a ubiquitous presence within woodlands across Britain (White 1995). Tolerant of a wide range of conditions, the species predominantly exists as shrubs 3.5–6 m in height that often survive under canopies of taller competitors (Bean 1970, 723; White 1995, 87). Pollen records suggest that hazel was a prominent feature of the Holocene landscape in Britain (Tallantire 2002), and those within the environs of Blick Mead demonstrate a consistent presence throughout its occupation (French *et al.* 2012, 30). Widely recorded in ethnographic and historical literature (see references in Bishop *et al.* 2013, 35), the gathering and probable consumption of hazelnuts in Mesolithic Britain is attested by large concentrations of charred remains, beyond that feasibly attributed to 'natural' causes, in discrete contexts (Mithen *et al.* 2001, 228).

FICARIA VERNA

Also common to woodlands throughout Britain, lesser celandine is a small, clustering perennial with dark green, heart-shaped leaves and bright yellow spring flowers (Sell 1994, 41). While able to tolerate a variety of conditions, it most frequently occurs on seasonally wet or flooded soils (Taylor and Markham 1978, 1013). It is therefore likely that lesser celandine existed within the immediate environs of Blick Mead. In late spring/early summer, plants form 5 to 100 mm long tubers from swollen roots which persist during the plant's dormancy period until winter when new leaves are formed (Taylor and Markham 1978, 1011–1026; Klooss et al. 2016, 28). While both the leaves and tubers of lesser celandine are edible, they contain protoanemonim, a mild toxin that can induce vomiting (Klooss et al. 2016, 28). This exists in very low quantities in young leaves, however, and can be easily degraded by drying or heating tubers (Klooss et al. 2016, 28). As with hazelnuts, Mesolithic collection of lesser celandine in Britain has been inferred from large quantities of remains in secure archaeological contexts (Bishop et al. 2013, 39).

Plant utilisation at Blick Mead

While evidence exists for the collection of hazelnuts and lesser celandine tubers elsewhere in Mesolithic Britain, it cannot be assumed that the remains from Blick Mead represent consumption. Rather, in such low numbers, it is equally feasible that they entered the archaeological record 'naturally'. Hypothetically, they may represent material that was present when the tree throw was burnt clear of vegetation prior to occupation. Certain features of the probable lesser celandine tuber may suggest an anthropogenic source, however. The exterior surface shows wrinkling, characteristic of tubers dried prior to charring, while the interior structure shows tissues compressed against the internal epidermis wall to create cavities, characteristic of fresh tubers (Hather 1993, 22–23). This may represent partially dried material that was accidentally charred during drying. Indeed, accidents during drying by fires to remove protoanemonim and allow long-term storage of tubers is considered a key way in which remains would have entered the archaeological record (Bishop et al. 2013, 41). If true, the charred plant remains recovered from Trench 24 would represent the first evidence for the exploitation of plants at Blick Mead, a hitherto invisible activity but one that is likely to represent an essential part of subsistence and survival (Hather and Mason 2002). The processing of further samples taken from the tree throw may work to clarify this picture.

Table 3.6: The contents of the processed sample from tree-throw hollow [111]

Item	Amount / (weight)
Microliths	2
Bladelet fragments (>1 cm)	6
Bladelet fragments/chips (<1 cm)	39
Burnt flint	(68 g)
Bone fragments (<1 cm)	2
Charcoal fragments (>5 mm)	(<1 g)
Charred parenchymous tissue fragments	4
Charred hazelnut shell fragment	1
Charred cf. lesser celandine fragment	1

CHAPTER 4

The Lithic Material

– Barry John Bishop with contributions by David M. John, Randolph Donahue, Keith Bradbury and Peter Webb

> I had always had an interest in history but never had the opportunity to take it further. My involvement with Blick Mead came at a very opportune period in my life. Having just had to give up my job on health grounds, I was looking for a new direction. I had never been on a dig site and had no idea what to expect, but was instantly made to feel at home by the team. I was keen to learn and found willing teachers in both the professionals and experienced volunteers alike. I remember early on, Barry Bishop explaining how a flint core I found had been produced. He brought back to life someone dead.
>
> The encouragement and skills given to me by the professionals on the team led me to have the confidence to volunteer with Wessex Archaeology which led to me being taken on as a paid archaeologist, a dream come true. I have since retired as an archaeologist but continue to be involved with Blick Mead. To find evidence of a momentous event/period in our history through archaeology gives you a great buzz, but to find it on your own doorstep, in Amesbury, is truly awesome.
> — MALCOLM GUILFOYLE-PINK, volunteer and Amesbury resident

This chapter focuses on reporting on the struck flint and unworked burnt flint fragments recovered during the 2005–2013 excavations at Blick Mead (primarily Trenches 19, 22 and 23). It also provides an interim statement on those from the adjacent terrace between 2014 and 2015 (Trench 24) as a separate section. Analysis of the latter assemblage is still ongoing at the time of writing and thus any conclusions offered here may be open to review and amendment in subsequent reports.

Separate reports on the cause and significance of crimson flints from springs at Blick Mead, use wear on selected pieces and portable XRF analysis of a slate artefact are presented at the end of this chapter.

The lithic material from excavations at Blick Mead, 2005–2013: Trenches 19, 22 and 23

Large quantities of struck flint dateable to the Mesolithic, as well as unworked burnt flint, were recovered, most of this coming from waterlain sandy-silt deposits, of which a maximum of 16 m^2 have so far been excavated. Later deposits at the site also produced Mesolithic struck flint mixed with struck flint dateable to the Neolithic or Bronze Age, testifying to continued activity at the site.

The high quantities of flintwork recovered at the site were initially unexpected. This, combined with the intractability of the wet and clay deposits, meant the excavation procedure at this time involved *in-situ* recovery of the flintwork alongside thorough searching of the spoil on the side of the trenches. In order to maintain stratigraphic integrity all of the latter material has been recorded as unstratified and contextualised only according to the Trench from which it originated. As further excavations proceeded and methodologies for retrieval advanced, tighter stratigraphic control could be implemented. In the 2012 season total sieving was

implemented involving all excavated sediment being passed through a 2 mm mesh. This has resulted in the recovery of higher quantities of struck flints, particularly small pieces measuring 15 mm or less in maximum dimension, from later phases of fieldwork. In the following text, a consideration of the spatial distribution of the material precedes its description and discussion.

Distribution

HORIZONTAL DISTRIBUTION ACROSS THE SITE

Small quantities of unstratified struck and / or unworked burnt flint were recovered from Trenches 1/20, 11 and 13 (Table 4.1). Trenches 19, 22 and 23 all produced substantial assemblages of both struck flint and unworked burnt. The distribution of the struck flint indicates a substantial spread potentially over a considerable area; Trench 23 is located c. 40 m to the north-east of Trench 19 and they lie at opposite ends of the site. Due to the size of the trenches however, it is uncertain whether the densities of struck flint and unworked burnt flint so far found represent a continuous spread between and perhaps beyond the trenches, or a series of more or less discrete scatters.

Table 4.1: Quantification of struck flint and unworked burnt flint at Blick Mead

Trench	Total Excavated Area (m2)	Struck Flint (no.)	Burnt Stone (wt:g)
1/20	6	13	3,145
11	5	2	0
13	3	12	0
19	16	23,129	56,854
22	10	4,645	10,719
23	15	2,807	6,774

N.B. The lower alluvial layers, which contained the highest densities, were only encountered in Trenches 19, 22 and 23. The material from the other trenches, which did not reach this horizon, came from more recent deposits and is considered residual.

VERTICAL, OR STRATIGRAPHIC DISTRIBUTION

The pattern of deposition was similar for all trenches. By far the largest quantities of struck flint and unworked burnt flint came from deposits of fine-grained clayey silts and sands which were found towards the bottom of the excavated sequences overlying Quaternary sand and gravels deposits. These lower fine-grained deposits were only certainly encountered in Trench 19 (hereafter referred to in this report as the 'basal clay horizon', or BCH and equate to Young *et al*'s Unit L1, see Chapter 3) and Trenches 22 and 23. However, in Trench 6/10, located to the west of Trench 19, a series of clayey layers ([5], [9], [10]) was partially excavated at the base of the trench but which produced no struck flints or unworked burnt flint. If these layers were to equate to the BCH in Trench 19, it would suggest that the spread of cultural material within this horizon ceased in this direction, and this would accord with the apparent diminishing of the densities of struck flint towards the west in Trench 19. However, the deposits in Trench 6/10 had been severely disturbed by medieval, later and probably earlier landscaping, activities, and correlation between the clay layers recorded there and the BCH as seen in Trench 19, or the lower clay layers in Trenches 22 and 23, has yet to be established.

Trench 19

In Trench 19 the bulk of the artefactual material came from the basal clay horizon (BCH; context [59] and its sub-divisions), which accounted for 97.1% of all of the stratified struck flint and 97.0%

Table 4.2: Quantification of struck flint and unworked burnt flint by context from Trench 19

Context		Deposit Type	Area Excavated (m²)	Struck Flint (no.)	Burnt Stone (no.)	Burnt Stone (wt:g)
+		Unstratified	16	5,114	242	4,098
50		Topsoil	16	6	0	0
57		Upper Cobble Layer	12.25	45	4	66
52, 75		Middle Clay Horizon	12.25	80	24	485
58		Lower Cobble Layer	11	396	142	1,311
59 / B		Basal Clay Horizon	1	38	23	498
59 / C		Basal Clay Horizon	1	70	12	438
59 / 61		Basal Clay Horizon	1	221	49	1,393
59 / 62		Basal Clay Horizon	1	279	106	2,658
59 / 63		Basal Clay Horizon	1	431	132	1,856
59 / 64		Basal Clay Horizon	n/a	272	109	1,361
59 / 65		Basal Clay Horizon	1	253	41	1,235
59 / 66		Basal Clay Horizon	1	415	30	461
59 / 67		Basal Clay Horizon	1	306	18	737
59 / 76		Basal Clay Horizon	1	865	419	4,249
59 / 77		Basal Clay Horizon	1	9,951	2,027	18,604
59 / 92		Basal Clay Horizon	1	4,387	2,491	17.404
		Total Basal Clay Horizon	11	17,488	5,457	50,894
		Total Trench 19		***23,129***	***5,869***	***56,854***

of all the stratified unworked burnt flint from that Trench (Table 4.2). The remainder of the stratified material came from two later cobble layers (contexts [57] and [58]) that were interspersed with a middle clay horizon (contexts [52] and [75]). No struck flint or unworked burnt flint was found in any of the alluvial deposits that continued to form following the construction of the upper cobble layer, although a few pieces were found in the topsoil, which had formed on chalk dumped in the area following the widening of the A303 in the 1960s and which may have arrived from elsewhere along with the spoil.

In terms of technological attributes and condition, the struck flint from Trench 19 can be divided into two reasonably distinct assemblages; the first is limited to those pieces from the BCH, the second comprising the pieces from all layers overlying this. These are clearly different in terms of technology, composition and condition and will be discussed separately below.

THE BASAL CLAY HORIZON IN TRENCH 19

The struck flint from the basal clay horizon (BCH) is technologically homogeneous and of Mesolithic date, although there are a very few larger flakes and cores that do appear later in date and these are considered to be intrusive from the overlying layers. The flintwork from the BCH is predominantly in a good or only very slightly chipped condition, and most of it has recorticated. There is, however, some variation in the condition of this material. Although most pieces are either sharp or only show minimal edge chipping or rounding, around 2–5% of the pieces are more extensively abraded. Similar proportions of flakes, often also the most chipped, are also very heavily recorticated, leading

to localised disintegration of their thinner edges, and a wide variation in the degree of recortication is seen throughout the assemblage. This does suggest that whilst the majority of pieces had been relatively freshly made when deposited into the water, many older pieces that had spent longer in an active burial matrix or had been around for some time were also included.

The degrees to which pieces have recorticated should not be taken as a direct and infallible indicator of age, however. As noted above, recortication varies considerably across the assemblage, but also on individual pieces, with some faces or even parts of faces becoming blue-white and other parts remaining completely unrecorticated. Recortication on the most easily dateable pieces, the microliths, is also variable, but there are no indications that the earlier types are more recorticated than the later ones. Instead, recortication may be more influenced by raw material type than straightforward chronology, with some types being more prone to recortication; translucent black flint and the cherts, for example, appear to have rarely recorticated whilst other types mostly have. Nevertheless, it is notable that around 90% of the Mesolithic assemblage does show some degree of recortication, whilst the later prehistoric pieces (see below) are invariably and completely unrecorticated.

VERTICAL DISTRIBUTION

In order to elucidate the stratigraphic position of the lithic material *within* the BCH, one of the 1 m × 1 m squares, context [77], was excavated in five horizontal spits (Table 4.3), numbered successively in this report [77.1] to [77.5], [77.1] being the highest.

Table 4.3: Vertical distribution of struck flint and unworked burnt flint in square [77] of the Basal Clay Horizon in Trench 19

Spit	All Struck Flint from [77] (%)	Struck Flint >15 mm (%)	Struck Flint >15 mm (as % of total from spit)	Burnt Flint weight (%)	Burnt Flint ave. clast size
[77.1] Highest	188 (*1.9*)	103 (*3.7*)	54.8	1,019 g (*5.5*)	5.4 g
[77.2] Upper Middle	597 (*6.0*)	277 (*10.0*)	46.4	2,112 g (*11.4*)	12.4 g
[77.3] / [77.4] Middle[1]	4,493 (*45.2*)	1,656 (*59.6*)	36.9	11,298 g (*60.8*)	14.6 g
[77.5] Lower Middle	4,258 (*42.8*)	699 (*25.1*)	16.4	4,058 g (*21.8*)	9 g
[77.6] Lowest	415 (*4.2*)	45 (*1.6*)	10.8	117 g (*0.6*)	2.5 g

In total, this 1 m × 1 m square produced 9,951 pieces of struck flint, of which 2,780 exceeded 15 mm in maximum dimension, along with 1,627 pieces of unworked burnt flint weighing a total of 18,604 g. The majority of both the struck flint and the unworked burnt flint were in the middle and the lower middle spits, with significantly fewer pieces in either the upper or lowest parts of the layer. Interestingly, there are some differences in the distribution of the sizes of the material. The proportion of smaller and lighter pieces, those measuring less than 15 mm, increases significantly with depth, whilst the pieces of burnt flint in the lowest spit are smaller on average than in any of the others. The largest pieces of burnt flint, however, do concentrate in the middle spits.

This layer had formed from slow aggregation of silt-clay and sands deposited in conditions of slow moving or standing water, such as a pond or cut off channel. The differences in the distribution of the lithic material through the deposit would suggest that it mostly had entered the water during the formation of the middle parts of the layer. The high proportions of smaller pieces in the lower parts of the deposit might be accountable by the occurrence of processes such as bioturbation and even puddling. Although the concentration of lithic material within the middle of the layer does not categorically exclude the possibility that it entered the water from the erosion of dry surfaces, it does

1 Spit [77.3] and [77.4] are the same spit, partially excavated as [77.3] in 2012 and [77.4] being the remainder excavated in 2013.

The Lithic Material

support the notion that it was deposited after the deposit had started to form and therefore into what must have been open water. In this case, both the contemporary flintwork and also older pieces lying around appear have been gathered up and deliberately placed into the water.

HORIZONTAL DISTRIBUTION

It is difficult to confidently assess the spatial distribution of struck flint and unworked burnt flint within the BCH, as collection methods have evolved over the project (see Chapter 1) The following attempts to question whether any patterning in the distribution of lithic material within the BCH may be present, and includes calculation based on all of the material and, in order to mitigate against the effects of the differential use of sieving, only those pieces that measure greater than 15 mm in maximum dimension.

DISTRIBUTION OF STRUCK FLINT FROM THE BASAL CLAY HORIZON IN TRENCH 19

Figure 4.1 shows that that the distribution of struck flint within the BCH in Trench 19 varies considerably in density, with clear and substantial increases towards the south of the Trench, although it is the second most southerly square that contains the highest quantities. By excluding the pieces measuring 15 mm or less the quantities do even out to some extent, but the general pattern is maintained and the two southernmost squares still contain significantly higher amounts than any of the others. Interpreting these patterns is problematic. The Trench was investigated over a number of years, the excavation starting from the north and continuing to the south. The very low numbers of struck flint in the northern squares may be accounted for by the early excavation strategy, where the (very intractable) deposits

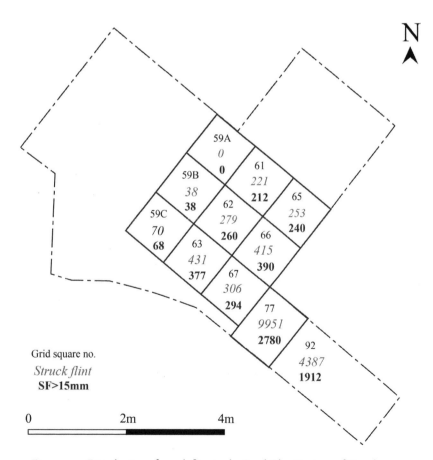

Figure 4.1: Distribution of struck flint in the Basal Clay Horizon of Trench 19.

were examined by hand on the side of the Trench. In order to maintain stratigraphic integrity and ensure no cross contamination of finds between deposits, all the retrieved artefacts were assigned as being unstratified even though it was clear that most came from the BCH. Sieving was introduced in 2012, with [77] being totally sieved. Square [92] was also completely sampled for organic remains and although these were separated from the lithics it is possible that the residues still contain lithic material which will be analysed later in the project. It should also be remembered that only a small 'window' of 11 m² has yet been opened up on what is almost certainly a much more extensive spread of cultural debris, and the patterns as seen so far may not accurately reflect the wider distribution.

DISTRIBUTION OF BURNT FLINT FROM THE BASAL CLAY HORIZON IN TRENCH 19

As can be seen in Figure 4.2, the pattern of the distribution of burnt flint is less clear but as with the struck flint the quantities do tend to increase towards the south. The two most southerly squares have also provided significantly more than any of the others with the second most southerly square producing the most. Again, it is difficult to make definitive statements concerning the distribution of the burnt flint, as recovery techniques developed greatly over the years that the trench has been investigated.

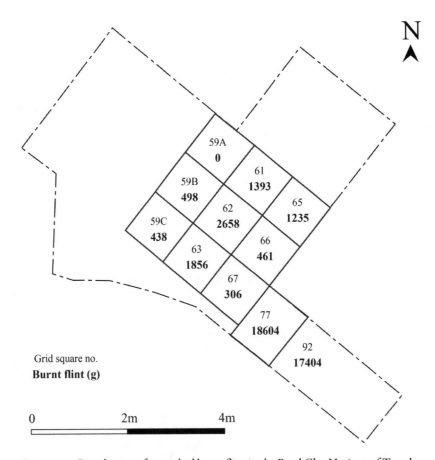

Figure 4.2: Distribution of unworked burnt flint in the Basal Clay Horizon of Trench 19.

The post-basal clay horizon layers in Trench 19

The flintwork from the post-BCH layers consists mostly of Mesolithic material of a similar character to that from the BCH, but there are also much higher numbers of larger thick flakes and irregularly reduced flake cores and conchoidally fractured chunks, which are much more typical of Neolithic or Bronze Age industries. Unlike the Mesolithic assemblage, which is mostly recorticated, the

The Lithic Material

pieces considered to be later show no signs of recortication. They are also in a significantly poorer condition, with the majority exhibiting extensive abrasion and chipping. The chipping had often occurred on the Mesolithic pieces post-recortication, and therefore long after they had been made and originally deposited, presumably at the same time as the Neolithic and Bronze Age material became chipped.

The post-BCH layers contain both higher proportions of larger flakes as well as cores and conchoidally fractured chunks; for example, the cores and large conchoidally fractured chunks contribute 6.1% of the assemblage from three layers, compared to 1.8% of that from the BCH. Complementing this, the post-BCH layers also contain lower proportions of small fragments and chips. This might suggest that larger pieces were being preferentially deposited during the later periods, but it is also likely to reflect the lack of intensive sieving that was undertaken on these deposits. Nevertheless, the assemblages from the post-BCH layers does support the possibility that larger struck pieces were gathered alongside unworked cobbles and dumped into the water, possibly to consolidate the soft clay and allow closer access to the water.

Trench 22

In Trench 22 the lower clay layer (context [91]) produced the largest and densest concentrations of both struck flint and burnt flint, with relatively smaller although still substantial quantities recovered from the overlying upper clay layer (context [68]) and the peat filled post-medieval ditch and overlying peat formation (contexts [89] and [69]) (Table 4.4).

The assemblages from both the clay layers and the peat deposits are indistinguishable from each other and closely comparable to the material from that of the BCH in Trench 19. They are clearly blade-based and can be dated to the Mesolithic. Intrusive pieces from later industries are either absent or very rare. Although the material from the peat is clearly residual it is likely to have originated from the clay layers and is in a predominantly good condition showing no, or only very minor, edge damage. As with the BCH in Trench 19, the assemblage from the clay layers suggests that the flintwork was deposited into slow moving or stagnant water.

Trench 23

Other than a few unstratified pieces of burnt flint, all of the lithic material from Trench 23 came from a series of clay horizons that form the lowest excavated levels. Within these, the bulk of the struck flint and burnt flint came from the middle clay horizon (context [79]) (Table 4.5).

Table 4.4: Quantification of struck flint and unworked burnt flint by context from Trench 22

Context	Feature	Area Excavated (m^2)	Struck Flint (no.)	Burnt Stone (no.)	Burnt Stone (wt:g)
+	Unstratified	10	291	65	1,244
69	Peat formation	9	180	89	1,421
89	Peat in ditch	1	382	121	1,216
68	Upper Clay Horizon	2	338	96	1,305
91	Lower Clay Horizon	2	3,454	841	5,533
Total Trench 22			***4,645***	***1,212***	***10,719***

The struck flint from the two lowest clay layers, contexts [79] and [90], is indistinguishable to that from the BCH in Trench 19 and the lower clay in Trench 22 in terms of condition, raw material use and technological attributes. That from the stony clay layer, context [70], however, is more similar to the assemblages from the post-BCH layers in Trench 19. Most of it is comparable to the Mesolithic flintwork, but there are also quantities of later prehistoric struck flints, including a transverse arrowhead of Later Neolithic date (see below). There are also notably large flakes and blades present and the material is also in a much more chipped and abraded condition than that from the underlying layers.

Table 4.5: Quantification of struck flint and unworked burnt flint by context from Trench 23

Context	Feature	Area Excavated (m²)	Struck Flint (no.)	Burnt Stone (no.)	Burnt Stone (wt:g)
+	Unstratified	15	0	11	129
70	Upper 'Stony' Clay Horizon	2	159	148	1,893
79	Middle Clay Horizon	2	2,129	396	4,154
90	Lower Clay Horizon	2	519	92	598
Total Trench 2			**2,807**	**647**	**6,774**

The unworked burnt stone

Nearly 79 kg of unworked burnt stone, all identifiable pieces of which consisted of flint, were recovered from the excavations at Blick Mead. Virtually all of it has been heavily burnt to the extent that it has changed colour to a grey/white and become 'fire-crazed' and highly fragmented. Where identification was possible, its cortex suggests the flint has a similar derivation to that of the struck assemblage and originates from Quaternary alluvial and/or colluvial deposits as present in the vicinity. None of the pieces considered in this section show any evidence for having been struck or otherwise worked, although around 2% to 5% of the struck assemblage is also burnt.

The distribution of the burnt flint across the site has been noted above and it is clear that it is predominantly associated with the Mesolithic struck assemblage and was deposited within the clay horizons in Trenches 19, 22 and 23 although smaller quantities were also found in later deposits in Trenches 1/20, 19 and 22 (Table 4.6).

The sheer quantity of the burnt flint and the intensity to which it had been heated argues strongly against it being the incidental product of hearth use or arising from the fire-setting of vegetation; instead it must be concluded that it had been purposefully produced. The deliberate production of burnt flint is often noted on later prehistoric sites, particularly the classic 'burnt mound' sites of the Later Neolithic/Bronze Age (Buckley 1990; Hodder and Barfield 1991), or the flint-filled pits sometimes found on Iron Age sites (e.g. Cunliffe 1976, 30–34; Smith 1977, 46–47). Large quantities of burnt flint are much more rarely found in Mesolithic contexts, Nevertheless, there is slight but increasing evidence for the large-scale and systematic burning of flint during the Mesolithic (Clark and Rankine 1939; Butler 1998; Harding 2000; Lewis and Walsh 2004; Bishop 2008a; 2010)

Many explanations for these accumulations of burnt flint and other stone have been proposed although probably the most prevalent view interprets them as representing the waste generated from using stone to heat food, with the heated stones used either to boil water or to provide direct heat for roasting. In one experiment, O'Kelly (1954) managed to bring 454 litres of water held in a

The Lithic Material

Table 4.6: Quantification and distribution of unworked burnt flint by context, shown in stratigraphic order

Context	Deposit	Total number of pieces	Max. weight of single clast (g)	Total weight (g)	Density (g:m2)	Ave clast weight (g)
TRENCH 19						
+	**Unstratified**	242	177	4,098	256	16.9
57	Upper Cobble Layer	4	28	66	5	16.5
75	Middle Clay Horizon	16	73	282	142	17.6
52	Middle Clay Horizon	8	51	203	23	25.4
Total Upper Clay Horizon		*24*	*-*	*485*	*30*	*20.2*
58	Lower Cobble Layer	140	143	1,233	112	8.8
59B	Basal Clay Horizon	23	69	498	498	21.7
59C	Basal Clay Horizon	12	161	438	436	36.5
61	Basal Clay Horizon	49	123	1,393	1,393	28.4
62	Basal Clay Horizon	106	244	2,658	2,658	25.1
63	Basal Clay Horizon	132	106	1,856	1,856	14.1
64	Basal Clay Horizon	109	52	1,361	N/A	12.5
65	Basal Clay Horizon	41	344	1,235	1,235	30.1
66	Basal Clay Horizon	30	125	461	461	15.4
67	Basal Clay Horizon	18	172	737	737	40.9
76	Basal Clay Horizon	419	202	4,249	4,249	10.1
77	Basal Clay Horizon	1,627	396	18,604	18,604	11.4
92	Basal Clay Horizon	2,491	193	17,404	17,404	7.0
Total Basal Clay Horizon		*5,057*	*396*	*50,894*	*4,626*	*10.1*
Total Trench 19		**5,469**	**396**	**56,854**	**3,553**	**10.4**
TRENCH 22						
+	**Unstratified**	65	102	1,244	124	19.1
69	Peat Formation	89	98	1,421	157	16.0
89	Peat in ditch	121	99	1,216	122	10.0
68	Upper Clay Horizon	96	126	1,305	653	13.6
91	Lower Clay Horizon	841	154	5,533	2,767	6.6
Total Trench 22		**1,212**	**154**	**10,719**	**1,072**	**8.8**
TRENCH 23						
+	**Unstratified**	11	32	129	9	11.7
70	Upper Clay Horizon	148	120	1,893	947	12.8
79	Middle Clay Horizon	396	101	4,154	2,077	10.5
90	Lower Clay Horizon	92	67	598	299	6.5
Total Trench 23		**647**	**120**	**6,774**	**452**	**10.5**
TRENCH 1/20						
+	**Unstratified**	151	112	3,145		20.8
Total Trench 1/20		**151**		**3,145**		

trough to boil within 35 minutes and keep it simmering for nearly four hours using hot stones, long enough to cook a 4.5 kg joint of meat. Food could be boiled by being placing in skin bags and held over heated stone or, alternatively, the food could have been roasted on a bed of hot stone, or buried in pits alongside heated stone, which would have slowly steamed or baked it. The scale of the burning of flint recorded here may argue that large-scale cooking was occurring, perhaps involving many people and the aggregation of the wider community, and this resonates with the large quantities of animal bones recovered (cf. Woodman 2001; Milner 2009, 78–81)

The struck flint and worked stone

RAW MATERIAL USE

All of the worked stone comprises flint with the exception of a smoothed sandstone slab and a possible slate microlith (see below). Numerous rounded pebbles and cobbles of sarsen sandstone were also found throughout the artefact-bearing deposits. Sarsen is naturally present in the region. There is no evidence that the pieces here were collected or brought to the site, and none show any evidence for deliberate modification or of damage from use. Nevertheless, at other Mesolithic sites similar stones have been shown to be imported and a number of uses for them can be envisaged, including as anvils for working bone, wood or flint and as pounders for processing plant remains and cracking hazelnuts (e.g. Holst 2010). As none of those from Blick Mead show any macroscopic evidence of use they will not be discussed further, but they have been retained in the archive should further study be considered desirable.

Describing and quantifying the flint raw materials used to make the struck assemblage was hampered by the development of recortication, which frequently masked the original nature of the flint. Nevertheless, from the unrecorticated pieces and from recent breaks it is evident that the colour of the flint, its texture and the type of cortex varies considerably (Figure 4.3).

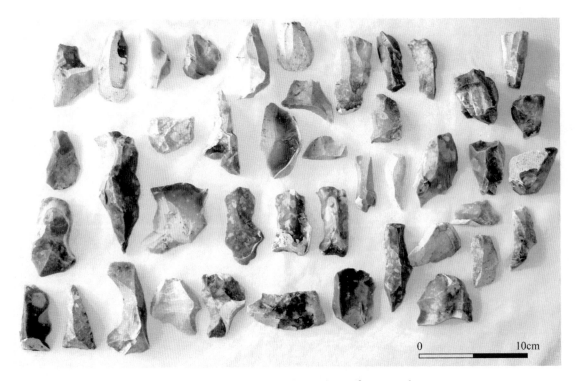

Figure 4.3: Selection of large flakes and cores from Trench 19.

The Lithic Material

The bulk of the flintwork, probably more than 80%, comprises a mottled semi-translucent light grey to light/mid-brown glassy flint containing differing proportions of opaque yellow, grey or brown cherty patches. Even within this rather broad description there is much variation, however, and it is not clear to what degree these variations are attributable to different sources of the flint, or to natural variation within the flint seam or even within individual nodules. Some pieces are purely translucent and fine-grained, whilst others comprise mostly coarse-grained and opaque cherty flint; each may represent either a different type of flint or merely different aspects of the same flint source or nodule. However it is constituted, this material tends to have a thick (up to 10 mm) rough and relatively unweathered cortex, although some abrasion and battering is evident and thermal faulting is commonly present. The size of some pieces of flint struck from these demonstrates that the unworked nodules could exceed 100 mm in diameter and may have been considerably larger; unworked nodules collected at the site, themselves possibly 'caches' of raw materials, could reach up to 250 mm in diameter. It is also clear that the raw materials had largely retained their nodular shape and could be matched within the alluvial or redeposited colluvial deposits exposed at the site.[2] Some of the cortex retained on these pieces is much more rounded, weathered and sometimes chattermarked, indicating that these pieces came from cobbles that had experienced greater degrees of rolling within alluvial environments.

It is also worthy of note that the large flakes and cores considered to date to the Neolithic or Bronze Age from the post-BCH layers in Trenches 19 (context [59]) and the stony clay layer in Trench 23 (context [70]) are virtually all made from a near opaque dark brownish to black, often tinged green, mottled glassy flint that mostly has a rolled and/or battered cortex typical of cobbles from far-transported gravel terrace deposits. Similar material is found amongst the Mesolithic assemblage but it is not common.

Also present within the Mesolithic assemblage, but probably contributing less than 5%, is a relatively flawless translucent black flint. This is typical of the finest quality flints from the Upper Chalk although these are not commonly encountered in the Salisbury Plain area. Also utilised but again contributing less than 5% of the assemblage are nodules of 'bullhead bed' flint, which has a distinctive green glauconitic cortex and an orange band immediately beneath. This is found at the junction of the Cretaceous Upper Chalk and underlying Tertiary deposits, such as the Thanet Sands, and is commonly used for manufacturing prehistoric flintwork in Kent, Essex and East Anglia (Shepherd 1972). The nearest exposed deposits of Thanet Sand can be found c. 16 km upstream of the River Avon in the Vale of Pewsey (British Geological Survey 2010), although the extent and location of any flint-bearing deposits are not mapped. A further small proportion of the assemblage is made from a coarse-grained, opaque, white through to mid-grey 'stony' chert. The nearest *in-situ* sources of chert-bearing deposits are probably the Early Cretaceous sandstones exposed along the Nadder valley in the Burcombe/Barford area, c. 16 km to the south-west of Amesbury (British Geological Survey 2007). The main chert bed here is the Boyne Hollow Chert Member but this contains predominantly brown to black cherts, and it remains uncertain as to where the lighter coloured chert used at Blick Mead may have originated.

Lastly, a possible microlith made from slate that must ultimately originate from western Britain, and a smoothed slab of exotic sandstone from an unknown source, have also been identified (see below). Further work is being conducted to try to establish more precisely where these originated (e.g. Webb, this chapter, below).

2 Quaternary alluvial/colluvial deposits were recorded in Trench 22 (context [96]). Within this poorly sorted mix of silt-clay, sand, gravel, pebbles and cobbles are moderate quantities of large nodular cobbles of flint that can weigh up to 7 kg. These are often complete but thermally flawed, and some have fragmented along such flaws. Their cortex ranges from thick, rough and with only minor abrasion and knocking, to thin and displaying considerable 'chattermarking'. This indicates that they have received considerable variation in the degree to which they have been 'rolled' and some clearly have not travelled far in an alluvial environment although could have moved further as constituents within a body of colluvium.

Although the ultimate origins of the raw materials used at Blick Mead are varied and far-flung, it is evident that most were obtained from derived sources which include (peri-) glacially derived colluvium and alluvial Terrace Gravel deposits, which may have collected flint from numerous and widespread locations. Local sources of derived flints include deposits formed by erosion out of the steep chalk hill upon which Vespasian's Camp rests, and also from the colluvially filled palaeochannel, which contains mass-weathered flint nodules displaced by the receding of the springs and the westward meandering of the present River Avon. This is a flint-rich part of the landscape and it is likely that most of the flint used at Blick Mead was gathered from such close-by sources. However, Mesolithic landscape occupation is characterised by considerable mobility and movement, so there is also no reason not to suppose that some of the raw materials used here may have come from further afield, as would be supported by the wide variety of flint types present.

Description of the assemblage

A total of 30,608 struck flints have been recovered from the excavations in the wet areas of Blick Mead. Of these, 15,670 pieces, or 51.2% of the total, measure 15 mm or less in maximum dimension and are hereafter referred to as 'micro-debitage'; the remainder will be referred to as the 'macro-assemblage'. This distinction has been made because the proportions of micro-debitage recovered are heavily influenced by the use or absence of sieving and therefore can lead to distortions when comparing contexts that have been sieved with those that have not. The arbitrary figure of 15 mm was chosen as the upper limit for the micro-debitage as it was thought that the larger and more technologically distinctive pieces were more likely to reflect on the way that lithic materials were perceived and used at the site (cf. Brown 1991).

The assemblage has been catalogued and classified according to each piece's position within a simplified scheme that has been broadly based on the notion of the *chaîne opératoire;* the sequences in which a piece of raw material made be converted into useful implements, their use and eventual discard (Table 4.7). This acknowledges the knapping process as dynamic and consisting of a number of incremental and even cyclical processes, each of which can, although need not, take place at different times and places within the broader landscape (Conneller 2000; 2008). The spatial structuring of activity can be an important means by which the landscape can be understood and inhabited, and lends to some places a sense of history and belonging (Ingold 1993; Edmonds 1997; McFadyen 2009). By taking such an approach it is hoped that a better understanding can be made of the traditions of technological engagement that led to the creation of this assemblage, as well as the significance of the social and material conditions under which it was made. It is an important concept when considering Mesolithic assemblages as, due to the highly mobile nature of Mesolithic societies, assemblage variability is determined by both time and place, and the specific activities considered appropriate for each.

By assigning each piece to its perceived position within the knapping sequence a degree of subjectivity is unavoidable. Nevertheless, by considering all of the material together, basic knapping trajectories can be established, and the bulk of the debitage is sufficiently technologically distinctive to allow confidence in assigning each piece's position within that path (see Technological Strategies below).

As noted above, at least two chronologically distinct assemblages are present amongst the Blick Mead material. The assemblages from the BCH in Trench 19, the clay layers (contexts [68] and [91]) in Trench 22 and the two lower clay layers in Trench [23] (contexts [79] and [90]) are clearly dominated by blade-based reduction strategies that on technological and typological criteria can be dated to the Mesolithic. Such material also predominates within the assemblages from the layers post-dating the BCH in Trench 19, from the peat in Trench 22 and from the upper clay layer (context [70]) in Trench 23, although in all of these cases there are also minor but notable proportions of flakes and cores of later prehistoric date. These can only be confidently dated to the Later Neolithic or Bronze Age periods; the presence of a transverse arrowhead certainly indicates that some of it belongs to the

The Lithic Material

Table 4.7: Quantification of struck flint (N.B. symbol (ps) following context number indicates the deposit was partially sieved and (s) indicates it was 100% sieved – others were not sieved)

Trench	Context	Deposit	Decortication Flake	Decortication Blade	Crested Blades	Core Maintenance Flakes	Platform Rejuvenation Flakes	Platform Rejuvenation Blade	Unclassified Flake Fragment	Useable Flake	Useable Blade	Micro-debitage	Micro-burin	Microlith	Other Retouched	Transverse Axe	Core	Conchoidal Chunk	Context Total	Total Macro-assemblage (>15 mm)	% Macro-assemblage (>15 mm)
1/20	56	Clay		1		2			2	6	2	1						1	13	12	92.3
11	22	Cobble Layer									1								2	2	100
13	27	Topsoil		1						1	1	6			1				12	6	50.0
19	+ (ps)	Unstratified	207	132	19	601	58	58	803	1,098	1,113	792	21	34	82	2	42	53	5,114	4,322	84.5
19	50	Topsoil		2		2			2	2		0							6	6	100
19	57	Upper Cobbles				14			5	11	10	2			2		1		45	43	95.6
19	52	Middle Clay		3		7			20	17	21	5	2			1	1	2	80	75	93.8
19	58 (ps)	Lower Cobbles	24	3	1	57	4	2	34	60	62	110	1	2	8		15	13	396	286	72.2
19	59B	Basal Clay	4		1	9	2		3	8	8	5				1	2	1	38	38	100
19	59C	Basal Clay	6	1		11			9	19	16	2			1		4	1	70	68	97.1
19	61	Basal Clay	3	20	3	29	5		39	54	37	9		1	3		9	10	221	212	95.9
19	62	Basal Clay	26	12		36	4	4	50	56	33	19	2		7		11	18	279	260	93.2
19	63	Basal Clay	20	34	1	42	6	4	82	70	87	54			7		13	10	431	286	87.5
19	64	Basal Clay	29	6	3	35	4	3	71	38	34	26		1	5		5	13	272	246	90.4
19	65	Basal Clay	25	7	1	38	11	4	35	49	38	13			7		13	12	253	240	94.9
19	66	Basal Clay	21	11		60	11	17	71	103	76	25	1	1	12		3	3	415	390	94.0
19	67	Basal Clay	12	15	2	49	4	5	37	64	89	12	3		6	1	7		306	294	96.1
19	76 (ps)	Basal Clay	24	14	1	53	3		173	120	133	313	1	10	6		7	6	865	552	63.8
19	77 (s)	Basal Clay	142	50	2	432	15	7	797	526	566	7,171	35	71	37	2	24	73	9,951	2,780	27.9
19	92 (s)	Basal Clay	147	24	6	239	8	2	621	399	359	2,475	9	24	12		19	43	4,387	1,912	43.6
22	+	Unstratified	24	2	1	40	3	3	38	57	56	48		2	6		3	8	291	243	83.5
22	69 (ps)	Peat formation	12	5	2	19	4	2	29	31	31	35			5		2	3	180	145	80.6
22	89 (s)	Peat in ditch	16	3		20	1		20	32	27	252	1	4	1			5	382	130	34.0
22	68 (ps)	Upper Clay	26	5	2	46	2	1	67	63	56	61		2	2		5		338	277	82.0
22	91 (s)	Lower Clay	53	15	4	109	3	1	269	196	177	2,548	7	28	13		6	25	3,454	906	26.2
23	70 (ps)	Upper Clay	10	2		11	2	2	26	36	20	44			4		1	1	159	115	72.3
23	79 (s)	Middle Clay	55	15	1	71	5	2	228	139	217	1,339	10	10	17	2	15	4	2,129	790	37.1
23	90 (s)	Lower Clay	8	4		22	3	1	42	44	75	308	2	3	3		3	2	519	211	40.7
Total No.			894	387	49	2,054	156	119	3,571	3,299	3,345	15,670	95	194	248	9	211	307	30,608	14,938	
Total %			2.9	1.3	0.2	6.7	0.5	0.4	11.7	10.8	10.9	51.2	0.3	0.6	0.8	0.1	0.7	1.0	100	48.8	

beginning of that range, but many of the later prehistoric pieces are thick and crudely struck, and may perhaps best fit within Later Bronze Age or even Iron Age industries.

METRICAL AND TECHNOLOGICAL CONSIDERATIONS

The Mesolithic assemblage was produced over a period of nearly 3,000 years, as evidenced by the microlith typology (see below) and radiocarbon determinations. It must therefore be regarded as a palimpsest of chronologically mixed knapping events, and this does limit some of the questions and methods of analysis to which it can be put. Detailed statistically based metrical and technological analyses, which in other situations have the potential to refine dating and chart changes in the technological approaches to flintworking, are not appropriate here due to the lack of chronological clarity of individual or broad sequences of knapping events. Nevertheless, a number of general observations are worth making.

It has been noted above that the raw materials available for use are large, the nodules potentially reaching 250 mm in diameter. Nevertheless, none of the flakes or blades from Blick Mead approaches such a size. A small number of flakes and blades do exceed 100 mm in maximum dimension with a few blades having dimensions consistent with Late Glacial or Early post-Glacial industries (Barton 1989; 1991; 1998). However, none of these have been struck from well-managed opposed platform cores or have particularly complex striking platform preparation; conversely, the largest are either crested or come from early stages in the knapping sequence and represent attempts to decorticate or dress nodules.

It appears from remnant scars on many cores that the nodules were frequently 'quartered' (i.e. broken down into smaller pieces, but not necessarily only into four) and these often extensively shaped prior to the main stage of flake and blade production. The flakes and blades considered to represent routine reduction rarely exceed 50 mm in length with the largest being around 80 mm. The majority of those over 15 mm in length fall within the 25–40 mm bracket. The narrowness of the blades is also fairly uniform. This is difficult to quantify precisely, as the narrower and more fragile pieces are the most prone to breakage. Of those that remain complete, over 80% have a length / breadth ratio within 0.35–0.5.

The classification scheme is based upon the principal technological attributes of the pieces which vary according to the pieces' position within reduction sequence. The decortication and core preparation flakes and blades mostly exhibit plain or cortical striking platforms that at most had only been cursorily trimmed. These tend to be deep, averaging around 4–5 mm but sometimes considerably more, and over half have pronounced bulbs of percussion and visible points of percussion. This does strongly suggest that the raw materials were quartered, decorticated and the shape of the intended core established with relatively imprecise knapping blows, most probably using hard hammer percussion. Conversely, around three-quarters of the flakes and blades classified as being from routine production have finely edge trimmed striking platforms, although facetted and/or abraded platforms are rare, contributing only a few per cent of the total. The platforms tend to be lipped and are narrow, averaging at around 2 mm and sometimes even less, which often led to the platform shattering upon impact. Bulbs of percussion were nearly always either imperceptible or hemispherical and discrete, typical indicators of soft hammer percussion (Pelegrin 2000).

It is also important to note that, although detailed analyses have not been attempted for the reasons given above, no significant metrical or technological differences have been noted between the material from the BCH in Trench 19 and the lower clay horizons in Trenches 22 and 23.

DECORTICATION FLAKES AND BLADES

Decortication flakes and blades are defined as those that retain cortex over at least 50% of their dorsal surface. Here they include many large pieces struck during the initial shaping of nodules. The largest of these exceed 100 mm in maximum dimension and must have been struck from nodules significantly

larger than this. Most are significantly smaller, although they do tend to be larger than the blades and flakes struck during routine reduction. They include many flakes from the initial preparation of the raw materials as well as those struck to remodel partially reduced cores in order to extend their working lives.

A total of 1,281 decortication flakes were recovered, of which just under a third (30.2%) were of blade proportions (i.e. at least twice as long as they are broad). The manufacture of blades is not a requirement of decorticating raw materials, and this suggests that the production of blades was an ingrained aspect of flintworking practices, rather than a specific technique reserved for potentially useable pieces. Decortication flakes and blades form 4.2% of all of the struck flint recorded from Blick Mead, or 8.6% of all pieces measuring more than 15 mm. They certainly indicate that raw materials were being decorticated at the site but the quantities present are not excessive and only around 10% of the decortication flakes and blades are primary, in that their dorsal surfaces are entirely covered with cortex. This suggests the possibility that the raw materials may have been preliminarily dressed closer to where they were collected. This might have been not far, however, as suitable raw materials can be found in a variety of sources in the general vicinity (see Raw Materials, above).

The proportion of decortication flakes and blades within the Mesolithic horizons are remarkably uniform across the trenches. Excluding the micro-debitage they form 8.9% of the assemblage from Trench 19, 8.4% from Trench 22 and 8.2% from Trench 23. The proportions within the later layers are, however, somewhat more variable although perhaps not significantly so. In Trench 19 they contribute 7.8%, in Trench 22 13.1% and in Trench 22 10.4%.

CRESTED FLAKES AND BLADES

A total of forty-nine blades had traces of cresting along their main dorsal ridge, representing 0.2% of the entire assemblage and 0.3% of all pieces greater than 15 mm in maximum dimension. Very few of these can be considered true primary crested pieces, that is, those created by knapping a vertical crest upon a core prior to and in order to facilitate the removal of further blades, but most appear to have been created in order to rejuvenate the faces of cores that were already in the process of being worked. They are therefore more akin to rejuvenation flakes and it appears that true cresting in the sense of core preparation was not routinely practised here.

CORE PREPARATION AND MAINTENANCE FLAKES

Flakes apparently struck in order to shape, prepare or sustain the core contribute 2,054 pieces or 6.7% of the overall assemblage, which rises to 13.8% if pieces less than 15 mm are excluded. Just under a fifth (19.8%) is of blade proportions; the remainder, comprising 1,647 pieces, are flakes.

Technologically they represent a very disparate group, but all have been interpreted as representing attempts at modelling the core and maintaining its ability to produce flakes or blades. They include flakes removed to shape and prepare the core, those struck to maintain its suitability for continued reduction, such as by removing bowing or developing flaws, and also those struck to form new striking platforms and core faces on cores that have already been partially reduced.

PLATFORM REJUVENATION FLAKES AND BLADES

Platform rejuvenation flakes and blades were struck to remove parts of the striking platform, in order to realign it, repair edges or readjust platform/core face angles. A total of 275 have been identified representing 0.9% of the assemblage or 1.8% of that over 15 mm, and nearly half (43.3%) are of blade proportions. Almost half of these rejuvenated the core principally by removing parts of the core face, these sometimes being detached from the base of the core face and creating a plunged blade with a distal end that retains part of the striking platform. The remainder were struck transversely across

the striking platform; around half partially removing it and the others removing it completely (true core tablets).

FLAKES AND BLADES FROM ROUTINE REDUCTION

Flakes and blades considered to have been made during routine reduction comprise 6,644 pieces and form the largest category of the macro-assemblage. They primarily represent the intended products of flint reduction, but it is unlikely that all were seen by the knapper as being potentially useful. There are several possible reasons for this: many of these pieces are small, irregular in shape, some may be considered too thick or they retain pronounced hinge or step fracture scars on their dorsal faces. They include pieces that were badly struck or appear to have been unsuccessful, in that potentially useable flakes and blades became detached from the core before reaching their anticipated length. Between a quarter and three quarters are also broken, depending on how narrow and thin they are, with the more fragile pieces being more likely to be incomplete. This certainly reflects the post-depositional history of the assemblage, which includes probable trampling by animals and humans prior their eventual deposition in to the water, but many pieces may have broken during reduction, due to factors such as thermal flaws or adverse inclusions, or shortly after they were detached.

MICRO-DEBITAGE

The micro-debitage consists of flakes, blades, fragments and pieces of knapping debris that measure 15 mm or less in maximum dimension. Small flakes and pieces of shatter are generated in considerable numbers during reduction, from the deliberate trimming of cores and the retouching of flakes and blades, and also accidentally as by-products generated during the detaching of larger flakes. Their recovery is largely determined by the sieving programme, as sieving results in considerably higher numbers being recovered than when not employed. Micro-debitage from the unsieved contexts contributed an average of 8.1% of the overall assemblage from the site, but this increased to nearly a fifth (19.2%) of the assemblages from the contexts that had been partially sieved, and over two-thirds (67.7%) of the contexts that had been total sieved. Although large quantities of micro-debitage were recovered, it is still not clear whether this represents *in-situ* knapping or redeposition. Small flakes and pieces of knapping shatter are produced in vast quantities during knapping, not least within blade-based technologies where a high degree of core maintenance is undertaken. At the Mesolithic site of Woodbridge Road in Guildford, where sieving was also undertaken, micro-debitage accounted for nearly 90% of an assemblage that totalled over 50,000 pieces (Bishop 2008a). The majority of these pieces measured 3 mm or less and it was concluded that the flintwork had been knapped *in situ*. At Blick Mead the majority of the micro-debitage measures between 5 and 15 mm and, although certainly present, smaller pieces are relatively underrepresented. It remains possible, therefore, that the Blick Mead flintwork does not present material knapped *in situ*, or even the erosion of knapping scatters into the water, but instead suggests that the flintwork was actually gathered up, with the smaller pieces more likely to go unnoticed, and discarded into the water. As noted above, however, the small size of the areas so far excavated means the exact depositional circumstances of the assemblage have yet to be elucidated

UNCLASSIFIABLE FLAKE FRAGMENTS

These consist of broken flakes and blades measuring more than 15 mm in maximum diameter but which remain too fragmentary to ascertain their original shape or size. A total of 3,571 pieces were identified, representing 11.7% of the total assemblage or just under a quarter (23.9%) of the macro-assemblage. This high figure testifies to the thin and fragile nature of many of the flakes and blades produced at Blick Mead, and a high proportion of even those that can be classified are broken to

some extent. The high degree of breakage amongst the assemblage would also be consistent with the possible redeposition of the material.

CORES AND CONCHOIDAL CHUNKS

General observations

A total of 211 complete cores were recovered, representing 0.7% of the entire assemblage or 1.4% excluding the micro-debitage. Each has been individually described and catalogued and forms part of the site archive. Additionally, 307 conchoidally fractured chunks, a further 1.0% of the entire assemblage, were recorded. These mostly represent cores that disintegrated, either during shaping and preparation or during reduction, and illustrate the thermally flawed nature of much of the raw material. A few of the complete cores also appear to have partially disintegrated during earlier attempts at reduction but were reshaped to allow reduction to continue. Of the complete examples 165, or 78%, have at least at some point in their productive lives produced blades, these accounting for nearly three quarters (72.8%) of the complete examples, although many of these had additionally been used to produce flakes. The complete cores ranged between 15 and 543 g in weight with an average of 78 g. Both the smallest and largest of the cores were blade types but the flake cores were on average slightly larger with a mean weight of 90 g, as compared with 74 g for the blade cores.

Distribution

All of the cores came from Trenches 19, 22 and 23; the highest proportions coming from Trench 23 where they contributed 1.7% of the macro-assemblage, whilst in Trench 19 they contributed 1.5% and in Trench 22 only 0.9%. The vertical distribution of the different types of cores in Trench 19 varied markedly; less than a fifth (18.8%) of those from the BCH were flake types whilst these contributed nearly half (46.7%) from the overlying layers (Table 4.8). They also differed morphologically. The flake cores from the BCH included examples that had been prepared but abandoned before sustained flake and blade production had occurred, along with exhausted cores that could easily have produced blades earlier in their productive lives. Conversely, most of the flake cores from overlying layers consist of either minimally flaked cobbles or multi-platform types that have large broad flakes removed from many different angles, and which are most comparable to Later Neolithic or Bronze Age examples.

Most of the cores from stratified contexts in Trench 22 had been worked to produce blades, the exceptions being a centripetally worked example from the upper clay (context [68]) and a possibly re-used core from the lower clay (context [91]). The lack of later prehistoric cores from the overlying peat supports the notion that the struck flint predominantly, if not exclusively, derives from the Mesolithic deposits.

All but three of the cores from stratified contexts in Trench 23 were blade types. The exceptions include two examples that had produced flakes and quite possibly blades, but which had been re-used as hammerstones, and a large angular chunk that had been abandoned at an early stage due to the development of persistent thermal faults.

Overall, core reduction at Blick Mead does show a great deal of expediency, both in terms of dealing with the vagaries of the quality of the raw materials and also in the planning and the adoption of different approaches used to produce the desired flakes and blades. Nevertheless, the majority do demonstrate consistency in the methods used to prepare and work cores and most can be placed within reduction strategies that involve a number of incremental stages. Although some initial dressing and decortication of the cores may have taken place closer to where the raw materials were gathered, all other stages in the production of cores can be identified.

More than one in six of the complete cores have only been minimally worked prior to abandonment (see Table 4.8). These fall broadly into two types. Half represent the flaking of unprepared

Table 4.8: Core striking platforms

Striking platforms

Number and alignment of platforms	Type (Clark et al. 1960)	All Cores for Blick Mead						Cores from Stratified Contexts: Trench 19			
		All Flake Cores (no.)	All Flake Cores (%)	All Blade Cores (no.)	All Blade Cores (%)	Total (no.)	Total (%)	Flake Cores from BCH	Blade Cores from BCH	Flake Cores from post-BCH layers	Blade Cores from post-BCH layers
Minimal platform use	-	18	39.1	18	10.9	36	17.1	9	11	5	
Single, worked all around	A1			6	3.6	6	2.8		3		
Single, worked partially around	A2	5	10.9	61	37.0	66	31.3	3	37	1	2
Two opposed platforms	B1	2	4.3	41	24.9	43	20.4	1	22		3
Two platforms at oblique angles	B2			3	1.8	3	1.4		1		
Two platforms at right angles	B3			8	4.9	8	3.8		4		3
Multi-platforms	C	16	34.8	22	13.3	38	18.0	6	15	3	
Keeled platforms	D,E	5	10.9	6	3.6	11	5.2	3	2		
Total		**46**	**100**	**165**	**100**	**211**	**100**	**22**	**95**	**9**	**8**

pieces of raw material, either for the opportunistic production of a few flakes or to 'test' the raw materials' suitability for further reduction. The other half were made on pieces of flint that had been pre-formed to some extent. These are mostly quartered pieces and some have also been more finely shaped, even to the extent that striking platforms were prepared, but have then been abandoned due to the development of non-rectifiable handicaps to reduction. In most cases it appears that these involve the emergence of thermal faults within the flint, but with many it is not entirely clear why they were rejected. These differences can be illustrated by the cores from Trench 19. Here the minimally worked cores concentrated in the post-BCH layers where they formed nearly a third (29.4%) of all cores. All had only produced flakes and most if not all are likely to date to the Neolithic or Bronze Age. This group can be contrasted to the minimally worked cores from the BCH. They comprise only 17% of all cores from here and over half of these had produced some blades before being discarded prior to sustained reduction (e.g. Figure 4.4.1).

The largest group of cores are those with a single platform, which represent over a third (34.1%) of all complete examples. Nearly all were made using pre-shaped blanks (95.8%) and most (91.7%) have been worked only partially around their striking platform, usually on only one of their principal faces (i.e. 'front' types, cf. Evans 2004) (e.g. Figure 4.4.2). All of those worked all of the way around the platform were made on pre-shaped blocks and these are often pyramidal or conical in shape (e.g. Figure 4.4.3).

Contributing just over a quarter of all cores (25.6%) are those with two striking platforms. These are dominated by cores with opposed platforms (79.6%) (e.g. Figure 4.5.4) but some have new platforms created on their sides or backs, often at a right angle to the original (e.g. Figure 4.5.5).

Examples with three or more striking platforms contribute nearly a fifth (18.0%) of the complete cores. Over half of these are flake cores and many have been worked by removing flakes seemingly randomly, resulting in intensively worked blocky or globular-shaped cores with numerous platforms

but with only short sequences of flakes removed from each. Some of the blade cores also have multiple platforms although in many cases these are continuous or keeled (e.g. Figure 4.5.6).

Eleven cores have acutely angled keeled or bifacially worked striking platforms. With one of these the bifacial removals are limited to one end of the core, resulting in it becoming wedge-shaped. The remaining ten were flaked around all or around most of their perimeters, resulting in centripetally worked lenticular or dome-shaped cores (e.g. Figures 4.6.7 and 4.6.8). These are morphologically reminiscent of the bifacial or Levallois-like cores of the Later Neolithic, but they do not display any evidence for attempts to create a specific platform to detach a 'main' flake, nor are there any that have had this flake detached. Additionally, half also retain blade scars, and it would seem likely that these at least are part of the Mesolithic industry. They are unusual, but a small number of similar examples were found amongst the comparable assemblage at Downton, where they were interpreted as representing core axes (Higgs 1959, figs 115, 117, 120) and a similar hacking or chopping use could be envisaged here.

A number of large flakes were also used to produce blades from along their lateral margins or across their ventral surfaces. In most cases these are large decortication or mass reduction flakes that were used opportunistically to produce fine bladelets. There are a few examples, however, where the blades may have been removed to provide a suitable chisel-like working edge on the flake, and these are comparable to pseudo-burins (cf. Rankine 1952, fig. 6; Wymer 1962, 346; Jacobi *et al.* 1978, 218; Bishop 2008b, figs 6 and 7) (e.g. Figure 4.6.9).

Morphology and technological strategies

Taken together, the cores reflect a variety of approaches to obtaining flakes and blades. As noted above, a few of the cores, particularly those from the post-BCH layers, are considered to date to the Neolithic or Bronze Age and show little structuring in the ways they were worked, often having large flakes removed seemingly haphazardly from numerous and random directions.

By far the majority of cores, however, demonstrate a standardised and incremental approach to preparation and reduction. Large conchoidal surfaces remaining on many show that the raw materials mostly comprised large flint nodules that had been quartered into convenient, roughly hand-sized brick-shaped chunks (e.g. see Figures 4.4.1 and 4.5.4). These were then further shaped, striking platforms prepared and flaking angles established, most often by removing flakes from the 'top' and allowing the use of one of the chunk's inner faces (i.e. non-cortical faces) as the 'front' of the core. In most cases it was also necessary to adjust at least one of the sides by further flaking, but very often the 'back' remained only superficially dressed and frequently retained cortex (e.g. see Figures 4.4.1 and 4.4.2).

Once a suitable striking platform and core face angle had been established regular blade or flake production could commence. With a third of these (33.9%) removals continued to be taken from the front until the core became exhausted or, in most cases, developed flaws that led to its abandonment (e.g. Figure 4.4.2). With around a fifth (26.8%), however, flaking continued across the same face but from a different direction and using a new platform (e.g. Figure 4.5.4). This was nearly always from the base, creating a single faced opposed platformed core, but occasional the new platform was aligned obliquely or at right angles to the original flaking direction. By flaking from the base of the core many of the flaws that may have formed on the core face, such as persistent hinge or step fracturing, could be more easily removed. It also often led to improvements to the original striking platform / core face angle, which as reduction continued would have become increasingly obtuse, hindering successful detachments. It would also serve to reduce any bowing on the core face that might develop from flaking in only one direction. Once an opposed platform had been set up, therefore, flaking often continued roughly alternating in both directions as this would have maintained the ability of both platforms to remain productive.

With nearly a third of the prepared cores (31.3%), once the original face had been exhausted or otherwise abandoned, flaking was then transferred to a new face, in most cases a side adjacent to the original face (77.1%) but occasionally from a new platform created at the 'back' of the core

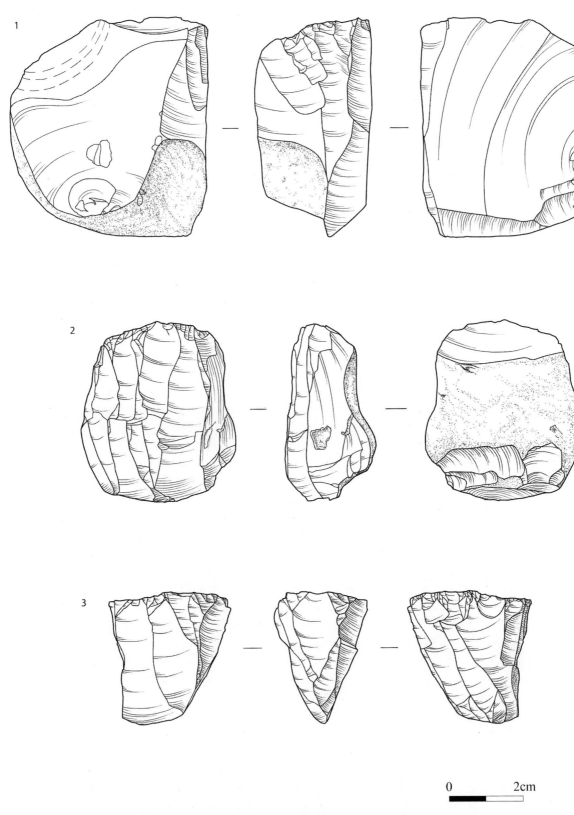

Figure 4.4: Flint cores 1–3. Illustration courtesy of Cate Davies.

The Lithic Material

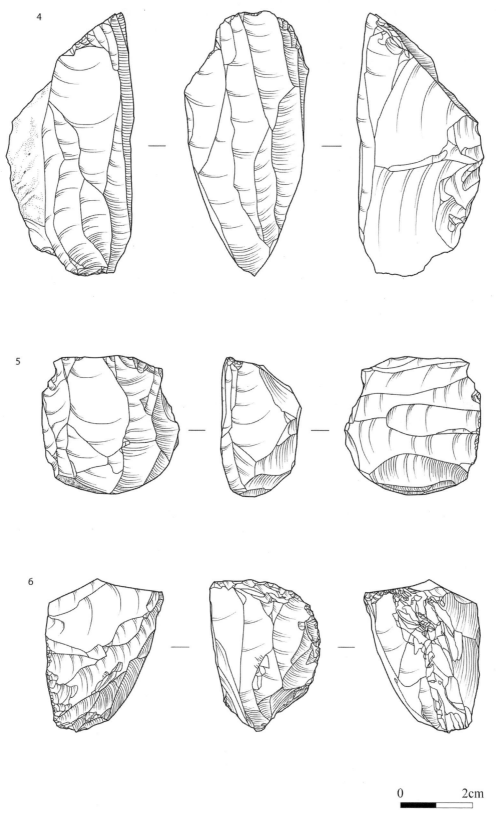

Figure 4.5: Flint cores 4–6. Illustration courtesy of Cate Davies.

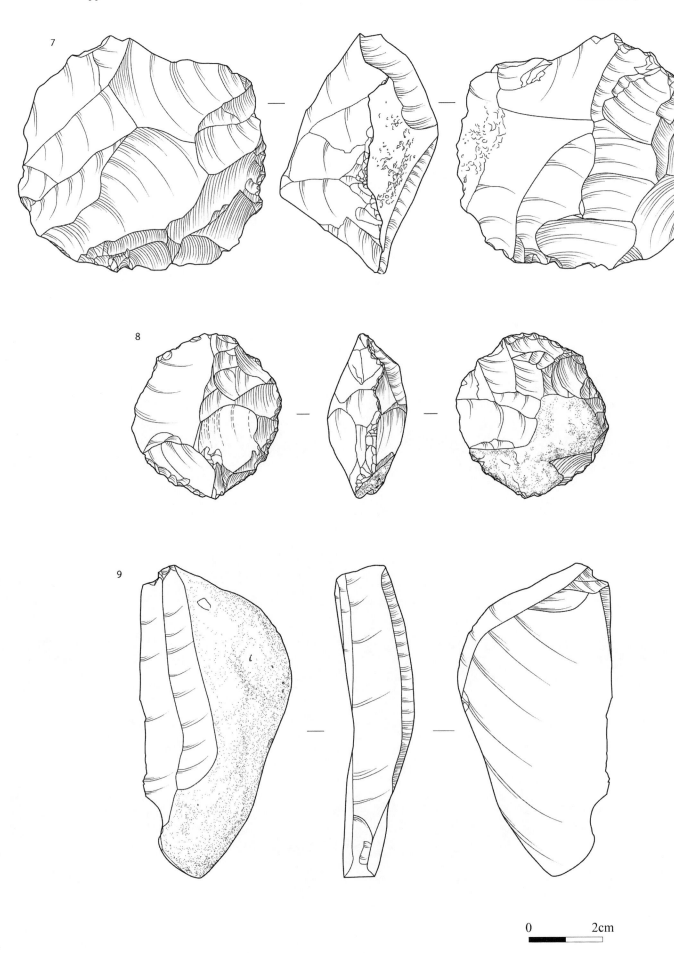

Figure 4.6: Flint cores 7–9. Illustration courtesy of Cate Davies.

(20.0%) (e.g. see Figure 4.5.5) or in one case (2.9%) on its base. The creation of new platforms usually necessitated further shaping of the core, to remove remnants of cortex and ensure suitable flaking angles.

The remainder of the prepared cores (8.0%) had yet further platforms created on their tops or bases leading them to become blocky in shape (e.g. Figure 4.5.6). It is also likely that more of the extensively reduced multi-platformed cores had been made using prepared or pre-shaped blanks, but the extent of flaking has removed all traces of their original form.

The majority of the prepared cores might be described as being asymmetrically faced, with the various faces, particularly the fronts and backs, treated in different ways (Evans 2004). It has been suggested that the shape of these and the ways in which they were worked may have reflected wider understandings of the world. As at Blick Mead, Evans notes that many of these types of core were used and discarded 'precisely at the junction of valley side and floodplain' and that it was 'as if their opposing sides were a metaphor of this land divide' (Evans 2004, 221). Such detailed referencing of landscape perceptions being embodied into cores might seem somewhat speculative to some, but it is certainly interesting that with so many of these examples, the backs of the cores were deliberately not worked in any way and cortex was retained, which would have provided clues as to the landscape origin of the raw materials and the knappers' connections with those places.

Retouched and other implements

A total of 194 microliths, 248 other retouched implements and nine transverse axes have been recovered from the spring area. Also recovered were ninety-five micro-burins; these are not normally considered to be true implements as they are by-products from microlith manufacture, but as they arise from secondary working they will be considered here. All secondarily worked pieces have been individually measured and described and these details form part of the site archive. This section provides a summary of what is present and outlines their significance. Where specific pieces are mentioned in the text, their number as recorded in the archive catalogue is given within 'curly' brackets {}.

Excluding micro-burins, implements account for 1.5% of the entire assemblage, or 3.0% of all pieces measuring over 15 mm. They represent a reasonably high proportion and as well as the preparation of raw materials and the production of flakes and blades, it is clear that tool use was also an important aspect of the occupations at Blick Mead. Additionally, the chipped condition of some flakes and blades precludes the identification of light retouching or utilisation traces, and finely retouched pieces are likely to have been underestimated, possibly significantly so, in these totals.

A wide range of types is present; in addition to the axes and micro-burins at least thirteen typologically distinct retouched flakes and blades have been identified (Table 4.9). The majority of these, 78.1% of those sufficiently complete to ascertain, were made on blades with most of the others made on narrow and thin flakes; these are all likely to belong to the Mesolithic industry. Retouched pieces from the lower clay deposits considered to be Mesolithic were particularly dominated by blades, which comprised 86.7%. Flakes are better represented within the assemblages from the post-Mesolithic deposits where they are present in roughly equal proportions to the blades. They include a number of edge retouched, notched, denticulated and other edge-retouched implements made on broad, thick and unrecorticated flakes, which are more reminiscent of Neolithic or Bronze Age implements.

ARROWHEAD

A single arrowhead was recovered during the excavations, from unstratified contexts in Trench 19 (Figure 4.7.10). It consists of a chipped and rather inelegantly made chisel type transverse arrowhead

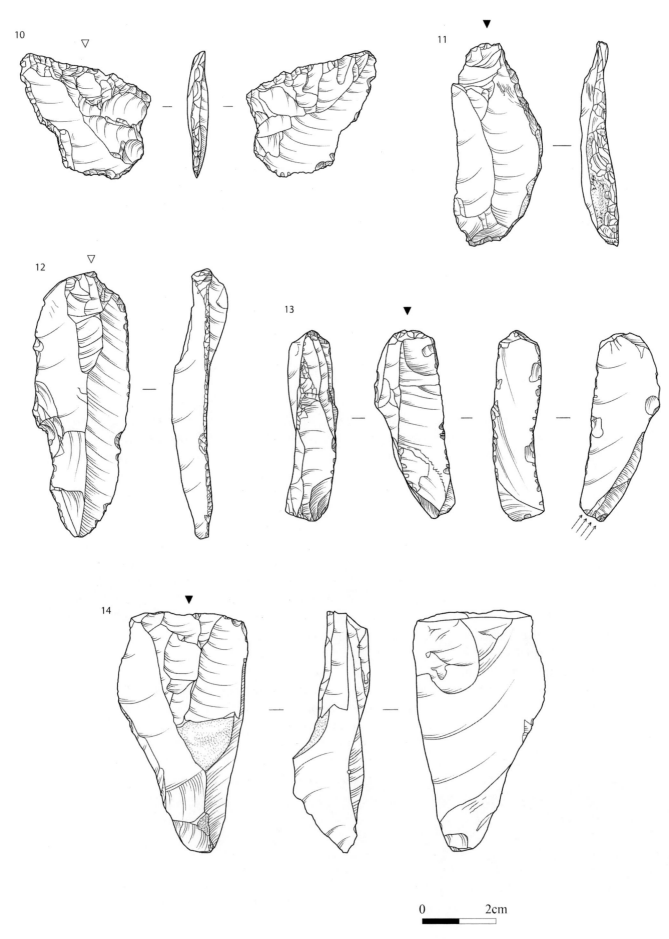

Figure 4.7: Arrowhead and blades. Illustration courtesy of Cate Davies.

Table 4.9: Quantification of retouched and other implements

Type	No.	% of Secondary worked pieces	% Implements excluding micro-burins
Arrowhead	1	0.2	0.2
Backed Blade	20	3.7	4.4
Battered Edge	5	0.9	1.1
Burin	16	2.9	3.6
Denticulate	8	1.5	1.8
Edge Retouched	83	15.2	18.4
Micro-burin	95	17.4	-
Microlith	194	35.5	43.0
Miscellaneous	1	0.2	0.2
Notch	33	6.0	7.3
Piercer	29	5.3	6.4
Scraper	20	3.7	4.4
Serrate	7	1.3	1.6
Truncated Blade	25	4.6	5.5
Transverse Axe	9	1.6	2.0
Total	**546**	100	100

of Later Neolithic date (Green 1980). It has invasive bifacial retouch that truncates its proximal end and which extends along its left lateral margin. Its cutting edge also exhibits very fine retouch. A fragment of a flake {99} from the clay and cobble layer in Trench 23 (context [70]) that has oblique truncation along its distal end and steep inverse retouch towards its proximal end might possibly represent a further chisel-type arrowhead.

BACKED BLADES

Twenty blades have abrupt retouch along all or most of one of their lateral margins. In many respects most of these are similar in form and in the nature of their retouch to the microliths, but unlike true microliths all either have their proximal ends intact or this end is missing, precluding their classification as true microliths. They are nearly all are broken but most were made using relatively small blades, and they vary from 6 to 23 mm in breadth. The longest, one of the few complete examples, measures 54 mm in length but most are unlikely to have greatly exceeded 30 mm when complete. Around fourteen of the twenty could potentially have been used as microliths. The remaining six are all significantly larger than the microliths and these all had steep blunting along one lateral margin and a sharp unretouched edge along the opposite margin. It is likely that these were blunted in order to aid handling or enable hafting and were used as cutting implements (e.g. Figure 4.7.11).

BATTERED EDGE BLADES

Two blades and three flakes have varying degrees of heavy battering or bruising along parts of one or more edges. Two {8} and {18} may have been struck from pounders or hammerstones, but the others appear to have been used to chop hard materials, perhaps bone, antler or seasoned wood (e.g. Figure 4.7.12). Although the damage is similar to that seen on the 'bruised blades' of the 'Long Blade' final Palaeolithic industries (Barton 1989), none here are of sufficient size or show any other technological features that would warrant assigning them to such an industry.

BURINS

Sixteen burins were recovered. These are characteristically Mesolithic implements that have long and narrow blade-like (burin) spalls removed to form sturdy steep-edged chisel-like implements. They are generally thought to have been used for graving and are particularly associated with antler and bone working (although see Barton *et al.* 1996 for other possible uses). The examples here were made on variably but consistently large blanks, nine on flakes and the remaining seven on blades, which ranged between 33 and 76 mm in length and 19 mm to 41 mm in breadth. Fourteen had been worked on their distal ends, one on its proximal end and the remainder on both ends. Ten had the burin spalls removed longitudinally along the axis of the flakes, with four the burin spalls were removed transversely and there are two dihedral examples (e.g. Figures 4.7.13 and 4.7.14). At least six of the longitudinal examples had been retouched prior to, and probably in order to aid, the detaching of the burin spalls. Despite the variability in the size and shape of the burins their working edges ranged between 5 and 12 mm across and were mostly slightly convex. Some of the burins also had additional blunting retouch along parts of their margins, most probably to aid handling.

DENTICULATES

Eight implements with denticulated edges were recovered, all but one made using flakes. The blanks were all large, varying from between 33 and 54 mm in length, and 32 and 42 mm in breadth, with the exception of the one made using a blade {120} which is 20 mm wide. One or two, all from unstratified contexts, would perhaps more comfortably sit within a Neolithic or Bronze Age context, but there are no reasons to doubt that most belong to the Mesolithic industry. The number of denticulations varies from 4 to 6 per cm of edge, and from being pronounced to quite shallow. They at least superficially resemble saws and could have been used cut hard materials such as bone or antler. An alternative use has been suggested for morphologically similar Bronze Age denticulates. These may have been associated with plant processing, including for 'combing' fibrous plants such as flax or nettle (Bradley and Brown 1992).

EDGE RETOUCHED PIECES

Eighty-three flakes and blades with simple edge retouch that has not significantly altered the shape or size of the blank were identified, these forming the second most common category of implements after microliths. They represent a disparate group and include roughly equal numbers of flakes and blades that are of variable shapes and sizes and which are only really associated by the presence of light retouch along their edges (Figure 4.8).

The edge retouched flakes and blades have been divided into those with retouch that forms either sharp or blunt edges (Table 4.10). With the former, the modification usually consists of fine shallow retouch that strengthens the edge but leaves it still sharp and suitable for cutting or light

Table 4.10: Shape and edge morphology of edge retouched flakes and blades

Form	No.	%
Blades with shallow retouch forming an acutely angled edge	20	24.1
Blades with steep retouch forming a blunt edge	15	18.1
Flakes with shallow retouch forming an acutely angled edge	23	27.7
Flakes with steep retouch forming a blunt edge	14	16.9
Unclassifiable fragments with shallow retouch forming an acutely angled edge	8	9.6
Unclassifiable fragments with steep retouch forming a blunt edge	3	3.6

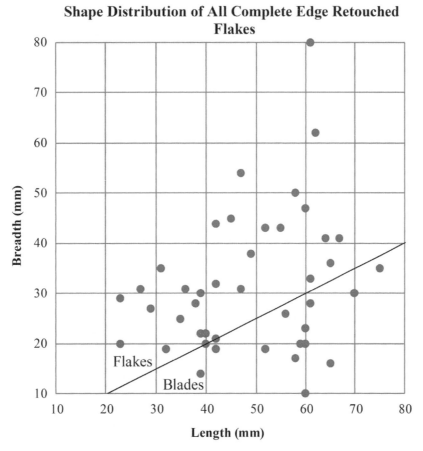

Figure 4.8: Shape and size distribution of all complete edge retouched flakes and blades (no. = 44). N.B. The proportion of flakes is over-represented in this figure as the blades are more likely to have broken.

sawing, although one these may actually represent a broken transverse arrowhead (see above). In some cases, however, it is not clear whether the modification was deliberately executed or consists of micro-chipping formed whilst using the unmodified edge in a cutting-like manner and applying heavy pressure (e.g. Tringham *et al.* 1974). The steeply retouched pieces have edges that are effectively blunted. These could be used in a manner similar to scrapers, but with most it is perhaps more likely that the blunting was undertaken to aid handling. Many of these have very sharp and often apparently lightly utilised opposite margins, suggesting that they too were predominantly used for cutting a variety of relatively soft to hard materials. The extent to which edges have been modified is highly variable but in most cases it focuses on the longer, lateral, margins. It ranges from being limited to short stretches of retouch to encompassing the majority of the flake or blades perimeter, and from being straight, concave, convex or sinuous. Taken together, the edge retouched pieces were probably used in a variety of ways and on many different materials, but the majority were probably used for cutting, sawing or scraping.

MICRO-BURINS

A total of ninety-five micro-burins were identified. Although retouched, they are not normally considered as true implements in their own right (although many would have been eminently suitable for a cutting, piercing or graving use – and see Donahue 2002) but are usually regarded as a waste product, characterised by a retouched notch and an oblique negative fracture facet (Rankine 1946; Finlay 2000, 26). They are commonly linked to the manufacture of microliths. The micro-burins vary considerably

Table 4.11: Micro-burin forms

Lateralisation of notch (assuming bulbar end held nearest to the observer and dorsal surface upwards)	No.	% of total micro-burins
Left proximal	9	9.5
Right proximal	58	61.1
Double micro-burination (medial section of blade)	1	1.1
Left distal	15	15.8
Right distal	6	6.3
Krukowski types	5	5.3
Unclassifiable	1	1.1

in size and shape. They range from 10 to 28 mm in length and from 4 to 21 mm in breadth, this variety presumably reflecting the very different sizes of the microliths that were being made. The angle to which the oblique fracture travelled along the blade also varies, from being virtually perpendicular to almost parallel to the lateral axis of the blade. Five examples were noted that have additional abrupt retouch on parts of their edges (e.g. Figure 4.10.15). These are often referred to as 'Krukowski microburins' (Wymer 1962, fig. 7:83; Barton 1992) and may result from attempts to re-sharpen microliths, or perhaps more plausibly, be accidentally produced when a microlith breaks during manufacture.

Micro-burins are dominated by examples notched on their right sides near the proximal (bulbar) end, with less than a quarter consisting of distal segments (Table 4.11). A single double ended microburin was also found, this presumably representing an unfinished microlith. The dominance of proximal sections notched on the right is a long-noted and seemingly very widespread phenomenon (e.g. Clark 1934; Hooper 1933; Lacaille 1942; Bishop 2008a). It shows an enduring standardisation in manufacturing techniques, which appears to be of only limited technological or functional utility. It may reflect handedness; if the blade was held at the bulbar end it would be easier for a right-handed person to produce a notch on its right side. As bulbar end is usually the thickest part of a blade it might be considered desirable to remove this prior to making the microlith, although it could always have been removed by simply snapping the blade. The micro-burin technique does allow an oblique truncation to be easily made on the ensuing remnant of the blade. However, as many microliths have oblique truncations on both ends this would still not account for the dominance of bulbar types with their right edges notched. It is possible that micro-burination was seen as an appropriate way to manufacture microliths, not necessarily prescribed, but following a long-established and well-understood tradition of working flint. This 'tradition' may have had its origins with the earlier obliquely truncated points, where the bulbar end was simply removed to form a sharp point.

Many micro-burins had 'failed', in the sense that the blade snapped away from the notch or the resultant break failed to produce the distinctive oblique fracture. Additionally, around seventeen of the pieces classed as notched blades may also represent failed micro-burins. Many examples of 'failed' micro-burins were observed, where the blades snapped away from the notch or the resultant break failed to produce the distinctive oblique fracture. Additionally, around seventeen of the pieces classed as notched blades may also represent failed or abandoned micro-burins (see below). Taking this into consideration, it can be seen that there are less than half as many micro-burins as microliths. This concords well with Finlay's experimental work (2000, 26), which has shown that discernible micro-burins are only produced in around half of the cases where this was technique was used, and microliths commonly outnumber micro-burins within most Mesolithic assemblages.

MICROLITHS

A total of 195 microliths were identified, these being the largest single implement type from Blick Mead, accounting for a third of the retouched component. Here they have been classed *sensu stricto* as

comprising blunted blades that have had their bulbar ends removed by abrupt retouch (Clark 1934, 55). Many of the backed blades and truncated blades also exhibit very similar types of retouch, often in comparable locations, but have not been classified as microliths as they retain their proximal ends.

There is a high degree of fragmentation amongst the microliths and only forty-five are entirely unbroken, although seventy are sufficiently complete to accurately estimate their original dimensions and 121 are still classifiable (see below). Most of the nearly complete examples have the tips of their points broken off which could have occurred during use. A few also exhibit flute-like scars that have been linked to impact fractures on projectile points (e.g. {154}, {463}, {527}, {546}; but see Rots and Plisson (in press) for the difficulties in distinguishing impact from other types of damage). Furthermore, twenty-nine, or 14.9%, of the microliths are burnt. This is a much higher proportion than seen within the rest of the struck flint assemblage, only 6.3% of the micro-burins are burnt for example. The tendency for microliths to be burnt has been noted at a number of other sites (e.g. North Park Farm; Jones 2013) and it seems these may have been either deliberately burnt, perhaps as a means of controlling their potency, or that they had been incorporated within carcasses of prey whilst being cooked, although in most cases the meat would have had to have been completely incinerated to achieve the degrees of burning experienced by the microliths. Breakages also frequently occur during manufacture, as has been demonstrated by experimental work (Finlay 2000, 26). At least two of the fragmentary examples ({R461} and {R475}) consist of complete spalls retaining pre-flaking microlithic retouch along one of their edges, suggesting they represent parts of microliths that broke during manufacture, and five of the micro-burins may similarly represent manufacturing accidents (see above). Taken together, the high rates of breakage combined with the discard of both old microliths and those in the process of manufacture suggests that retooling was an important activity conducted at Blick Mead.

Classification and dating

The classification of microliths into specific types is not straightforward; much variation exists between different classes and there is no universal consistency concerning the agreement or application of definitions. In addition, many microliths can show ambiguous traits with the types grading imperceptibly into each other (cf. Finlayson *et al.* 1996). Nevertheless, consistency in the morphological variance of microliths can be seen across southern Britain and beyond, with typological schemes proving useful in both describing and analysing chronological and geographical patterns within microlith populations (cf. Barton and Roberts 2004). The most useful and commonly used typological schemes are those of Clark (1934) and Jacobi (1978), with 121 microliths from Blick Mead being sufficiently complete to be placed within these schemes (Table 4.11; Figure 4.9).

The microlith population at Blick Mead is extremely diverse and includes examples from nearly all of both Jacobi's and Clark's classes. The most basic division of microliths is of those less than 7 mm and those 7 mm or more in breath (Jacobi 1976; 1978). The latter are also known as broad blade microliths and include Jacobi's types 1–4. They are normally considered to date to the earlier parts of the Mesolithic period, from its inception at around 10,000 cal BC until the early 8th millennium cal BC. Forty-five broad blade microliths have been identified of which thirty-six are sufficiently complete to be further classified. The most common is the simple obliquely truncated points (Jacobi's class 1) of which thirteen are present[3] (Figures 4.9.16–17; Figures 4.10.19–22; Figure 4.10.24), but these are outnumbered by twenty-three more complex types, which include isosceles and broad scalene triangles, bi-truncated pieces and convex backed points, the latter often having basal retouch

3 A total of seventeen simple obliquely truncated microliths were recovered. Thirteen of these fall into the broad blade category in being 7 mm or more wide and the remaining three fall into the narrow blade category, three measuring 6 mm wide and the remainder 5 mm.

Table 4.12: Classification of identifiable microliths

Jacobi (1978) microlith type	No.
1: Broad obliquely truncated	13
1: Narrow obliquely truncated	4
2a: Broad isosceles triangle	4
2aS: Broad scalene triangle	1
2b: Broad bi-truncated trapeze	1
3a: Broad bi-truncated rhomboid	2
3c/d: Broad bi-laterally blunted – Lanceolate	8
4: Broad convex/straight backed	3
5: Narrow straight backed	13
6: Narrow rod	9
7: Narrow scalene triangle	50
8: Narrow quadrilateral	4
9: Narrow crescent	4
10: Broad hollow-based (Horsham) point	1
11/12: Broad inversely retouched	2
– Narrow inversely worked tanged point	2
Total	**121**

Clark (1934) microlith type	No.
A: Obliquely blunted	17
B: Blunted along edge	26
C: Blunted along edge and across base	9
D1a: Isosceles triangle	8
D1b: Scalene triangle	48
D2: Crescent	3
D5: Sub triangular	1
D6: Trapezoid	1
D7: Rhomboid	2
D8: Trapeze	1
E: Inversely retouched base	2
F: Hollow-based (Horsham) point	1
G: Tanged	2
	121

(Figure 4.10.18; Figure 4.10.23; Figures 4.10.25–26; Figures 4.11.28–30; Figures 4.11.32–33). This mix of simple obliquely truncated and more complex broad blade microliths is most characteristic of 'Deepcar' type assemblages. These are particularly associated with the major river valleys of southern Britain and date to the latter part of the Early Mesolithic, after about 8,400 cal BC (Reynier 1998; 2000). Supporting a later date are the small sizes of the broad blade microliths, very few of which exceed 35 mm in length or are broader than 12 mm (cf. Pitts and Jacobi 1979). The few larger obliquely truncated points (e.g. Figures 4.10.16–17) may suggest some activity during the earlier parts of the Early Mesolithic. It should be remembered that only a very small portion of the site has so far been excavated.

Also of broad-blade dimensions are Jacobi's types 10–12, which have inverse basal retouch and are thought to belong to a Middle Mesolithic phase that has been identifiable in southern Britain during the 8th millennium cal BC. They include a typical hollow-based, or 'Horsham', point (Figure 4.10.27) that is characteristic of south-eastern industries, particularly those of the Sussex, Surry and Hampshire Weald (Clark 1934; Clark and Rankine 1939; Jacobi 1978). Of similar form to 'Horsham' points are a few of those classified here as lanceolate types (e.g. Figures 4.10.30 and 4.10.33), and 'Horsham' type assemblages often include a variety of relatively short obliquely truncated pieces as well as broad triangles and bi-truncated points. There are at least two other points with inverse basal retouch (Jacobi's class 12; Figure 4.11.31). Whilst these could be accommodated into typical 'Horsham' assemblages they are perhaps more typologically akin to those from 'Honey Hill' type assemblages. These assemblages appear to represent a Midlands and East Anglian variation of the 'Horsham' type assemblages and as well as including points with inverse basal retouch also contain many other complex broad blade types (e.g. Saville 1981a; 1981b). There are few dates available for the dating of 'Horsham' or other industries containing broad basally retouched points in Britain, although those that are available do fall within the 8th or very early 7th millennium cal BC (Reynier 2002; Jones 2013; L. Cooper, pers. com.). Unfortunately, the mid-8th millennium cal BC date obtained at Blick Mead (SUERC 42525) cannot directly date the basally retouched pieces, but it does provide evidence for occupation at that time occurring in close proximity to where the points were found.

The Lithic Material

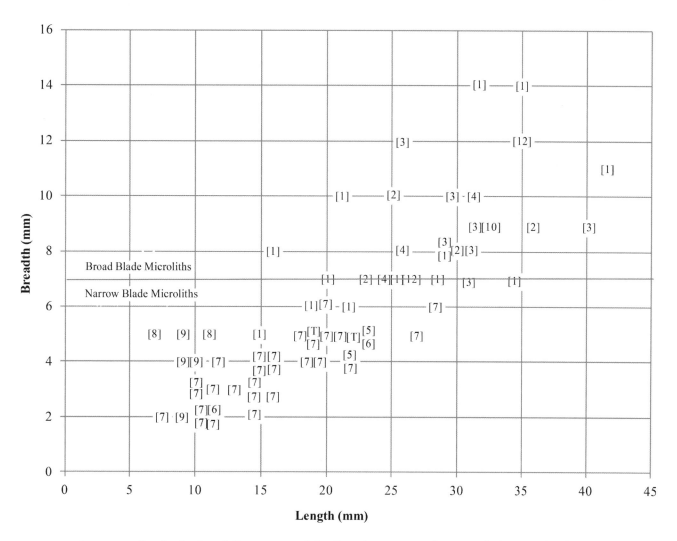

Figure 4.9: Size distribution of all seventy microliths whose dimensions can be accurately determined, indicated according to Jacobi's (1978) typological classes. [T] indicates tanged point.

The remaining microliths are of the heavily retouched 'geometric' narrow blade varieties, which superseded the more simply truncated broad blade varieties during the 8th millennium BC and continued to be made until the end of the Mesolithic during the later 5th millennium BC (Jacobi 1978).

A total of 144 narrow blade microliths were identified of which eighty-four could be classified to type. The sixty unclassifiable pieces cannot with certainty be placed within a specific type but the great majority look like fragments of scalene triangles, narrow backed points or rods.

As can be seen by Table 4.12 scalene triangles dominate the classifiable later microliths, accounting for 58.1% of the identifiable narrow blade examples (Figure 4.11.34; Figures 4.11.39–43). They vary considerably in size, from 8 to over 24 mm in length, and in form from very well-defined angular examples to those have that rounded or unpronounced angles and which form a continuum with crescentic or rod-like microliths (e.g. Figures 4.11.40 and 4.11.43). A few have ends that, although very narrow, are blunted by retouch, and could be classified as extremely elongated quadrilateral forms (cf. Froom 1972, fig. 7.9). Both unilaterally and bilaterally blunted types are present, the latter outnumbering the former by about 2 to 1. Due to the size of the microliths it is often difficult to positively identify what would have been the proximal or distal ends of the blade blank. However, for those where it is possible, it appears that those with the shortest side of the triangle (i.e. the less acutely angled tip) are at the proximal end of the blade outnumber by 2:1 those where it occurs on the distal end. Again, it is difficult to be certain but there also appears to be a strong tendency for those

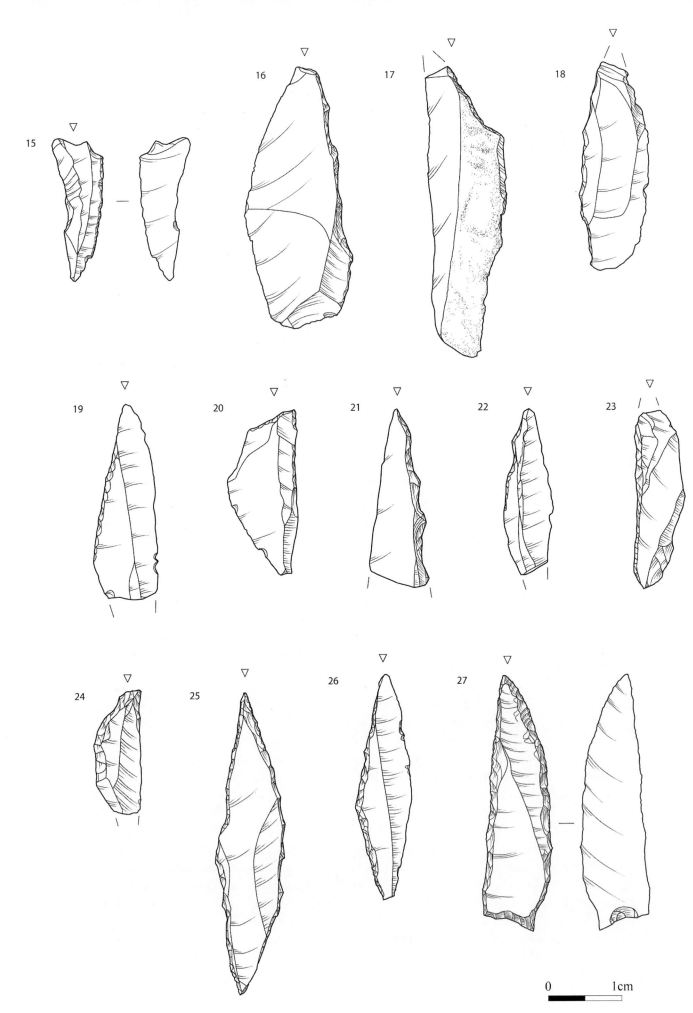

Figure 4.10: Microliths 15–27.

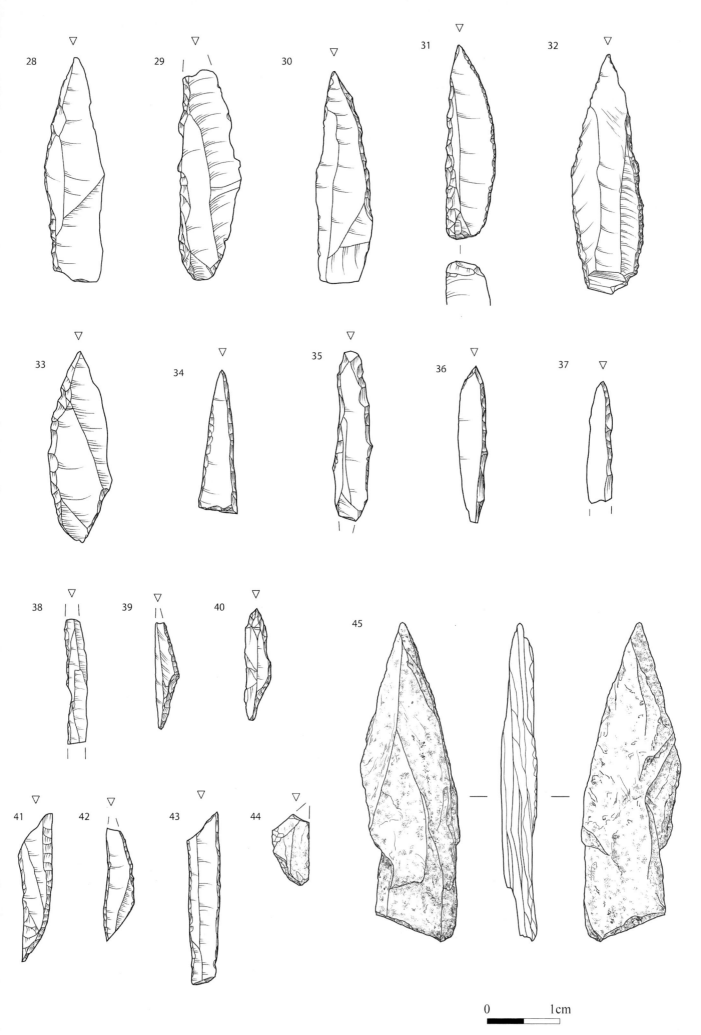

Figure 4.11: Microliths 28–45.

with the shorter side at the proximal end to be 'right hand lateralized', that is having the obtuse angle or 'shoulder' of the triangle on the right margin, whilst those with the short side at the distal appear mostly to be 'left hand lateralized' (cf. Finlay 2000, 27–28). What this might mean is not clear but again it demonstrates a remarkable standardisation in the way these implements were manufactured.

Also present in some numbers are narrow backed blades (Jacobi type 5) that have steep blunting along one side (Figures 4.11.36–38). Only one of these is complete, this being 22 mm in length and having an unretouched distal end with a slight oblique truncation forming its proximal end (see Figure 4.11.36). Another is estimated to be 23 mm long and it is unlikely that any would have exceeded 25 mm in length. Three are very narrow with almost rectangular cross sections and these are perhaps more comparable to the rods (e.g. Figure 4.11.38). Rods (Jacobi's type 6) have steep blunting along both sides, the retouch often converging along the longitudinal axis, forming very narrow pieces with rectangular cross sections (Figure 4.11.35). Two of these appear complete; one is 12 mm long, the other 23 mm, and both have pointed ends formed by retouch. Others might also be complete but they have snapped ends, which may be deliberate or caused through breakage. Some of the broken examples have squared-off ends. The remaining classifiable examples represent a variety of types, including small simple obliquely truncated points, crescents (Figure 4.11.44), quadrilaterals and small tanged points with inverse basal retouch, all of which are present only singly or in small numbers.

The typological dating of Later Mesolithic microliths is poorly defined due to the paucity of securely dated assemblages (but see analysis of Trench 24 below). Nevertheless, attempts have been made to produce a more refined chronology for these types based on changes in the proportions of the different types present within specific assemblages (Ellaby 1987; 2004; Jacobi 1976; 1987; Switsur and Jacobi 1979). It has been suggested that assemblages containing a significant proportion of rods may represent a 'pioneering' phase of the Later Mesolithic, with scalene triangles becoming dominant a little later at the expense of the rods, these being largely replaced by narrow backed points by the end of the 7th millennium BC (Ellaby 1987, 63–66; 2004, 22; Jacobi 1987, 164). If such schemes are correct, the high numbers of scalene triangles as well as backed points and rods here may reflect microlith use throughout the 6th and 7th millennia. A possible alternative explanation sees them representing an intermediate stage between rod-dominated and scalene triangle-dominated assemblages, a situation that has been suggested for comparable assemblages from Woodbridge Road in Guildford and Abinger Common, both in Surrey (Ellaby 1987, 65; Bishop 2008a, 152).

Ellaby (2004) has also identified a final Mesolithic microlithic group, based on the assemblage from Charlwood in Surrey and defined by high proportions of small scalene triangles and the presence of significant numbers of shouldered or tanged points that have inverse basal retouch. Radiocarbon dates from Charlwood and from the similar assemblage at Wawcott XXIII suggest a 5th millennium date. The tanged points such as found at Charlwood are certainly not common, but they are very similar to the two tanged points with inverse retouch found here. Additionally, some of the smaller scalene triangles have slightly concave sides along their acute ends, and although no inversely retouched do give the appearance of having tangs. If Ellaby's suggested dating for these pieces is correct, these tanged pieces would indicate microlith manufacture continuing at Blick Mead into the twilight of the Mesolithic period, as would be compatible with the two 5th millennium cal BC dates obtained on animal bone (SUERC 46224, SUERC 37208) and the four from the residential area on the terrace (SUERC 66820, SUERC 56919, SUERC 66822, SUERC 66823). Other indications of flintworking occurring late in the Mesolithic come from the crescents and quadrilateral pieces which although poorly dated are thought to be amongst the latest microliths made (e.g. Froom 1972).

The slate microlith: Coincidence or design?

One of the most intriguing finds from the excavations consists of a small piece of light greenish slate that has the form of an asymmetrical hollow-based, or 'Horsham', point (Figures 4.11.45 and 4.12). It measures 42 mm long by 13 mm wide and is 4 mm thick, weighing 2 g. Slate does not fracture

The Lithic Material

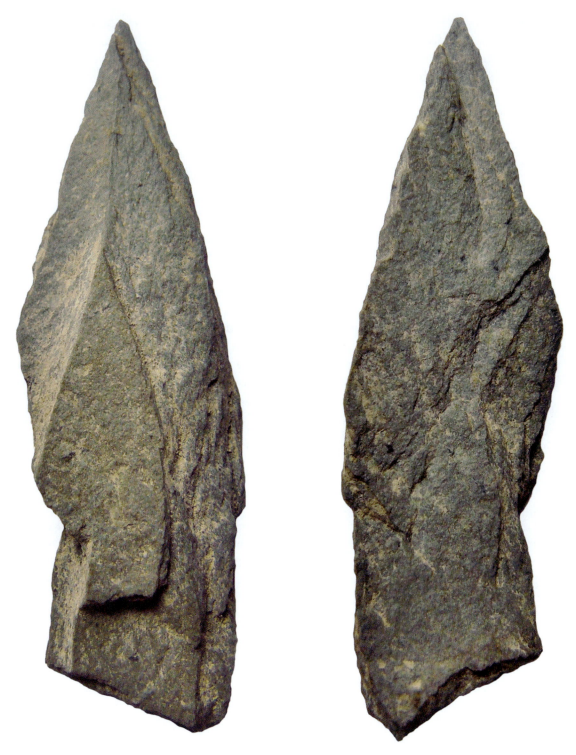

Figure 4.12: Possible microlith made from slate. Photograph courtesy of Barry Bishop.

conchoidally, so it is difficult to determine if it was deliberately shaped. Due to this uncertainty, it has not been included in the overall quantification tables. Nevertheless, a number of factors do point towards it having been purposely formed. Its shape is typical of this type of microlith. Its right side is gently curved from the base to its tip. The left side continues the flaring from the point to about half way along where it turns inwards, forming a slight shoulder. The base is slightly curved and at a slight oblique angle to the main axis of the piece. Parts of its edge have broken following the laminations

but its outline is formed by steep snapping, that cuts across rather than following the laminations, from the ventral side. Its concave base is formed by bifacial snapping, initially from the ventral and then also inversely, resulting in a concave bevelled edge, and mirroring the technique used to form the base of 'Horsham' points exactly. All of the edges are reasonably fresh with little evidence of rolling or abrasion. If this is a deliberate attempt to make a microlith using slate it is, as far as this author knows, unique in Britain, and no doubt opinions on its legitimacy will be divided.

Summary and significance of the microliths

The microliths form a high proportion of the implements found at Blick Mead although they do not dominate them, and whilst the repair and maintenance of microlithic tools such as hunting equipment must have been very important they were undertaken alongside a variety of other pursuits. They are remarkably varied and show that activities involving the manufacture and discard of microliths persisted throughout the occupation there, the chronology of the microliths closely conforming to the radiocarbon dates that have so far been obtained. A few of the larger simple obliquely truncated points can be compared with 'Star Carr' types and may indicate some activity during the early 9th millennium cal BC, but most of the 'early' microlith types can be accommodated with later 9th millennium cal BC 'Deepcar' or 8th millennium cal BC 'Horsham'/'Honey Hill' industries, occupation during the latter period also being attested by a radiocarbon determination. The evident 'Horsham' affinities of at least one of the microliths from this assemblage are interesting; these sites are concentrated in the Weald and especially around its western side in Sussex, Surrey and Hampshire although a few microliths with 'Horsham' traits have been found in the south-west (e.g. Berridge 1985). The possible associations of the other points with inverse basal retouch may suggest other axes of influence, extending northwards into the Midlands or towards East Anglia. The possible slate microlith presents an even more intriguing antithesis. If this is as it seems, then it represents a classic south-eastern microlith shape but formed by a material that originated far to the west. Some of the Blick Mead microliths therefore may be physical manifestations of long distant journeys and contact, either of forays by the local groups or by those visiting from outside the area. However, it is important to stress that generic basally retouched forms are found widely (Barton and Roberts 2004, fig. 18.4), and that that neither 'Horsham' nor 'Honey Hill' assemblages are perfectly classified, either typologically or in terms of their geographical spread. Finally, there is very little information on the composition or character of microlith groups within Wiltshire with which outside comparisons could be made. It does, however, give some support for the impression that the site might have had far-reaching influences. Later Mesolithic narrow blade microliths outnumber the earlier broad blade types by over 3:1; although this by itself cannot give a clue to the intensity of activity as it is likely that the numbers of microliths used per composite implement was higher during the Later Mesolithic (Myers 1987, 145). Again, a wide variety of types are present despite being dominated by micro-scalene triangles. In the absence of detailed information regarding Wiltshire assemblages, the closest and most useful comparisons have mostly been made with those from the more extensive sites recorded to the east, particularly along the Kennett Valley and in the Weald, although the extent to which this demonstrates direct experience or merely shared wider technological traditions is something that requires further work. Using these as a guide, and although in a mixed deposit, the range of types present would be consistent with 7th and 6th millennium BC microlith groups, with the tanged types combining with the 5th millennium BC radiocarbon dates to suggest rare and much sought after evidence for flintworking at the end of the Mesolithic.

On a broader theme, it is notable that although the typological affinities of some microliths are ambiguous, nearly all of the more complete examples can be placed with some confidence within a few closely defined shape categories. The extent to which these categories may have been recognised by the manufacturers is not fully resolvable, but it does appear that they repeatedly manufactured microliths according to closely defined stylistic parameters, and that these types can be traced across Britain and

The Lithic Material

beyond. Generally the microliths display carefully executed retouch and, particularly with many of the later examples which are remarkably small, must have required great dexterity to execute (Figure 4.13).

The reasons why such difficult and awkward work was deemed necessary are not easy to comprehend. Identically shaped sherds of flint could readily be found within the micro-debitage and on a practical level complex microlith manufacture would not always have been necessary in order to provide appropriately shaped pieces. A more functional approach views the adoption of an increasingly diverse range of smaller and more heavily retouched microliths during the 8th millennia cal BC as reflecting changes in hunting methods and technology, involving the replacement of arrows with two or three lithic armatures by those holding significantly higher numbers (Myers 1987; 1989). However, it remains hard to accept that some of the smallest pieces could have functioned efficiently at all; merely hafting them would have proved problematic. It is possible that the manufacture or use of very small microliths was perceived as conferring some benefit beyond what may have been functionally required, such as through conferring good providence on hunting expeditions. The ability to

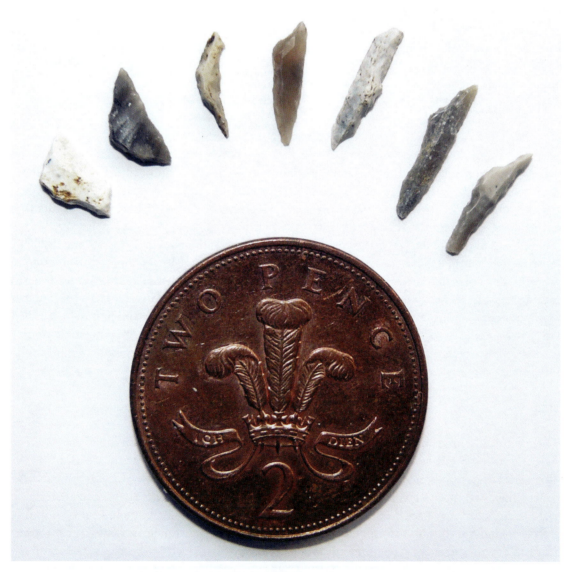

Figure 4.13: Selection of Later Mesolithic microliths. These are all complete and their shapes are fully determined by retouch which extends around all or most of their margins. Some are so diminutive they are difficult to hold, even just to examine, and their retouch can only be fully appreciated with the use of a magnifying glass. The difficulties in making and using these are evident. Photograph courtesy of Barry Bishop.

make and use small microliths may have been perceived as somehow socially prestigious or beneficial, and no doubt flintworking in general and the specific manufacture of tightly defined and easily recognisable implements would have contributed to acquiring and expressing identity. Alternatively, the manufacture of such diminutive pieces may have resulted from light-hearted competition between comrades or the pieces may have been seen as emblems of knapping prowess. It may even be that they were made by younger members of the community, whose dexterity and eyesight may have been more favourably suited to such tasks. Whatever the reasons were for making these tiny items in such specific ways, it is perhaps unlikely that the microliths themselves would have functioned as emblematic signifiers of the community, as they would be virtually invisible from any distance, especially if hafted. This suggests that the act of working flint and turning a blade into a microlith was important to the makers, not just the possession or display of the finished implements.

MISCELLANEOUS RETOUCH

A single blade was recovered that has been classified as miscellaneous as it does not fit within any formal tool categories {487}. It is perhaps closest in form to the 'chamfered pieces' identified by Reynier at the 'Horsham' industry site at Kettlebury in Surrey (Reynier 2002, fig. 6.4). It consists of a large blade with a facetted striking platform and has been bifacially thinned around its distal end and has additional fine retouch along part of left margin. It was possibly intended as a wedge or chisel-like implement, or might be an unfinished tool such as a burin.

NOTCHES

A total of thirty-three pieces were notched, twenty-three of which comprise blades. Twenty of the blades have the notches cut into the lateral margins, one being double notched. Two have notches cut into their distal ends and the remainder into its proximal end. Ten of the notches are on flakes, eight having the notches cut into the sides, one of which has been double notched, the other two having notches cut into their distal end.

The size of the notches vary considerably; the largest measures 29 mm wide by 5 mm deep but most are much smaller, being less than 10 mm wide and 4 mm deep. Most of these smaller examples are on blades and some of these may represent failed micro-burins, either being abandoned prior to making the oblique snap or with the snap occurring away from the notch. Some of the wider notches may represent blunting of the blade in order to provide a fingerhold and enabling it to be handled safely. Most of the larger notches are made on relatively sturdy flakes and are comparable to concave scrapers. These are normally considered to have been used in the manner of 'spoke shaves' or similar implements and may have been used for working wood such as for smoothing arrow shafts.

PIERCERS

Twenty-nine piercing tools were identified. Due to a lack of standard terminology all piercers, borers, awls and drills have been classified here simply as piercers. Twenty-two were made using blades. Thirteen of these have been only minimally retouched to accentuate and strengthened their naturally converging distal ends to form sharp needle-like points. Two have more extensive retouch, forming sturdy points that may have been used more akin to drills. Two had small notches cut on opposite sides at their distal ends forming spurs and resulting sturdy awl-like implements. The remaining five are distinctive in that they have asymmetric bilateral converging retouch on their distal ends, forming slightly curved sharp points (Figures 4.14.46–48). These are similar in form to the Upper Palaeolithic Hamburgian 'zinken' which are argued to have been used as scrapers and borers for antler working (see Kufel-Diakowska 2011, 238 and references therein). The relative simplicity in their manufacture means that they should not be used as indicators for flintworking of this date although a similar

The Lithic Material

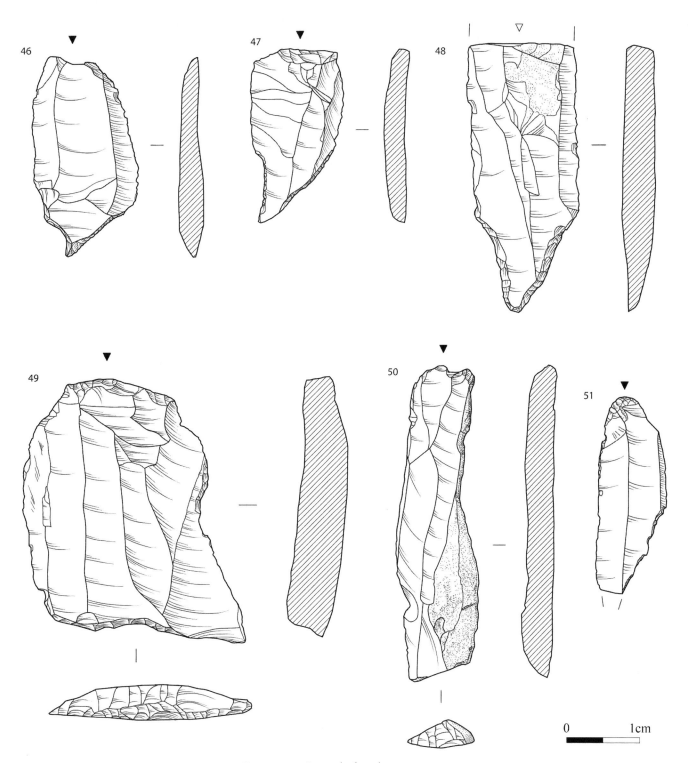

Figure 4.14: Retouched implements 46–51.

function, for the working of antler, may still be applicable. A number of other uses are also possible though, such as for piercing thick leather or hide.

Seven of the piercers are made using flakes. These comprise three minimally worked examples; one is a blade-like flake, another consists of a thick mass reduction flake with a distal end modified to form a sharp but sturdy point, and the remainder a narrow flake with a snapped distal end forming an awl-like trihedral point with clear signs of wear. One of the flake piercers has more extensive

retouch, this forms a sturdy but sharp point and two have retouch that formed spurs on one of their lateral margins. The remainder is a blade-like flake with a retouched distal end forming a sharp curved point, similar to the 'zinken-like' points described above.

SCRAPERS

Twenty scrapers were identified, representing a relatively small proportion of the implements; scrapers often constitute one of the largest retouched categories within struck flint assemblages. They were mostly made on flakes with only three being of blade dimensions, all three of which are classed as long-end varieties (i.e. at least 1.5 times as long as broad). Of the flake scrapers, twelve are classed as end-scrapers, two being long-end varieties; two as end-and-side scrapers; one as a side scraper and one is an unclassifiable fragment. The remainder is irregular; it appears to be an end-scraper that has broken and subsequently retouched along the break, forming a triangular-shaped implement with two retouched sides.

All of the scrapers have steeply retouched convex working edges but their sizes do vary markedly, from 25 to 61 mm in length, and from 15 to 41 mm in breadth. Scrapers are traditionally regarded as implements used to process hide and it is entirely possible that some or many of those recorded here were used as such. Nevertheless, ethnographic and experimental work has shown that, as with many tool types, scrapers may have been used for a variety of different tasks, including cutting, graving, chopping and even as projectile points; sometimes the same tool can even be used for different purposes at different times (Odell 1981; Andrefsky 1998).

SERRATES

Seven possible serrates were recovered, comprising narrow flakes and blades that have a series of closely spaced fine nicks made along their edges. None of these are particularly clear examples and with some the nicks are either very worn or possibly accrued incidentally as spalling arising from the piece being used as a cutting implement. Four are made using blades, two on narrow blade-like flakes and there is one unclassifiable fragment. One has been serrated along both of its lateral margins, the remaining six along only one. Of these, four have naturally blunt, cortical or blunting type retouch along opposite margins, which would have aided handling. The complete examples vary in size from between 36 and 60 mm in length, and from 18 to 26 mm in breadth. Serrates are commonly associated with plant processing, particularly harvesting silica-rich plants such as cereals, but which in a Mesolithic context could include reeds, rushes and sedges, all of which would have been common in the vicinity of Blick Mead. Such uses have been largely confirmed by use-wear experiments conducted on other Mesolithic assemblages. At Hengistbury Head serrates (called there micro-denticulates) were used in cutting or sawing soft plant material (Levi-Sala 1992), and at both Thatcham in Berkshire and the B&Q site in Southwark they show evidence of having been used for processing plants (Grace 1992; Donahue 2002, 84–85). This may include stripping the fibre from plants to make cordage and textiles (Hurcombe 2007; Juel Jensen 1994).

TRUNCATED BLADES

Twenty-five blades or broken probable blades have their distal ends, or in one case a proximal end, truncated by retouch were identified. The retouch is mostly abrupt and similar to that used to make the microliths. Fourteen have oblique truncation and some of these, particularly the narrower examples, are particularly reminiscent of simple obliquely truncated microliths, only differing in that their proximal ends are extant (e.g. Figure 4.14.51). There are also six examples with transverse truncations and five where the truncations are oblique but with a notable concavity. The complete examples measure between 18 and 57 mm in length, and between 8 and 30 mm in breadth. Some transversely truncated

The Lithic Material

pieces are similar to end scrapers, whilst the concave truncations often had one side accentuated to a point and in some cases these show traces of wear. These and many of the obliquely truncated ones frequently have further blunting around their acute point, strengthening the tip and suggestive of a use for piercing or graving tasks (e.g. Figures 4.14.49–50).

Truncated pieces are commonly found within Mesolithic tool inventories; they formed the most common retouched type (after microliths) at Charlwood and Woodbridge Road in Guildford, for example (Ellaby 2004; Bishop 2008a). At the former site it was suggested that 'a number of these may be argued to fall into the category of boring and piercing tools' (Ellaby 2004, 20). Complementing the probable use of many of the microliths as projectile points, it has also been suggested that backed and truncated blades may have been used in the manufacture of arrow shafts (Roger Jacobi, pers. comm.).

TRANSVERSE AXE/ADZES

Nine transverse axe/adzes were recovered from the wet areas of Blick Mead, four from the BCH and three from later contexts in Trench 19 (Figures 4.15 and 4.16), and two from the lower clay (context [79]) in Trench 23 (Figure 4.17). Two, both from the BCH, are burnt and fragmentary and one, from the lower clay in Trench 23, is missing its tip. The six complete examples varied quite notably in size, the smaller being 108 mm long and weighing 107 g whilst the largest is 161 mm long and weighs 434 g. They are typical of Mesolithic axe/adzes, falling within the small to medium categories (e.g. Rankine 1938; Field 1989). They all appear to have been made on roughly elongated nodules with the exception of one of those from the lower clay in Trench 23 which is clearly made on the distal end of a much larger flaked piece, possibly a quartered nodule. All are rather crudely formed, with large and rough flakes removed from predominantly sinuous ridges aligned along the axes of the implements; all seven of the complete or near complete examples have three principal ridges. Their transverse cross sections therefore tend towards the triangular but actually vary considerably along the length of the shaft. All are relatively straight in profile but there is no other evidence to suggest whether they were used in the manner of an adze or mattock, rather than as axes. Five of those that retain their tips were sharpened using the characteristic transverse blow, the other's tip is formed by fine radial flaking, and one of the others also has radial flaking on the other side from the transverse blow. Two of the examples with flaked butts have minor damage that might suggest hafting but there is no evidence for this on the other two.

Interestingly, no certain axe/adze shaping or thinning flakes, nor transverse axe sharpening flakes, were identified from Blick Mead, although the former are not necessarily easy to identify due to the crude manufacturing techniques employed in making the axe/adzes. This might suggest that the axe/adzes were not being manufactured, and perhaps not even being intensively used, at the site. If these were being made elsewhere, it again highlights the complexity of flint procurement, use and discard within the landscape, of which this site is only one part.

As a class, transverse axes were certainly being used during the 9th millennia cal BC at Star Carr, and appear to continue to be made through to the end of the Mesolithic period, during the 5th millennia BC. The precise function of these tools remains unclear; they have been traditionally associated with wood working and the felling of trees (e.g. Mellars and Reinhardt 1978), but could alternatively have been used as chisels or wedges, rather than as felling axes, or possibly even for digging, in the manner of a mattock or pick. Mellars and Reinhardt (1978) further notes that they are concentrated in river valleys and around springlines, and they speculate that they could have been used for making dugout canoes.

SANDSTONE SLAB

A sub-angular elongated rectangular block of sandstone was recovered from the basal clay horizon in Trench 19 (context [77.5]) (Figure 4.18). It is light yellowish brown fine to medium grained indurated

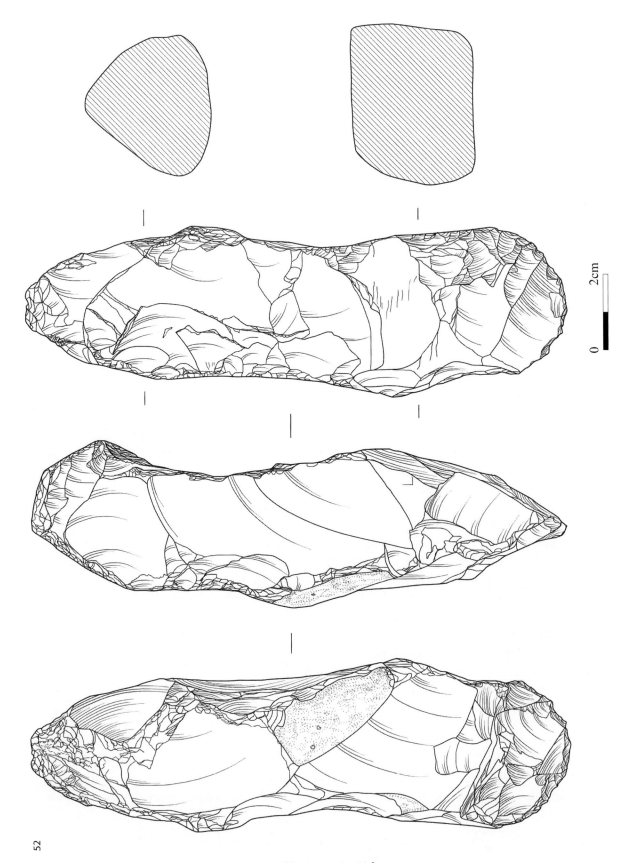

Figure 4.15: Transverse Axe/Adze 52.

The Lithic Material

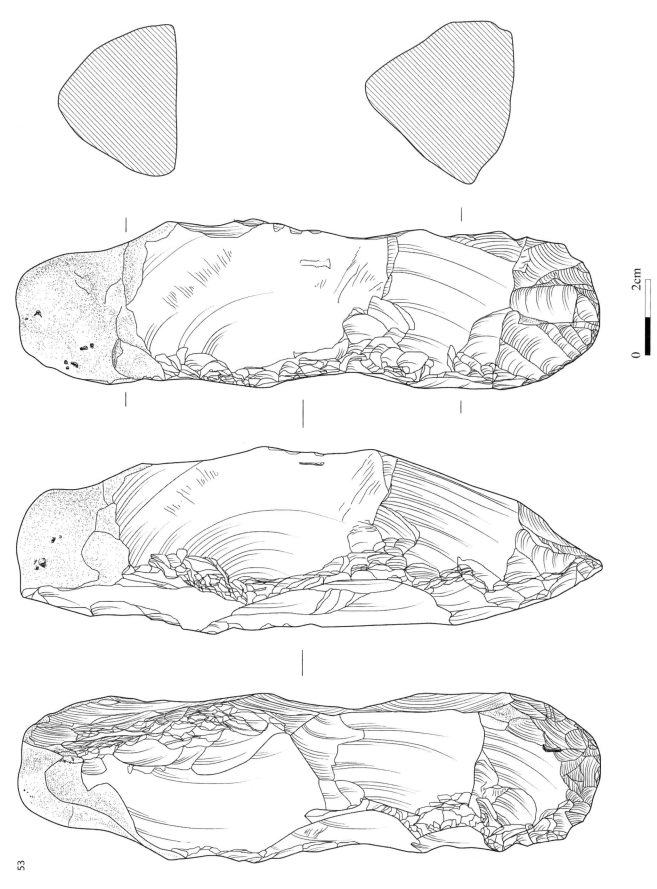

Figure 4.16: Transverse Axe/Adze 53.

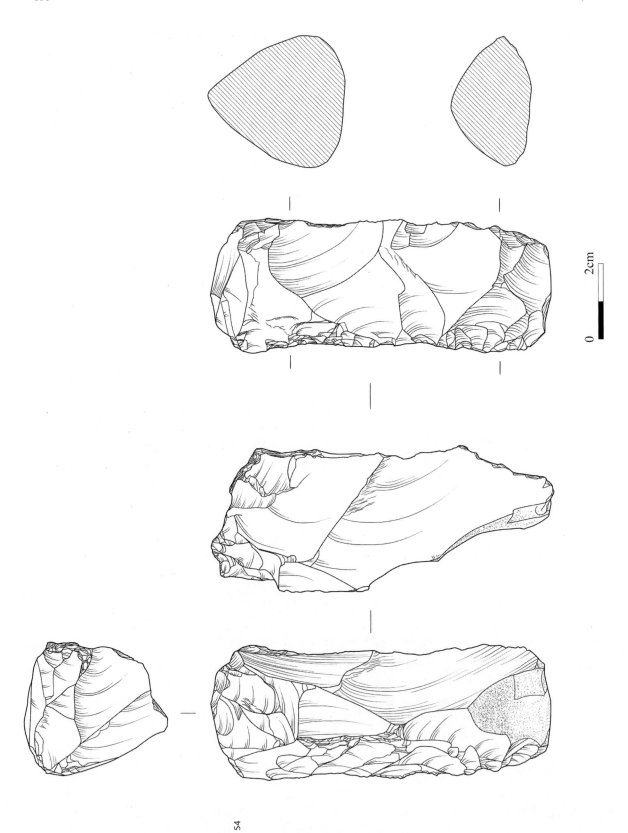

Figure 4.17: Transverse Axe/Adze 54.

The Lithic Material

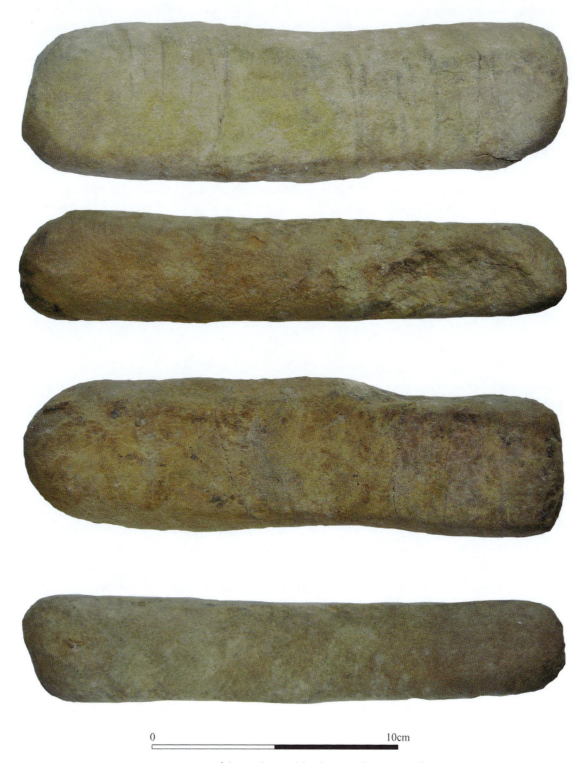

Figure 4.18: Four views of the sandstone slab. Photograph courtesy of Barry Bishop.

unbedded siliceous sandstone containing occasional mica flecks and is impregnated with a series of thin, c. 1 mm thick, beds of vein quartz.

It measures 198 mm long by 56 mm wide (its 'faces') and 34 mm deep (its 'sides'). It weighs 767 g. Its two faces are smooth. One very gentle undulates but is overall flat; the surface is very smoothed, almost polished although there are a few patches of shallow spalling where this has been lost. The

other face also has areas of fine smoothing but also larger areas where this has spalled away and is more undulating; this being most pronounced where there are quartz veins which rise out from the surface c. 0.5 mm. The two sides both contrast notably from the faces. They are both bevelled and have a rougher surface finish, consistent with fine pecking, along with a few shallow hollows that may have been formed through flaking. Its ends differ. One forms an abrupt angle to the sides and consists of two small facets, both of which are marginally concave and smooth. The other end is more bevelled and almost rounded but the very tip comprises a single facet, also slightly concave and smooth, and angled to longitudinal axis of the block, at c. 75° to its face and c. 80° to its sides. With imagination, its shape could be described as phallic.

Similar shaped stone slabs, often of indurated sandstone, are occasionally found at Mesolithic sites in Britain. These are unsurprisingly more common in the west and north of Britain where such stone is freely available (e.g. Jacobi 1980), but small numbers of exotic stones have been reported from sites in southern Britain (e.g. Rankine 1966; Jacobi and Tebbutt 1981). They are rarely discussed in depth although at Farnham in Surrey it was suggested that four sandstone slabs with patches of polishing and pecking may have been used both as polishers and anvils, such as for when producing micro-burins (Rankine 1936, 42). Other stones appear to have been engraved and these may have been used for decoration or as ceremonial objects (e.g. Berridge 1994).

Technological strategies

Consideration of all of the debitage allows the proposal of a simplified scheme used to produce the majority of the Mesolithic struck flint assemblage. It is not exclusive; sometimes blades were removed expediently from cobbles, including small alluvial pieces, with little evidence of careful preparation or shaping. Additionally, the centripetally worked cores appear to use their own technologically strategies that only occasionally produced blades and with these the core itself may have been the intended 'product'. Even within this scheme, certain stages could be omitted or elaborated upon.

The scheme has the potential to incorporate many landscape settings. The raw materials were not obtained in the same locations as the worked flint was deposited, and they were probably initially dressed closer to where they were gathered. It is perhaps also unlikely that all of the cores made at Blick Mead were used and discarded here. Many cores, as well as useable flakes, blades and tools, may have journeyed along with their makers, to be used and discarded at other sites. Similarly, many pieces found at Blick Mead may have been produced elsewhere but brought and used here. It should also be emphasised that although the scheme is presented as linear succession, it is perhaps more likely that elements of this are actually cyclical. For example, a few flakes and blades may be produced, used and discarded, and then reworked and further flakes and blades produced sometime later. Abandoned cores may be returned to, and this could occur long after they were initially worked. In some cases raw materials and partially prepared cores may have been cached for use in the future but never returned to. Nevertheless, the scheme outlined below can account for the bulk of the flintwork found at Blick Mead and offers some insight into the organisation of flint technology.

(1) Suitable raw materials sought and collected.
(2) The nodules are roughly dressed and protuberances removed, presumably close to where they were found as few flakes of this type are present at Blick Mead.
(3) The nodules are then 'quartered' into roughly hand-sized pieces, again probably close to where the raw materials were found.
(4) These are then further decorticated and roughly shaped into conchoidally fractured blocky shaped lumps, although the cortex is rarely completely removed.

(5) The front, usually the original inner surface of the nodule, is prepared by shaping the top, sides and base, but often the back is left cortical.
(6) A striking platform is created by removal of transverse flakes across the top of the core.
(7) Routine flake and blade production commences.
(8) If the platform develops problems the core might be discarded, rejuvenated or a new platform created, usually on one of the sides.
(9) Suitable blades used as they are, some are retouched to make formal tools.
(10) Tools used.
(11) Tools discarded.

Summary and discussion

Taken together, the struck flint assemblage from Blick Mead indicates a substantial Mesolithic occupation followed by further activity in the later prehistoric period. The later flintwork is principally associated with layer of unworked cobbles dumped into a marshy area, possibly to consolidate it and allow closer access to the water. The only dateable piece from this episode comprises a transverse arrowhead of Later Neolithic derivation, but there are indications that some of it may be later, of Bronze Age or even Iron Age date. It is possible that much of this flintwork was actually brought here along with the unworked cobbles for use as metalling, and it may have been of some antiquity before it was used as such.

The Mesolithic flintwork, which provides the vast bulk of the assemblage, principally derives from a deposit of waterlain clayey sands and, judging from its stratigraphic position and condition, it appears to have been discarded into the slow moving or stagnant water. It presumably derives from activity areas located on higher and drier ground in the close vicinity such as has been found in Trench 24. Similar depositional practices have been documented elsewhere, such as Thatcham in Berkshire. There, a number of more or less discrete knapping scatters were found spread along the edge of a river terrace (Wymer 1963; Healy *et al.* 1992), but it appears that some of the flintwork made at these locations was gathered up and deposited into the adjacent wetland (Churchill 1962, 366–367). Similar practices may also have occurred around the springs of the River Wandle at Carshalton in the London Borough of Sutton (Leary *et al.* 2005). Why this was considered necessary is not obvious; it could simply represent the removal of sharp and potentially hazardous flintwork from living areas, but there is little evidence for the 'tidying up' of debris at other sites. Its disposal may have expressed metaphorical concerns or have been implicated in ritualistic activities. Hopefully, further work at the site will help elucidate the relationship between the manufacture and the disposal of the flintwork.

One of the most obvious and notable aspects of the Mesolithic flintwork is its sheer abundance. So far 30,608 pieces of struck flint have been recovered, virtually all of which comes from excavating an area of just 16 m^2. This can be contrasted to the majority of Mesolithic sites in Britain, which consist of only small collections of flintwork; of the seventy Mesolithic sites recorded in the Stonehenge and Avebury Revised Research Framework, for example, only three have produced substantial assemblages (Wessex Archaeology 2012). Many of the others consist of the presence of a handful of struck flints, or even single pieces, and probably represent chance losses or the residues of short stays by small groups of people. Obtaining and preparing raw materials, manufacturing cores and the conversion of these into useful flakes, blades and other tools was clearly a very important and enduring aspect of being at Blick Mead. Another important feature of the assemblage is the number and variety of retouched and other implements present. As at with most Mesolithic assemblages, microliths are the most common type but even these contribute only around a third of the implements and no other specific type are dominant. There are huge problems in assigning specific functions to tool classes, but given the wide variety present it is at least reasonable to conclude that they were used for an equally wide range of

activities (cf. Mellars' (1976) 'balanced assemblages'). Together with the sheer size of this assemblage, it is difficult to avoid the conclusion that it represents a 'homebase', a location that saw extended and/ or repeated occupation by a wide section of the community undertaking a wide range of subsistence and other tasks. It needs to be stressed, however, that both the microlith typology and radiocarbon determinations indicate that the assemblage was manufactured over a long period, at least from the 8th through to the 5th millennia cal BC, and as such it represents a palimpsest of many occupations and activities. It is likely that the nature of occupation at the site did not remain static, although it is impossible to untangle the flintwork from each occupation. At Thatcham, for example, some of the scatters were considered to represent homebases, whilst others indicated more specialised and task-specific activities (Grace 1992). It is, of course quite possible that both situations could occur even within the confines of a single occupation, with most tasks being carried in some locations and more specialised activates limited to particular zones. Given the redeposition of the material at Blick Mead, the limited areas so far investigated and the considerable period within which it was generated, considerations of site zoning and the spatial organisation of living and working areas will have to wait. Nevertheless, considering the flintwork as an entity does provide for a *generalised* picture of the kinds of activities that took place here, an amalgamation of living practices of perhaps over thousands of years (cf. Conneller *et al.* 2012, 1017). In some ways this actually provides a further insight into settlement at Blick Mead. People went back there over a long period of time. It is inconceivable that they did not notice the debris of earlier occupation, the scatters of the familiar struck and burnt flint that steadily accumulated. By coming back over long periods of time a sense of history is created around a place, and it becomes associated with ancestors and earlier exploits, stories which given time may even become mythologised and incorporated into accounts of origins and creation (e.g. Taçon 1991; Edmonds 1999).

Sites with significantly large and varied flintwork assemblages are not common, and this is particularly so in Wiltshire. Probably the closest comparable site is at Downton, to the south of Salisbury. On the terrace overlooking the river an assemblage of some 38,000 worked flints containing both early (simple obliquely truncated points) and late (narrow blade, geometric) types of microliths. Retouched pieces were comparable in range to those from Blick Mead (Higgs 1959). Downton is located on the same River Avon as Amesbury and would be within relatively easy reach by water. A further comparable site in Wiltshire is Oliver's Hill Field in Cherhill located to the north of Amesbury (Evans and Smith 1983). This site produced a large quantity of Mesolithic flintwork and, although much disturbed by Neolithic ditch digging, indicated substantial settlement that focused around a tufa-depositing spring overlooking the River's Brook, a tributary of the Bristol River Avon. Here, 'the presence of a major base camp is inferred from the large quantity of flint debitage' (*ibid.*, 111). There is some debate as to the chronology of this occupation. Pitts who examined the flintwork argued, largely on the basis of the condition of the material and a single late radiocarbon date, that the assemblage of microliths containing what would normally be considered both early and late types in fact might represent a hitherto unrecorded regional Later Mesolithic industry (Pitts 1983, 75). The range of microliths from Cherhill is very similar to those from both Downton (Switsur and Jacobi 1979, 61) and Blick Mead. The wide range of radiocarbon dates from Blick Mead does, however, cast doubt on that premise and points to occupation over the *longue durée* at all three sites.

McFadyen, in a survey of northern Wiltshire sites, also puts forward a number of other sites that show more intensive and varied activities than most. Along with Cherhill these include Golden Ball Hill in Alton, Cow Down in East Kennett, Heywood Farm in Kington St Michael and Summerlands Farm in Christian Malford (McFadyen 2009, 133). As with Cherhill, these are all located in different drainage systems to Blick Mead and Downton, and their relationship to each other is far from certain. Nevertheless, they certainly give an impression of the intensity of Mesolithic occupation, and the importance of repeatedly visited 'nodes' within the landscape.

A number of comparable sites can also be found just beyond Wiltshire. These include Oakhanger in Hampshire, (Rankine 1952), Thatcham (Wymer 1962; Healy 1992; Reynier 2000) and Wawcott

The Lithic Material

(Froom 1972; 1976; 2012) in Berkshire, the Bourne Mill Spring sites at Farnham (Rankine 1936; Oakley *et al.* 1939; Clark and Rankine 1939) and the dense clusters of knapping scatters preserved within a hollow on the springlines at Bletchingley (Jones 2013), both in Surrey, and the springhead sites at Carshalton in the London Borough of Sutton (Leary *et al.* 2005), although this is not an exhaustive list. What is interesting about all of these is their longevity in occupation, the range of activities they witnessed and that are all located next to important water sources, including many that directly focus upon springs.

Interim report on the struck flint and unworked burnt flint from the Blick Mead terrace (Trench 24), 2014–2015

The excavations in Trench 24 resulted in the recovery of large assemblages of both struck flint and unworked burnt flint. This report provides a preliminary account of the material recovered during the 2014 and 2015 seasons. It does not include the assemblages recovered during the 2016 excavations and full metrical and technological analyses will be undertaken on all of material from the Trench when the investigations have been completed.

Quantification and distribution

The investigations during 2014–2015 in Trench 24 resulted in the recovery of 5,514 pieces of struck flint, just over half of which comprise flakes, flake fragments and pieces of conchoidal shatter measuring 15 mm or less in maximum dimension (micro-debitage). Three quarters of the struck flint was recovered from the colluvial deposits; much of the remainder came from tree-throw hollow [111] and smaller but still significant quantities were also present in remnants of the buried soils and some of the other features located beneath the colluvium (Table 4.13).

Nearly half of the 46.6 kg of unworked burnt flint also came from the colluvium, but feature [105/222] also contained a very substantial collection, amounting to nearly 15 kg, despite the relatively small size of the feature. Substantial quantities were also recovered from tree-throw [111] with smaller quantities coming from the buried soils and other features.

Table 4.13: Quantification of lithic material from Trench 24

Feature	Struck flints macro-debitage (no. >15 mm)	Struck flints micro-debitage (no. <15 mm)	Microlith	Other retouched	Unworked burnt stone (no. >15 mm)	Unworked burnt stone (wt:g)
Colluvium	2080	2068	17	11	1292	21767
Buried soil/Sub-soil	106	36	1	1	35	550
Tree-throw 111	393	628	19	6	319	5459
Posthole 115	5	6	1		7	40
Tree-throw/pit 105/222	25	39	1	1	512	14770
Pit hollow 206	44	26			3	48
Total	2653	2803	39	19	2168	46634

Description of the assemblages

COLLUVIUM

The colluvium contained large quantities of both struck flint and unworked burnt flint, the bulk of which came from its lowest horizons. It is in a varied but mostly good condition and is dominated by pieces generated from blade-based reduction techniques and similar technologically and in composition to the assemblages recovered from the buried soils and other features (see below). It appears that most of these pieces were reworked from the original ground surface and shallow features during the early stages of colluviation, but many do not appear to have moved far. The assemblage from these lower levels includes two scalene triangles, two rod-like microliths and a 'stemmed' or 'tanged' micro-tranchet microlith. The latter is particularly interesting as it is an uncommon type that has been associated with late 5th millennium BC industries (Barton *et al.* 1995, 105; Ellaby 2004; Jacobi 1980, 175). Other retouched pieces of Mesolithic date include two burins, a backed blade and a number of micro-burins.

Also recovered from the lower parts of the colluvium was an asymmetrical ripple-flaked oblique arrowhead, these being a form of transverse arrowhead belonging to the Later Neolithic (Clark 1934; Green 1980). These are formed by extensive ripple flaking and have acute tips, hollow bases and asymmetric 'tails' composed of a small sharp barb on one side and a longer and thicker stem on the other. This example's tip and stem is missing but it is otherwise in a good condition and is characteristically very finely worked. These types are generally rare; a notable cluster has been identified around Flamborough Head in North Yorkshire but many of the southern British examples have come from Later Neolithic Henge enclosures, including near-by at Durrington Walls, Woodhenge and from one of the ditches of the Stonehenge Avenue at the West Amesbury Henge (e.g. Cunningham 1929; Wainwright 1971; B. Chan, pers. comm.). Other possible Later Neolithic pieces include a fragment of another suspected transverse arrowhead, a centripetally worked Levallois-like core, a globular multi-platformed core and a small quantity of relatively large and thick but well struck flakes.

Struck flint was present throughout the middle and upper parts of the colluvium and although somewhat variable, its condition was generally much more chipped and abraded than the material from the lower horizons, with many pieces showing rubbing and 'sand glossing' indicating considerable post-depositional displacement.

A large proportion of this material displays traits of blade-based reduction and is comparable to the assemblages from lower in the sequence. There are a number of microliths, including five scalene triangles, six rods and one obliquely truncated point. The last piece is larger than the others recovered from Trench 24 and might be earlier, it possibly belonging to the middle parts of the Mesolithic. There are also significant quantities of poorly struck, thick and broad hard-hammer detached flakes, many with unmodified wide and markedly obtuse striking platforms. These pieces are more typical of later prehistoric industries, particularly those dating to the later second and first millennia BC. Overall, the assemblage from the bulk of the colluvium is of mixed date, probably spanning the periods from the Mesolithic through to the end of the Bronze Age or later, and are clearly redeposited.

The lower parts of the colluvium also contained a significant quantity of unworked burnt flint amounting to over 15 kg, which was concentrated to the north of the tree-throw [111] and around pit [105 / 222]. The size of the fragments, the types of flint involved and the degrees of burning are all indistinguishable from the material from pit, and there is little doubt that it is closely associated and probably originated from that feature. Large quantities of heavily burnt unworked flint were also found throughout the middle and upper parts of the colluvium, this indicating that comparable activities involving the intensive production of burnt flint were being conducted further upslope.

LOESS AND REMNANT OF BURIED SOILS

Remnants of soils preserved beneath the colluvium produced 144 pieces of struck flint that are mostly in a good, sharp condition. They form a general spread of lithic debris across Trench 24 and are dominated by blade-based reduction waste, although there are also high proportions of prismatic blades present. The only retouched pieces were a rod-like microlith and a flake with shallow retouch around its distal end. It also contained a small quantity of burnt flint along with a well-preserved *Micraster* echinoid flint fossil, which may have been collected although it is not possible to demonstrate this.

TREE-THROW [111]

The central tree-throw hollow, feature [111], provided the largest and most significant of the assemblages from the features in Trench 24. The struck assemblage amounts to 1,046 pieces which are mostly in a good condition and many pieces are still very sharp, indicating that the majority is more or less *in-situ*. The contextual integrity of the assemblage is confirmed by the identification of at least three sequentially refitting blades and further refits likely to be present. There is a small proportion that does show edge chipping and abrasion, this possibly having been incorporated as residual material eroded in from the general scatter within the soil horizons. The assemblage is technologically homogeneous and the product of a blade-based reduction system. Just over 60% comprises micro-debitage, possibly indicating that knapping had occurred within or close to the edge of the feature. All stages in the reduction sequence are represented, including primary core dressing and preparation waste, extensively reduced cores, potentially useable flakes and blades and a variety of retouched implements. These are dominated by microliths which include nine very small scalene triangles, nine rod-like microliths and a bi-truncated point. The triangles and rods are all Later Mesolithic types but the bi-truncated point could date to nearer the middle of the Mesolithic. The majority of the microliths are exceedingly small; the smallest complete scalene triangle measures only 8 mm long by 3 mm wide and is less than 1 mm thick, and the majority of rods, although nearly all broken so that their lengths cannot ascertained, measure only 1–2 mm in width. Their diminutive size, even by Later Mesolithic standards, suggests a degree of integrity and that they may be associated, and they may even have been made by the same person or group. There are also three micro-burins present, suggesting that microliths were being made here, and other retouched pieces include two truncated blades, a piercer, a notched blade-like flake, a relatively sturdy denticulated flake and a number of flakes and blades with light retouch. The cores are mostly blade producing types and include a classic Mesolithic pyramidal core.

A collection of nearly 5.5 kg of unworked burnt flint was also recovered from this feature. This all had been intensively burnt and mostly comprised large 'fresh' fragments, some weighing in excess of 100 g. It was concentrated along the feature's northern edge nearest to pit / tree-throw hollow [105 / 222], which contained even larger quantities, and together these demonstrate an intensity of activities involving the production of burnt flint in this area.

TREE-THROW / PIT [105]/[222]

The upper fill of the smaller tree-throw hollow [105] / [222] contained an exceptionally large quantity of unworked burnt flint, amounting to over 14 kg. This had all been intensively and uniformly burnt, causing the flint to become 'fire-crazed' and attain a consistent grey-white colour, as is indicative of deliberate burning. Although fragmented, many large pieces survive with several exceeding 200 g. These show that most of the flint consisted of large nodular fragments with a rough cortex, along with a few smaller, rounded alluvial cobbles also being used. This feature also contained twenty-two unburnt struck pieces. These are mostly in a good or only slightly chipped condition and are technologically similar to the assemblages from the other features and buried soils. They include a blade

core made on a large flake or quartered nodule, a narrow obliquely truncated microlith and a possible notched flake.

The lower fill produced a further forty-three pieces of struck flint which are mostly in a good or only slightly chipped condition and are similar to those from the upper fill. There are no microliths or other retouched pieces but the assemblage is clearly blade-based and includes an opposed platform blade core. It also produced a complete elongated nodule that has had a few flakes removed from either end. Although only minimally worked, it is of the right size and shape to suggest it could have been used to produce a transverse axe and is comparable to the nodules used to make some of the finished axes found in the adjacent wet areas at Blick Mead. Only twelve further pieces of burnt flint were found in the lower fill, contrasting with the very large quantities that came from the upper fill.

POSTHOLE [115]

Posthole [115] produced small quantity of unworked burnt flint and twelve struck pieces, the majority of which consists of micro-debitage. A fragment of a narrow obliquely truncated point of Later Mesolithic date is present and many of the other pieces were produced by blade-based reduction.

PIT / SCOOP [206]

Pit [206] produced seventy struck flints which include a number of blades but also a high proportion of competently struck but relatively wide and thick flakes. There are no retouched pieces included but two cores were found, a minimally worked example and a multi-platformed flake core. Although no diagnostic pieces are present, the flakes and cores are more typical of later prehistoric industries, particularly those of the Later Neolithic, and it is possible that this feature represents an intrusion cut from higher levels but whose edges had become obscured by colluvial reworking.

Discussion

The excavations conducted in Trench 24 have enhanced understandings of the findings from the waterlogged deposits in the other trenches and suggest a probable source for that material.

In concordance with the assemblages from the other trenches, both the quantities of unworked burnt flint and struck flint recovered from Trench 24 are remarkably large, despite the small size of the trench, and are surpassed by those from only a very few sites in Wiltshire.

The thick deposits of colluvium in Trench 24 have produced struck flint assemblages that span the Mesolithic through to the Bronze Age, and attest to the intensive use of this part of the landscape during these periods. The struck flint from the underlying features and buried soils is technologically homogeneous, represents the complete knapping sequence and can be firmly placed within the Later Mesolithic period by its microlith component. The notably diminutive size of most of the microliths from the features, which are limited to rods, scalene tringles and a single stemmed point, indicates that the occupation occurred during the very latest stages of the Mesolithic, a possibility strengthened by the tight late 5th millennium BC radiocarbon date sequence. The condition of this material indicates that it has experienced only minor post-depositional movement, supporting the notion that the tree-throw hollows and other features along with the remnants of buried soils at the base of Trench 24 represent a contemporary Mesolithic surface and dwelling structure(s).

The struck flint from these features is closely comparable in terms of its technological signature to the assemblages from the earlier trenches excavated at Blick Mead, with which it is undoubtedly associated; it would seem that the flintwork was being produced within settlement contexts on the dryland, and much of it discarded into the adjacent water.

The unworked burnt flint indicates deliberate burning on a scale that exceeds what might be expected from casual hearth use and accords well with the exceptionally large quantities that were

recovered close by from the previous work conducted at Blick Mead. It is most likely to have been generated through cooking activities, but if so would be on scale very rarely encountered at Mesolithic sites and further underlines the exceptional nature and scale of occupation at Blick Mead. It matches in character and quantity the high amounts found discarded into the water nearby.

The colluvium overlying the features and soils also contains significant quantities of struck flint and unworked burnt flint, much of this is likely to have been displaced from the Mesolithic horizons but there are indications of later prehistoric activity in the vicinity. Most notable is the recovery of a ripple-flaked arrowhead which draws comparison with others found at Later Neolithic monumental sites in the area and indicates that, at least in this sense, Blick Mead was drawn into the wider Stonehenge Neolithic ceremonial landscape.

Mesolithic stone working at Blick Mead and beyond: An overview

With the exception of the microliths it is not possible to chronologically sub-divide the Mesolithic assemblage, despite the microlith typologies and radiocarbon determinations indicating that it had been produced over many thousands of years. Although this homogeneity is in many ways frustrating, it does enable us to make certain inferences concerning the social implications of flintworking within a Mesolithic context.

Stone working has played a particularly prominent role in Mesolithic studies as all too frequently it represents the principal or only form of evidence found on archaeological sites of the period. Basic techniques involve the deliberate pre-shaping of cores and careful preparation of striking platforms, which facilitate the repeated production of uniformly shaped and sized prismatic blades. These have often been associated with highly mobile forms of residency, as standardised blanks are seen as portable and quickly convertible into a wide variety of tools including easily repairable composite forms (e.g. Kuhn 1994; Smith 1992).

The form and composition of inventories have traditionally been seen as rather passively reflecting economic subsistence and technological responses to environmental change (e.g. Eertkens 1998; Myers 1987; 1989; Torrence 1989). A number of recent approaches have also focused on the relationship between stone tools, mobility and landscape. Rather than seeing a straightforward adaptive role, these have tended to concentrate on the ways in which mobile lifestyles might structure the undertaking of routine activities such as acquiring and working flint (Conneller 2000; Edmonds 1997; Ingold 1993; Warren 2009). These consider how the working of flint, from gathering raw materials to the discard of implements, can be understood as networks of related activities that bind people and the materials they interact with to particular places in the landscape.

A number of more recent approaches also focus on the relationship between stone tools and landscape. Rather than seeing a straightforward adaptive role, these have tended to concentrate more on the ways that the scales, rhythms and tempos of mobile lifestyles structure the ways in which routine activities such as flintworking can be undertaken (Ingold 1993; Edmonds 1997). Warren (2009), for example, outlines how the working of flint could be understood in terms of networks of related acts that connect people, places and materials. Such networks extend across and help enculturate the landscape, providing a medium through which ideas about community and identity can be played out (e.g. Edmonds 1997; Conneller 2000; McFadyen 2008; 2009).

As we have seen, the flintwork from Blick Mead and its adjacent terrace was manufactured according to very formulaic processes and procedures. Although we have very little idea of how these may have changed at the site through time, the majority of the flintwork suggests similar, almost prescribed, ways of doing things were followed over a long period. This can be seen in numerous aspects of the flintwork, from the basic *chaîne opératoire* of core production through to the way microliths were sharpened or the repetitive ways in which the micro-burin technique was employed. From a broader perspective, chronological and regional variations do exist within the Mesolithic but, for the most part, the techniques

used to work flint, along with the implements made, closely reflect those from other areas; flint technology may be regarded as standardised and conservative. Methods of working and the repertoire of products do change over time and distance, but despite requiring considerable personal knapping skills, they do so slowly, and show few signs of innovation, idiosyncrasy or ostentation. Knapping follows long-held traditions and was undertaken through communal ideals of how things should be done. By reflecting cultural norms, flint technology has the ability to stand as a metaphor for the values of the wider community. Complex flintworking techniques and skills were passed down in barely modified form from generation to generation. This required extended periods of learning and practice, repetitive emulation and the honing of skills. The arduous and enduring work required to become a flint knapper would no doubt be accompanied by tales of great flintworkers past and present, of stories of where the flint came from and how it came to be, and of eagerly anticipated successes in hunting and other pursuits. This socialisation would establish a person's place as a valued member of the community, and through this re-commitment to its long-held traditions and values, reaffirm their sense of belonging.

Microwear analysis of a tranchet axe and a pre-form from excavations at Blick Mead
– Randolph Donahue and Keith Bradbury

Excavations at Blick Mead have yielded nine tranchet axes from Mesolithic contexts in the wet areas of the site and one tranchet shaped pre-form from the base of a tree throw [105] on the adjacent terrace. The lack of precise stratigraphy within the wet areas does not lend itself to dating of particular artefacts with the twelve radiocarbon dates returned from there situating their deposition/ disposal between the 7596 and 4695 Cal BC.

In 2015 Trench 24 yielded a complete elongated nodule that has had a few flakes removed from either end from the underlying fill of tree throw [105] (Context [221]). Although it is only minimally worked, it could have been used to produce an axe comparable to those used to make some of the finished axes found in the adjacent spring (Barry Bishop, pers. comm.). The fill also contained forty-three flakes, blades, fragments associated with blade production and twelve pieces of burnt flint, plus some 'wood charcoal' (Robyn Veal, pers. comm.).

A sample of the charcoal from Context [221] returned a date of 7960–7716 Cal BC (95%), this providing a match with the 8th millennium BC radiocarbon dates from two of the Mesolithic posts found at the 'old' Stonehenge car park (Vatcher and Vatcher 1973, 57–63 and Allen 1994, 471–473).

The School of Archaeological Sciences, University of Bradford carried out microwear analysis of the pre-form and a complete tranchet in July 2016. Microwear analysis can be used to distinguish whether a stone tool has been used to work, fashion or cut wood, hide, bone, etc. Images of the axes were magnified at various levels up to 200×, and moulds were taken of the edges to create 'positives', which in turn were analysed under a microscope.

It was assumed that obtaining a positive use wear result from the tranchet axe was unlikely due to it being heavily patinated. However, counter to expectations, the microscopic analysis of the axe showed a single thin bright line along a portion of the cutting edge. No such evidence was found on the faces. This polished edge was interpreted as being symptomatic of it being used for wood-working.

In contrast, the faces and edges of the pre-form tranchet axe were clean, sharp, and unpatinated and microwear analysis revealed no traces of use. It is possible that the context of it being put into a tree throw hollow with the remains of a fire was a non-practical act of deposition. Indeed, it may have been deliberately placed and be a symbolic and ritualistic act. Parallels can be drawn with the placement of Mesolithic struck flint in tree throw holes on the Eton Rowing Course, Berkshire dated to 5220–4940 Cal BC (Lamdin-Whymark 2008), and at Gatehampton Farm, Goring, Oxfordshire

(Brown, A. 1995, 80–81). Wessex Archaeology also recorded 'a possible in situ (large) tranchet axe/pick from a possible tree throw hole at a site at Herne Bay, Kent (Leivers, Dinwiddy *et al.* 2006). It has been suggested that the tree throw hollows created from fallen trees could have 'served as landscape markers or as foci for settlement camps' in the Mesolithic and Early Neolithic (Evans, C., *et al.* 1999, 249–250). As the large tree trunks could have taken centuries to rot down entirely, these places may have been remembered for a long time.

Portable XRF analysis of a possible slate tool
– Peter Webb

The tool and a comparative sample (Preseli slate) were measured first in December 2013 and again in January 2014 at The Open University using a Niton XL3t-900 portable X-ray fluorescence spectrometer. The analytical results incorporating major elements (quoted as % oxides) and trace elements (quoted as mg/kg = ppm) for both samples are listed on an Excel file (<http://www.buckingham.ac.uk/research/hri/fellows/jacques>). On account of the variable geometry of the sample when presented to the instrument, the data are approximate, for major elements especially. Relative abundances are probably more reliable than absolute quantities. In order to make major element quantities more comparable, values have been normalised to a mass fraction of 95% thus allowing for unanalysed constituents such as Na_2O and combined H_2O.

The specimen is a micaceous slate, possibly with incipient porphyroblast development, and therefore is a low grade metamorphic rock probably derived from what was originally a silty mudrock. It is similar to many Lower Palaeozoic slate formations from parts of Wales, the Welsh Borders, northern England and south-west England. Consequently, it is appropriate to compare these results with compositions of shales (including slates, which were formerly shales) from similar areas as recorded in a British Geological Survey–Open University programme report (Plant and Jones 1989). The BGS data were presented according to age of deposit. An initial review of the data had suggested that Tremadoc age shales might bear closest resemblance, largely on account of the average Rb/Sr ratio and trace element abundances, but subsequent retrieval of source data courtesy D. G. Jones (BGS) showed that two compositions included in the averages were not in fact shales (see red data in 'Compositions of Tremadoc shales ...'). Re-averaging the remaining Tremadoc data produced a much poorer match. Of individual Tremadoc age samples, there are some tolerable matches for individual trace and major elements, but few are hugely convincing. Although trace elements and Rb/Sr match quite well for Tremadoc slates from the Dolgellau area, the major elements are not a very good match.

While the composition of the slate tool is not hugely dissimilar to many shales, there seem to be several discrepant features among major elements, including rather low Al_2O_3, high CaO and high TiO_2. These could be useful diagnostics for identifying a matching composition, as would be the Rb/Sr ratio, should further analyses become available. The composition of the tool shows no obvious resemblance to any of the average compositions of Palaeozoic-age shales although some individual values are tolerable matches.

Although the tool has aspects of its composition that are similar to some shales, the slate tool is clearly layered and it may be that compositions of individual layers are being preferentially measured by the direct PXRF analysis, whereas the BGS compositions represent whole rock averages. The PXRF TiO_2 and Zr values are high, which tend to be in detrital minerals and may reflect heavy mineral enriched layers. There may also be discrepancies, largely for MgO, P_2O_5 and to a lesser degree for Al_2O_3 and SiO_2 due to insensitivity of the analytical system and the imperfect geometry which affects the results for these analytes more than most others.

In conclusion, the best compositional match is with a Tremadoc slate from Mid-Wales. It is necessary to be cautious, however, and it is probably justified only to claim, based on petrography, that the rock is most likely to come from parts of northern or western Britain, where low grade slatey metamorphic rocks occur. There is most definitely no resemblance to compositions of Preseli slates. The composition derived by PXRF, accompanied by petrographic characteristics, provides a stringent diagnostic for matching the object to a suitable source.

The cause and significance of crimson flints in springs associated with the Mesolithic settlement at Blick Mead
– *David M. John*

Since 2005 archaeological excavations have revealed a low-lying depression (Blick Mead) to the north-east of Vespasian's Camp to be part of a complex of springs in the locale. Today the Blick Mead spring usually flows feebly during wetter winter months and the water flows into the Hampshire Avon and via a spring-fed pool before entering river (Figure 4.19). All the springs in the area would have been more active during the Middle Mesolithic when climate modelling show winters to be wetter, summers warmer and the ground water table significantly higher than today.

Blick Mead: Springs past and present

Today the only perennial springs in the vicinity of Blick Mead are those in the bed of a large pool that during the winter months also receives water from the site spring via a culvert under a causeway constructed in the eighteenth century. The shallows along the steep northern side of the pool are strewn with nodular flints derived from erosion and slumping of the bank above.

The flints in the excavated site spring at Blick Mead form discontinuous beds associated with fine grained sediment and clay. Some flints are nodular or cobble-like and are likely to have been mainly derived by slope wash from the outcrop of 'Head Gravel' lying immediately to the north. Other flints unearthed at the site show varying degrees of thermal flawing, weathering and some smooth, rounded flints are probably much-rolled alluvial cobbles. The presence of a wide variety of flint types led Bishop (this chapter) to suggest that some may have been brought from a distance before being deposited. Large quantities of worked knapped flints have also been discovered and represent the full reduction sequence.

There is evidence from the seventeen radiocarbon date sequences that Mesolithic populations returned to this place between the early 8th and late 5th millennium BC. There has been much speculation as to why this site was of such interest over such a long period of time. Of particular interest is the observation that many flints removed from the large pool on the present-day spring line turn a striking magenta colour. Accounting for this phenomenon, and whether it would have been observed during the early prehistory at the site, might help in addressing the question as to why the locality was so well known and remembered for over 2,000 years.

The cause of the red colouration of the flints

Originally the reddish discoloration of the flints was attributed to staining by inorganic encrustations, possibly manganese and iron oxides. Microscopic examination has revealed the crust to be cellular in nature and to be formed by the freshwater red alga *Hildenbrandia rivularis*. This alga is widely reported from springs,

The Lithic Material

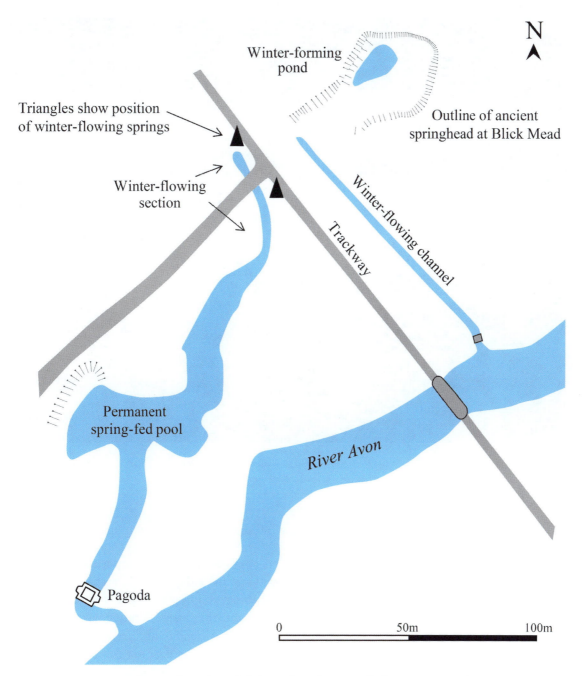

Figure 4.19: Map showing the outline of Blick Mead, nearby seasonally flowing springs and watercourses and the spring-fed pool that flows into the River Avon. Outline of Blick Mead modified from Figure 2 in Jacques and Phillips (2014). Illustration courtesy of David John.

streams, rivers and lakes in the British Isles (Sheath and Sherwood 2011) and similar habitats throughout Europe, Asia, Australia, New Zealand and Pacific islands; only rarely are its crusts very conspicuous. The *Hildenbrandia rivularis* crusts on the flints in seasonally flowing stream and large pool near Blick Mead are usually crimson or blood-red in colour although elsewhere are known to vary from pink, red to blue or turquoise (Figure 4.20). Colour variation is attributed to differences in ambient light conditions, especially the degree of shading by trees, rock overhangs, bridges and marginal vegetation. The stream flowing from Blick Mead and the flints in the shallows along the northern bank of the spring-fed pool are shaded by trees. Evidence from the small vertebrates found at Blick Mead (Parfitt, Chapter 7, this volume) point to the nearby presence of woodland,

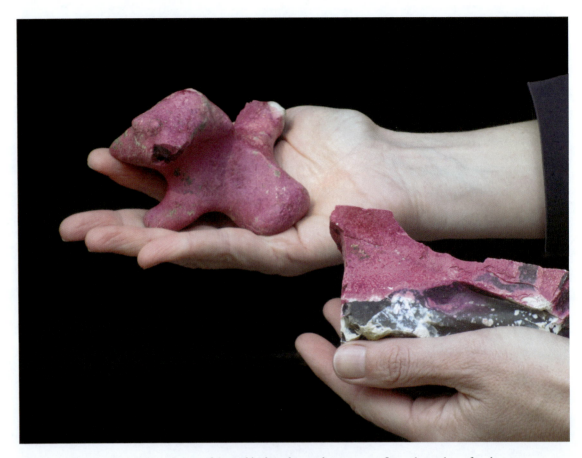

Figure 4.20: Colour change of the *Hildenbrandia rivularis* crust on flint taking place after drying. Photograph courtesy of Tim Roberts.

at least in some periods during the Mesolithic, so any spring fed pools are most likely to have been shaded.

The actual colour of the *Hildenbrandia rivularis* depends on the relative proportions of the two groupings of light-harvesting phycobiliprotein pigments that mask the green of the chlorophyll. The red phycoerythrins are a green, yellow and red light absorbing group, and the other pigment group is the blue phycocyanins that absorb blue, green and yellow light. The change in colour on drying of the flints from crimson to violet or purplish-red (magenta) probably relates to differences in photostability of the pigments, with the red phycoerythrins much less stable than the blue phycocyanins. After a few months, the violet or magenta colour also fades unless flints are stored in the dark. There are specimens of *Hildenbrandia* in the Herbarium at the Natural History Museum in London that still retain their colour after 150 years in storage. These pigments are of considerable economic importance since they are widely used in many industries including in pharmaceuticals, neutraceuticals and as a natural, non-toxic dye in food and cosmetics (see Sonani *et al.* 2016).

The crusts adhere very closely to hard surfaces where initially forming small discs before fusing to form an almost continuous layer. The edges of these discs are single-celled, typically a light or rose red and towards the centre become several cells thick as well as darker in colour. Microscopic examination reveals the surface to be a layer of closely packed polygonal and isodiametric cells, so readily distinguishing *Hildenbrandia* from an inorganic encrustation. The surface cells terminate vertical tiers of up to ten cells (rarely to sixteen) (o) and these are 5–8 (rarely 10) μm wide. Sometimes the cells are square or slightly flattened and the filaments they form are occasionally branched near their apices. The upper inner cells sometimes divide to produce dense aggregations that act as vegetative reproductive propagules known as gemmae. The gemmae readily detach and develop into a new colony when carried to a suitable hard surface. The springs in the Blick Mead

area would be expected to have been perennial and very active at least before about 4,400 BC when climate models predict wetter winters and a groundwater water table about 2–5 m higher than today (Whitehead and Edmunds 2012). There is no reason to believe that *Hildenbrandia rivularis* would have been any less conspicuous on the flints associated with spring-fed pools and outflowing stream during the Mesolithic period than today. An important factor governing the distribution and growth of *Hildenbrandia rivularis* is rate of water flow since silt and debris will tend to accumulate on flints under stagnant conditions and therefore prevent or restrict colonisation and subsequent growth. Crusts do not develop on inorganic encrustations or very friable chalk and on hard rock surfaces may be outcompeted by faster growing aquatic mosses, lichens and other cryptogamic plants. Today the green aquatic lichen *Hydropunctaria* (formerly *Verrucaria*) *rheitzophila* appears to be the only encrusting organism competing with *Hildenbrandia* on flints in the spring-fed pool.

Ecological conditions: Springs and spring-fed habitats

There is no reason to believe the properties of the spring water in the Blick Mead area have changed significantly over the past several thousand years. All springs issue from 'Late Cretaceous Seaford Chalk formation', a subdivision of the 'Upper Chalk' that typically contains many seams of nodular and semi-tabular flints. Those springs supplying the pool close to Blick Mead had a pH of 6.5–8.7 in October 2013 and in the same month the following year, October 2014). The pH falls within the range (pH 6–8.8) known for springs and spring-fed aquatic habitats in the British Isles (see Sheath and Sherwood 2011) and in Europe (see Gutowski *et al.* 2004; Żelezna-Wieczorek and Ziutkiewicz 2008; Simić 2008; Starmach 1969) from where *Hildenbrandia rivularis* is recorded. Water temperature in the pool varied from 12 to 14 °C (October 2013, 2014), often reaching 16 °C away from the most active spring areas. The water temperature probably fluctuates during the winter period when the pool is known to increase in depth by about 2 m (Mike Clarke, pers.comm.).

There are many springs, spring-fed pools and water courses within a 30 km radius of Blick Mead. One unnamed site (SU154 405) was along the bank of the River Avon and several active springs were observed here in October 2014. Another site visited was Figheldean (SU151 475) where the shallow (<1 m) river bed was strewn with flints. Crusts of *Hildenbrandia rivularis* were observed on flints at both sites where the pH varied from 7.3 to 7.6 and the water temperature from 12.5 to 14.7 °C. Several spring sites were visited but only flowing in October 2014 were the following: West Amesbury Henge (SU142413), Alton Priors (SU108622), West Kennet Barrow, Walden Spring (SU107683); no flints or other hard surfaces suitable for *Hildenbrandia* were observed at any of these springs. Only springs issuing from the Seaford Chalk Formation (formerly part of 'Upper Chalk'), such as those at and close to Blick Mead contained significant quantities of flint. All the other spring sites visited issued were at the junction of the 'Middle Chalk' group and the Grey Chalk Subgroup (formerly 'Lower Chalk'), or only from the latter subgroup. The Seaford Chalk Formation is softer and contains abundant flint nodules compared to underlying sequences.

Special significance of magenta-coloured flints

It is inconceivable that pre-historic peoples visiting the springs at Blick Mead could have failed to notice the crimson or blood-coloured flints strewn over the floor of shallow pools and outflowing streams. These coloured flints might well have been collected as talismans or revered objects and, just possibly, suitably sized and shaped flints might have been deliberately deposited in the springs in order to ensure a continual supply of these red-coloured objects. The length of time for *Hildenbrandia* to encrust a small, cobble-like flint in continuously flowing water is unknown. An experiment was undertaken over a two-year period (September 2014 to 2016) in the large spring fed pool close to Blick Mead designed

to determine the rates of colonisation and growth of *Hildenbrandia rivularis*. Unfortunately, the experimental flints were disturbed and too few were retrieved to obtain meaningful results.

In conclusion, one of the reasons the springs at Blick Mead were important and possibly venerated as far back in time as the Mesolithic might have been the presence of crimson or blood-coloured flints which on drying turned a striking magenta colour. The phenomenon is due to the presence on the flints of crusts of the freshwater red alga *Hildenbrandia rivularis*. Such a phenomenon of strikingly coloured flints caused by *Hildenbrandia* has not been recorded at other archaeological sites in the British Isles.

CHAPTER 5

Aurochs Hunters: The Large Animal Bones from Blick Mead

– Bryony Rogers, Kurt Gron, Janet Montgomery, Darren R. Gröcke and Peter Rowley-Conwy, with a contribution by Sophy Charlton

> My involvement in the Blick Mead Project began in 2011 while I was still a sixth form college student. The chance to be able to access first-hand such significant archaeology at a young age changed what I wanted to do with my life. I have now studied a degree in archaeology, got a First, worked for a commercial unit and have just completed my MSc in Zooarchaeology at York. The archaeology and the people at Blick Mead have been central to furthering my love for the subject. I was given responsibility from early on and owe the project a great deal.
> —JOSHUA WHITE, volunteer, Great Yarmouth, Norfolk

The site of Blick Mead has attracted an unusual degree of interest. In addition to its intrinsic importance as a Mesolithic site, its location around 2 km east of Stonehenge and its temporal overlap with the massive Mesolithic posts in the former Stonehenge carpark mean that it is the earliest settlement site in the region of the monument (e.g. Parker-Pearson *et al.* 2015). The site has provided an animal bone sample of modest size but great importance. Faunal remains reveal much about the socio-economic basis and cultural practices of their time. Very few Mesolithic faunal assemblages are known from Britain, so any new discovery greatly advances our understanding of the period. In the following report we do two things. First, we present a zooarchaeological analysis of the material; the most remarkable aspect of this is the high proportion of aurochs (*Bos primigenius*), so far unequalled at any other Mesolithic site in Britain and the near continent. Second, we present a stable isotopic analysis of aurochs teeth. We thus aim not only to get a better understanding of the site and its inhabitants, but also of the life of the extinct ancestor of modern domestic cattle, by focusing on their diet and migratory habits.

The current excavations at Blick Mead began in 2005. Mesolithic remains have been discovered in Trenches 19, 22, 23 and 24. The assemblages of struck flint and burnt stone indicate a substantial Mesolithic occupation at the site. The radiocarbon dates from twelve fauna and six pieces of charcoal span the period between 7960–7716 and 3636–3381 cal BC (see Table 2.1) and reinforce the suggestion that the site marks a 'persistent place' in the landscape.

Parts of this assemblage were initially examined, and its importance understood, by the late Tony Legge. We dedicate this study to his memory.

Zooarchaeological Analysis

A total of 2,430 fragments of animal bone were recovered from Blick Mead. Prior to October 2012 the site was not sieved, and hand collection was used to retrieve the remains. However, upon the first significant discovery of Mesolithic material in Trench 19, all of the spoil from layer [59], the sealed Mesolithic deposit, was sieved, as were the Mesolithic contexts from Trenches 22 and 23. Layer [59] was divided into nine 1 m × 1 m squares (Contexts [59]A, [59]B, [59]C, [61], [62], [63], [65], [66] and [67]) to allow the distribution of the finds to be examined. Contexts [77] and [92] were also

part of this sealed deposit and any remains found in the spoil heap from this layer were recorded as context [64] (David Jacques, pers. comm.). All of the finds were washed. Layer [59] sits below the water table; it is described as being dark brown, viscous, silty clay. The remains were concentrated in the southern corner of this layer with 907 fragments coming from context [77] alone (Figure 5.1). 65, 16 and 48 fragments came from Trenches 22, 23 and 24 respectively. Table 5.1 lists the Number of Identified Specimens (NISP) of the assemblage. Despite the wide range of the Mesolithic radiocarbon dates (see above, Table 2.1), there was no stratigraphic reason to subdivide the animal bones into chronological sub-units. All the bones are therefore treated as a single assemblage, but it must be remembered that they span some 4,000 years.

The fragments were identified by Bryony Rogers under the supervision of Peter Rowley-Conwy using the Durham University reference collection. Each fragment has been given a unique reference number and recorded onto a catalogue, which is held with the archive. Numbers in curly brackets (e.g. {1234}) in this report refer to this catalogue.

Where possible, they were identified to element and species, the level of epiphyseal fusion was noted and, if the element was not complete, the part present was also recorded. They were not recorded by identifiable zones. Size was also recorded, as were any interesting features such as cut or gnaw marks. Tooth wear stage was recorded following the method of Grant (1982). If it was not possible to identify the element, fragments were recorded as either Bone Fragment or Tooth Fragment. Ribs and vertebrae, with the exception of the atlas (cervical vertebra 1) and the axis (cervical vertebra 2), were recorded only as Bone Fragments. Each fragment was given an individual record number. Only twenty-seven of the identifiable fragments were sufficiently well preserved to have measurements taken. Measurements follow von den Driesch (1976).

The preservation of the bones was very poor, most fragments being very small and highly eroded; this is typical for chalk environments with water percolating through them. The total weight of all the fragments was 9.353 kg, with an average fragment weight of 3.8 g. Ninety-one fragments, most of which were unidentifiable, show evidence burning. All save one of these burnt fragments, which is unstratified from Trench 22, came from Trench 19. Excluding two of these fragments, which were unstratified, all were recovered from contexts [77] and [92], both of which are part of the sealed Mesolithic layer.

Some bone fragments from the southern corner of Trench 19 were a blue/green colour. This has been seen at other sites including a context from San Josecito Cave, Mexico. In this case, Robels *et al.* (2002) identified diagenetic trace elements in the bone, including copper, strontium and zinc. They postulated that a series of physical and chemical diagenetic processes led to the transfer of particular metal ions into the bone, resulting in a change in its colour (Robels *et al.* 2002). It is possible that a similar process happened at Blick Mead. All the fragments were recovered from context 77.4 in Trench 19, which is close to the springline, so it is thought that the colour change was caused by the minerals and *Hildenbrandia rivularis* algae. These algae are known to turn red-oxidised flint magenta pink upon contact with the air (John, Chapter 4, this volume).

Fragment {1316}, a metatarsal of roe deer (*Capreolus capreolus*), has an iron cylinder concreted to its interior surface. Fragment {1317}, an unidentified fragment, has evidence of being in contact with the iron on fragment {1316}. Both fragments were from context [77.5] in Trench 19. The iron on the bones may have been caused by natural precipitation from the soil (Vicky Garlick, pers. comm.).

Results

Two hundred and seventy-one bone fragments were identified (Table 5.1). Twelve of these, unidentifiable morphologically, were identified using ZooArchaeology by Mass Spectrometry (ZooMS) by Sophy Charlton at York University. Of these, ten were aurochs, one was wild boar, and one was either red deer or elk. Eight further fragments were analysed using ZooMS; five were identified as terrestrial herbivores of unknown species, and three were unidentifiable (Charlton, this Chapter, below).

Aurochs Hunters: The Large Animal Bones from Blick Mead

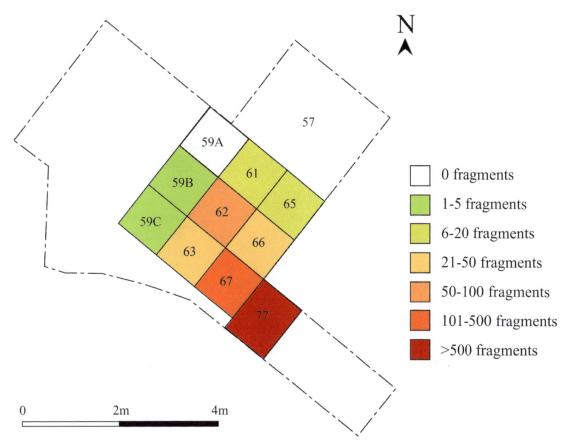

Figure 5.1: Distribution of bone fragments in Layer [59].

AUROCHS, *BOS PRIMIGENIUS*

Aurochs remains make up 57% of the identifiable assemblage, totalling 155 fragments. A few domestic cattle bones were recovered (see below). Four further fragments were identified as probably aurochs; although visually relatively small, they were regarded as not small enough to be classified definitively as domestic. They were recovered from context 67 in Trench 19, from where many aurochs fragments were identified, so it was concluded that these fragments too are likely to be aurochs.

Aurochs were found in all four trenches. The majority, 133 (85%), came from Trench 19. Thirteen (8%) were recovered from Trench 22, nine (3%) from Trench 23 and two (1%) from Trench 24. These proportions are the same as those of the total fragments recovered from each trench, suggesting that the aurochs remains were evenly spread across the whole site. Within Trench 19 most are concentrated in the south, closest to the spring (Figure 5.1). Ninety-two of the fragments (70% of the fragments from Trench 19) came from the sealed Mesolithic deposit; three of the fragments came from Contexts 75 and 76 which were underneath Layer [59].

Almost all aurochs body parts were represented, with the foot and ankle bones comprising the majority of the assemblage (Table 5.2). The Minimum Number of Individuals (MNI) was calculated in the simplest possible way, by taking the fewest number of elements from a single side that through side-by-side comparison could be determined to have come from different carcasses. The aurochs MNI was calculated to be four, based on three adult-sized left proximal metatarsals, as well as one unfused distal metapodial epiphysis from a neonate or very young individual. The Minimum Number of Elements (MNE) was also calculated with the most common elements being 1st and 2nd phalanges with eight and fourteen elements recovered respectively. Ten of the fragments refit, including two 1st phalanges, a 3rd phalanx, a naviculocuboid and a metacarpal; they were counted in the bone count as separate fragments but were counted as single fragments in the MNI.

Aurochs were the only animal from Blick Mead showing any signs of butchery. Five aurochs fragments exhibited cut marks (Figure 5.2). The proximal end of a left metacarpal has quite deep chop or gouge marks (Figure 5.2A), as does the proximal end of a left radius. The coracoid process of a right scapula has two deep cut marks (Figure 5.2B), and a calcaneum also has cuts. The fifth fragment, no. 1119, has a flint fragment embedded in it (Figure 5.2C). This is an aurochs 2nd phalanx recovered from context [77.4] in Trench 19. The small fragment of flint is on the distal lateral side. A scalpel was used to carefully remove the remaining soil from around the flint, to see if it was only adhered to the bone by mud. This proved not to be the case, so the phalanx was X-rayed in an attempt to determine whether the flint penetrated the bone. Conventional X-rays were taken by Vicky Garlick of the Durham University Conservation Laboratory, and digital radiographs by Tina Jakob of the Durham University Archaeology Department. Although it was determined that the flint fragment did not penetrate the bone, there was evidence of compression of the bone under the flint. This was apparently caused by the flint impacting the bone. This is shown in Figure 5.3D, the area of the bone under the flint appearing as a brighter white than the rest. An arrow strike would probably have caused a more penetrating injury, so hunting seems unlikely to have been responsible. Evidence from an aurochs from Mullerup in Denmark suggests that the torso would have been the main target when hunting an aurochs (Leduc 2014). The Blick Mead example is therefore interpreted as resulting from butchery, the tip of a flint knife breaking off in the bone.

Fourteen aurochs bones were sufficiently well preserved for measurements to be taken (Table 5.3). Two of these were complete astragali. They are of similar sizes, and one is left and the other is right, so it is possible that they may be from the same individual. Distal breadth (Bd) could be taken on both, but only one (no. 1120) was sufficiently well preserved to allow greatest lateral length (GLl) to be taken accurately. The level of erosion on specimen 1120 suggests that the actual GLl is likely to be at least 10 mm longer than the measurement that could be taken. Figure 5.3 plots both astragali, compared to those from Denmark (Degerbøl and Fredskild 1970) and Star Carr (Legge and Rowley-Conwy 1988). The actual measurement on specimen 1120 from Blick Mead is plotted, along with an estimate based on the trend line from the Star Carr and Danish aurochs; the true measurement is expected to fall on the line between the two points. Aurochs are sexually dimorphic, the males being larger than the females, and two size groupings are visible in Figure 5.3. Both Blick Mead specimens fall into the larger group and are thus clearly male. Aurochs teeth are not sexually dimorphic, but the lengths of the two M3s, 45.3 mm and 45.8 mm (Table 5.3) fall well above the largest British domestic cattle (see e.g. Rowley-Conwy and Owen 2011, 335). The other measurements all fall into the established aurochs range published by Degerbøl and Fredskild (1970).

DOMESTIC CATTLE, *BOS PRIMIGENIUS TAURUS*

Five *Bos* teeth from Blick Mead were visually quite small. Four of these came from Trench 24: three from Context 103 and one from Context 101. These are the upper contexts of Trench 24, where the other bones of domestic animals were found (see below). They were accordingly identified as domestic cattle (Table 5.1). The remaining fragment, a lower right M3, was found, unstratified, in Trench 19. This specimen measured 36.5 mm in length, well below the aurochs range and in the Neolithic domestic range (Rowley-Conwy and Owen 2011, 335).

RED DEER, *CERVUS ELAPHUS*

Red deer were the second most common species found at the site comprising 17% of the total identifiable assemblage. Forty-six fragments were recovered (listed in Table 5.2). Four more fragments – two metacarpal fragments, a possible humerus and a tooth fragment – were classified as possibly red deer based on size. A further two fragments: a 2nd phalanx, and a morphologically unidentified fragment

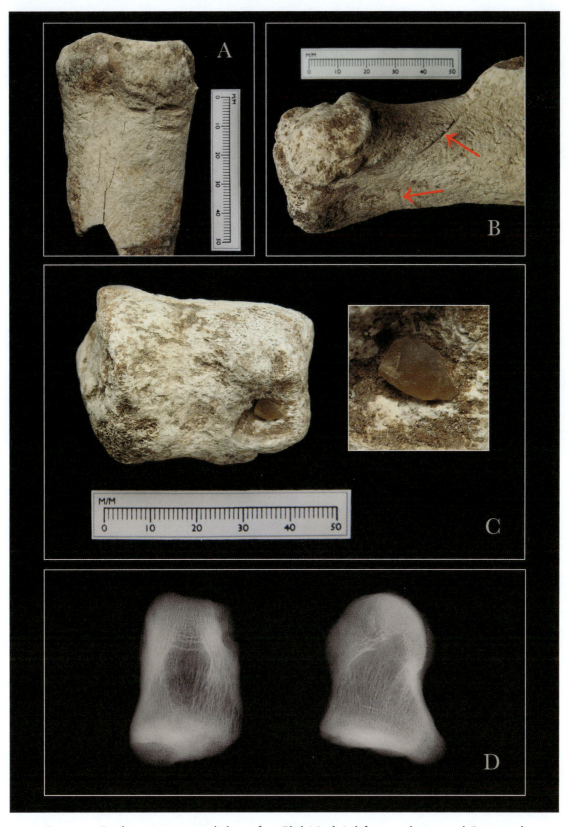

Figure 5.2: Butchery traces on aurochs bones from Blick Mead. A: left proximal metacarpal; B: coracoid process of right scapula, arrows indicate cutmarks; C: the flint adhering to fragment 1119; D: X-ray or fragment 1119, showing compression of the bone beneath the flint. Photographs A–C courtesy of Jeff Veitch; Photograph D courtesy of Tina Jakob.

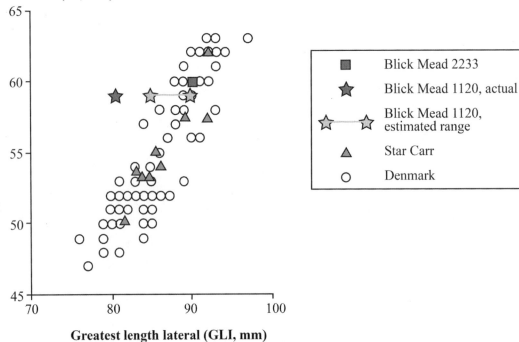

Figure 5.3: Measurements Bd and GLl of the Blick Mead aurochs astragali compared to those from Star Carr and Denmark. The estimated range of Blick Mead 1120 is shown as well as the actual measurement. Measurements follow von den Driesch (1976). Star Carr from Legge and Rowley-Conwy (1988, Table 8); Danish aurochs from Degerbøl and Fredskild (1970, Table 19).

determined by ZooMS, were also classified as either red deer or elk (*Alces alces*). These six uncertain fragments are not included in the element count (Table 5.2).

Red deer were not recovered from Trench 24, and only two fragments each were discovered in Trenches 22 and 23. The remaining forty-two fragments were found in Trench 19 and, like the aurochs, were concentrated in the southern corner of the trench, with sixteen fragments retrieved from the combined context [77]. A further four fragments were recovered from context [67], which is the most southern corner of layer [59]. Most of these are from the limbs, the majority being foot and ankle bones. The MNI for red deer was calculated as two, the number of left calcanei, left magnums and left naviculocuboids.

Four of the Blick Mead red deer could be measured (Table 5.3). One of these was an astragalus. While the separation between the sexes is less clear than in aurochs, males still tend to be larger than females (Legge and Rowley-Conwy 1988). The Blick Mead individual is noticeably smaller than many of the Star Carr individuals, which suggests that it came from a female (Figure 5.4A). One red deer scapula was also measurable. Scapula is problematic because various factors influence size. Age is one: the bone grows markedly *after* fusion, when the bone appears to be adult (Legge and Rowley-Conwy 1988; Rowley-Conwy 2013, fig. 15.6). Among full-grown adults however the males are once again larger than the females (Rosvold *et al.* 2014; Legge and Rowley-Conwy 1988). Most of the animals from Star Carr were adult. The Blick Mead scapula is so small in comparison that it is likely to come from a female (Figure 5.4B).

ELK, *ALCES ALCES*

Five fragments were identified as elk (listed in Table 5.4). These comprised four first or second molars, of which three were upper and one was lower, and a distal tibia. A metapodial fragment was also identified as possibly elk. All of these remains were from the Mesolithic layer in Trench 19, including the two fragments classified as elk or red deer (see above), or were unstratified.

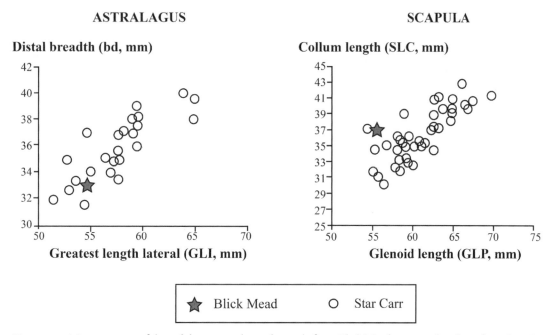

Figure 5.4: Measurements of the red deer astragalus and scapula from Blick Mead compared to those from Star Carr (from Legge and Rowley-Conwy 1988, Table 7).

ROE DEER, *CAPREOLUS CAPREOLUS*

Eight fragments were identified as roe deer (listed in Table 5.4). All except one, a left lower P4 from Context 90 in Trench 23, were from Trench 19. Within Trench 19 six of the seven fragments were from context [77] and one was from Context 92, both of which are in the sealed Mesolithic layer. All of the bones in the assemblage are limb bones, predominantly hind limb bones: femur, tibia, astragalus, metatarsal and 2nd phalanx; or teeth, two left lower P4s and a right upper first or second molar. This means that the MNI for roe deer is two, based on the two lower left P4s. The MNI here is the same as the MNI at Three Ways Wharf in Uxbridge, despite over 200 fragments being identified as roe deer or of roe deer size there (Rackham and Pipe 2011).

WILD BOAR, *SUS SCROFA FERUS*

Twenty-three fragments, 9% of the assemblage, were identified as wild boar (listed in Table 5.4). All were recovered from Trench 19. Nineteen came from the sealed Mesolithic layer; of the remaining four fragments, two were unstratified and the other two were found in Context 75. The MNI of wild boar has been calculated as three, based on the number of right astragali. This is relatively high considering the small number of bones found.

DOMESTIC PIG, SUS *SCROFA DOMESTICUS*

Five fragments of *Sus scrofa* were so small that they are believed to be of domestic size. One of these was a lower left M3 with a WA of 16.6 mm; this falls within the range of 13.9 to 17.5 mm for domestic pigs from Durrington Walls (Albarella and Payne 2005). Four of these fragments were recovered from Trench 19 and one from Trench 24. Three of them: a scaphoid, a lower M3, and a 1st lateral phalanx, were recovered from Context [67]; and a lower M3 was discovered in context [77.2]. Both of these contexts were part of the sealed Mesolithic layer. It is of course possible that these are small wild boar rather than intrusive domestic pigs – it is not always possible to distinguish between them (Rowley-Conwy, Albarella and Dobney 2012). The fifth pig fragment, a lower left incisor, was from Context [101], one of the uppermost layers in Trench 24.

SHEEP, OVIS *ARIES ARIES*; OR GOAT, *CAPRA AEGAGRUS HIRCUS*

Nine bones (3% of the identifiable assemblage) were identified as sheep or goat. One of these was a complete humerus, unfused proximally but fused distally, giving it an approximate age of between ten and thirty-six months, based on Silver (1969). The humerus was not as chalky as the rest of the bones, and was generally much better preserved; for this reason, and the fact that sheep are not found in Mesolithic Britain (Serjeantson 2014), the bones have been interpreted as intrusive. Five of the fragments came from Trench 22 and were either unstratified or came from Context [89]. Trench 22 which was disturbed by a medieval/post-medieval ditch digging (David Jacques, pers. comm.). The three fragments recovered from Trench 19 were found in Contexts [71] and [75] which are above the sealed Mesolithic Layer. The final fragment, a mandibular articulation, came from Context [100] in Trench 24, which is above the context where domestic cattle remains were found.

RABBIT, *ORYCTOLAGUS CUNICULUS*

A complete rabbit tibia was recovered from Trench 22. It was unstratified. It is very well preserved. A rabbit ulna was recovered from Context [100] in Trench 24. Rabbits were introduced to Britain long after the Mesolithic (Sykes and Curl 2010).

DOMESTIC DOG, *CANIS FAMILIARIS*

An upper left P4 was discovered in context [77.5] of Trench 19. It was not considered to be intrusive. Its greatest length is 19.9 mm. Degerbøl (1933, Table 19B) lists measurement from seven prehistoric and eighteen recent wolves. All of these are much larger than that of the Blick Mead specimen, the smallest being 23.3 mm. Degerbøl (op. cit., Table 49) gives two measurements of domestic dogs from the Mesolithic site of Sværdborg I, of 20 and 19.7 mm respectively. Measurements from Britain are scarce, but van Wijngaarden-Bakker (1974, 342) gives a measurement of 19.0 mm for a Beaker period dog from Newgrange in Ireland. From these measurements, it seems reasonably certain that the Blick Mead specimen is indeed a domestic dog, not a wolf.

BIRD (*CF. PASSERIFORMES*)

The synsacrum of a bird tentatively referred to as a passerine was found in Context [90] of Trench 23. It is thought to be intrusive and not part of the Mesolithic assemblage.

Discussion

In the early seasons of excavation there was a bias towards larger bone fragments such as those of aurochs, elk and red deer, due to the lack of sieving. Sieving during the later seasons reduced this bias and enabled the recovery of many smaller, more ephemeral fragments such as the pig 1st lateral phalanx. This is less than 5 mm long and so might have been missed during hand collection (Davis 1987).

The MNIs of all taxa are so small that it would not be meaningful to calculate the MNI percentages. The use of MNI to quantify the animal remains from archaeological sites puts too much emphasis on the chance recovery of multiples of the same fragment, particularly in assemblages where the total number of fragments is small (Grayson 1984). The weaknesses of MNI are highlighted at Blick Mead where the MNI of aurochs, four (from 155 fragments) is only one higher than that of wild boar – of which only twenty-three fragments were recovered. The MNI of red deer and roe deer are the same, two of each species, despite only eight fragments of roe deer being identified compared to forty-six of red deer. This disparity is highlighted to an even greater extent when the MNI of roe

deer at Blick Mead and Three Ways Wharf are compared; both sites have an MNI of two despite over 200 fragments of roe deer being recovered from Three Ways Wharf. It is also very unlikely that only four aurochs were killed during the 4,000-year period that Blick Mead was occupied.

The Number of Identified Specimens (NISP) as listed in Table 5.1 is more useful, especially in combination with the skeletal part frequencies listed in Table 5.2. A considerable proportion of the fragments found at the site from all of the major species, particularly aurochs, are foot and ankle bones. Taken at face value, these could suggest that Blick Mead was a kill site or hunting site rather than a homebase, since the lower limbs and head are often discarded and not returned to the base camp (Legge and Rowley-Conwy 1988). In Binford's study of Nunamiut hunting camps he noted that there was a dominance of mandibles, upper forelimbs and limb extremities, without phalanges; the parts of higher value were taken back to the base camp (Binford 1978). However, at Blick Mead the preservation in the chalky deposits was fairly poor, which may account for the high representation of the harder foot bones (Marean 1991). Furthermore, there is a high proportion of proximal hind limb bones, which suggests that Blick Mead was indeed a base camp.

BLICK MEAD IN ITS BRITISH AND EUROPEAN CONTEXT

The large proportion of aurochs makes the Blick Mead faunal assemblage unique both in Britain and the adjacent parts of the European mainland. Aurochs are usually a relatively minor component of Mesolithic assemblages; for example, only 16% (a total of 174 fragments) of the identifiable fragments found at Star Carr, in Yorkshire, were aurochs (Legge and Rowley-Conwy 1988).

Southern England has yielded four other Mesolithic assemblages. Their percentages of the large mammals are compared to Blick Mead in Figure 5.5 (top). They are all relatively small, but nevertheless large enough to reveal that Blick Mead is unique among them in its large proportion of aurochs. Cherhill comes closest, with 39% aurochs, but also has a large proportion of red deer (Grigson, in Evans *et al.* 1983). Faraday Road is dominated by wild boar (Ellis *et al.* 2003), while Three Ways Wharf (Scatter C West) is dominated by red deer (Rackham and Pipe 2011). Blick Mead, Faraday Road and Three Ways Wharf thus present the remarkable pattern of each specialising on one species. Thatcham presents a different trend, with red deer and wild boar both being relatively common (King 1962), while Cherhill has similar proportions of aurochs and red deer. Only 3% of the remains from Thatcham and Faraday Road were aurochs, and none at all were recovered in the Holocene Scatter C at Three Ways Wharf. The differences in the proportions of species found at each site suggests that different areas may have been utilised for different resources, possibly by the same band or bands of hunter-gatherers.

Figure 5.5 (bottom) compares Blick Mead with selected sites from Denmark, which has produced more Mesolithic animal bone assemblages than any comparable region in Europe. Ringkloster, Agernæs and Asnæs Havnemark are from the Late Mesolithic Ertebølle culture, while Sværdborg I, Ulkestrup Lyng Øst and Lundby II are from the Early Mesolithic Maglemosian culture. These large assemblages show little tendency to specialise on any species; only at Asnæs Havnemark does the proportion of roe deer exceed the proportion of aurochs at Blick Mead – but this may be due to the site's unique location at the end of a long, thin peninsula rather than a particular preference for the taxon. Aurochs decrease through time in Denmark, and are completely absent from Asnæs Havnemark. This site is on the island of Zealand, where aurochs were eradicated by Mesolithic hunters when the post-Glacial sea rose and cut this area off (Aaris-Sørensen 1980, 1999).

One site perhaps more comparable to Blick Mead is Auneau in northern France (Leduc and Verjux 2014). Like Blick Mead, this site was occupied for a long period, approximately 8200–5500 cal BC. Faunal remains have been recovered from some seventy pits, each presumably representing a separate event. Only two pits have faunal assemblages large enough to be useful in this context. Pit 34 has a NISP of 309, and shows a specialisation of roe deer, which form 87% of the bones. Pit 32 has been radiocarbon dated to c. 6800–6500 cal BC. It has a NISP of ninety-three, but significantly 53% of these are aurochs. The MNI for this species is four, of which two were juvenile (Leduc and Verjux 2014).

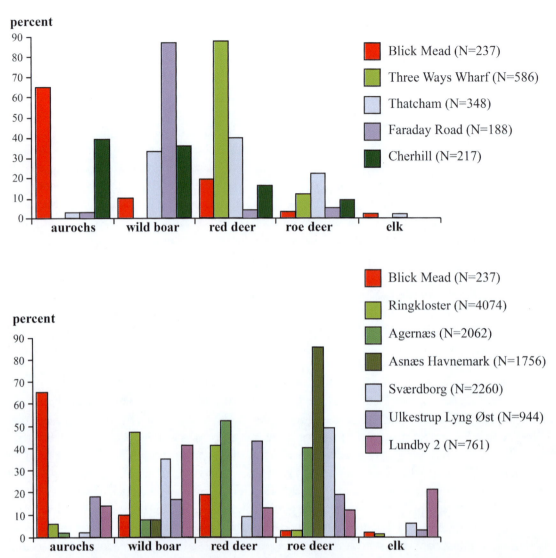

Figure 5.5: The Blick Mead animal bone frequencies compared to those from other Mesolithic sites. Percentages are calculated just from the totals of the five species plotted. Top: comparison with other southern English sites. Bottom: comparison with selected Danish Mesolithic sites (Faraday Road from Ellis *et al.* 2003, Table 3; Thatcham from King 1962, pp. 355–361; Three Ways Wharf Scatter C West from Rackham and Pipe 2011; Cherhill from Grigson, in Evans *et al.* 1983, Table 1; Ringkloster from Rowley-Conwy 2013 and unpublished; Agernæs from Richter and Noe-Nygaard 2003; Asnæs Havnemark from Ritchie, Gron and Price 2013; Sværdborg I from Aaris-Sørensen 1976; Ulkestrup Lyng Øst from Richter 1982; Lundby II from Rosenlund 1980).

Isotopic analysis

During tooth formation and mineralisation enamel is deposited sequentially down the length of the crown: the earliest enamel formation occurs at the cusp (or tip) of the tooth, the latest closest to the Enamel Root Juncture (ERJ) or cervix (Zazzo, Balasse and Patterson 2005). The food and water consumed by the animal during the formation of each tooth affects the isotopic ratios of various elements incorporated into the tooth enamel (Towers *et al.* 2011). Sequential samples taken down the length of the tooth can therefore show change in isotope concentrations over the course of the tooth's formation (Bentley and Knipper 2005). These can in turn be used to reconstruct the animal's diet and mobility, though it should be borne in mind that values do not represent discrete time-slices but running averages, due to the c. one-year maturation time of enamel (Zazzo, Balasse and Patterson 2005; Britton *et al.* 2009; Towers *et al.* 2010).

Three isotopic ratios were analysed at Blick Mead:

(1) The $\delta^{13}C$ values from a given herbivore tooth are linked to the $\delta^{13}C$ values of the plants it consumed (Towers *et al.* 2011). Variations in $\delta^{13}C$ can be caused by water availability, temperature, altitude and the amount of recycled CO_2 in dense low-light woodland (also known as the canopy effect) (Heaton 1999). As a ruminant shifts from pre-birth, to milk ingestion and non-rumination, and then to plant consumption and rumination in early life, $\delta^{13}C$ can change (Towers *et al.* 2014). However, in this study only third molars were used which form entirely after the onset of rumination and therefore these issues will not impact on the data obtained.
(2) The $\delta^{18}O$ values of a tooth are affected by the $\delta^{18}O$ values of ingested water, which may change seasonally with temperature (Balasse 2003). Oxygen isotopes can also be used to show mobility of animals and humans; this can be seen in an unexpected change in the $\delta^{18}O$ values, or from finding $\delta^{18}O$ values not consistent with the area where the remains were located (Tornero *et al.* 2013).
(3) Sr-87/Sr-86 can also be used to track mobility. Strontium in teeth is ingested from dietary plants, and comes from the soil in which the plants grow. Plant values reflect both the underlying geology and atmospheric deposition via rainwater (Price *et al.* 2002; Montgomery 2010). It is thus possible to determine the likely geology on which the plants in the individual's diet grew (Balasse and Ambrose 2002).

The different isotopes used in combination provide a better understanding of the lives of animals and humans in the past (Balasse *et al.* 2002; Müller *et al.* 2003; Britton *et al.* 2009). In migration studies, strontium and oxygen can be used to determine seasonality of migration and also more precise geographical origins of the individual (Britton *et al.* 2009). Carbon and strontium were combined to examine mobility by Balasse *et al.* (2002), allowing differences between coastal and inland diets to be determined; this could not have been inferred from either of the isotopes independently. Towers *et al.* (2011) used a variety of isotopes to get a better understanding of the seasonality and movement of Early Bronze Age cattle from two barrows at Gayhurst and Irthlingborough. This includes the only previous aurochs from Britain for which $\delta^{18}O$ and $\delta^{13}C$ intra-tooth enamel profiles have been obtained.

To understand of the lives of the aurochs at Blick Mead, incremental isotopic analysis was carried out on the two mandibular M3s in the assemblage: fragments 421 (hereafter referred to as BM421) and 422 (hereafter referred to as BM422). These teeth were relatively well preserved and certainly came from different individuals, since they exhibit very different levels of wear: BM421 was in early wear, while BM422 was well worn. BM 422 was directly dated to 6881±33 bp (SUERC-60917), or 5793–5723 cal BC at 1σ, or 5845–5686 cal BC at 2σ. BM421 contained insufficient collagen to be dated. We sampled two cusps from BM421: the mesial (anterior, or first) and middle (central, or second), to see whether they might produce different values. The teeth are shown before and after sampling in Figure 5.6.

The samples were taken in the Durham University Archaeology Grinding Laboratory by Bryony Rogers under the supervision of Kurt Gron and Janet Montgomery. The cementum was removed from the outside of the buccal lobe on the medial and the middle cusps lobes of BM421, and the middle lobe of BM422, using a diamond dental burr-equipped hand-held rotary dental drill. This burr was then used to take intra-tooth samples of enamel at 2–3 mm intervals from the top of the tooth down to the Enamel Root Juncture (ERJ). The burr was cleaned with acetone between each sample, and prior to use all equipment was cleaned using distilled water and acetone to prevent contamination. Twenty-four samples were taken from the mesial lobe of BM421, twenty-two from the middle lobe of BM421, and eleven from BM422. The distances from the ERJ were measured using Workzone digital callipers.

Around 20 mg of enamel powder was collected for each sample. These were taken across the entire width of the cusp except for the mesial lobe of BM421, where it was only possible to sample half of the cusp for the final ten samples due to a deep crack down the centre of the lobe (see Figure 5.6 top right). These samples were transferred to the Stable Light Isotope Facility at the University of Bradford for further preparation and analysis for their $\delta^{13}C$ and $\delta^{18}O$ values, following a protocol modified after Sponheimer (1999) and according to established laboratory procedures (Towers *et al.* 2011). Between

0.5 and 2 mg of enamel was added to 1.8 ml of NaOCl solution (1.7% v/v) and agitated for 30 minutes. The samples were rinsed with water and spun in a centrifuge three times. The water was then removed and 1.8 ml of NaOCl solution (1.7% v/v) was added for 30 minutes. The samples were centrifuged again, rinsed three times with distilled water and freeze-dried. Oxygen and carbon isotope ratios were measured using a Finnigan Gasbench II connected to a Thermo Finnigan MAT 253 continuous flow isotope ratio mass spectrometer. The carbonate fraction of enamel was reacted with anhydrous phosphoric acid at 70 °C releasing CO_2, from which values of $\delta^{18}O_{VSMOW}$ and $\delta^{13}C_{VPDB}$ were directly obtained using a CO_2 reference supply. They were normalised through calibration to the measured and accepted values of the NBS19 international standard and two internal standards: Merck Suprapur $CaCO_3$ and OES (ostrich egg shell). Analytical precision was determined by repeat measurement of an internal enamel laboratory standard to be ± 0.2 ‰ f(1σ) or $\delta^{18}O_{VSMOW}$ and ± 0.1 ‰ (1σ) for $\delta^{13}C_{VPDB}$.

Strontium isotope results

For analysis of the Sr-87/Sr-86 ratios, three additional samples were taken from the middle lobe of BM421 from the ridges between samples BM421-41 and BM421-43, BM421-51 and BM421-53 and BM421-60 and BM421-62 (see Figure 5.6). These samples were sent to the Laboratory for Archaeological Chemistry at the University of Wisconsin-Madison for preparation, and then to the Isotope Geochemistry Laboratory at the University of North Carolina for analysis, using standard methodology detailed by Sjögren, Price and Ahlström (2009).

Water samples were taken from the Blick Mead spring and springline and the River Avon close to the site. They were tested for their δ18O values in the Durham University Earth Sciences Laboratory. They were first filtered through a 0.45 μm filter before 75 nl of each sample was injected into a LGR Liquid Water Isotope Analyser. The samples were then calibrated against three stable isotope water standards supplied by IsoAnalytical. These standards had an isotopic range of ~80 ‰ in d18O. Each sample was injected ten times with the results of the first two injections rejected to avoid contamination with the previous sample. A mean of the remaining eight samples was then calculated. Each sample was repeated three times and the mean calculated. The mean $\delta^{18}O$ value for the spring water was −6.65‰ with a range of −6.72‰ to −6.55‰. The mean $\delta^{18}O$ value for the river water was −6.53‰ with a range of −6.59‰ to −6.49‰.

Unexpectedly, there was a considerable difference between the two cusps or BM421. For $\delta^{13}C$ this amounted to almost 2‰, well outside the standard error. The analyses were therefore repeated. The difference may have been caused by the larger quantities of enamel used in the first run not fully reacting with the NaOCl, and so not showing the true $\delta^{18}O$ and the $\delta^{13}C$ values (Towers 2015, pers. comm.). For the second run therefore the amount of enamel power added to the reaction was on average halved; sample BM421-15 could not be repeated due to insufficient sample remaining. The results of this second run are used below as it is more likely that these samples would have fully dissolved. The discrepancy between the two lobes is however also visible in the second run. A running average was generated to reduce the effects of anomalous results and to produce a smooth curve. All the values are listed in Appendix D2. Figures 5.7 and 5.8 show the values for oxygen and carbon isotopes respectively, with the individual values, above, and the smoothed curves created by the running averages below.

In addition to the incremental analysis of the teeth, five aurochs bone fragments from Trench 19 were sampled for bone collagen carbon and nitrogen isotope analysis. Three calcanei, an astragalus, and a naviculocuboid were sampled. Standard extraction protocols were carried out in accordance with Ambrose and DeNiro (1986); DeNiro (1985) and Longin (1971). While collagen was extracted from all of the bone fragments, only two, BM557 (the calcaneum with cut marks) and BM658 (the naviculocuboid), produced enough for bulk isotope analysis. These two samples were analysed by the University of Bradford's Light Isotope Laboratory. The results of these analyses are displayed in Table 5.6. The C:N ratios of both samples are between 3.22 and 3.41, which falls within DeNiro's (1985) acceptable atomic C:N range indicating low likelihood of diagenesis. The ratios themselves

are in accordance with the expected values for terrestrial herbivores (Bocherens and Drucker 2003) and are in agreement with a diet from closed forest environments.

Oxygen isotope results

The $\delta^{18}O$ values from the two lobes of BM421 (Figure 5.7) are similar in absolute value, but they do not track each other; this was the case in both runs of the samples. However, both lobes produce remarkably homogeneous data sequences. This contrasts with the $\delta^{18}O$ profile from the Irthlingborough aurochs M3, which falls by more than 2‰ towards the ERJ, suggesting a summer maximum and a winter minimum. The middle lobe from BM421 is a sine curve. This shows two summer peaks towards each end of the plot, with a winter minimum in between. In domestic cattle M3 formation spans just over a year, starting around 9.5 months and finishing before 24 months (Sharma *et al.* 2004). The first summer peak occurs approximately a quarter of the way down the tooth, indicating that tooth formation began in spring. If tooth formation in aurochs was similar, this correlates with the birth season of May to June as described by van Vuure (2005) for the last surviving animals of this species.

The $\delta^{18}O$ values from the mesial lobe of BM421 show a rather different pattern. The highest point falls slightly before that on the middle lobe, while the lowest point falls slightly after that on the middle lobe. This may suggest a slight difference in the formation time of the two lobes. The two lobes remain within 1‰ of each other, not a significant difference given analytical uncertainty of +/− 0.4 ‰ (2 sd).

The $\delta^{18}O$ values from the middle lobe of BM422 fall between the two lobes of BM421. They track the middle lobe of BM421 with a slight offset. This suggests that this individual was either born slightly earlier in the year, or started tooth formation at an earlier point in its life (Fricke and O'Neil 1995). BM422 is significantly more worn than BM421, Grant's (1982) Stage g/h compared to Grant Stage a. The remaining portion of the tooth thus represents the summer, autumn and early winter of the animal's second year of life.

The $\delta^{18}O$ values of BM422 track those of the Irthlingborough aurochs (Towers *et al.* 2011), which are around 2‰ higher. The $\delta^{18}O$ values of the Irthlingborough aurochs, however, have a much wider range (2‰), showing a more pronounced seasonal variation than the Blick Mead individuals.

Carbon isotope results

The $\delta^{13}C$ values are shown in Figure 5.8. The mesial lobe from BM421 remains relatively constant, with less than 0.75‰ variation, although this exceeds analytical uncertainty of +/− 0.2‰ (2sd) until about 15 mm from the ERJ when it decreases sharply by over 1‰. Around 9 mm above the ERJ the values flatten out. The middle lobe of BM421 is also relatively flat, staying within 1‰ throughout. However, it is considerably lower until around 8 mm from the ERJ, when the two lobes come together.

The middle lobe of BM422 shows a similar pattern to the mesial lobe of BM421, becoming lower towards the ERJ. It occurs later in the formation of the tooth, the offset mirroring that in the $\delta^{18}O$ values. As such it can be explained by differences in either the time of birth or the developmental rate in the individuals. Near the ERJ the $\delta^{13}C$ values of BM422 briefly fall, a change also visible in BM421 although to a lesser extent. Like BM421, the $\delta^{13}C$ values of BM422 do not fall after the winter trough seen in the $\delta^{18}O$ profile.

The $\delta^{13}C$ values of both Blick Mead teeth differ from those of the Irthlingborough aurochs. Irthlingborough does not change in a way corresponding to the changes observed in the $\delta^{18}O$ values, despite falling towards the ERJ. Initially, as the $\delta^{18}O$ values decrease the $\delta^{13}C$ values remain constant, within 0.2‰; then they increase by 1‰ before finally falling by around 0.5‰ around 15 mm before the ERJ.

Three samples used for strontium isotope analysis were also tested for $\delta^{13}C$ and $\delta^{18}O$. The $\delta^{13}C$ results are shown in Figure 5.8. They differ from the results produced at Bradford but remain within 1‰ of the Bradford results.

Figure 5.6: The aurochs lower M3s sampled incrementally. Top: BM421. Bottom: BM422. Both are shown before and after sampling. Photograph courtesy of Jeff Veitch.

Aurochs Hunters: The Large Animal Bones from Blick Mead

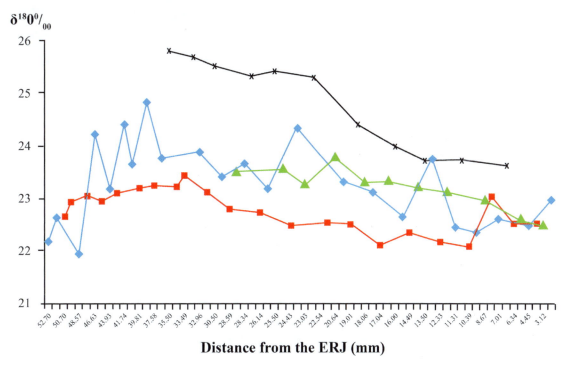

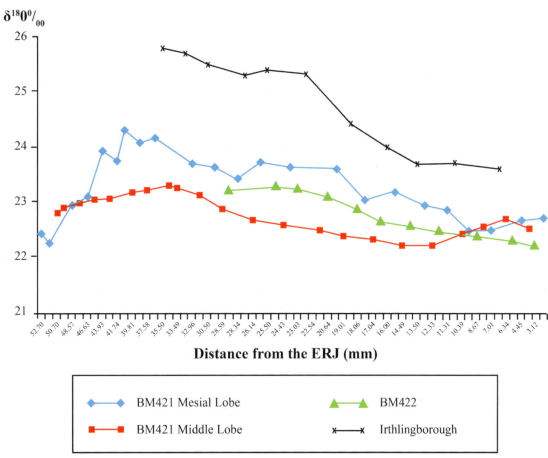

Figure 5.7: Oxygen isotope values from the Blick Mead aurochs teeth (run 2) compared to the results from the Irthlingborough specimen. Top: actual values. Bottom: running average. Values are listed in Appendix D2.

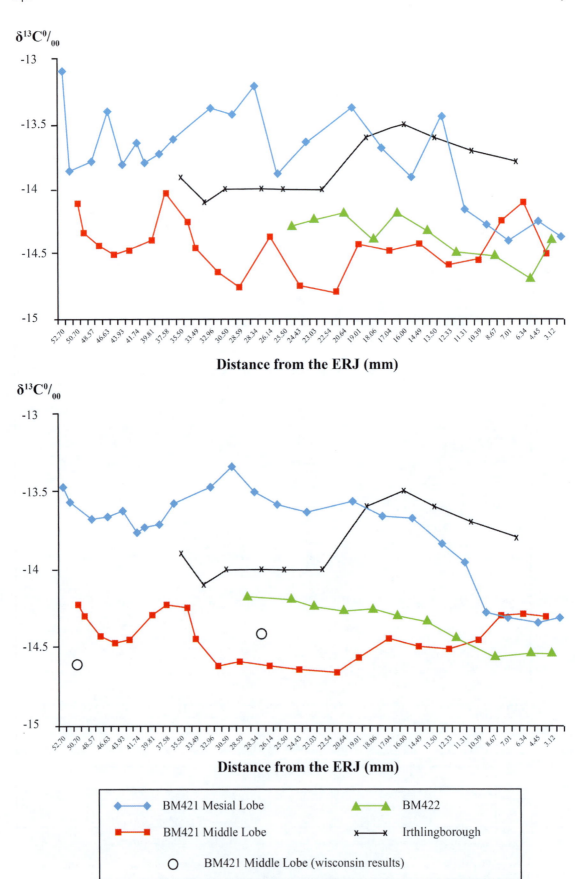

Figure 5.8: Carbon isotope values from the Blick Mead aurochs teeth (run 2) compared to the results from the Irthlingborough specimen. Top: actual values. Bottom: running average. Values are listed in Appendix D2. The Sr-87/Sr-86 results from the three samples are listed in Table 5.5. Variations between them are minimal: less than 0.0001 variation.

Diagenesis

One possible cause of these results is diagenesis. This has however been discounted for several reasons. Firstly, while the quantities of carbonate in the samples are higher than in modern teeth, they are not significantly high (Towers 2015, pers. comm.). In order to check this, the isotope ratios of carbon and oxygen have been plotted against the percentage of CO_3 (Figure 5.9). There is no correlation between either the isotope ratio or the quantity of CO_3 in the sample. This was true for both runs of the samples. A correlation might have suggested that the lower or higher isotope ratios were diagenetic, and not the result of changes in diet or climate.

The difference between the two lobes of BM421 could suggest diagenesis in this tooth, particularly given the crack down the mesial lobe. However, this lobe was not sampled across the crack: only one half of the lobe was sampled (Figure 5.6 top right). Furthermore, the carbon in carbonates is more resistant to diagenetic change than the oxygen (Wang and Cerling 1994). There are some differences between the $\delta^{18}O$ values in the two lobes from BM421. However, this is less than the difference in the $\delta^{13}C$ values between the two lobes.

The low values for the oxygen isotope ratios also suggest that diagenesis should be discounted. The teeth were recovered from a chalk environment. The $\delta^{18}O$ value for chalk is high, so any diagenetic change would increase the $\delta^{18}O$ values (Jenkyns *et al.* 1993). Given that the $\delta^{18}O$ values are already low, the incorporation of diagenetic chalk-derived oxygen is unlikely as this would imply the original biogenic values were even lower and more extreme.

The strontium concentrations in the main group of samples were not measured, so it is not possible to determine if they are physiologically unusually high and indicative of post-mortem addition. The age of the teeth and the crack in the mesial lobe of BM421 could suggest that diagenesis might have occurred, since the strontium isotopes are comparable with those of the chalk burial environment (Evans *et al.* 2010). However, enamel is considered to be considerably more resistant to strontium

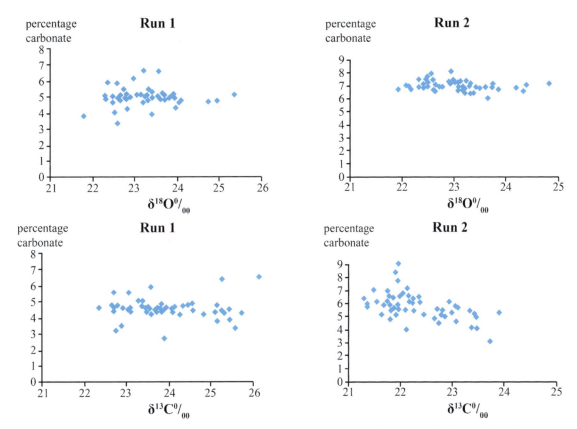

Figure 5.9: Comparison between the Blick Mead carbonate percentages and the oxygen (top) and carbon (bottom) values. Both runs of the samples are plotted.

diagenesis than dentine or bone and is usually a reliable reservoir for biological strontium (Budd *et al.* 2000). The strontium isotope ratios from the teeth are therefore likely to be a true reflection of the values in life.

Discussion

Based on modern precipitation maps, the $\delta^{18}O$ values for both Blick Mead aurochs are very low. They are over 2‰ lower than the Irthlingborough aurochs, which would be expected to have a lower $\delta^{18}O$ value than the Blick Mead aurochs due to Irthlingborough's more north-easterly location (Darling *et al.* 2003) and because global temperatures in the Early Holocene were warmer than during the Bronze Age (Roberts 2014). It is possible that the Irthlingborough aurochs tooth could have been curated and thus significantly predate the Early Bronze Age barrow in which it was found. However, the Irthlingborough aurochs $\delta^{18}O$ values fall within the range of the Bronze Age domestic cattle teeth also recovered from the barrow (Towers *et al.* 2011), suggesting the Irthlingborough aurochs and cattle are contemporary and consistent with the region of burial. However, these expectations are based on modern $\delta^{18}O$ values for precipitation, groundwaters and surface waters, and contours, and these may have changed between the Mesolithic, the Early Bronze Age, and today. If the aurochs were drinking only from the spring at Blick Mead this would explain why the $\delta^{18}O$ results are so homogeneous, as springs fed from underground aquifers rather than directly from seasonal rainfall can average out seasonal change. It would however not explain why they are so low: the spring is thought to have formed in the Early Holocene (John, Chapter 4, this volume), so the lower $\delta^{18}O$ values obtained cannot be explained by the aurochs drinking from a spring tapping an underground aquifer formed largely during the last glacial, and thus having a $\delta^{18}O$ value that reflects much colder temperatures. Today, the River Avon, into which the spring flows, has almost identical $\delta^{18}O$ values to the spring, that is, −6.5‰, suggesting neither is anomalous and both contain water in line with Darling *et al.*'s (2003) oxygen isotope map.

When the enamel carbonate to drinking water conversion equation of Chenery *et al.* (2012) is applied to the $\delta^{18}O$ means, prior to the running average being applied, the resulting rainwater $\delta^{18}O$ values range from −9.2‰ to −13.7‰. Mean annual modern precipitation in Britain ranges from −4.0‰ to −9.0‰ (Darling *et al.* 2003), so although the higher values could be consistent with areas of eastern Scotland and northern England, values below −10.0‰ are clearly inconsistent with Britain today. None of the oxygen isotope ratios fall within the range for south-west England (although it must be remembered that the Chenery *et al.* (2012) equation was derived from archaeological humans rather than cattle, and the two species may not have comparable metabolisms and thus may not fractionate oxygen isotopes during uptake and incorporation in a comparable manner). A possible explanation of the anomalously low $\delta^{18}O$ values is therefore that the aurochs migrated to Blick Mead after developing their M3s in a more northerly region such as Scotland. Scandinavia is even a possibility because the site was first occupied when Britain was still connected to mainland Europe. Aurochs tooth BM422 has been directly dated to too late a date for this to be a possibility. BM421 could however not be directly dated, and could therefore be early enough for a long migration to be theoretically feasible. However, it seems most unlikely.

The results from the Sr-87/Sr-86 values are consistent with the animals being local to the site (Evans *et al.* 2010). It is difficult to reconstruct water sources and rainfall patterns in the Mesolithic. There are areas in the UK which today have similar Sr-87/Sr-86 values and also low oxygen isotope ratios, for example around the Humber estuary. This location, however, would not explain why the $\delta^{18}O$ curves are so flat. The possibility cannot be ruled out that the aurochs could have migrated from somewhere in the now-submerged Doggerland where no Sr-87/Sr-86 or $\delta^{18}O$ biosphere data are available. Alternatively, it could have followed a migration route that never left chalk. Both oxygen and strontium isotopes could theoretically be explained by the aurochs having come from the Alpine region or the Massif Central through France, where there are areas of chalk. However, this migration

also seems highly unlikely, and could only have occurred in the Early Mesolithic when there was a land bridge connecting Britain to the continent.

This discussion of the oxygen and strontium isotopes thus suggests that, while migration cannot be ruled out, it is most unlikely that the aurochs came from far away. We therefore conclude that the aurochs were most probably local. We are unable to account for the low $\delta^{18}O$ values. Perhaps the values in the spring water have changed, or alternatively the values in rainwater may have done so, since the Mesolithic.

The enamel $\delta^{13}C$ values indicate the feeding behavioural ecology of the animals. The decrease in the mesial lobe of BM421 by around 1.3‰, and the lesser decrease in BM422, could be explained by the canopy effect: under tree cover, $\delta^{13}C$ values can be reduced by up to 4‰. This is due to an increase in the recycled CO_2 under tree cover related to the amount of light reaching leaves for photosynthesis (Heaton 1999). This decrease occurs at the same time as the $\delta^{18}O$ values decrease from summer peak to winter trough, which could indicate that the animals moved into a more wooded area for the winter. It could also be explained by a dietary change, away from leaves and towards branches and bark. The animals might also have eaten acorns or other autumn fruits. Such behaviours were observed in sixteenth-century Polish aurochs (van Vuure 2005). The decrease is small, possibly insignificant in BM422, which could indicate that the woodland into which they moved was not very dense, so the increase in the amount of recycled CO_2 was only small. There could be other causes of this variation. The age of a plant can affect its $\delta^{13}C$ values, and this would vary throughout the year, with most young plants appearing in the spring and summer (Heaton 1999). However, Donovan and Ehleringer (1992) found that the $\delta^{13}C$ of a plant increased with age; while at Blick Mead the values decreased in autumn when the plants would be older.

The middle lobe of BM421 however does not track the mesial lobe, indicating instead a relatively constant diet throughout the year. It is not currently possible to determine which lobe gives a true reflection of the diet of the animal. As a result it is not possible to draw a definitive conclusion for the $\delta^{13}C$ for BM421.

The $\delta^{13}C$ values for the Blick Mead animals are similar to those of the Irthlingborough aurochs (Towers *et al.* 2011). This is likely to be due to their having similarly mixed diets, obtained from a relatively dense woodland settling (Wright and Viner-Daniels 2015) despite their different locations.

The repeatable difference between the two lobes of BM421 for the $\delta^{13}C$ values are around 1‰. This is only just outside the margin of error of the samples, 0.4‰ to 2σ, and so is not significant. However, the two sample groups – measured on the same instrument, from the same samples – show a wide range of values from the same tooth. This highlights the potential for over-interpretation of results which vary by less than 1‰. We have argued that the difference is unlikely to be caused by diagenesis. The discrepancy between the results from the same lobe tested at Bradford and in Wisconsin/North Carolina is smaller: between 0.5‰ and 1‰. This further highlights the problems: the samples sent to Wisconsin were not the same as those tested in Bradford, but they were taken from the ridges between the Bradford samples and so should not be very different from them.

It is not possible to determine which $\delta^{13}C$ values give the best reflection of the aurochs' diets. The results are not different enough to suggest that there is an inherent difference between the lobes. Experiments on modern cattle teeth, with no preservational or diagenetic effects, could determine if there is an inherent difference between the lobes of the same tooth.

Conclusions

Our analyses of the Blick Mead animal bones make a valuable contribution to our understanding of Mesolithic diets and to the behavioural ecology of the now-extinct aurochs. The high percentage of aurochs is unique in Britain and the near continent. The poor preservation and fragmentary nature

of the remains may have caused a bias towards larger animals, but the proportion of aurochs is still significantly higher than at any other site. Blick Mead appears to fit within a landscape of specialisation, with different resources utilised at different sites. We have tentatively argued that skeletal part frequency does not resemble that expected at a hunting camp. This could support the suggestion that Blick Mead was a homebase. This agrees with the conclusions from the study of lithic assemblage (Bishop, Chapter 4, this volume).

It is likely that the aurochs were non-migratory, and did not move large distances away from Blick Mead. This is based on the strontium isotope results, despite the low $\delta^{18}O$ values, and is supported by the $\delta^{13}C$ values. It is possible that the inhabitants of Blick Mead chose this location for their homebase because of its natural resources, perhaps including an unusual abundance of aurochs. The $\delta^{18}O$ results suggest that the aurochs were indeed born in spring, like their historically recorded counterparts. The $\delta^{13}C$ results suggest that aurochs may have moved into denser woodland during the winter. Further work needs to be done to determine if there is an inherent difference between the different lobes of the same tooth, but taken together the isotopes do not suggest long-distance migration.

Table 5.1: The animal bones from Blick Mead. The totals are Number of Identified Fragments (NISP)

Species	Total	Trench 19	Trench 22	Trench 23	Trench 24
Aurochs, *Bos primigenius*	155	139	13	1	2
Aurochs? cf. *Bos primigenius*	4	4	0	0	0
Red Deer, *Cervus elaphus*	46	42	2	2	0
Red Deer? cf. *Cervus elaphus*	4	4	0	0	0
Elk, *Alces alces*	5	5	0	0	0
Elk? cf. *Alces alces*	1	1	0	0	0
Red Deer or Elk, *Cervus* or *Alces*	2	2	0	0	0
Roe Deer, *Capreolus capreolus*	8	7	0	1	0
Wild Boar, *Sus scrofa ferus*	23	23	0	0	0
Sheep/Goat, *Ovis* or *Capra*	9	3	5	0	1
Domestic Cow, *Bos primigenius taurus*	5	1	0	0	4
Domestic Pig, *Sus scrofa domesticus*	5	4	0	0	1
Bird, *Aves*	1	0	0	1	0
Dog, *Canis familiaris*	1	1	0	0	0
Rabbit, *Oryctolagus cuniculus*	2	0	0	0	2
Total identified	271	236	21	5	9
Unidentified	2159	2065	44	11	39
Total	2430	2301	65	16	48

Table 5.2: Skeletal distribution of the aurochs and red deer bones

	Aurochs (N = 155)					Red Deer (N = 45)				
Element	L	Unsided	R	MNI	MNE	L	Unsided	R	MNI	MNE
Horn core/Antler		2		1	1		1		1	1
Pre-maxilla	1			1	1					
Upper molar	1			1	1	1			1	1
Lower M3	1		1	2*1	2	1			1	1
Lower incisor	1			1	1					

Element	Aurochs (N = 155)					Red Deer (N = 45)				
	L	Unsided	R	MNI	MNE	L	Unsided	R	MNI	MNE
Tooth fragment		33					5	1	1	1
Atlas (C1)		1		1	1		1		1	1
Axis (C2)		1		1	1					
Acapula			2	2	2	2			1	1
Proximal humerus		1		1	1					
Distal humerus	2		1	2	3	2		1	1	2
Proximal radius	2		3	3	4	1		1	1	2
Distal radius	1		2*²	1	1	1			1	1
Ulna		1		1	1					
Cuneiform			2	2	2		1		1	1
Magnum			1	1	1	2			2	2
Scaphoid		1		1	1			1	1	1
Lunate	1			1	1					
Unciform	1			1	1	1			1	1
Metacarpal	4	3	4	2	4	1	2		1	1
Pelvis	1	1	1	1	2					
Proximal femur	1		3	3	4	2			1	1
Distal tibia			1*²			2		2	2	3
Astragalus	3		1	3	4	1		1	1	2
Calcaneum			3	3	3	2			2	2
Naviculocuboid	2		2	2	2	2			2	2
Metatarsal	5*³	2	1	3	3	2	3		1	1
Metapodial fragment		6		2	5					
1st phalanx		8		2	8					
2nd phalanx		14		4	14		1		1	1
3rd phalanx		4		1	4					
Sesamoid		1		1	1					
Limb bone fragment		2		1						
One fragment		19		1						

*¹ These teeth have been identified as coming from separate individuals based on their wear stages.
*² Includes one mid-shaft fragment.
*³ Includes one fragment which was identified as possibly left.

Table 5.3: Measurements from bones at Blick Mead, following the definitions of von den Driesch (1976), except humerus HT, from Legge and Rowley-Conwy (1988)

Fragment Number	Trench	Context	Element	Fusion	Side	Measurement
AUROCHS						
421	19	59C	M3 (lower)		R	L = 45.3
422	19	59C	M3 (lower)		L	L = 45.8
727	19	77.4	Humerus	F	R	SD = 43.5
2233	19	65	Astragalus		L	GLl = 83.19, Bd = 59.92
1120	19	77.4	Astragalus		R	BD = 68.9, GLl = ((80.6))

(Countinued)

Table 5.3: (Continued)

Fragment Number	Trench	Context	Element	Fusion	Side	Measurement
559	19	Unstrat	Metatarsal		L	BP = 51.2
1121	19	77.4	1st phalanx	F		SD = 27.6, BD = 32.8
560	19	Unstrat	2nd phalanx	F		GLl = 50.5, BD = 36.8
670	19	92	2nd phalanx	F		GL = 45.4, BP = 34.0, BD = 23.6, SD = 26.4
1118	19	77.4	2nd phalanx	F		GL = 40.5, BP = 33.8, BD = 38.4, SD = 28.8
1119	19	77.4	2nd phalanx	F		GL = (34.9), SD = 29.5
2181	19	Unstrat	2nd phalanx	?		SD = 25.4, BD = 27.6
2351	19	67	2nd phalanx	F		GLl = 49.3, Sd = 26.9, Bd= (26.7), Bp = 34.6
2361	19	67	2nd phalanx	F		GLl = 46.5, Bp = 32.6, Bd = 27.8, Sd = 25.1
RED DEER						
1125	19	77.4	Scapula	F	L	GL = 55.5, SLC = 36.7
1	19	61	Humerus	F	L	HT = 42.6
1122	19	77.4	Tibia	F	L	DD = 30.7
532	19	Unstrat	Astragalus		L	GLl = 54.7, BD = 33.0
WILD BOAR						
1890	19	77.4	Lower M1		R	L = 17.3, WA = 9.9, WP = 11.0
6	19	61	Humerus	F	L	HT = 38.0
657	19	92	Humerus	?	R	SD = 19.8
99	19	77.2	Astragalus		R	GLl = 41.0
665	19	92	Astragalus		R	GLl = (49.6)
ROE DEER						
101	19	77.2	Tibia	F	R	BD = 26.9
100	19	77.2	Astragalus		L	GLl = 28.9, BD = 17.7, Dl = 15.9
RABBIT						
634	22	Unstrat	Tibia	F, F	L	GL = 92.9, BP = 13.3, BD = 12.4
DOMESTIC DOG						
726	19	77.5	Upper P4		L	GL = 19.9, GB = 11.9, B = (8.3)

Table 5.4: Skeletal distribution of the elk, roe deer and wild boar from Blick Mead

	Roe Deer (N = 8)				
Element	L	Unsided	R	MNI	MNE
Lower P4	2			2	2
Upper M1 or M2			1	1	1
Distal femur	1			1	1
Distal tibia			1	1	1
Astragalus	1			1	1
Metatarsal	1			1	1
2nd phalanx		1		1	1
	Elk (N = 5)				
Upper M1 or M2			2	1	2
Lower M1 or M2		1	1	1	2
Distal tibia			1	1	1
Metacarpal		1		1	1

Element	L	Unsided	R	MNI	MNE
	Wild Boar (N = 23)				
Lower canine	1		1	1	2
Lower M1			1	1	1
M3 fragment		1		1	1
Lower M3	1	1		1	2
Lower P4 lower		1		1	1
Molar fragment		1		1	1
Distal humerus	1		1	1	2
Ilium	1			1	1
Distal tibia	2			1	1
Astragalus	1		3	3	4
Calcaneum	2	1	1	2	3
2nd phalanx		1		1	1
Bone fragment		1			

Table 5.5: Results of Sr-87/Sr-86 analysis of the Blick Mead teeth

Sample Number	Distance from the ERJ (mm)	Sr-87/Sr-86
BMSr-1	48.78	0.708598
BMSr-2	26.14	0.708656
BMSr-3	6.34	0.708671

Table 5.6: The bulk collagen results from aurochs bone samples from Blick Mead

Sample	$\delta^{13}C$	Average	$\delta^{15}N$	Average	C:N
BM557a	−23.70	−23.62	3.62	3.62	3.41
BM557b	−23.78		3.62		3.29
BM658a	−23.71	−23.74	3.82	3.81	3.27
BM658b	−23.54		3.81		3.22

Analysing fragmentary skeletal material from Blick Mead
– Sophy Charlton

Within prehistoric skeletal assemblages, it is often common for significant amounts of bone to be heavily fragmented and/or morphologically indistinct, therefore rendering them osteologically 'unidentifiable'. This was indeed the case for the Blick Mead assemblage, with 2,160 fragments of unidentified bone recovered. The identification of the species a bone belongs to is important however, as it can allow for primary data to be obtained and relative species frequencies to be assessed, which in turn can help inform on a range of themes such as prehistoric economies, hunting strategies, foodways and diet. Species identification also importantly provides insights into the relationships between humans and fauna within the archaeological past.

The frequency with which we recover very small, heavily fragmented and/or disarticulated skeletal material within prehistoric (and later) archaeological contexts has prompted the emergence

of biomolecular techniques to aid identification when traditional zooarchaeological analyses are insufficient. The most notable of these has perhaps been a technique known as Zooarchaeology by Mass Spectrometry (ZooMS). ZooMS is a novel mode of archaeological proteomic analysis, and is a method of collagen peptide mass fingerprinting, which allows for species or genus level identification of collagenous materials. It has therefore predominately been used as a qualitative analytical technique for taxonomic identification of archaeological materials (e.g. Buckley *et al.* 2009, 2010; Stewart *et al.* 2013), and has previously been successfully applied to material of a prehistoric date (Welker *et al.* 2015; Charlton *et al.* 2016). ZooMS was utilised on the skeletal assemblage recovered from Blick Mead to try to determine the species identification of bone fragments classified as 'unidentifiable' following zooarchaeological analysis.

Materials and methods

Twenty bone fragments classified as 'unidentifiable' following zooarchaeological analysis (just under 10% of the total number of unidentified fragments) were chosen for ZooMS analysis. The fragments were all small in size and morphologically indistinct. Unfortunately, many of the fragments were also visibly poorly preserved. All material analysed derived from Trench 19, but came from a range of different contexts within the trench. This was done in order to assess if differential collagen preservation was evident between different archaeological contexts.

A novel ZooMS methodology was used on the twenty bone fragments, following Charlton *et al.* (2016), and aimed, if possible, to combine both ZooMS and isotopic analysis, in order to obtain greatest amount of biomolecular information from these samples as possible.

A modified Longin collagen extraction protocol using ultrafiltration on c. 400 mg of bone was undertaken (Brown *et al.* 1988; Charlton *et al.* 2016), followed by ZooMS analysis. Briefly, samples were initially cleaned manually using a scalpel, and then were demineralised in 0.6 M aq. HCl solution at 4 °C, and the resulting insoluble fraction gelatinised in pH3 HCl for 48 h at 80 °C. The supernatant solution was then ultrafiltered (30 kDa MWCO, Amicon) to isolate the high molecular weight fraction, which was then lyophilised. Lyophilised collagen samples were then removed from falcon tubes and transferred into eppendorfs. 75 μl 50 mM AmBic (ammonium bicarbonate buffer, pH8.0) was added to each 'empty' tube used during lyophilisation, vortexed and then centrifuged. 1 μl trypsin (Promega) was then added to each sample, and digested for 16 h at 37 °C. Following this, samples were centrifuged at 13 k RPM for 1 minute and then 1 μl 5% TFA was added to stop enzymatic digestion. Peptides were then extracted using C_{18} ZipTips (Agilent), which were eluted using 50 μl 50% ACN in 0.5% TFA.

MALDI-TOF-MS analysis, using 1 μl eluted peptides and 1 μl α-cyano-4-hydroxycinnamic acid matrix solution (Buckley *et al.* 2009; Welker *et al.* 2015) spotted onto a ground steel plate, was undertaken in triplicate for each sample on a Bruker Ultraflex III MALDI-TOF/TOF at the University of York. Spectral analysis was performed using the open-source cross-platform software mMass (Strohalm *et al.* 2010). Replicates were averaged for each sample and manually analysed for peptide markers following Welker *et al.* (2015), and taxonomic identification achieved by comparison to the ZooMS peptide marker series database published in Welker *et al.* (2017).

Results and discussion

Seventeen of the twenty samples analysed yielded identification information via ZooMS, to either species or genus level (Table 5.7). Three samples were unfortunately unsuccessful, due to a lack of species-specific peptides present, caused by poor collagen preservation. It is interesting to note that two of the three failed samples derive from the same context (#76), and that only one other bone

Table 5.7: ZooMS identifications of samples run in this study

Sample Number	Context	Trench Number	ZooMS ID
1001	76	19	Unidentifiable
1002	62	19	Terrestrial herbivore
1003	62	19	Terrestrial herbivore
1004	66	19	Unidentifiable
1005	66	19	Elk/Red deer
1006	37	19	Terrestrial herbivore
1007	76	19	*Bos* (Aurochs)
1008	76	19	Unidentifiable
1009	62	19	*Bos* (Aurochs)
1010	62	19	*Bos* (Aurochs)
1011	75	19	*Bos* (Aurochs)
1012	75	19	*Bos* (Aurochs)
1013	67	19	Wild boar/Pig
1014	66	19	*Bos* (Aurochs)
1015	61	19	Terrestrial herbivore
1016	63	19	*Bos* (Aurochs)
1017	63	19	*Bos* (Aurochs)
1018	67	19	*Bos* (Aurochs)
1019	67	19	Terrestrial herbivore
1020	67	19	*Bos* (Aurochs)

analysed from this context resulted in an identifiable spectrum. In addition to the failed samples, five samples contained insufficient collagen markers to provide precise identification. Instead, they were identified as containing peptides indicative of terrestrial herbivores, but species identification was not possible (Table 5.7).

Of the successful samples, the most widely identified species was the aurochs (*Bos primigenius*) (10–12 samples identified to species; Table 5.7). ZooMS analysis cannot distinguish between the wild and domestic forms of a species, but given the Mesolithic date of the material and the zooarchaeological information available, the identification of a wide number of fragments to *Bos* indicates that these samples are aurochs (*Bos primigenius*), rather than domesticated cow (*Bos taurus*). The identification of the majority of fragments studied here as *Bos* is in line with initial zooarchaeological analysis undertaken on the skeletal material, which revealed 61% of the assemblage was aurochs (Legge 2014) – making it the most well-represented species at the site. More recent zooarchaeological analysis also supports this interpretation of aurochs as the dominant faunal species at Blick Mead (Rogers *et al.*, this volume; Peter Rowley-Conwy pers. comm.). The high proportion of aurochs remains at a Mesolithic site is unusual, and raises interesting questions regarding the hunting strategies and resource exploitation of Mesolithic peoples utilising the site and the surrounding landscape.

Additionally, one further sample was identified using ZooMS as elk/red deer, and one as wild boar/pig (*Sus scrofa*) (Table 5.7). Again, the identification of both of these species is unsurprising, as from zooarchaeological assessment, 17% of the Blick Mead assemblage was identified to be red deer (*Cervus elaphus*), and 9% as wild boar/pig (*Sus scrofa*) (Rogers *et al.* 2015; Table 5.7).

Unfortunately, all samples produced poor collagen yields of less than 2% (from retentate only; following ultrafiltration), meaning that insufficient collagen was extracted to allow for isotopic

analysis of δ^{13}C and δ^{15}N. In a number of samples, the collagen yields were less than 0.5%. Collagen C:N ratios are believed to remain stable within bone with collagen yields up to 1% (Dobberstein *et al.* 2009). As such, isotopic analysis of δ^{13}C and δ^{15}N was unfortunately not undertaken on the bone fragments analysed here. This poor collagen preservation is likely to be due to the depositional context in which the skeletal remains were found, and analysis is further hindered by the small size of the bone fragments analysed here.

The material analysed here was recovered from a chalkland area and fieldwork has shown that the Mesolithic material lies within deposits indicative of slow-moving water, which is also believed to be alkaline (Jacques and Phillips 2014). The Mesolithic deposits within Trench 19, where the bone samples analysed here derive from, were also noted during excavation to be within an area of the site with a high water table currently (Jacques and Phillips *ibid.*). Additionally, water appears periodically, thus water levels at the site are not constant throughout the year (David Jacques, pers. comm.). This kind of water movement is extremely detrimental to bone collagen preservation, and the taphonomic actions of water can significantly decrease the amounts of collagen preserved. Indeed, site hydrology, particularly where water movement fluctuates, has been noted to be one of the most significant factors affecting bone diagenesis and collagen preservation (Nielsen-Marsh and Hedges 2000). O'Connor (2000, 23) notes that collagen preservation is likely to be poorest in 'moist, slightly alkaline burial environments, and bones from chalk or limestone soils' – sadly the exact conditions present at Blick Mead. Indeed, although radiocarbon dates have been obtained from some skeletal remains from the site, other faunal remains provided insufficient collagen yields for AMS dates (David Jacques, pers. comm.).

Conclusion

This work has shown the initial application of the ZooMS methodology to bone fragments previously considered 'unidentifiable' from Blick Mead. The findings from this analysis align well with initial zooarchaeological analyses of the skeletal assemblage (Legge 2014; Rogers *et al.*, this volume). However, the poor collagen preservation within fragmentary samples from the site has limited the degree of findings via ZooMS somewhat, and meant that undertaking stable isotope analysis of δ^{13}C and δ^{15}N on 'unidentified' fragments was not possible. Nonetheless, determination of the level of collagen survival within bone from the assemblage, particularly that which is fragmentary or small in size, is a useful addition to our growing body of knowledge on the site. For example, it highlights the need to perhaps choose larger pieces of more visibly well-preserved bone for any future biomolecular work using collagen, in order to ensure adequate volumes of collagen for analysis. Furthermore, there is variability in both the water table levels and the depositional matrixes across the site – therefore meaning that collagen preservation may be better in other areas of the site.

Importantly, the ZooMS results obtained from Blick Mead support the zooarchaeological analysis undertaken, and crucially, also highlight that the predominance of aurochs appears to be a distinct feature of the faunal assemblage at Blick Mead, rather than the result of taphonomic bias due to the large size of aurochs bone. This therefore highlights the potential of ZooMS as a means of cross-referencing or underpinning zooarchaeological interpretations from fragmentary prehistoric skeletal assemblages.

Overall, therefore, the application of ZooMS to other 'unidentifiable' bone fragments from British Mesolithic assemblages could allow us to obtain useful information on Mesolithic ecologies and the types of faunal species which Mesolithic populations were targeting and utilising. This is particularly pertinent given that the British Mesolithic is a period which has long suffered from a lack of skeletal material – and as such, this has often hampered our understanding of diet, ecology and environments. The method applied here can therefore be seen to be a useful additional tool in future analyses of Mesolithic skeletal assemblages, alongside traditional zooarchaeological assessments.

CHAPTER 6

Smaller Vertebrates from the Mesolithic Site of Blick Mead

– Simon A. Parfitt

> I am a person who enjoys a new challenge; at the time of starting on the Blick Mead dig I was a serving forty-eight-year-old police officer, with a desire to broaden my horizons and try something new. I had no experience of archaeology, no qualifications and no knowledge of history pre-medieval times. My wife was invited to take part in the dig and bullied me into going with her as I did not fancy spending my rare weekends off in the cold and rain.
>
> I fell in love with it straightaway, being lucky enough to find Mesolithic tools on my first dig, not that I recognised them, I just knew they were something. I quickly realised I had a lot to offer the dig as police investigations have many skills that are transferable: patience, being methodical, awareness of cross-contamination of finds, recording of finds both in situ and for later analysis and storage, and finally a knack for spotting something unusual.
>
> Over the years, with help from our team of experts, I have added knowledge of finds and excavation techniques to the list, and have recently been given responsibility for recording the finds with my wife. Now I have some twelve years of experience, I am asked to take on more challenging parts of the excavations which makes me feel really valued and proud of what I have achieved. I am thrilled to have been part of a project that has helped improve our knowledge of a period of which little is known and work with a great team of people.
>
> — MICK SMITH, volunteer, Soham, Cambridgeshire

An assessment of Mesolithic small vertebrates and potential for environmental reconstruction at Blick Mead was carried out in 2013 (Parfitt in Jacques and Phillips 2014). This demonstrated that small mammal, fish and amphibian remains were present in the main Mesolithic horizon (context [59]) in Trench 19 and in an overlying later prehistoric context [74]. Trench 19 lies within a wet area of likely spring fed pools near the right (north side) bank of the river and on the northern end of a meander loop. Blick Mead is about 150 m from the present main channel of the River Avon and close to the boundary between the alluvial floodplain and the valley-side. This boundary is marked by a conspicuous break of slope immediately to the west, rising about 1.8 m above it (Chapter 3).

Twelve radiocarbon dates on large mammal bones associated with the Mesolithic industry span the first half of the Holocene Thermal Optimum, a period of nearly 3,000 years that encompasses the both the Boreal and Atlantic periods. Slope wash and trampling were probably responsible for mixing the sediments and incorporating earlier material, as evidenced by a radiocarbon date (SUERC 42525, 8542 ± 27 BP, 7593–7569 Cal. BC (68%)) that falls within the Pre-boreal period. Because of the positive results from the assessment samples, it was anticipated that a fuller analysis would provide additional information on the local environment and the animal resources which existed when the area was visited by Mesolithic hunter-gatherers.

Methods of processing and analysis of samples taken in 2014

In 2014, a series of large samples was collected from the Mesolithic horizon (context [59]) in Trench 19. The focus of the sieving programme was a particularly rich concentration of artefacts and burnt flint ('context' [92]) in the southern sector of the trench. In all, sixteen sub-samples were processed by wet sieving. The resulting residue was air dried at room temperature, and then graded into several size fractions to aid sorting. Each size fraction was then thoroughly picked for small vertebrate remains using a binocular microscope to ensure total recovery of the smallest identifiable remains from the finest (1–2 mm) fraction.

Identifications to skeletal element and taxon were aided by comparisons with modern reference material at the Natural History Museum (NHM), London. Measurements (to the nearest 0.01 mm) were taken complete teeth using a 'Dinolite' USB microscope. Identification of taphonomic modifications was based on criteria of Andrews (1990) and Fernández-Jalvo and Andrews (2016) and comparisons with the taphonomic comparative collections in the Department of Earth Sciences at the NHM. Digestion categories recorded in vole molars followed the system outlined by Fernández-Jalvo *et al.* (2016).

Results

The samples yielded a diverse small vertebrate fauna that includes fish, amphibians and lizards, as well as small mammals (Appendix B1, Table B1).

Several are new records for the site, including pike (*Esox lucius*), a lizard (*Lacerta* sp.), mole (*Talpa europaea*), common shrew (*Sorex araneus*), water vole (*Arvicola terrestris*), grass vole (*Microtus* sp.), wood mouse (*Apodemus sylvaticus*) and marten (*Martes* sp.); the tentative identification of yellow-necked mouse (*Apodemus flavicollis*) is confirmed by the more abundant material from the 2014 samples. Appendix B1, Table B1 shows the distribution of the identified smaller vertebrates found in each sub-sample, summarising the number of identified specimens for each taxon; full details of the assemblage and the few measurements it was possible to take are given in Table 6.1.

The fragmentary condition of much of the material has led to uncertainty about some of the identifications. This applied especially to murids, represented in southern Britain by three indigenous species: harvest mouse (*Micromys minutus*), yellow-necked mouse (*Apodemus flavicollis*) and wood mouse (*Apodemus sylvaticus*). Whereas teeth of the tiny harvest mouse are distinctive and can be separated from those of *Apodemus* on the basis of size alone, the morphology of *A. flavicollis* and *A. sylvaticus* molars is very similar and the size distinction between the two species is by no means clear cut, especially in juveniles of *A. flavicollis*. This is illustrated by measurements of the upper incisor published by Fielding (1966), who demonstrated that although there is a good separation, significant overlap in size range of each species makes certain identification impossible for any but the largest and smallest adult specimens. In Figure 6.1 data from Fielding (*ibid.*) are plotted as histograms and compared with measurements of *Apodemus* from Blick Mead and a sample of recent harvest mouse upper incisors. The Blick Mead upper incisors include three specimens (including one not fully grown juvenile) that fall well within the yellow-necked mouse range; the remaining two specimens are within the overlap zone. Similarly, measurements of the molars (Table 6.1) identify large individuals consistent with yellow-necked mouse, as well as smaller molars that can be attributed to wood mouse. Ecologically this distinction is significant as the yellow-necked mouse prefers mature deciduous woodland, whereas scrub and more open habitats provide optimal conditions for the wood mouse.

Taphonomy

In order to interpret the assemblage, both the composition of the fauna in terms of species, and the taphonomy of the remains need to be taken into account. The latter includes assessing the overall condition of the bones, as well as relative abundance of the skeletal elements and surface alterations (Andrews 1990; Fernández-Jalvo *et al.* 2016) to provide insights into how the bones came to be deposited at the site. Elucidating these processes is an essential prerequisite to interpreting the environmental context and links with the Mesolithic occupation.

Given that many of the small mammals in the assemblage are burrowers, careful consideration was given to the possibility that post-Mesolithic material had worked its way down through the sediment profile. This is considered not to be a significant issue as the sediments are waterlogged, and this would have impeded burrowing by small mammals and earthworms (Armour-Chelu and Andrews 1994). Significantly, no later archaeological material (e.g. prehistoric pottery) was recovered in the samples. This observation further supports the view that the deposit was effectively sealed from later intrusions. One possible exception is the complete first upper molar of water vole (specimen 16.5). Although digested, the tooth is better preserved than the other teeth from the Mesolithic horizon and may represent a later intrusive element.

The most prominent feature of the small vertebrate assemblage found in the Mesolithic horizon is its exceedingly poor state of preservation. This is apparent in the heavily skewed skeletal element profile, which is dominated almost entirely by teeth (Table 6.1). Even these more durable elements are generally fragmented and visibly corrode, often consisting of little more than shattered pieces of enamel indicating that dentine and cementum had been leached away. The main process responsible for the poor preservation of teeth and the destruction of the chemically and physically less robust bones is hostile burial conditions, in particular alkaline leaching (cf. Fernández-Jalvo *et al.* 2002) and acid etching from contact with plant roots (cf. Lyman 1994).

Reconstructing the pre-burial taphonomic history of the bones is difficult because of the intensity of post-depositional leaching, which has obliterated and obscured earlier stages of modification. This is quite typical of bones from highly calcareous sediments in chalk-land settings and tufas. Leaching is usually a result of percolating inorganic and humic acids – degradation of the organic content of the bone is more likely to occur in dry situations. Some traces survive, however, including characteristic digestion on small mammal teeth (Table 6.1). Evidence of digestion shows that some of the teeth found their way to the site in pellets of birds of prey or in scats of a small mammalian predator. Taking account extremes in the degree of digestion (from light to moderate/heavy), it is probable that more than one predator species was responsible for depositing microfaunal remains at the site. Although predators contributed to the bone accumulation, the extent of this contribution, and the identity of the species concerned is as yet unknown.

The most striking aspect of the small vertebrate assemblage is presence of calcined and charred bones (Table 6.1). Burning is not evenly distributed across the main taxonomic groups, with relatively few burnt small mammal teeth (6%) and amphibian bones (17%) but a substantially higher proportion of the fish bones (80%) exhibiting signs of intense heating. In some cases, the bones are grey-white in colour and exhibit warping, splitting and mosaic cracking. These are features associated with heating to a high temperature and for a prolonged period (Shipman *et al.* 1984). Whether the charring and calcining is related to directly to cooking of is difficult to determine. It may be significant, however, that all of the salmonid vertebrae are calcined. These probably represent waste from meals that were discarded in, or near the fire. Whether the small mammals and amphibians were also cooked and eaten is less easy to determine (Medina *et al.* 2012, Romaniuk *et al.* 2016). These may simply represent the 'background' scattering of bones from natural deaths and predator scats and pellets that were burnt incidentally because they were lying close to the camp fire.

Table 6.1: Summary of taphonomic alterations of small vertebrates from the Mesolithic horizon (Trench 19, context [59])

Taxon	No. teeth/ bones	Calcined/ Charred	Digestion	Root marks	Soil corrosion
Fish (teeth)	3	-	1	1	-
Fish (bones)	32	28/0	-	-	-
Anuran	0/6	1/0	-	2	1
Lacerta sp.	0/1	-	-	-	-
Talpa europaea	0/2	-	-	1	-
Sorex sp.	1/0	-	-	-	-
Clethrionomys glareolus	71/0	-	9 (light); 1 (medium-heavy)	30	1
Arvicola terrestris	-	-	2 (light)	6	-
Microtus sp.	8/0	-	-	1	-
Microtine rodent	19/1	-	-	6	-
Apodemus spp.	11/0	?1/?1	2 (light)	5	-
Rodent	62/2	2/3	-	4	1
Small mammal	1/4	2/0	-	2	-
Martes sp.	1/0	-	-	1	-

Environmental interpretation

The fauna is overwhelmingly dominated by woodland species, in particular bank vole (*Clethrionomys glareous*), yellow-necked mouse (*Apodemus flavicollis*) and marten (*Martes* sp.). Of these, bank vole is a very useful indicator of local conditions, for its ecology is entirely dependent on the well-developed scrub layer of bramble or bracken and dense undergrowth, particularly in old deciduous forests. Mature deciduous forest is the optimal habitat for the yellow-necked mouse, an extremely agile climber that can be found in the highest canopy of forest trees. Open woodland with good ground cover would accommodate the common shrew, mole and wood mouse. The presence of *Microtus* (probably field vole *Microtus agrestis*), albeit at low frequencies, suggests areas of rough grassland nearby. The water vole is usually thought of a species closely associated with lakes and slow-flowing rivers and streams with well-vegetated banks. During the Early Holocene, however, small mammal assemblages from British archaeological sites shows that water voles also occupied dry grasslands until at least the Roman period (Montgomery 1975; Yalden 1999). The pre-Roman water voles are characterised by being relatively small, with incisors that suggest an adaptation to burrowing (Montgomery 1975). In this respect, they resemble continental populations that inhabit dry grasslands at the present day. The apparent shift in the ecological preferences of water voles in Britain from the Roman periods onwards may be the result of increased competition from other grassland rodents or introduced lagomorphs (e.g. brown hare or rabbit). Stronger evidence for aquatic habitats is provided by the presence of pike and salmonids, the latter occurring in low numbers in most of the sub-samples. The marshy fringes of the River Avon and shallow water would have provided suitable habitats for amphibians, represented by seven bones in six (32%) of the sub-samples from the Mesolithic horizon.

The most interesting mammal recovered by sieving is undoubtedly marten, represented by an incomplete premolar. The tooth cannot be identified to species, but biogeographically, pine marten (*Martes martes*) is the only real possibility (Yalden 1999). In Britain, this once widespread and common carnivore was all but wiped out by human persecution and only a small population survived

Smaller Vertebrates from the Mesolithic Site of Blick Mead

in mountainous and remote parts of north-western Scotland, Cumbria and north Wales. It has now, once again, become a familiar sight in other parts of Britain thanks to successful reintroduction programmes. Hunting of pine marten for their pelts is known from Danish Mesolithic sites (Richter 2005), where systematic butchery provides clear evidence for skinning; the single tooth fragment from Blick Mead is insufficient to determine whether pine martens also were hunted for their pelts at this site. Pine marten is record from other Mesolithic sites in Britain, including Star Carr, Thatcham I (Yalden

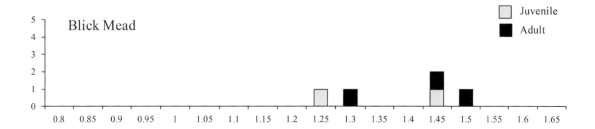

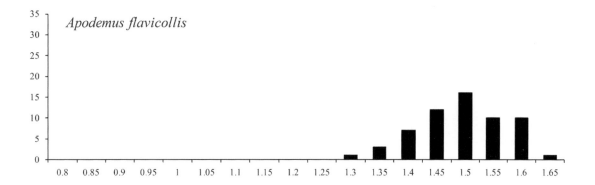

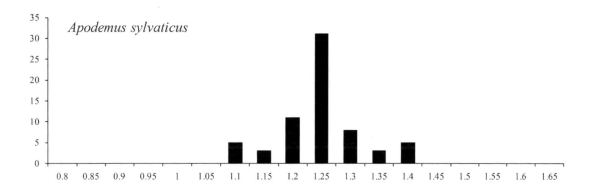

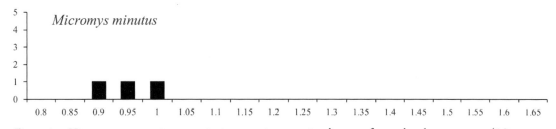

Figure 6.1: Histograms comparing upper incisor anterior-posterior diameter for modern harvest mouse (*Micromys minutus*), wood mouse (*Apodemus sylvaticus*), yellow-necked mouse (*Apodemus flavicollis*) with the Mesolithic sample from Blick Mead (data from Fielding (1966) and Parfitt [unpublished]).

1999) and Three-Ways Wharf (Lewis and Rackham 2011). Again, the interpretation of these often isolated finds is uncertain (Overton 2016) as the finds may simply represent natural deaths unconnected with human activity at the sites. The record of marten from Blick Mead adds further detail to the environmental context of the site. In a lowland context, it is a typical inhabitant of deciduous or mixed forest. It is an excellent climber, negotiating slender branches and leaping from tree to tree in pursuit of squirrels and birds resting in trees.

CHAPTER 7

Discussion

– *David Jacques*

> As Mayor of Amesbury in 2011–2012 I was humbled to be a 'hands on' witness to the discovery of Blick Mead and saw that it could become the catalyst needed for Amesbury to rebrand itself. A museum is planned for the town now and we hope it will be an alternative point of attention to Stonehenge. I am indebted, we all are, to Blick Mead for the way it has brought our community together and regenerated our town. We are not in the shadow of Stonehenge anymore!
> — ANDY RHIND-TUTT, Mayor of Amesbury, 2011–2012

Blick Mead and the terrace site provoke a number of fundamental questions: i) why was this locale a 'persistent place' for nearly 4,000 years during the Mesolithic period?; ii) what was its relationship with other Mesolithic sites in the vicinity?; iii) is there any evidence for it being a Mesolithic–Neolithic transitional place?; and iv) is there any evidence for the establishment of the Neolithic ritual landscape of Stonehenge being in part a response to Earlier Mesolithic activity?

Ascertaining what was advantageous for people and animals in terms of the environment at Blick Mead is a useful way to approach the first question. Richard Bradley, for example, has argued that natural places which were long-term foci for particular activities had qualities that distinguished them from other locations (Bradley 2000, 97–115). The observations that follow are informed by the specialist reports included in this volume and incorporate Mike Clarke's astute insights about the area gained during his thirty-nine-year period of working at Vespasian's Camp.

The QUEST survey at Blick Mead (Young *et al.*, Chapter 3, this volume) is an important first step towards obtaining a better understanding of the environmental setting at the site. The results from the eleven boreholes from Blick Mead suggest a remarkably stable environment across the near 3,000-year period of the radiocarbon dates from the wet area. The investigation also reveals that the thin waterlain deposit containing the Mesolithic assemblage in Trenches 19, 22 and 23 (H3a) rested on a gravel bench about 1 m above the general level of the alluvial floodplain, indicating that Blick Mead was on an elevated position above a very much wider main channel of the River Avon during the Mesolithic (Parker Pearson 2012, 156–157). The site's elevation suggests it was rarely subject to flooding and the condition of the faunal and lithics assemblage, dating across a near 3,000-year period and all contained with the 20 cm H3a unit, suggests it was subject to minimal post-depositional movement.

Bishop (Chapter 4, this volume) observes that the distribution of the lithics suggests it 'mostly entered the water during the formation of the middle part of the layer (H3a)' and therefore 'must have been deposited in open water'. Both the preservation of the faunal record and the condition of the lithics indicates that they were put into a slow energy waterlogged environment and hardly moved. Detailed examination of this sediment in column and bulk samples will hopefully provide new insights into the processes involved in creating this archaeological accumulation, but clearly a possible reason for the lack of disturbance and soil formation in this layer over such a long period of time would be the presence of permanent standing water.

A spring is first recorded close to Blick Mead, just south of the eighteenth-century causeway/avenue that creates the site's southern border, on an 1877 Ordance Survey map. It is active today, along with others along the spring line and spring fed pool to the south-west of the site. Travertine or tufa particles are often seen as a reliable indicator of springs and their presence is recorded in the lower

alluvium in QUEST's bore-hole findings at Site 2 and two others (BG17, BH19) closer to Blick Mead. Tufa and travertine particles are not normally formed where spring arise and become deposited some distance downstream (David John, pers. comm.), so it is possible that they might have derived from Blick Mead or other springs nearby. The bore-hole findings also provide evidence for depressions in the underlying sand and gravel and if springs were present at Blick Mead in the Mesolithic these are likely to have been water filled. Tony Brown has questioned whether the upwellings of water at Blick Mead and along the springline originate from classic chalk springs however. He suggests that they derive instead from water being released from underlying gravels at the margins of a palaeochannel where sealing clays/silts are relatively thin (Chapter 2, this volume). Possible sources of water are groundwater flowing off the adjacent valley-side slope, as observed further downstream along the spring-line, and the substantial dry valley confluent with the Avon valley just upstream from Blick Mead.

The leaching evident on the faunal assemblage from Trenches 19, 22 and 23 is typical of bones from highly calcareous sediments in waterlogged chalk-land settings (see Chapters 6 and 7). The process also indicates long term wetness in these areas of the site, as does the presence of particular insects from samples taken from Mesolithic contexts in Trench 19 (Young *et al.*, Chapter 3, this volume). The results of a ground-penetrating radar magnetometer survey of the south-west corner of the Countess Farm area, nearby Blick Mead, by the Stonehenge Hidden Landscapes Project, suggest that such 'wet' areas were not just restricted to Blick Mead either (Appendix A2, this volume).

A pond at Blick Mead has been marked on Ordnance Survey maps from the late nineteenth century onwards and has also been detected by a geophysical survey of the site (Appendix A3). A pond feature was also revealed in Trench 14 (Appendix A1). This is likely to be the 'pond' needed for watering dairy cattle mentioned in two letters by Countess Farm tenant farmer Christopher Ingram in the late eighteenth century (see Chapter 1, this volume). Taken together, the various specialist chapters, along with indicators of Later Middle Bronze Age and Anglo-Saxon ritual uses of the site in the appendices (see Appendix C1 and Appendix C3), situate the Blick Mead area within a wet environment. The various data sets provide substance for ongoing research and discussion.

The specialist reports also indicate that the locale may have contained a variety of ecological niches that provided key resources including accessible water, wood, a variety of food and flint nodules. The present springline has a constant temperature range which varies between 10 and 16 ºC all year. If such conditions were present in this area during the Early Holocene this would have provided more accessible and better-quality water than would be available from the River Avon (John, Chapter 4, this volume). Such resources are scarce in the high chalklands of Salisbury Plain. Furthermore, the banks of the River Avon, which measured c. 60 m wide in the Early Mesolithic close to the study area, would have been less defined and stable than their modern equivalent (Parker Pearson 2012 156–157).

Blick Mead may thus have provided easier access to water for animals and people than the river. The area is also shielded by the hill of Vespasian's Camp and protected from the prevailing south-westerly wind by the steep eastern scarp of the Camp. The sheltered position and constant temperature water results in an extended growing season, with vegetation emerging earlier and persisting for longer here. Evidence is starting to emerge of possible plant exploitation at the site (Maltas, Chapter 3, this volume), and the vegetation may have also attracted fauna, which in turn may have influenced the movement of people and contributed towards giving the place certain associations.

Indications of animal trampling have been found at the Late Mesolithic Countess Farm site, which shares the same terrace as Blick Mead (Leivers and Moore 2008 14–19). The potential impact of large wild herbivores, in terms of their movement, resource value and symbolic associations, is under-researched in the Stonehenge landscape. Phenomenological approaches tend to privilege the topographical sight-line experiences of people, but usually lack attention to the 'experience' of wild animals and how they might influence human behaviour. In addition, salmonoids, pike and possibly pine marten and toad were hunted (Parfitt, Chapter 6, this volume). Wild fowl, eels, beavers and varieties of fish were also likely to be abundant (Tony Brown, pers. comm.).

Blick Mead and its surrounds are likely to have been abundantly wooded in the Mesolithic (Parfitt *ibid.*; French *et al.* 2012, 13–14 and 30) and therefore rich in fuel and building material for shelters

and log boats. The site is well placed to be connected to locales up and down the Avon. The journey down river to the large Mid- to Late Mesolithic site at Downton (Higgs 1959) by canoe, for example, may have taken about four hours (Mike Clarke, pers. comm.). Ames has argued that boats could have enabled hunter-gatherer groups to make longer distance forays in shorter time periods and therefore be in a better position to create far flung networks of families and alliances (Ames 2002, 44). The topographical and resource advantages at Blick Mead area may have enabled such networks to persist, which in turn could have been a factor in underpinning the sense of place Blick Mead had over the *longue duree*, as evidenced by its radiocarbon date range, which spans nearly four millennia. The good transportation links and variety of food resources across different seasons also gives a context to the evidence for large gatherings at the site.

Fieldwork has also revealed an accessible supply of flint nodules for making tools was available at the site (Bishop, Chapter 4, this volume). Such resources are less widespread in the Stonehenge landscape than has been understood until recently. An 'in press' report on the geology of the area, commissioned by Highways England to assess the proposed Stonehenge Tunnel route, has revealed that much of the area between King Barrow Ridge and the Stonehenge Visitors Centre is likely to be devoid of flint due to the chalk there being of a unique phosphatic type for England (Mortimore *et al.*, in press, 31). The report states that 'the Neolithic flint mines at Durrington Walls lie within Seaford and Newhaven chalk formations ... just east of the Stonehenge faults and phosphatic chalks, which may have limited the lateral extent of flint bearing chalk and possibly its depth too' (Mortimore *et al. ibid.*). Blick Mead is within the flint rich Seaford and Newhaven chalk formation area and it is apparent that in this landscape the 'near absence of flint bands from the phosphatic chalks' (Mortimore *et al. ibid.*) to the west may have in part dictated where people lived.

The discovery of nine tranchet axes/adzes in the wet areas of Blick Mead and one pre-form from the base of tree throw [105] in Trench 24 on the terrace could support the idea that the raw material for such prestige tools was found and fashioned here, or that the objects were being imported (Bishop, Chapter 4, this volume). One axe from Trench 19 exhibits use wear, but the pre-form appears to have been placed in the tree throw area 'fresh' which hints at ritual (Donohue and Bradley, Chapter 4, this volume). Moreover, the red algae *Hildenbrandia rivularis*, present in the water in the spring-fed pool at the end of the present spring line which starts close to Blick Mead, turns red oxidised flint into a bright magenta pink within two days of it being removed from the water. This change is permanent and a rather magical and special effect, even to twenty-first-century eyes. *Hildenbrandia* is an algae which only grows in certain conditions. If this transformative phenomenon was present in the Mesolithic, it is likely to have been noticed and may perhaps contributed in some way to the site's potentially 'special' associations (John, Chapter 4, this volume). This phenomenon has not been previously recorded at an archaeological site in the British Isles.

The above observations provide a basis for the identification of Blick Mead as a homebase site, a problematic term that has a connotation of a single and relatively 'fixed' location. The environmental and social advantages noted above appear to have led to the area being utilised for thousands of years, so it is likely that there were a series of similar 'places' at different times in this locale. The assemblage in the wet areas may have originally been homebase debris, middened from the terrace. The homogeneous waterlain deposit (H3a) containing the finds may be the result of such material being dispersed by slow moving water. This assemblage could also have been influenced by cultural factors. The numerous intact microliths found in the assemblage are not in a condition to merit being discarded and are also too light to have been carried an equal distance if thrown with the much heavier pieces of knapping debitage, as per Binford's 'throwing zone' model (Binford 1978, 330–361; and see Mellars 2009, 507). One of these microliths is the possible slate point. With slate exotic to the area (Webb, Chapter 4, this volume), and the artefact seemingly fashioned in the style of a 'Horsham' point and undamaged, this find may capture a moment when people from different places met at the site and exchanged ideas and technologies. Slate artefacts are not unknown; Jacobi noted four other instances being found at Mesolithic sites which are within a 100 km radius of Blick Mead (Jacobi 1981, figs 7 and 18) and Froom suggests that the one found at Wawcott III

may have come from 'North Devon or North Cornwall' (Froom 1971, 3). However, if the Blick Mead slate artefact represents a deliberate attempt to make a microlith it would be unique in Britain (see Bishop, Chapter 4, this volume).

Bishop (*ibid.*) also reports that the microlith types at Blick Mead are 'extremely diverse' and suggestive of axis of influence stretching to the Midlands, East Anglia, the Weald and the far West. The sandstone, chert and sarsen artefacts found at the site also indicate materials moving considerable distances. Again, artefacts made from such materials have been found in Mesolithic contexts at sites in the broader region at Farnham, Broomhill and Cherhill (Rankine 1956; Palmer 1970, Evans 1981) which are all close to springs.

The event of a large tree on the terrace falling into the artefact rich low-lying wet area at Blick Mead in the late 5th millennium BC may have provided an additional focus for activity. The tree that created feature [111] would have left a visually striking c. 2.5 m high root 'wall', along with a prominent white chalk mound and hollow. The worked sarsen artefact was found on the mound (Bishop, Chapter 4, this volume), and the remains of two aurochs teeth, the smallest microliths found across the site, tool making debitage, refits, burnt flint and the remains of burnt edible plants were discovered within its hollow [110]/[210]. Nearby, the upper fill of tree throw hollow [105]/[104] contained a large amount of uniformly burnt pieces of flint, burnt on an intensive scale rarely seen at Mesolithic sites. These may have been brought into the main tree throw dwelling area later to provide 'convector heating' within the shelter, which would have had safety advantages. The radiocarbon dates from contexts [107], [109] and [212] (west and east) in the main throw area are broadly contemporary and suggest, along with the particular artefacts found within it, that the various features between the mass root wall and posthole [109] were part of a dwelling of some kind. One interesting point about the heavily fired burnt flint here is that it represents a smaller-scale of use than is indicated by the large quantities of unworked burnt flint burnt and animal bones in the spring, which hint at mass gatherings and feasting on an exceptional scale. The residues of occupation within this tree throw may represent a much smaller group visiting the site, or one place to stay among many.

At the time people were working and living here, at the twilight of the Mesolithic period in the very late 5th millennium BC, the Blick Mead area must have had long and particular associations for generations of hunter-gatherers. In another context, Caitlin Moran captures through metaphor a sense of what visits there might have meant to an individual and perhaps the collective – 'A casting on stitch done in the same place, over and over again, gets stronger ... I don't travel to broaden the mind. I return – something completely different' (Moran 2012, 247).

Feasting

The worked flint, intensely fired burnt flint and the remains of aurochs, wild boar and red and roe deer indicate that hunting, butchery, cooking and large-scale food consumption took place close to Blick Mead during the Mesolithic. The cooking of salmon/trout, pike and possibly toad, plants and rodents also points to intensive use of food resources in the area, and hints at lengthy stays here. In terms of the larger animals, particularly aurochs, it is difficult to escape the conclusion that the quantities of meat produced by them, as well as the efforts needed to kill and render them, created an opportunity for structured social rituals, such as large-scale feasting.

Conneller's ideas about potential symbolism in the composite nature of Mesolithic weapon design might usefully be extended to feasting occasions (Conneller 2008, 160–176). She argues that composite material culture can actively project biographies of individuals involved in their creation. In this way, people who found flint nodules or pebbles in a particular place, others who created cores from it in another place, the blade maker, the microlith and barb shaper, the shaft maker, the people

who attached the tools to the shaft, the people who threw the weapons into the animal, and those who butchered it, processed it, displayed it and cooked it, and those who ate it, could all be connected and have aspects of their identities evoked. Artefacts, then, can be argued to highlight active connections between things, rather than separateness, especially in a culture that may have been animistic. Many pre-literate societies materialise narratives as *aides mémoires* (Ong 1982, 31–72) and, at Blick Mead, all of the stages of tool making are present, alongside evidence for very large-scale fires, hunting and eating. Rather than simple dumping of material into the wet areas, such artefact collections may have served as a 'record' of event(s) that memorialised the active connections and 'entanglements' between people, animals and things (Hodder 2012).

Spielmann (2002, 195–207) argues, in another context, that large feasting events are crucial for small, dispersed communities in terms of the structured 'exchange' events they offer. They can be drivers for economic efforts to provide food, rather than the other way round. Blick Mead, with its potential communication links via the river, hunting grounds and evidence for long term cohesive groups, may have been ideally suited as a feasting place where traditions and acts of memory were played out.

Aurochs

The percentage of aurochs from the identified remains (57%) is the highest found nationally and from the near continent for a Mesolithic site (Rogers *et al.* and Charlton, Chapter 5, this volume). Physically, these animals were the most powerful in the landscape, and may also have been so in symbolical terms (see below). Rather than moving through densely wooded areas, aurochs herds more likely preferred routes with long sight lines in order to observe predators (Peter Rowley-Conwy, pers comm.). They ate prodigiously, thus open places frequented by them would have had generally lower levels of vegetation. Their eyes, like modern cattle, were positioned to the side to spot predators from the flanks. Some of the remains from Blick Mead show them to be more than twice the size of modern cattle at the shoulder. They were probably ferocious fighters, fast and agile, and so tracking and killing them would have been extremely dangerous, relying on teamwork and a sensitive knowledge of terrain.

The isotopic results from two of the Blick Mead aurochs (BM421 and BM422) point to them being local animals (Rogers *et al. ibid.*) and their availability could have been another factor in site location and advantage. However, Aurochs BM421 and BM422 have oxygen values which are 2% below what would be expected from the southern British climate in the Mesolithic. Periodic and severe climatic downturns in northern Europe, including northern Britain, are known, with the 8.2 k (Wicks and Mithen 2014) and 7.7 k events standing out. Could severe cold events change the local composition of the rain water and explain the apparent anomaly in the Blick Mead aurochs oxygen values? The radiocarbon date returned for BM 422 is 5845–5678 cal BC (95% probability SUERC 60917; 6881±33 bp).

Various 'rules of engagement' (Brittain and Overton 2015) with aurochs can be tentatively divined from the site location and data. Rogers *et al.* (*ibid.*) note that almost the whole aurochs skeleton is present in the faunal remains, so they could have been killed at Blick Mead, or forced into the nearby river and killed from canoes (Peter Rowley-Conwy, pers. comm.). Their movements might have also been tracked by people and dogs onto nearby Salisbury Plain. Recent isotopic analysis of a domesticated dog's tooth found in the Mesolithic horizon (H3a) in Trench 19 revealed that it travelled to the site far from the local area and was eating the same meat as people were eating, particularly aurochs, and also red deer, wild pig and fish (Rogers *et al.* 2016). This dog has been interpreted as being a prestigious hunting dog travelling a long way with people to a prestige hunting site (Rogers *et al. ibid.*).

The area around Stonehenge in the Early Mesolithic would have been 'open woodland … and open country', and have been 'certainly … visible from higher ground' (Allen 1995, 55 and 473) from

vantage points like Coneybury Hill and King Barrow Ridge, where a small concentration of Mesolithic worked flint has been found (Darvill 2006, 66). Elsewhere, the environs are described as 'cleared' in this period (Allen 2002, 149). Was the vegetation low here partly because of the regular presence of aurochs? One of the questions thrown up by Mortimore *et al.*'s recent geological analysis of the Stonehenge area is what the influence of the phosphatic chalks, which are 'extremely rich in radium' (Mortimore *et al.* in press, 26), that is, have radioactive minerals, had and have on animals/vegetation/landscape and the groundwater in the area. Current investigations include analysing the solubility of the phosphatic chalk and its minerals to see if these could have contributed to change in the soil chemistry and hence vegetation (Mortimore, pers. comm).

King Barrow Ridge slopes down to Stonehenge Bottom (Figure 1.2, this volume) which, in pre-Greater Cursus times may have been a water course draining close to Lake and then the River Avon (Bowden *et al.* 2015, 2 and 25). A fording point exists here where a natural funnel created by a palaeo-channel forms a side valley and directs one's line of sight hundreds of metres westwards, to the area where the Mesolithic posts were situated (as identified in the old Stonehenge car park; Vatcher and Vatcher 1973, 57–63). This funnel, running straight from the fording point, could have potentially corralled aurochs and other large herbivores moving towards this open vista and, if they were coming the other way, in the direction of the ford, via the two side valley funnels to the west of the Stonehenge knoll. Long funnel shapes prevent cattle from seeing potential predators from the flanks and can create anxiety for them. For this reason, straight high-sided funnels used to be a standard part of traditional abattoir design to increase cattle bunching and movement towards the area where they would be killed (Gonjor 1993, 16–17). Rather than the Mesolithic posts establishing lines of sight to Beacon Hill on the eastern horizon for phenomenological purposes (Parker-Pearson 2012, 137), perhaps they were set up to mark the broadly east–west/west–east movement of aurochs, and probably other large herbivores, through a relatively open landscape. Perhaps they, and the newly discovered Boscombe Down post monument (see below), functioned in part as 'time' markers to predict when the animals would be at certain places. These markers on the Stonehenge knoll would have been visible from higher ground on the northern, eastern and western ridges encircling the Stonehenge landscape, but not the southern part. Viewed in this way, this part of the landscape would have been a place of advantage for hunting groups with long sight lines across the Plain, predictable side valley routes where large herds of aurochs and other animals could be observed entering or departing the area, and places to hide. The putative water course at Stonehenge Bottom – at certain points in the year draining into the Avon – potentially provided a route back to the homebase to take the remains of large animals away.

Blick Mead and the first monuments in the Mesolithic

The three earliest radiocarbon dates from Blick Mead are contemporary with the 8th and 7th millennia BC Mesolithic post-built monuments on the Stonehenge knoll. A further post-hole at Boscombe Down, similar in monumental dimensions and topographical position to those on the knoll, but previously assumed to be of Early Bronze Age date, has been recently dated by Wessex Archaeology to the Early Mesolithic (8430–8250 cal BC, Alistair Barclay, pers. comm). Such posts are unrivalled in north-western Europe as Mesolithic monuments (Parker Pearson 2015, 4). They illustrate that this landscape was well known and regarded as special in some way even in the Early Mesolithic. Arguably, Blick Mead and these monuments should be seen as fixed points in the cultural landscape of the 8th to 7th millennia BC. It is likely that a locale used by the communities who made, placed and used them has been found at the site (Parker Pearson *ibid.*). This part of Salisbury Plain may have become redolent with myths and traditions associating them with special, perhaps sacred, hunting grounds over a long period by hunter-gatherer groups.

After the Mesolithic

In addition to linking the earliest monumental structures found at Stonehenge with Blick Mead, the latest Mesolithic radiocarbon dates from the site show that activity was happening there at the dawn of the Early Neolithic. This encourages questions surrounding Mesolithic–Neolithic transitions to be brought into focus in this landscape for the first time.

The earliest evidence for Neolithic activity in the area to date derives from a domestic cattle-sized long bone fragment found underneath Stone hole 27 at Stonehenge and dated to 4340–3980 cal BC (Serjeantson in Cleal *et al.* 1995, 441; and Allen *ibid.*, 477). This was residual and has been described as 'indicative of pre henge activity that is otherwise invisible' (Darvill 2006, 66). However, the new late 5th millennium BC radiocarbon date sequence from Blick Mead is contemporaneous with it and raises the intriguing possibility that local and long term knowledge about the knoll being a 'special place' could have been passed on to Early Neolithic groups.

The evidence from the main tree throw hollow in Trench 24 [111] (Figure 2.14, this volume) illustrates that people at Blick Mead were still only using Mesolithic technology at this very late stage in the English Mesolithic. Lithic design and technology therefore seem to have stayed remarkably stable over the near four millennia of visits to the site. Keeping to similar technological designs over a period that saw dramatic climate change, including Britain becoming an island for the first time, suggests that making tools was not just a utilitarian pursuit. Working flint at Blick Mead may have also been an important way of retelling and resetting cultural frameworks.

The microlith form is absent from the first 'Neolithic' place in the landscape, the Coneybury Anomaly, about 1.5 km to the west of Blick Mead, which has been recently re-dated to 3760–3700 cal BC (Barclay 2014, 11–13). If microlith manufacture reflected and reproduced long term hunter-gatherer memes this suggests a fairly rapid and profound change in beliefs. However, Mesolithic-looking blade technology is present in the Anomaly assemblage. What did this blade technology 'mean'? What did the shift from microlith technology 'mean'? What did 'being' Mesolithic and Neolithic entail? It is important to note that the transitions that we observe as archaeologists (in this case Mesolithic–Neolithic) were not necessarily apparent to those who lived through them and that changes may have been long, drawn-out and complex, but the late 5th millennium BC dates from Trench 24, especially when seen in relation to the dates for the assemblage in the Coneybury Anomaly, suggest that the Blick Mead area may have been inhabited, or visited, by communities on the cusp of these changes.

The Coneybury Anomaly, a pit which appears to have been the repository of residues from ceremonial feasting, contains a uniquely high percentage of wild animals for a Neolithic site in Britain (just over or under 50% of the MNI dependent on whether the two pigs identified were wild or domestic; Maltby 1986). Its lithic assemblage includes Early Neolithic tool types, such as two leaf-shaped arrowheads, but is dominated by blade and bladelet types typical of both the Early Neolithic and Mesolithic (24% of the assemblage, Harding in Richards 1991, 225). The assemblage has been described as 'exactly what might be expected if there was an element of continuity from the Mesolithic' (Searjantson 2011, 261) and arguably fits the model proposed by Cummings and Harris that posits that the Early Neolithic 'package' had to take its place within an 'existing scheme of animals, people and things' in certain areas and places (Cummings and Harris 2011, 365).

The Anomaly is situated on Coneybury Hill and would have been intervisible with the western flank of Vespasian's Camp to the east, the River Avon to the south, King Barrow Ridge to the north and the Stonehenge knoll to the west. The material in the pit may have been chosen to evoke Mesolithic life ways, for example, the wild fauna, some of it directly associated with river valleys, such as beaver and trout, and the blade tool types; while others project Early Neolithic ones, for example, in the choices of cereal grain, domesticated fauna, pottery and tools, such as the leaf-shaped arrowheads and the fragment of a polished stone axe. The assemblage could be interpreted as signifying hunting and feasting tropes that had had long ancestry at nearby Blick Mead, along with those of

the Early Neolithic (Reynolds 2012, 13–14). The prominent location for this event on the high ridge is suggestive of a high-profile display, with the amount of meat produced for the feast potentially feeding hundreds (Parker Pearson 2012, 25). Taken together, the assemblage from the Coneybury Anomaly and the activities associated with it, could be argued to mark a transition between the Late Mesolithic and Early Neolithic in ways suggestive of a moment of large scale celebration of cultural appropriation or assimilation.

Christie's discovery of a pit containing pine charcoal at the western end of the Greater Cursus (Christie *et al.* 1963, 370–382) is also suggestive of an understanding of Mesolithic activity being deliberately referenced in a Neolithic monument. The Greater Cursus is a monumental east–west raised inter-valley route which runs down-slope across Stonehenge Bottom to reach the western terminus: both direction and topography parallel the suggested route taken by aurochs suggested above. Thomas *et al.* (2009, 44) and Saunders (2015) also consider whether the orientation of the Cursus might have reflected Earlier Mesolithic routes between the River Avon and Till interfluves. The Stonehenge Riverside Project has revealed signs of a Mesolithic hunting camp west of Stonehenge itself and at West Amesbury Henge, situated close to a spring, and a place where erection of bluestones has been tentatively dated to the early 3rd millennium cal BC (Allen 2016), a Mesolithic/Early Neolithic lithics assemblage has also been found by that team (Allen *ibid.*, 1000).

At Blick Mead, the colluvium overlying the Mesolithic features in Trench 24 contained significant numbers of struck flint in fresh condition suggestive of Neolithic activity in the vicinity. Charcoal recovered from the top of the fill of the tree throw shelter [210] at the interface with the colluvium returned an Early Neolithic date showing nearby activity contemporary with the construction of the Greater and Lesser Cursus monuments, as well as some long barrows in the landscape. The scoop feature which contained seventy struck pieces of flint, including Later Neolithic blades [206], intersected the edge of the tree throw mound. The find of an oblique ripple-flaked arrowhead of Later Neolithic date from the same area draws comparison with others found at Durrington Walls, Woodhenge and the Stonehenge Avenue ditches at West Amesbury Henge and Marden Henge, and is a striking and rare find. The few found in Wiltshire are found at Late Neolithic ritual sites and are almost identical in size, shape and angle of their point (Figure 7.1). With their long asymmetric tails and distinctive rippled patterning, it is not inconceivable that an expert individual or a small school of people made these objects (Bishop in Hilts 2017). The arrowhead's presence at Blick Mead is therefore highly significant as it suggests that the site was valued in some way as part of the wider Stonehenge ritual and ceremonial landscape around 2500 BC. If the lower cobble surface revealed in Trenches 19 and 23 was first laid by hand in the Later Neolithic (Chapter 4, this volume) then plentiful evidence of previous Mesolithic occupations would have been encountered. Blick Mead may have already been long understood as a place of origin in the landscape by this time (Parker Pearson 2015, 43).

Animism and totemism

Of associated interest is the mixture of wild animal bone with domesticates, some of which were curated, in the foundation deposits for the ditch at Stonehenge (Serjeantson 1995, 442–445), the digging of which has been dated to Stage One of Stonehenge, around 3,000 cal BC (Bayliss, 511–535). Was an older symbolism attached to these different human-animal lifeway choices? As at the Coneybury Anomaly, dug around 700 years earlier, wild and domestic seem to be being chosen as active cultural signifiers.

In trying to make sense of the choices and deposition of the faunal remains in the Stonehenge ditch it is helpful to refer to the concepts of animism and totemism. The latter has been defined as the 'the recognition of personhood in a range of human and other than human contexts' (Harvey

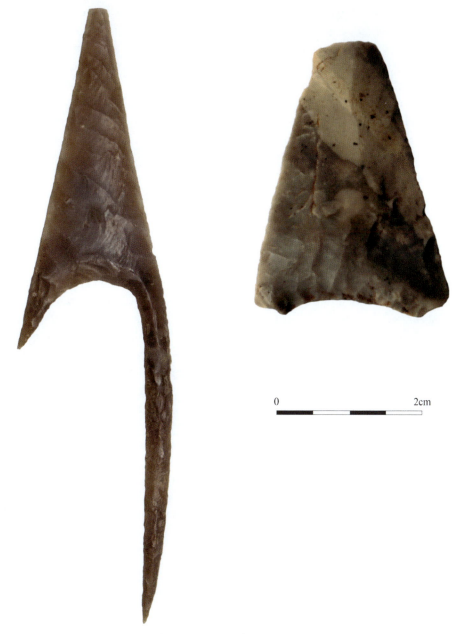

Figure 7.1: Ripple-flaked arrowhead from Blick Mead (right, photograph courtesy of Vicky Ridgeway) and a comparable but complete example from Marden Henge (left, photograph courtesy of Jim Leary).

2005, 18) and regarded as a hunter-gatherer belief system. Totemism has been argued to symbolise spiritual connections and between people and things in ways that essentially separates them as entities (Reynolds 2012). Archaeologists have been understandably cautious about spirituality at Stonehenge, but we know from comparative religion about animism and totemism and they do provide frameworks to reconsider the human-animal-object relationships seen at Stonehenge phase one.

The nationally high proportion of wild animals in the Coneybury Anomaly suggests that there was something different about the cultural make up of this landscape in the Early Neolithic and it has been argued here that the evidence for Mesolithic people utilising the area for nearly four millennia, through to a potential contact point with Neolithic pioneers, may be part of an explanation for that. The unusually large proportion and choice of wild animals in the faunal assemblage of the Stonehenge ditch also suggests that the areas associations with hunting and early pastoral farming persisted 700 years later.

The parts of the Stonehenge ditch excavated so far contain more wild animal remains than any other Henge ditch in Britain, as well as a uniquely high proportion of antlers from hunted deer (57%) (Serjeantson 1995, 442–445). Much as we should try not to impose modern notions about separations of domestic and wild, it is difficult not to accept that some version of this distinction was being expressed in the ditch, as it seems to have been in the Anomaly assemblage.

The animal bones in the ditch must have been greatly valued and it is interesting to speculate whether they may have been regarded as ancestors, equivalent with the human remains found in the Aubrey Holes, which were either contemporary with the digging of the ditch (Parker Pearson *et al.* 2009, Table 2; Parker-Pearson 2012, 185) or slightly later (Pryor 2016, 198). If so, this would be seen as an animistic religious response. A totemic response to these bones would be to see them as spirits in their own right, things that groups could interact with as separate entities. Fuglestvedt has suggested such a belief system became more popular in the Late Mesolithic and Early Neolithic in Norway as it reflected new ideas about separateness, boundaries and territories (Fuglestvedt 2011, 35).

Wild animals remains are often mixed with domesticates in the ditch in significant places, for example, in the north-eastern entrance ditch terminals domestic cow and aurochs remains were placed in Segment 1 and domestic cow and red deer in Segment 100 (Serjantson 1995, *ibid.*). In other segments particular animal body parts are foregrounded; for example, the southern entrance ditch terminals each contain a curated domesticated cattle jaw, dating between 3350–2920 Cal BC and 3360–2920 Cal BC respectively. A totemic analysis of this symbolism might see it as signifying that people would be entering the southern entrance through a powerful, composite, ancestral cattle's 'mouth' and, perhaps, by extension they would be at the threshold of entering a 'body' that could 'transform' them. Equally, the cattle skulls and horns, aurochs teeth and fused cervical vertebrae (so from an old animal), plus deer antlers, in the segment terminals either side of the north-eastern entrance could have been seen as signifying a 'guarded' threshold to pass through via horns, antlers, teeth and raised hackles. If so, this reading would also be a totemic one in that the particular qualities of these animals or animal parts would have metaphorical values. An animistic approach might understand these bones as providing contagion (contact). On this reading, an aurochs bone buried at the bottom of the ditch gives the ditch (and the whole construction) the literal qualities of an aurochs. These may be either physical (for example, strength) or some value associated with the aurochs. With the ditch and the Aubrey Holes being round the symbol may have been that all the various animals and their qualities were connected in some way. This would also be an animist appreciation.

Applying animist and totemist understandings to the motivation for moving the bluestones in the late 4th millennium–early 3rd millennium BC also provides new insights. Presumably they were considered to embody some important ancestral qualities rather than just being stones. Moving them may have been seen as animating them. Seen this way the construction of the various Stonehenge phases would not be seen in a classical sense as temple/home to god(s); the work may have been seen as a manifestation of God(s). Construction, knowing where things were and moving things, would therefore have been motivated by spiritual experiences, including ancestor worship, an animist and totemic fundamental. The design of the ditch circle, along with the Aubrey Hole circle, may have brought together ideas about different cultural notions of 'the land', its ancestry and the way it was 'lived' in by animals as well as people. The Stonehenge knoll and its broader landscape had been well known and utilised for millennia before the advent of the Neolithic and the fact that Blick Mead was still in use as a Mesolithic place in the very late 5th millenium BC arguably allows us to begin to approach evidence for processes of change in material culture, belief systems and subsistence strategies in the area for the first time.

Conclusion

Until now, Earlier Mesolithic find spots in the Stonehenge landscape have been described in isolation, but they can now be brought together as a result of the discoveries at Blick Mead to reveal potential

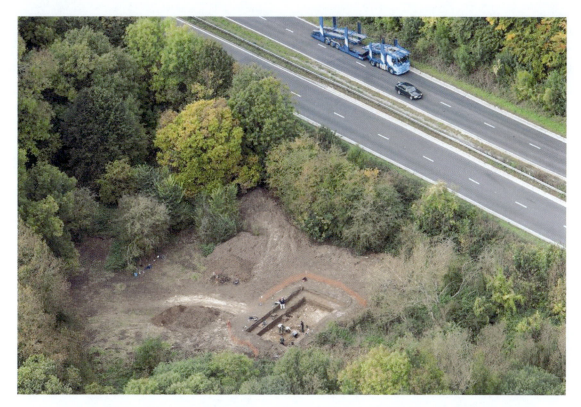

Figure 7.2: Blick Mead from the air. Road running diagonally from top middle of image is the A303, the site of a proposed 8 m-high flyover planned to filter traffic into the Eastern Portal for the Stonehenge Tunnel
Photograph courtesy of QinetiQ (Boscombe Down)

patterns of use in the landscape. The evidence suggests a much deeper Mesolithic occupation of the area, with hunting groups foraying out from sheltered locales at Blick Mead up on the nearby ridges and the Plain in search of animals. Later Mesolithic culture in the landscape seems particularly dense, especially if the sites and activity at Blick Mead, Coneybury, Countess Farm, Durrington Walls and perhaps even the Stonehenge knoll, are drawn together. There is also the possibility of transportation links with nearby sites like Downton and others further afield.

We can go as far as describing Blick Mead as the 'first place' in the Stonehenge landscape, one that evidentially endured throughout the Mesolithic period and possibly beyond as a culturally determined and desired locale. In the near future, the Late Mesolithic may well emerge as a starting point for understanding the better-known archaeology of the Stonehenge landscape. If the construction of the Stonehenge tunnel and associated developments do go ahead as proposed, however, will these fragile remains survive, and with them their new insights about the early establishment of this landscape?

Appendices

APPENDIX A

Fieldwork

– Tom Lyons, Tom Phillips and David Jacques

Appendix A1: Blick Mead trench reports and field surveys

This appendix reports on the findings of excavations in Trenches 1–14, 18, 19 and 20 at Blick Mead and 15, 16, 17 and 21 north-east of Vespasian's Camp at the field site, in other words those trenches which did not reach the prehistoric horizons reported on above. They are included here in order to provide a full account of all of our fieldwork at Blick Mead.

Trench 1/20

Located in the north-east of the spring (see Phillips, Lyons and Jacques, Chapter 3, Figure 1.3, this volume), Trench 1/20 measured 2 m × 3 m. It was excavated to investigate a compacted chalk surface known to exist close to modern ground level and was later re-opened to investigate what was below the surface. The earliest recorded deposit was layer [34]=[56], a mid-grey silty clay. It measured at least 0.6 m thick but was not fully excavated. Two small sherds of Early Iron Age pottery were recovered from layer [34], along with several fragments of burnt flint.

It was sealed by the chalk surface [33], which was 0.15 m below ground level and comprised a deliberately laid surface, consisting of small lumps of weathered chalk with the occasional fragment of abraded brick (Plate 5). Some of the fragments of brick were large and can be dated to the eighteenth and nineteenth centuries. The surface filled the trench and therefore it was extended by 2 m towards the north-west to seek an edge to the surface; this was encountered a further 1 m to the north-west.

The sequence was completed by topsoil layer [32], a very dark greyish brown clayey silt, which contained a fragment of medieval pottery.

Trench 2

Located in the north of the spring, Trench 2 measured 1 m². The earliest recorded deposit was layer [80], a mid-grey silty clay, which equates to layer [34] in Trench 1/20. It measured at least 0.2 m thick but was not fully excavated. Layer [80] was sealed by a compacted flint surface [81] consisting of fragments of unworked flint. The flints were tightly packed and appeared to form a metalled surface. Sealing flint surface [81] was topsoil layer [32]. The topsoil contained a flint blade, possibly Neolithic in date, along with several fragments of burnt flint.

Trench 3

Located in the north of the spring, Trench 3 measured 3 m × 2 m. It was positioned in an area of the spring which forms a shallow pond at certain times of the year. The trench was sited as a result of

burnt flint fragments found on the surface. Trench 3 was hand excavated to a total depth of 0.94 m; the earliest recorded deposit was layer [82], a dark grey silty clay measuring at least 0.4 m thick with inclusions of waterlogged organic matter. It was sealed by layer [83], a light grey silty clay, which was more friable than [82] and contained occasional inclusions of chalk. Topsoil layer [32] completed the sequence, measuring 0.1 m thick.

Trench 4

Located approximately 5 m to the north of Trench 3, Trench 4 measured 1 m². It was hand excavated to a total depth of 0.8 m; the earliest recorded deposit was layer [84], which comprised re-deposited chalk measuring at least 0.14 m thick. It was sealed by layer [85], a blueish grey silty clay measuring 0.16 m thick, which was very similar to layer [34] in Trench 1 and layer [80] in Trench 2. Layer [85] was sealed by the compacted flint horizon or metalled surface [81] seen in Trench 2 approximately 10 m to the south-east. In Trench 4 the flint surface measured 0.2 m thick and was sealed by topsoil layer [32], which measured 0.24 m thick.

Trench 5

The purpose of Trench 5 was to determine the presence or otherwise of the flint surface [81] found in Trench 2, 8 m to the south-east, and Trench 4, only 2 m to the west. The trench measured 1 m². The flint surface was found to be present 0.15 m below ground level.

Trenches 6 and 10

Located in the south-west of the spring, Trenches 6 and 10 were positioned to investigate a potential linear depression, possibly a ditch, visible on the surface. The two trenches revealed that there was some degree of deliberate terracing or cutting in to the slope, presumably to manage the water in the spring. Two well-preserved wooden stakes found in the bottom of the terraced feature date this water management to between the fourteenth and seventeenth centuries.

Trench 6 was excavated first, its western end being positioned against the north-east to south-west orientated slope of the terrace. The potential linear feature could be seen running along the bottom of, and parallel with, the terrace. Trench 6 measured 3.5 m × 1.5 m. Excavation revealed natural geology (chalk) at the western end of the trench, close to the base of the terrace. Towards the east of the trench there was a pronounced change of slope, which was interpreted as the possible cut of a terrace [15], based on its correlation with the linear feature on the surface. Natural geology was still visible at the eastern end of the trench. Feature [15] contained at least four fills [11]–[14] making it approximately 0.6 m deep. The fills appeared to have accumulated naturally as did the sequence of layers which sealed the feature. The most noteworthy fills were [12] and [13]. Fill [13] was a blueish grey silty clay which produced an iron artefact, possibly part of a medieval horseshoe (Lorraine Mepham pers. comm.). Fill [12] was a very dark brown clayey silt with inclusions of small snail shells, which yielded two small sherds of pottery (11 g) dating to the Early Iron Age. At least two wooden stakes were also recovered from fill [12]. They were clearly worked and one had been driven vertically in to the ground. One of the stakes returned a radiocarbon date of AD 1310–1440 cal. (95% probability; SUERC 27212, 545 ± 30 BP). Another stake returned a date of AD 1470–1650 cal. (95% probability; SUERC 27216, 330 ± 30 BP).

Layer [10] was a light brown silty clay measuring 0.2 m thick, which sealed the natural geology at the western end of the trench. It was sealed by layer [5], a dark brownish grey clayey silt measuring 0.24 m thick. Layer [9] was a narrow band of dark brown chalky silt with moderate – frequent inclusions

of natural flint pebbles. Of the upper layers, layer [4] was the most noteworthy. It consisted of a light brownish grey clayey silt measuring 0.46 m thick. It contained several fragments of post-medieval brick. The sequence was completed by topsoil layer [1], which equates to layer [32].

Trench 10 was opened as a continuation of Trench 6 directly to the east, with the intention of finding the other side of the cut for feature [15]. A cut was tentatively identified although it was not at all clear. Layer [16] was the earliest deposit in the sequence, recorded at the eastern end of Trench 10. It consisted of a mid-grey silty clay measuring at least 0.7 m thick.

Trench 7

Located in the north-east of the spring, Trench 7 measured 5 m × 3 m and was positioned to investigate the supposed eastern edge of the spring. However, the trench revealed that the current eastern edge is entirely artificial, comprising redeposited natural chalk, which had been dumped and to a certain extent landscaped. It was presumed that the dumping had occurred during the widening of the A303 in the late 1960s as a crisp packet dated by type was found at the base of the trench.

Trench 7 was hand excavated to a total depth of 1.2 m; beyond which a high water table stopped excavation. The earliest recorded deposit was layer [20], which consisted of a brownish grey clayey silt measuring at least 0.06 m thick. This layer represents buried subsoil, effectively the subsoil which was present before the redeposited chalk was dumped. It was sealed by layer [19], a very dark greyish brown clayey silt measuring 0.1 m thick, which represents the 1960s topsoil. At the eastern end of the trench layer [19] was sealed by layer [26], a pale greyish brown clay measuring 0.3 m thick, with frequent inclusions of unworked flint. This layer must also be redeposited as it seals the 1960s topsoil.

Layer [19] was sealed by layer [18], a 0.6 m thick dump of redeposited chalk natural. The chalk was homogeneous and 'clean', as if it had been moved in large blocks rather than by hand. The only possibility is that it was moved by machine and therefore the most likely interpretation is that this occurred during construction of the road, only 20 m to the north. Modern topsoil layer [17] completed the sequence, measuring 0.2 m thick.

Trench 8

Located in the south of the spring, Trench 8 measured 4 m × 2 m and was positioned on a shallow slope at the eastern edge of the spring. It appeared that natural chalk was located only 0.2 m below ground level and no features were present. However, subsequent findings of redeposited chalk, not only in Trench 7 to the north but also in Trench 19 approximately 5 m to the south, calls in to question whether the chalk encountered in Trench 8 was in situ geology or more redeposited material.

Trench 9

Located in the west of the spring, Trench 9 measured 1 m^2 and was positioned to investigate the terrace adjacent to the spring area to the west. Natural chalk was encountered 1.44 m below ground level. The natural was sealed by layer [86], a light brown silty loam, measuring 1.04 m thick. This was interpreted as colluvium or agricultural soil, part of a lynchet which has presumably built up over a considerable period of time. The top of the slope of the terrace on the western side of the spring matches a field boundary on estate and ordinance survey maps from 1824; the thick soil has built up against this boundary. A single sherd of Early Iron Age pottery (5 g) (Lorraine Mepham pers. comm.) was recovered from layer [86], approximately 0.4 m above the natural chalk (Mepham, Appendix C4, this volume).

Layer [86] was sealed by subsoil layer [87], measuring 0.2 m thick. It was very similar in appearance to the layer below, but contained occasional inclusions of unworked flint. Topsoil completed the sequence, a greyish black silty sand measuring 0.2 m thick.

Trench 11

Located in the north of the spring, Trench 11 originally measured 2 m × 4 m and was positioned on the terrace slope leading down in to the spring from the north. Subsequently a 1 m × 4 m extension was added to the west. The earliest recorded deposit was layer [49], which consisted of a mid-brown silty loam measuring at least 0.2 m thick. This was very similar to layer [86], the agricultural soil encountered in Trench 9. Sealing layer [49] was a metalled surface [22] formed by unworked flint cobbles, which was located 0.3 m below ground level at the top of the slope and up to 0.5 m at the base of the slope. The cobbles had been deliberately laid (Plate 2) and spread across the entire trench, from the flat area at the top of the slope down to the base of the slope. The metalled surface was also found in Trenches 2 and 4 to the east, in Trench 12 approximately 8 m to the south and in the west end of Trench 14. The surface was dated by a number of small fragments of post-medieval brick and barbed wire (which was directly on top of the cobbles). Buildings are recorded about 20 m to the north-west of this area on estate maps from 1824.

Subsoil layer [48] sealed the metalled surface. It consisted of a greyish brown silty loam measuring 0.15 m thick. Completing the sequence was layer [21], a mixed deposit of redeposited material, presumably dumped during construction of the road.

Trench 12

Located approximately 8 m to the south of Trench 11, Trench 12 measured 2 m². It was positioned on the terrace to the west of the spring. Natural chalk geology was encountered 1.6 m below ground level. Layer [25] was the earliest deposit in Trench 12. It consisted of a mid-greyish brown silty loam, which measured 1.3 m thick. The upper 0.4 m was hand excavated; an auger was then employed to record the total depth. Layer [25] equates to layer [86] in Trench 9, the thick layer of colluvium/agricultural soil. Overlying layer [25] was metalled surface [24], which is the same as surface [22] in Trench 12, formed of closely packed unworked flint cobbles. Here, the metalled surface was only present in the north of the trench. Topsoil layer [23] was the final deposit in the sequence. It was similar to layer [21] in Trench 11 and measured 0.3 m thick. The topsoil yielded several fragments of post-medieval tile and a horseshoe.

Trench 13

Located to the south of Trench 3, Trench 13 measured 3 m² and was opened to investigate deposits in the area of the spring where a shallow pond still forms during wetter spells of weather. The trench was only excavated to a depth of 0.7 m because of a high water table. Chalk was encountered in the northern corner of the trench approximately 0.4 m below ground level, sloping down towards the south. It was assumed that this was natural bedrock at the edge of the spring. However, only a small section was exposed and given the extent of redeposited chalk in other parts of the spring, the possibility exists that this was also redeposited natural. Sitting on the chalk were a number of unworked flint cobbles and at least one fragment of post-medieval brick [31]. The cobbles may be the remains of a metalled surface, possibly the eastern edge of the cobbled surface seen in Trench 11 (layer [22]) and Trench 12 (layer [24]), which would mean it extended for at least 12 m from the higher ground on the terrace down to the edge of the wettest part of the spring.

Fieldwork

Layer [29] extended across the base of the trench. It comprised a dark grey silty clay, measuring at least 0.2 m thick although it was not fully excavated. Layer [29] contained a fragment of post-medieval tile. At least three wooden posts had been driven vertically in to the layer. These were square, machine cut posts and obviously modern.

Layer [29] was sealed by layer [28], a greyish brown clayey silt measuring up to 0.54 m thick. A fragment of post-medieval tile and a horseshoe were recovered from the layer. The sequence was completed by topsoil layer [27], measuring 0.1 m thick.

Trench 14

Trench 14 was located directly to the south of Trench 13. It measured 8 m long by 1 m wide at the northern end and 2 m wide at the southern end. The northern end of the trench, close to the higher ground of the terrace, was only excavated to a depth of 0.3 m (the top of flint surface [39]) while the south of the trench was machine excavated to a depth of 1.2 m, which revealed a pond-like feature [44], of post-medieval date (Plate 3). This presumably represents deliberate cleaning-out or maintenance of the spring area.

The earliest recorded deposit was layer [47], a light blueish grey sandy silt with occasional orangey mottling (oxidisation), measuring at least 0.32 m thick. It was sealed by layers [45] and [46]. Layer [45] was very similar to [47] but with inclusions of unworked flint cobbles. Layer [46] measured 0.24 m thick and consisted of a slightly blueish grey silty clay, which once again displayed orange mottling (oxidisation).

A medieval/post-medieval pit [44] truncated layers [45] and [46]. It measured at least 3 m wide and 0.3 m deep. Its single fill [43] was a dark greyish brown silty clay which contained fragments of medieval/post-medieval tile and brick. A series of layers sealed the pit, the most noteworthy of which was layer [39], which contained frequent inclusions of unworked flint and extended from the western end of the trench. At this point it appeared to be a metalled surface, similar to that seen in trenches to the north and is further evidence of stabilising the wet ground around the edge of the spring.

A fragment of a seemingly deliberately broken copper alloy dagger refashioned from the tip of a Middle Bronze Age rapier was found in the spoil of Trench 14 (Mepham and Lawson, Appendix C3, this volume).

Trench 18

Trench 18 was located directly to the north of Trench 6. It was opened to determine whether a similar sequence existed to that in Trench 6. Unfortunately, the water table was too high and the upper levels were very mixed. The trench was therefore shut down at approximately 0.3 m depth.

The field site

The field site is situated in a clearing immediately north-east of Vespasian's Camp's northern ramparts and directly south of the A303, at OS NGR 414690/142020 (see Figure A1). Following geophysical survey of the area (see Sabin and Donaldson, Appendix A3, Figure A9 'Area 1', this volume), four trenches, 15, 16, 17 and 21, were excavated to target potential earthworks and features.

It became clear during excavation that much of the field area was covered in thick deposits of redeposited soils. For example, a 1 m × 1 m test pit in Trench 15 was hand excavated to a depth of 1.7 m through the redeposited material, without reaching any *in-situ* natural chalk. Trench 16, at the western end of the field, was the only trench where natural chalk geology was encountered, approximately 0.4

m below ground level; the trench did not contain any archaeological features. The likely cause for the disturbed ground is the dumping of material related to the widening of the A303 in the late 1960s. A photograph of the field area, later supplied by QinetiQ, shows machinery operating at the site. The site may have been a spoil heap landscaped in to the side of the hill when finished. Alternatively, the side of the hill may have been quarried for chalk during the road construction and subsequently reinstated with disturbed material to 'tidy up' when the road was finished. Many of the anomalies identified in the geophysical survey as burnt material or ferrous objects were probably fragments of modern rubbish within the spoil (*ibid.*).

The western and northern rampart walkover surveys

In 2007 a basic walkover survey from the top of the bank of Vespasian's Camp's north-western rampart down to the vallum was undertaken. Only 50 m of the northern most section of the rampart was surveyed, however forty-nine sherds of Iron Age pottery were recovered, identifications of which extend the known range of the Iron Age occupation of the site from the Early Iron Age through to c. 50 BC (Mepham, Appendix C2, this volume). This result potentially questions the long running assumption that the hillfort was restricted to a largely Early to Mid-Iron Age context (Hunter-Mann 1999), and hints that the Camp may have been an important part of the landscape for much of the Iron Age.

In 2015 a walkover survey was conducted in a 10 m² area of the base of the northern rampart due to a tree throw revealing some large and fresh-looking pieces of Iron Age pottery. This resulted in the finding of a further thirty-one pieces of Iron Age pottery.

Overall, the focus of the assemblage is on the Middle Iron Age, extending into the early first century BC, and with earlier sherds also present. There are certainly parallels with the Danebury assemblage, and others within the region of north Hampshire and central Wiltshire (e.g. Battlesbury Bowl, Warminster), and there is discussion as to whether the 'better' wares (i.e. the well-burnished wares in relatively fine fabrics) were the subject of regional distribution rather than purely local manufacture, though there has not yet been a concerted programme of petrological and/or chemical analysis to prove this one way or the other. However, it is reasonable to suspect that some pottery wares were traded over longer distances. It is certainly possible to see Vespasian's Camp as one of a series of Iron Age sites linked by trading contacts (Mepham, Appendix C4, this volume).

Appendix A2: Geophysical survey 2013
– Eamonn Baldwin

In September 2013, I was invited to undertake a trial geophysical survey at Blick Mead, Amesbury, in Wiltshire, after recent archaeological investigations (Jacques 2014) had revealed substantial Mesolithic deposits preserved in waterlogged spring-like conditions. The site was located just below the north-east slope of Vespasian's Camp.

Survey area

The proposed area of investigation was a small terrace which overlooked the spring from the north-west. Centred on NGR 414880E 142030N, it is thought to be a possible large lynchet (Jacques 2014, 8). Recent research demonstrates the terrace escaped landscaping evident elsewhere across the estate (*ibid.*). The northern extent of the terrace was curtailed in the late 1960s with the building of the A303 dual-carriageway.

Historic mapping from the nineteenth century depicts a field boundary approximately 5 m below the edge of the terrace; by the 1930s the field boundary has been elaborated into a larger drainage ditch. In the 1970s the existence of a circular walk or track traversing the survey area is noted on Ordnance Survey maps; this path however, is not recorded in later mapping and is not evident on the ground today.

Geological background

The survey area lies over cretaceous period chalk bedrock (Seaford Chalk Formation) which is overlain with superficial deposits of Quaternary period river terrace sands and gravels, locally with lenses of silt, clay or peat and organic material (1:50 K BGS map sheets).

Two boreholes sunk into the terrace in 2013 as part of an environmental archaeological analysis encountered the presence of layers of clay (mixed with inclusions) directly beneath the topsoil and ranging between 0.9 and 1.4 m thickness; one borehole struck solid chalk at approximately 3.9 m at the centre of the terrace (Young *et al.* Chapter 3, BH1 and BH23).

Previous investigations

Previous geophysical investigations were undertaken at Blick Mead in 2009 by Archaeological Surveys Ltd for the Open University. Earth resistance and magnetometer surveys over the spring area revealed features most probably associated with the former field boundary noted in historic mapping (noted above); it also mapped a possible made-surface north of this feature (see Sabin and Donaldson, Appendix A3, this volume).

Further magnetometer survey over an area of cleared woodland 200 m to the west of the spring and immediately south of the A303 provided inconclusive evidence for the potential survival of archaeological features (*ibid.*, 11).

However, in 2012 a large-scale magnetometer survey – led by the University of Birmingham in conjunction with the Ludwig Boltzmann Institute for Archaeological Prospection (LBI ArchPro) – recorded an extensive network of amorphous responses approximately 70 m north of Blick Mead (on the opposite side of the A303); these anomalies extended over an area of at least 25 ha and were interpreted as most probably being the result of water movement associated with the River Avon and/or an earlier marsh-land or former flood plain (SHLP 2014). Previously, alluvial features were also identified in this area during trial trenching for the A303 Stonehenge Improvement Scheme (Leivers and Moore 2007, 16).

Farther afield, magnetometer and resistance surveys within the southern interior of Vespasian's Camp conducted by the Ancient Monuments Laboratory identified a possible ring ditch 700 m south-west of site (Cole 1995).

Survey objective

The aim of the geophysical survey was to establish the presence, or absence, of buried archaeological remains within the deep sub-soils of the terrace. With an overburden of up to 3.9 m (noted above), ground-penetrating radar was the technique chosen on account of its ability to detect deep subsoil anomalies (features), as well as its ability to estimate the approximate depth of a feature. As an appreciable slope was evident across the width of the terrace, a 3D laser scan survey was also conducted to provide topographic corrections for the GPR transect profiles (radargrams).

Method

The survey baseline was set-out along the edge of the terrace and located to the Ordnance Survey reference system (National Grid – OSGB36) with a Leica 500 differential global positioning system (DGPS). Survey tapes were used to extend the grid perpendicularly over open ground towards the tree line to the north-west.

GROUND-PENETRATING RADAR

Ground-penetrating radar (GPR) survey is an active geophysical technique involving the transmission of electromagnetic (radio) pulses from a transmitter antenna moved across the ground surface. When the pulse reaches an interface between different materials, some of the energy is reflected back to a receiving antenna whilst some travels further into the ground and is reflected from a deeper sub-surface discontinuity. The amplitude of the returned pulse is dependent on the velocity of the radar wave as it passes through a material. The relative dialectric permittivity (RDP) is a measure of the ability of a material to conduct the radar wave and will vary depending on the composition, porosity and moisture content of the material. The travel times of each pulse are recorded and allow an approximate depth measurement to be made by assuming a dialectric constant value, although these depths should only be considered as estimations.

SURVEY METHODOLOGY

GPR survey was conducted over 657 m^2 of open terrace with a Mala X3M GPR system and 250 MHz antenna. The system was cart mounted with a calibrated survey wheel to ensure that transect lengths were accurately recorded.

Raw radar scans were acquired at a sample interval of 0.05 m × 0.25 m along survey transects, in zigzag method. The sample rate was set to 768 samples per scan. For data collection, a constant dialectic value of 9 was assumed for sub-soil conditions. It was anticipated however that the radar signal would lose strength passing through the thick clay layer noted in the augur survey (see above) so a large time window of 205.7 nanoseconds was set to provide enough time for deeper returns.

The post-acquisition processing of the transect profiles (radargrams) was carried out in GPR-Slice v6 software. Raw data were initially reformatted and corrected for dc-drift before time zero correction.

During collection the raw radargrams were subject to very strong, low frequency interference from an unknown source (perhaps due to proximity to military installations in the area), which was removed through a band-pass and re-gain filter set within a 125 to 500 MHz range.

Background removal and smoothing filters were further applied to remove banding and line noise as well as minimise high-frequency random noise. Hyperbola reflections identified within the radargrams were measured to help build an estimated velocity profile of the sub-soils necessary to adjust the time/depth of the profiles as well as perform a migration process. Not surprisingly, considering the expected high clay content of the subsoil (see above), the assumed velocity profile dropped steeply from 0.105 to 0.022 m/ns offering an estimated ground-penetration depth of no more than 3.5 to 4 m – at best.

A Hilbert (magnitude) transform was applied to the all radargrams intended for time-slicing; this was to allow the production of time-slices thinner than the expected size of the antenna wavelet (see Goodman 2013, Section XII).

Before final time-slicing and interpolation, radargrams were corrected for the effects of topography and tilt using a surface model derived from the laser scan survey (see Appendix A1).

Results

Representative radargrams are presented in Figure A3 and reveal a succession of layer reflections of varying intervals which may correspond to soil interfaces noted in BH2 and BH24 (Young *et al. ibid.*). Correlating these layers to those recorded in the borehole survey is not straightforward, partly because the radargram depth is based on an estimated velocity (which can vary greatly and be highly inaccurate), but also due to reflections caused by varying moisture content of the sub-soil(s) which are not always visible. For example, the very strong band of high amplitude reflections [F01] visible in radargrams occurs right across the breath of the survey area and is already apparent at a very shallow level. The signals are particular noisy and vary considerably in depth and amplitude. They possibly result from the moisture content of the clay combined with some several sharp contact soil changes noted within it including layers with flint clasts (Young *et al. ibid.*, BH1 and BH23).

However, as BH2 also notes the presence of Made Ground (ash and tarmac) close to the surface and, it may be worth considering if construction activity associated with the road widening scheme of the late 1960s may also have caused some superficial disturbances across the terrace. An isolated point reflector [F02] clearly visible within layer F01 may represent a sizeable/solid inclusion in the soil such as a larger rock/flint nodule or alternatively, a possible modern disturbance.

Deeper layer reflections [F03] in the radargrams are less noisy and more consistent with expected pedological interfaces. These layers fall steeply and are representative of the general hillside topography, possibly representing layers of chalky matrix noted in BH2 which overlie the chalk bedrock. It is possible the very strong reflections [F04] evident in some radargrams represent chalk bedrock. This could indicate that the signal is only just penetrating as far as the bedrock in the central survey area (where the bedrock is known to be deeper; see above).

In the north-east end of the survey area, a very reflective layer [F05] is prominent across several radargrams; it is noticeably horizontal and also forms quite a distinctive shape (c. 6 m × 3 m) in the time-slice data (Figure A5). It is however, possibly a discrete pocket of soil, perhaps correlating to the interface, noted at a similar depth of 69.04 m OD in BH24, between clayey silt and underlying gravelly, silty clay. If this correlation is correct, it would also suggest that the estimated velocity profile of the signal was perhaps more successful than anticipated. There are no other anomalies of note apparent within the profile data that may suggest the presence of archaeology.

Viewing the data in plan as time-slices (Figures A4 and A5) reinforces the interpretation of the layer reflections (F001-05) as relating to interfaces between sub-soil layers as they move gradually down the slope. It also illustrates how the deeper (chalky) geological layers form a more valley-like shape in contrast to the surface topography of the terrace. Additionally, when the data were cut into very thin time-slices, a very slight sub-circular anomaly [F06] c. 5 m in diameter became apparent (Figure A6). Although the signals were composed of very weak reflections, they seemed distinct from the more pedological responses at this depth. A corresponding response was unfortunately not visible in the radargrams, but the time-slices suggest that they relate to a change/feature at least 1 m below the ground surface. The anomaly was tentatively identified (based purely on form) as being possibly anthropogenic and therefore of potential interest (Figure A7).

NOTES ON STANDARD PROCEDURES: LASER SCANNING

The Leica C10 is a pulsed (or time of flight) based laser scanner with an operational range from 0.1 to 300 m. Fully automated, it has a 360° × 270° field-of-view and the high-speed capacity to record the three-dimensional outline of its surroundings at a pre-determined resolution over a chosen area. By measuring the returns of laser points scattered by a rotating mirror, it can generate up to 50,000 co-ordinates per second; the positional accuracy of each point is approximately 6 mm over 50 m.

Figure A1: Site location with GPR survey area outlined.

Figure A2: Topographic surface model with GPR survey area outline and radargram profiles with locations marked.

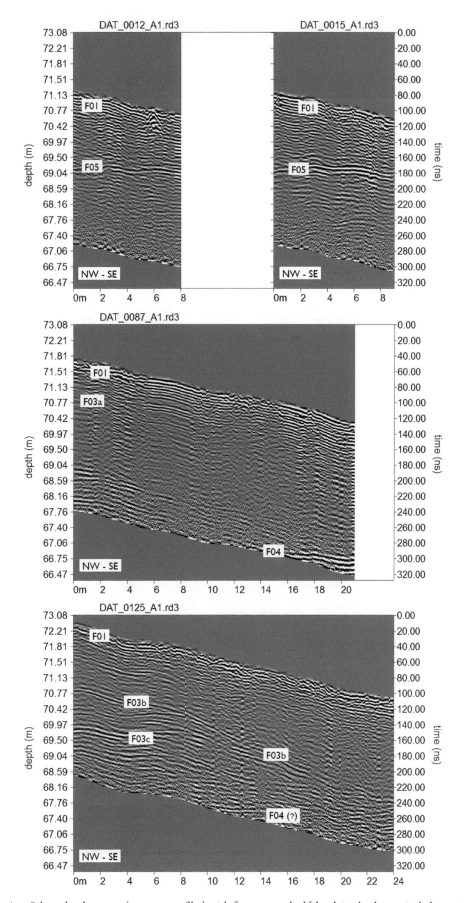

Figure A3: Selected radargrams (transect profiles) with features marked [depth in absolute units below surface].

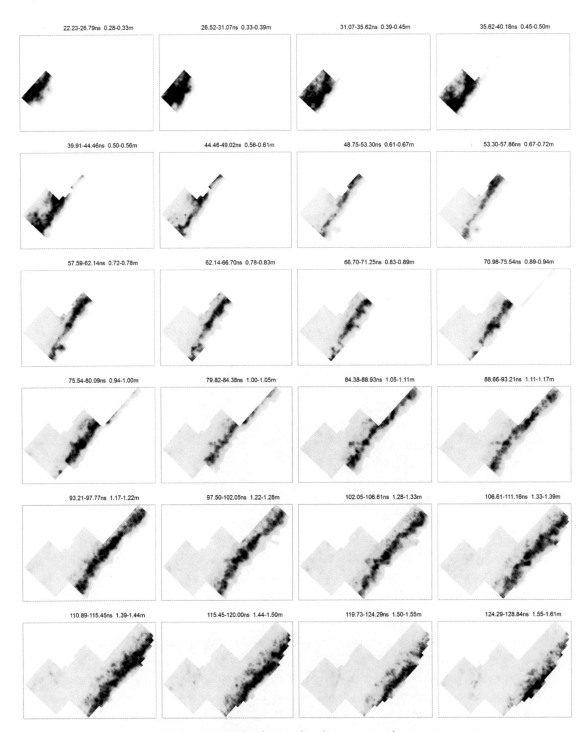

Figure A4: Amplitude time-slices between 22 and 129 ns.

The co-ordinates are stored as a series of XYZ measurements which visually constitute a 'point cloud' representing the geometric form of the structure as scanned in 3D. Laser scan survey operates a line-of-sight system, so in order to achieve full coverage of the area to be surveyed a number of setups were required to ensure that there were no voids in the data and to maintain a consistent level of measurement resolution (i.e. distance from the scanner).

To record fully the topography of the terrace and the spring in the round five scan positions (set-ups) were necessary. The individual scans (instrument setups) are later registered (stitched together) during postprocessing using proprietary software (Cyclone 8.1.1) to form a single conjoined dataset

Fieldwork

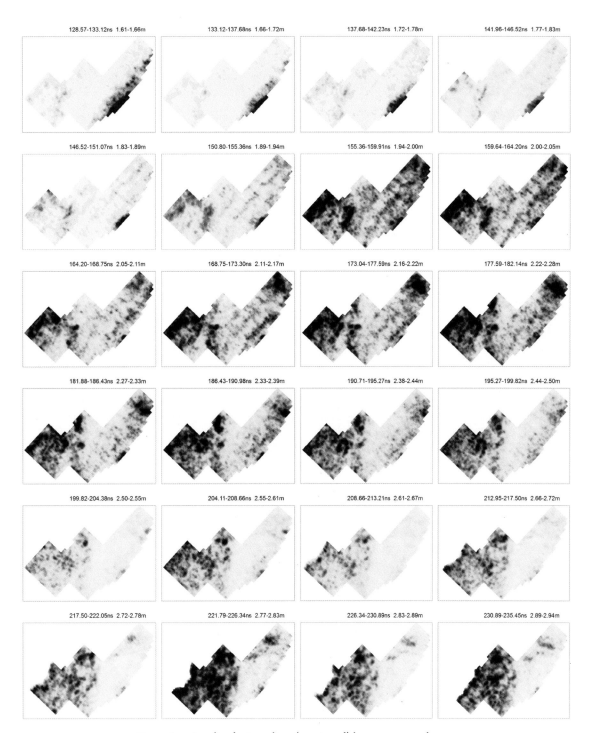

Figure A5: Amplitude time-slices (continued) between 130 and 253 ns.

(multiple overlapping point clouds). Accurate registration of scans was assisted through the use of highly reflective black and white targets in the field which were later identified within the laser scan software and used to identify the position of the scanner in relation to the other setups. The use of field targets ensured that the individual scan datasets were registered together with a Mean Absolute Error of ≈0.001 m.

During field survey, the tripod-mounted reflective targets were set-up over ground control points established with a survey grade Global Positioning System (Leica 1200 GPS receiver). This ensured

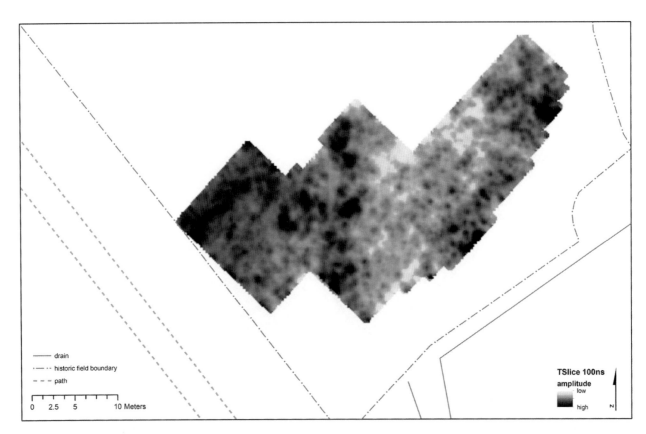

Figure A6: Geo-rectified time-slice of 2 cm thickness at 100 ns.

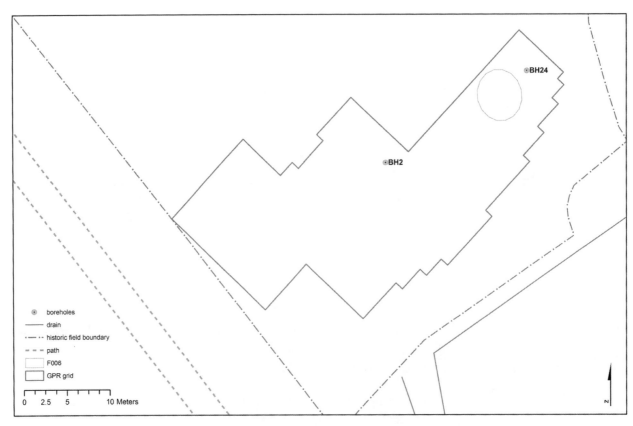

Figure A7: Feature of potential interest: Interpretation from time-slice data.

that the arbitrary co-ordinates of the final 'registered' dataset (point-cloud) were transformed onto British National Grid (OSGB36).

Appendix A3: Geophysical Survey 2009
– David Sabin and Kerry Donaldson

Two areas of geophysical survey were undertaken to the east of Vespasian's Camp hillfort, north-west of Amesbury in Wiltshire. Area 1, immediately east of the hillfort, was subject to magnetometry only, whilst Area 2, within a shallow depression approximately 200 m further east, was subject to both magnetometry and earth resistance survey (resistivity).

The results of magnetometry from Area 1 have not provided conclusive evidence for the presence of features with archaeological potential. Clusters of strong discrete positive anomalies may indicate pit-like features and their high magnitude may indicate the presence of burnt material; however, the location of strong dipolar anomalies in the area, indicative of ferrous objects, may infer a relatively recent origin.

Geophysical survey within Area 2 has provided a number of anomalies that may relate to features already know from small trial excavations. The earth resistance survey located a low resistance feature that would be typical of a ditch-like feature crossing the area with a south-west to north-east orientation. A zone of high resistance immediately to the north of the ditch could represent a made surface. Both features have been identified by excavation in the area.

Magnetometry within Area 2 located a broad zone of magnetic debris possibly related to dilapidated fencing material. The zone has a similar south-west to north-east orientation reflected by the ditch-like feature identified by the resistivity survey.

Site location, description and survey conditions

The survey areas were located to the north-west of Amesbury, bounded on the western side by the Iron Age hillfort of Vespasian's Camp, on the northern edge by the A303 and to the south and east by dense tree cover within the northern part of Amesbury Abbey Park. The site is centred on Ordnance Survey grid reference SU 146 420 (see Figure A8). The geophysical survey covered two small areas: Area 1 is 0.65 ha and Area 2 is 0.06 ha. Area 1 was situated in a clearing immediately north-east of Vespasian's Camp's northern ramparts and directly south of the A303. Area 2 was located adjacent to a spring approximately 200 m to the east of Area 1. The ground conditions across the site were generally considered to be favourable for the collection of data although the extent of the survey was limited by dense vegetation.

Equipment configuration, data collection and survey detail

The detailed magnetic survey was carried out using a Bartington Grad 601–602 gradiometer. This instrument effectively measures a magnetic gradient between two fluxgate sensors mounted vertically 1 m apart. Two sets of sensors are mounted on a single frame 1 m apart horizontally. The instrument is extremely sensitive and is able to measure magnetic variation to 0.03 nT (recorded values are to 0.01 nT). All readings are saved to an integral data logger for analysis and presentation.

Magnetic data were collected at 0.25 m centres along traverses 1 m apart. Survey Area 1 was separated into 30 m × 30 m grids giving 3600 recorded measurements per grid; Area 2 was separated into 20 m × 20 m grids giving 1600 measurements per grid. This sampling interval is very effective at locating

archaeological features and is the recommended methodology for archaeological prospection (English Heritage 2008). The earth resistance survey was carried out using TR Systems Ltd Resistance Meter TRCIA 1.31 using a mobile Twin Probe array. The standard mobile frame for the TRCIA instrument has a 0.5 m electrode separation and readings were recorded at 1 m intervals across Area 2 only. The instrument was set to filter stray earth currents which can cause errors within the resistance measurements. The area was set out with 20 m × 20 m grids (also used for magnetometry) giving 400 readings per grid.

The survey grids were set out to the Ordnance Survey OSGB36 datum using a Penmap RTK GPS. The GPS is used in conjunction with Leica's Smartnet service where positional corrections are sent via a mobile telephone link. Positional accuracy of around 10–20 mm is possible using the system.

Area 1 grids were arranged to coincide with the OSGB36 National Grid whilst Area 2 grids were set out to obtain maximum coverage.

Magnetometry data downloaded from the Grad 601–602 data logger are analysed and processed in specialist software known as ArcheoSurveyor. The software allows greyscale and trace plots to be produced for presentation and display. Survey grids are assembled to form an overall composite of data (composite file) creating a dataset of the complete survey area.

The following schedule sets out the data and image processing used in this survey:

(1) clipping of the raw data at ±30 nT to improve greyscale resolution;
(2) clipping of processed data at ±5 nT to enhance low magnitude anomalies;
(3) zero median/mean traverse is applied in order to balance readings along each traverse;
(4) raw earth resistance data have been shown with absolute readings of between 13.38_ and 28.02_;
(5) processed data have been clipped at 2SD (Standard Deviation) giving a range of 15.5_ to 24.2_.

Results

GENERAL OVERVIEW: MAGNETOMETRY

The detailed magnetic survey was carried out over a total of two survey areas covering a total of 0.71 ha. Geophysical anomalies located can be generally classified as positive linear and discrete anomalies of an uncertain origin, linear anomalies of an agricultural origin, areas of magnetic debris and disturbance and strong discrete dipolar anomalies relating to ferrous objects. Anomalies located within each survey area have been numbered and are outlined below.

Data quality was generally good although the area of coverage was limited by thick ground vegetation and trees. Uneven surfaces were particularly hazardous within Area 2.

GENERAL OVERVIEW: EARTH RESISTANCE SURVEY

The earth resistance survey was carried out over Area 2 only and covered 0.06 ha. Geophysical anomalies located can be generally classified as high resistance anomalies associated with the edge of a depression and a possible made surface, a high resistance anomaly of uncertain origin, a high resistance anomaly associated with vegetative remains, a low resistance anomaly within a former pond and a low resistance anomaly indicative of a ditch-like feature. Data quality was good although the area of survey was limited by thick vegetation. Stray earth currents were not apparent within the survey area.

ANOMALIES IN AREA 1 (MAGNETOMETRY ONLY)

Area centred on OS NGR 414690, 142020.

Fieldwork

Anomalies with an uncertain origin:

(1) Discrete positive anomalies generally >20 3 nT may relate to areas of burning or highly enhanced material within pit-like features. The anomalies tend to cluster towards the eastern part of the surveyed area. Clusters of strong dipolar anomalies related to ferrous objects also occur within the eastern part of the survey area. The discrete positive responses could also be related to ferrous objects (see Discussion below).
(2) Positive linear anomalies within the central part of the survey area may indicate ditch-like features.

Anomalies with an agricultural origin:

(3) A series of parallel linear anomalies cross the western end of the survey area. The anomalies are parallel to the eastern bank of Vespasian's Camp hillfort and their appearance is consistent with agricultural marks.

Anomalies associated with magnetic debris:

(4) Strong discrete dipolar anomalies occur across much of the survey area although tend to cluster towards the eastern side. These anomalies are typical of buried ferrous objects.

ANOMALIES IN AREA 2 (MAGNETOMETRY AND RESISTIVITY)

Area centred on OS NGR 414908, 142027.

Anomalies associated with magnetic debris:
(5) A roughly linear zone of magnetic debris crossing the central part of Area 2 may indicate ferrous material associated with a former boundary.
(6) Areas of magnetic debris probably caused by modern ferrous material.

Anomalies with an uncertain origin (resistivity):

(7) Low resistance linear anomaly that may indicate the course of a former channel or ditch.
(8) A zone of high resistance that may represent a made surface.
(9) A moderately high resistance linear anomaly of uncertain origin. The feature lies parallel to (7) and may represent a former bank.

Anomalies related to extant surface features:

(10) A zone of low resistance located within the base of a depression or former pond.
(11) A high resistance anomaly that correlates with the edge of a former pond or depression.
(12) High resistance associated with decayed vegetation and a tree stump.

Discussion

AREA 1

Although the area lies immediately adjacent to Vespasian's Camp hillfort, no anomalies could be confidently interpreted as prehistoric or of archaeological significance; however, clusters of discrete positive anomalies, possibly indicative of pit-like features, were located towards the eastern end of Area 1. However, discrete positive anomalies outlined above, show significant levels of enhancement

unusual for pit-like features cut into chalk geology. With values of 20–95 nT recorded, if the anomalies relate to cut features, then the fill material is likely to contain a significant proportion of burnt material; typical values for prehistoric storage pits are in the range of 3 and 15 nT. It is of note that clusters of strong dipolar anomalies occur within the vicinity of the mainly positive discrete responses and an alternative interpretation is considered. All anomalies, whether visible as positive or negative, relate to dipolar sources. Where only a single positive or negative pole is observed, often the opposing pole is orientated in such a way that it is not recorded by the gradiometer. It is possible that relatively high magnitude discrete positive anomalies are associated with ferrous objects having an orientation where the negative pole is not apparent; this can occur when elongated iron objects are buried near vertical.

AREA 2

A broad zone of magnetic debris (5) correlates approximately with low and high resistance anomalies (7 and 9) that suggest a linear feature with a south-west to north-east orientation. Nineteenth- and twentieth-century Ordnance Survey mapping indicate the presence of a small pond and field boundary and it is likely that the anomalies are associated with these features. The zone of magnetic debris may indicate the presence of decayed wire fencing or other relatively modern ferrous material. Low resistance linear anomaly (7) may indicate a former ditch-like feature associated with the former field boundary and/or drainage for a nearby spring. It is presumed the small pond-like feature visible on Ordnance Survey maps is as a result of pooling of spring water. Excavations prior to the geophysical survey have demonstrated that the area has been subject to human activity within the prehistoric and historic periods. It is likely that there is broad agreement between the geophysics and excavation results

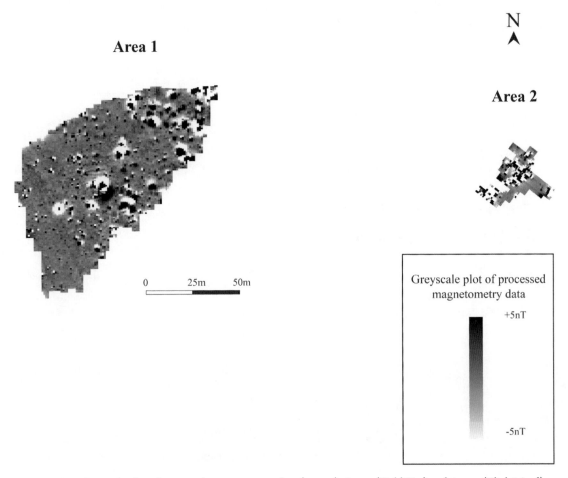

Figure A8: Greyscale plot of processed magnetometry data (1:1000). Area 1 (Field Site) and Area 2 (Blick Mead).

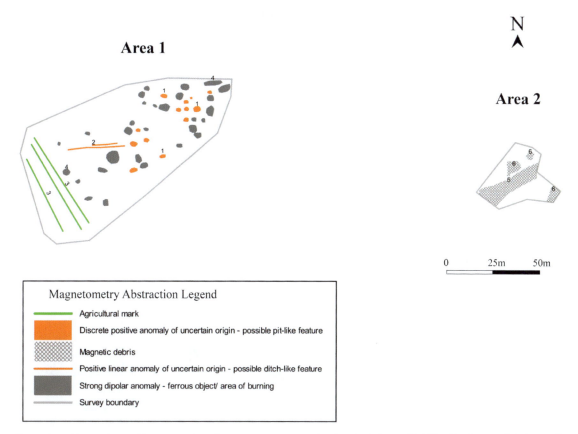

Figure A9: Abstraction and interpretation of magnetometry anomalies (1:1000). Area 1 (Field Site) and Area 2 (Blick Mead).

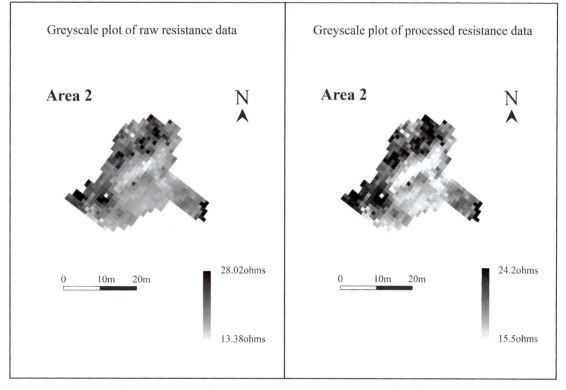

Figure A10: Greyscale plots of raw and processed resistance data (1:500).

in that a former ditch crosses the site and that immediately to the north of this, there is evidence for a made surface consisting of flint nodules.

Conclusion

Discrete positive anomalies, clustering towards the eastern end of survey Area 1, may indicate the presence of pit-like anomalies. The features are very enhanced suggesting the presence of burnt material; however, an alternative interpretation considers that the anomalies may relate to the positive pole of ferrous objects where, due to their orientation, the opposing pole is not apparent. Earth resistance survey within Area 2 has located a low resistance anomaly indicative of a ditch-like feature and a zone of high resistance that may support excavation evidence for a made surface immediately to the north-west of the ditch. The excavation work, carried out prior to the geophysical survey, has indicated the archaeological potential of these features and it is hoped that the geophysics has assisted in defining their extent.

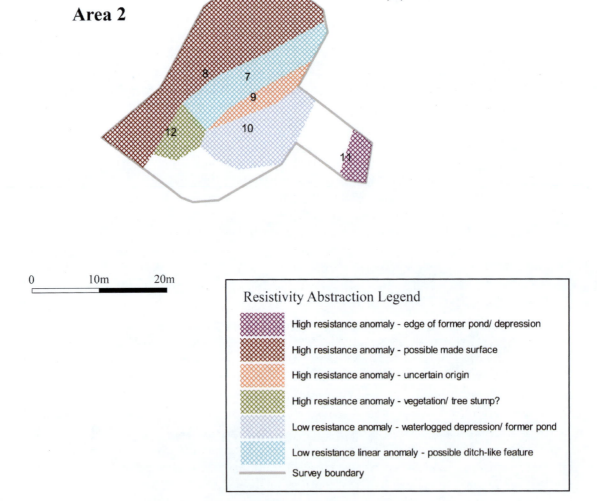

Figure A11: Abstraction of interpretation of resistivity anomalies (1:500).

APPENDIX B

Ecofacts

Appendix B1: Bulk samples from Trench 19
– *Simon A. Parfitt*

In addition to the primary aim of recovering small vertebrate remains, sorting the residues from the wet-sieving programme also provides information on the coarser components within the 'Mesolithic Horizon' (context [92]) in Trench 19.

Grading the residues allows the size distribution of the coarser particles to be quantified (Table B4). These are fairly evenly distributed across the 3.35, 2 and 1 mm size fractions, contributing an average of 30.8%, 19.3% and 26.8.1% to the residue retained by the respective size sizes. Larger clasts (>8 mm) typically make a smaller contribution, ranging from 4.5% to 15.5% (mean 9.3%) of the total residue weight.

The principal contents of each sample are listed in (Table B5). A representative sample of each category was picked, but in most cases it would have been too time-consuming to collect all of the debitage and burnt flint. Material of anthropic origin is particularly common, most notably struck flint. The struck flint is mostly debitage, but cores, bladelets and microliths were also found. Flint nodules, many of which are fire-cracked and burnt, account for the bulk of the residue. Burnt organic remains are represented by small pieces of wood charcoal and occasional charred seeds and hazelnut shells. The effects of burning are also apparent in the large mammal remains. Some of the bones and teeth have been heated to high temperatures resulting in calcination, whereas others blackened suggesting lower temperatures or a shorter duration of exposure to fire. Unburnt fragments are invariably amorphous and rounded; tooth fragments are mostly from ungulates and include a range of sizes consistent with the species identified in the large mammal report (Rogers *et al. ibid.*).

Appendix B tables

Table B1: Smaller vertebrates from sieved samples. Counts represent the number of identified specimens (NISP); sub-samples from the Mesolithic horizon are ranked by NISP, from largest to smallest

	Trench 19 (Context)	[74]	[59]	[59]	[59]	[59]	[59]	[59]	[59]	[59]	[59]
	Sub-sample no.		92.17	92.4	92.16	77.1	92.3	92.11	92.12	92.10	92.14
Fish	Salmonid and pike		6	3	3	1	3	4	4	3	3
Anuran	Frog and/or toad		1	2		1	1				
Lacerta sp.	Lizard									1	
Insectivore											
Talpa europaea	Mole				2						
Sorex araneus	Common shrew								1		
Rodent											
Clethrionomys glareolus	Bank vole	1	19	9	4	8	4	4	3	4	4
Microtus sp.	Vole		2		1		2	1			
Arvicola terrestris	Water vole		1	1	2		2			1	
Microtine rodent	Vole		4	1	1			2	3	4	1
Apodemus sylvaticus	Wood mouse		1								
Apodemus flavicollis	Yellow-necked mouse		3			1		1			1
Apodemus sp.	Mouse	1	2			1				1	
Indet rodent		3	12	8	9	5	5	5	4		4
Small mammal			1				1				
Carnivore											
Martes sp.	Marten		1								
TOTAL (NISP)		5	53	24	22	17	17	17	16	14	13

Table B1: cont

	Trench 19 (Context)	[59]	[59]	[59]	[59]	[59]	[59]	[59]	[59]	[59]	[59]
	Sub-sample no.	92.2	92.15	92.6	92.8	92.13	92.18	92.5	92.1	92.9	92.7
Fish	Salmonid and pike	1	2				2	1			
Anuran	Frog and/or toad				1				1		
Lacerta sp.	Lizard										
Insectivore											
Talpa europaea	Mole										
Sorex araneus	Common shrew										
Rodent											
Clethrionomys glareolus	Bank vole	4	2	5	2	2		1		2	2
Microtus sp.	Vole	2									
Arvicola terrestris	Water vole	1				1					
Microtine rodent	Vole	2	2						1		
Apodemus sylvaticus	Wood mouse								1		
Apodemus flavicollis	Yellow-necked mouse	1									
Apodemus sp.	Mouse										
Indet rodent		1	5	4	2	1	2	1		1	
Small mammal					1	1					1
Carnivore											
Martes sp.	Marten										
TOTAL (NISP)		12	11	9	6	5	4	3	3	3	3

Table B2: Measurements of insectivore and rodent teeth from the Mesolithic horizon (context [59]) in Trench 19

Taxon	Measurement	
Sorex araneus		
12.4	P⁴ length	1.55 mm
Arvicola terrestris		
16.5	M¹ length	3.59 mm
	M¹ width	1.55 mm
Clethrionomys glareolus		
Assessment sample (77.1)	M_1 length	2.28 mm
3.5	M_2 length	1.37 mm
	M_2 width	0.72 mm
4.7	M_2 length	1.34 mm
	M_2 width	0.75 mm
11.7	M_2 length	1.40 mm
	M_2 width	0.79 mm
12.6	M_2 length	1.31 mm
	M_2 width	Broken
14.6	M_2 length	1.36 mm
	M_2 width	0.77 mm
8.2	M¹ length	1.85 mm
	M¹ width	0.93 mm
17.8	M¹ length	1.67 mm
	M¹ width	0.91 mm
17.19	M² length	1.33 mm
	M² width	0.77 mm
17.20	M² length	1.36 mm
	M² width	0.75 mm
Apodemus spp.		
Assessment sample (77.1)	Upper incisor A-P diameter	>1.45 mm (juvenile)
1.2	Upper incisor A-P diameter	>1.26 mm (juvenile)
11.5	Upper incisor A-P diameter	1.31 mm
14.4	Upper incisor A-P diameter	1.47 mm
17.10	Upper incisor A-P diameter	1.48 mm
2.2	M_1 length	1.70 mm
	M_1 width	1.01 mm
17.13	M_1 length	1.66 mm
	M_1 width	1.01 mm
17.14	M_1 length	Broken
	M_1 width	1.18 mm
17.15	M_2 length	1.25 mm
	M_2 width	1.11 mm

Ecofacts

Table B3: Summary statistics of measurements (in mm) of *Clethrionomys glareolus* molars from the Mesolithic horizon (context [59]) in Trench 19

Measurement	N	Range	Mean	SD
M_1 length	1		2.28	
M_2 length	5	1.31–1.40	1.36	0.03
M_2 width	4	0.72–0.79	0.76	0.03
M^1 length	2	1.67–1.85	1.76	
M^2 width	2	0.88–0.93	0.91	
M^2 length	2	1.33–1.36	1.34	
M^2 width	2	0.75–0.77	0.76	

Table B4: Blick Mead, Trench 19, context [92]: Weight of residues from wet-sieved bulk samples from the 1993 season

Sub-sample No.	8 mm		3.35 mm		2 mm		1 mm		<1 mm		Total
	Weight (g)	%	Weight (g)	%	Weight (g)	%	Weight (g)	%	Weight (g)	%	Weight (g)
92.1	9	7.1	61	48	29	22.8	28	22	-	-	127
92.2	24	8	76	25.5	57	19.1	90	30.2	51	17.1	298
92.3	38	12.7	66	22.1	55	18.5	87	29.2	52	17.4	298
92.4	40	7.1	129	22.9	113	20.1	189	33.6	92	16.3	563
92.5	6	4.5	58	43.9	26	19.7	26	19.7	16	12.1	132
92.6	27	9	82	27.3	53	17.7	86	28.7	52	17.3	300
92.7	14	4.7	72	24	58	19.3	95	31.7	61	20.3	300
92.8	90	13.9	222	34.2	153	23.6	167	25.8	16	2.5	648
92.9	9	7	26	20.2	26	20.2	39	30.2	29	22.4	129
92.10	59	14.9	115	29	59	14.9	86	21.7	77	19.4	396
92.11	49	8	146	23.9	121	19.8	192	31.5	102	16.7	610
92.12	88	14.1	176	28.3	116	18.6	153	24.6	89	14.3	622
92.13	62	10.8	226	39.4	106	18.5	132	23	48	8.4	574
92.14	68	10.5	248	38.2	114	17.6	169	26	50	7.7	649
92.15	66	8.3	268	33.6	162	20.3	206	25.8	95	11.9	797
92.16	165	9	724	39.6	375	20.5	387	21.2	177	9.7	1828
92.17	491	15.5	1109	35.1	516	16.3	694	21.9	353	11.2	3163
92.18	6	6.1	23	23.2	18	18.2	32	32.3	20	20.2	99
Total weight (g)	1311		3827		2157		2858		1380		11533

Table B5: Blick Mead, Trench 19, context [92]: Sediment inclusions from the samples sieved during the 2013 season

Sub-sample no.	Charred seeds	Charred wood	Charred hazelnut shell	Bones – large mammal	Bones – small mammal	Bones – fish	Bones – amphibian	Bones – reptile	Struck flint	Burnt/Fire-cracked flint
92.1		+	+	+	+		+		+	+
92.2		+		+	+	+			+	+
92.3		+		+	+	+	+		+	+
92.4	+	+		+	+	+	+		+	+
92.5		+		+	+	+			+	+
92.6		+	?	+	+				+	+
92.7				+	+				+	+
92.8	+	+		+	+		+		+	+
92.9		+		+	+				+	+
92.10		+		+	+	+		+	+	+
92.11		+		+	+	+			+	+
92.12		+		+	+	+			+	+
92.13		+	+	+	+				+	+
92.14		+	+	+	+	+			+	+
92.15		+	+	+	+	+			+	+
92.16		+		+	+	+			+	+
92.17		+		+	+	+	+		+	+
92.18		+	+	+	+	+			+	+

Figure B1: Trench 19, context [92]: Weight of residues retained by 8 mm, 3.35 mm, 2 mm and 1 mm sieve meshes. Within each size fraction, the samples are arranged according to total weight of residue, with the lightest on the left and heaviest on the right.

APPENDIX C

Miscellaneous Artefacts

The excavations produced various artefacts which post-date the Mesolithic and Neolithic occupation identified at Blick Mead, but which nevertheless merit description and publication. These comprise a Late Bronze Age copper alloy knife, a small assemblage of Iron Age pottery and an Anglo-Saxon disc brooch.

Appendix C1: Copper alloy knife
– Lorraine Mepham and Andrew Lawson

Catalogue

Short length of two-edged tapering copper alloy blade. Length 32 mm, tapering in width from 20 to 15 mm; thickness 2 mm. At the wider end, the blade is broken across a small circular perforation, placed centrally (a feature of the original casting, representing an axial rivet hole). The opposite end has been further damaged over the break. The blade has bevelled edges and a slight central ridge or midrib. There is a slight angularity to the central midrib on one side; on the opposite side, a transverse chevron appears to have been fairly crudely incised, though at what stage in the object's history is uncertain.

Found in spoil from Trench 14, Blick Mead, Vespasian's Camp, 2009.

Discussion

The object can be identified as part of a Late Bronze Age knife, re-using a Middle Bronze Age rapier or dagger. Such knives are relatively common; some were re-used objects, but by no means all. There are parallels, for instance, with examples from Ewart Park Tradition hoards from Norfolk, dating to around the ninth century BC, such as Eaton, Norwich (Norfolk Museums Service 1977, fig. 67) and Costessey (Woolhouse *et al.* 2008, fig. 8, no. 10), but there are other examples from sites closer to Vespasian's Camp, for example, an unstratified find from Wylye, Wiltshire (Moore and Rowlands 1972, no. 89).

The circumstances of the deposition of this object at Blick Mead remain uncertain. It is not obviously part of a hoard (few of this period are known from Wiltshire), or smith's collection. Isolated finds of metalwork are also relatively rare, although the scarcity of both hoards and isolated finds may be due more to a low incidence of metal detecting activity in a county which contains large areas of grassland, such as the Salisbury Plain Training Area than a real absence (Lawson 2007, 294). Deposition in a 'watery place', such as Blick Mead, could be seen as votive, and the knife may have been deliberately destroyed prior to deposition.

Appendix C2: Iron Age pottery
– Lorraine Mepham

A small group of pottery (ninety-five sherds) probably dates to the Iron Age, although the dating is proposed largely on the grounds of fabric, in the absence of much that is diagnostic.

The condition ranges from fair to good; there are two reconstructable part profiles, and in general sherds have suffered relatively low levels of surface and edge abrasion. This suggests a correspondingly low incidence of reworking and redeposition, although some of the pottery was recovered from various unstratified or poorly stratified contexts across the rampart. The assemblage also included a single piece (18 g) of fired clay comprising part of a flattish, slab-like piece with one slightly curving edge, possibly part of an oven plate.

Several fabric types were recorded, with the broad groupings of sandy wares, shelly wares, flint-gritted wares (i.e. flint inclusions probably incidental rather than added deliberately as temper) and grog-tempered wares. The shelly wares also contain glauconitic inclusions. Most of the fabrics appear relatively well finished; the sandy wares (including those containing rare flint or rare shell) are frequently burnished, and these could be regarded as a 'fineware' component of the assemblage.

The earliest sherds appear to be those from layer [52] (Trench 19), which have Early Iron Age characteristics: sparse flint inclusions, incised decoration on rims, and no obvious surface treatments. This also applies to six other sherds from the rampart.

Most of the remainder is more broadly dated as Early/Middle Iron Age. The most complete profile (recovered from a tree throw on the rampart) belongs to a convex jar with upright rim (with a rim diameter of c. 300 mm), in a fine sandy fabric containing sparse shell inclusions; the basal section is missing. In a similar fabric is the upper part of a smaller, shouldered (probably bipartite) vessel (either jar or bowl) with a short, everted rim (rim diameter c. 150 mm). This vessel is well burnished both inside and out, and can be described as a 'fineware' vessel.

A rim sherd in a sandy fabric containing sparse fine flint inclusions, also burnished throughout, may be from a similar fineware form, and there are other possible finewares in similar sandy/flint-gritted fabrics, generally highly burnished. Two came from the same badger throw on the rampart as the rim sherd just described: a jar with an applied, finger-impressed strip around the rim, and a body sherd with a horizontal row of stamped ring-and-dot motifs. There are three other decorated sherds from fineware vessels: a rim with finger impressions around the neck, a rounded jar with an everted rim and a body sherd with a slight raised cordon, while a small, heavily abraded body sherd in a very fine-grained sandy fabric, found by the spring line, carries impressed dot decoration in a triangular (probably chevron) zone. From elsewhere in the rampart, the rim from a thin-walled, fineware, long-necked bowl (either biconical or rounded), burnished externally, was recovered.

In contrast, identifiable coarseware vessel forms are limited to an inturned jar rim in a sandy fabric with rare coarse flint inclusions, with oblique slashes across the rim, and a jar with an internally bevelled rim, in a shelly fabric. An upright rim in a well-sorted shelly fabric could also be of this period, and perhaps represents a saucepan pot, although the sherd is too small for definitive identification.

There is little direct evidence for use: one shelly ware sherd is sooted externally, and one sparsely flint-gritted sherd, well finished, has a post-firing perforation, which could have been for repair purposes rather than relating directly to the vessel's function.

Otherwise, the fabrics (sandy, flint-gritted, shelly) find parallels in other Wiltshire assemblages of Early/Middle Iron Age date, but tending towards the latter end of that sequence, for example, Battlesbury Bowl, Warminster (Every and Mepham 2008), and there is a small group from Beach's Barn, Netheravon, dated as Middle/Late Iron Age, which includes a similar range of fabrics, although that group included clear Late Iron Age bead-rimmed forms (Wessex Archaeology 2001). Decorative traits, however, can be better accommodated within the Early Iron Age traditions of the region. Finger impressions on vessel necks (rather than on rims or shoulders) are not common, but there is a parallel on an Early Iron Age vessel from Gussage All Saints, Dorset (Wainwright 1979, fig. 57, 699),

and there are finger-impressed neck cordons amongst the Early Iron Age assemblage from Potterne (Gingell and Morris 2000, fig. 55, no. 67; fig. 58, no. 90). Stamped ring-and-dot motifs and incised chevrons infilled with dots form part of the decorative repertoire of the early All Cannings Cross stylistic group (Cunliffe 1991, fig. A:2). Comparisons with the large and relatively well-dated assemblage from Danebury and other sites in the Danebury environs suggest that there are parallels from a broad timespan, ranging from ceramic phases 1–2 (incorporating the early All Cannings Cross component, and dated to the seventh and sixth centuries BC) to ceramic phases 4–5 (mid- to late fourth century BC) (Cunliffe 1984; Cunliffe 1995, 17–18; Brown 2000).

Five grog-tempered sherds may extend the date range into the Late Iron Age, although these do not resemble the usual local Late Iron Age grog-tempered wares which are the precursors to the Savernake industry, and probably are no later in date than 50 BC. One is from a small, shouldered vessel with a short everted rim.

The survival of flint-tempered wares into the Late Iron Age in the region should also be noted, and one coarse flint-tempered sherd here resembles the 'Silchester ware' and related types of central Berkshire and north Hampshire (e.g. Timby 2000, 239–243).

Appendix C3: A possible Anglo-Saxon disc brooch
– *Jörn Schuster*

Catalogue

Fragmented copper alloy disc. Thick disc with circular (diameter 3.2 mm) central depression and two wide-spaced concentric lines (radius 9.2 mm and 18.2 mm). Outer edge rounded (from wear). Slightly more than one third of disc remaining, the rest has been broken off. Top and back sides with numerous variously aligned scratches, cuts and scrapes; square, c. 10 mm wide depression (probably from hammer face) on top side, located near outer edge and more undulating broken edge; broken edges unworn. Back side very uneven, with sub-rectangular raised area in centre. No remains of spring lugs or catchplate.

From western edge of spring pool, springline, 2010.
Copper alloy.
Measurements: Length 38.3 mm; Width 24.4 mm; Radius c. 21.5–22.4 mm; Thickness at centre 2.7 mm, at top corner of depression 2.3 mm, at outer edge opposite centre 2.6 mm, at corner opposite depression 2.1 mm; Weight 9.4 g.

Discussion

As a consequence of the fragmentary condition of the object, in particular the lack of lugs and catchplate for the attachment of spring and pin, its identification as an Anglo-Saxon disc brooch has to remain tentative. If this assumption is accepted as correct it is, however, possible to find parallels for some of its decorative and structural details among the corpus of disc brooches. The type is generally dated to the fifth and sixth centuries – particularly the period between c. AD 450 and 550 – and mainly distributed in southern England, with concentrations in the 'Saxon' Upper Thames area and later also becoming popular with Anglo-Saxons in the South Midlands and Cambridgeshire (cf. Dickinson 1979, 53, 69, fig. 3.1; Leeds 1945, 49–52, fig. 30). According to Dickinson (1979, 40) the diameters of the Upper Thames brooches range from 26 to 45 mm; with a reconstructed diameter of 43.0–44.8 mm, the example from the site would be one of the larger specimen. The simple decoration of two (or more)

concentric lines is, for example, found on one of the two disc brooches in the mid-fifth-century grave 3 at Minster Lovell (Dickinson 1979, 43, 72, fig. 3.4c), as well as in grave 75 at Long Wittenham I, (*ibid.*, fig. 3.12d), the late fifth-/early sixth-century grave 5 at Berinsfield (Boyle *et al.* 1995, 76–77, 167, fig. 52 grave 5, 1) and, more locally to Vespasian's Camp, in grave 84 at Collingbourne Ducis (Egging Dinwiddy and Stoodley 2016, 47, fig. 2.51, 137). No traces of white metal coating were noted on the brooch, which is in keeping with Dickinson's (1979, 41) observation of the Upper Thames brooches where c. 45% of the more ornate brooches exhibited this finish, while only 18% of the undecorated examples were treated in this manner.

It is possible that the object was deliberately damaged or broken up for subsequent use as raw material, probably with the help of a hammer as indicated by the square depression near the edge of the disc. Alternatively, this treatment may have been a deliberate attempt to put the object beyond use prior to a possible ritual deposition in the spring environment. Both aspects – breaking an object and deposition in a watery environment – are recurring themes of ritual actions in Indo-European religious practices from the Neolithic to the medieval period (Henig 1984, 17; Müller 2002, 31, 56–92; 2006, 111). While the deposition of brooches and other personal items in springs is more familiar in a Roman or Romano-British environment, as exemplified by the spring offerings to *Sulis Minerva* at Bath (Cunliffe 1988) or the large number of such items deposited in the sanctuary and pool at Springhead (Schuster 2011, 286–291), there is also a longstanding tradition of spring and wetland deposit in the Germanic world. Examples for the latter are for instance the deposit at Bad Pyrmont, where more than 250 brooches of the first to fourth century AD had been placed in a spring (Teegen 1999), or the large Scandinavian and North German bog deposits of the Pre-Roman and Roman Iron Age, which are now interpreted as representing the equipment of defeated armies (Lund 2010, 51 with further literature). The incidences of wetland deposits in England show continuity from the fourth to the eleventh century. As in Scandinavia these deposits are dominated by weapons, but also include jewellery and tools (*ibid.*, 53; Semple 2010, 31).

APPENDIX D

Supporting Data for Lithostratigraphy, Isotope Analysis and Radiocarbon Dating

Appendix D1: Lithostratigraphic descriptions

Table D1: Lithostratigraphic description of borehole <BH2>

Depth (m OD)	Depth (m bgs)	Composition
70.83 to 70.73	0.00 to 0.10	Ash and tarmac; Made Ground
70.73 to 70.58	0.10 to 0.25	Topsoil
70.58 to 69.18	0.25 to 1.65	Yellowish brown flinty clay; flint clasts mainly small but up to 40 mm; sharp contact with:
69.18 to 68.33	1.65 to 2.50	Chalk rubble in pale buff chalky matrix; chalk clasts mainly <2 mm; scattered flint clasts; gradual transition to:
68.33 to 66.94	2.50 to 3.89	Chalk rubble with pale yellowish red staining; chalk clasts up to 40 mm; well-marked transition to:
66.94 to 65.83	3.89 to 5.00	Solid chalk

Table D2: Lithostratigraphic description of borehole <BH3>

Depth (m OD)	Depth (m bgs)	Composition
68.68 to 68.20	0.00 to 0.48	Topsoil with brick fragments
68.20 to 67.93	0.48 to 0.75	Buff mottled orange red; flinty sandy clay; gradual transition to:
67.93 to 67.45	0.75 to 1.23	Greyish buff stoneless sandy clay; sharp contact with:
67.45 to 67.35	1.23 to 1.33	Chalk rubble (very wet); sharp contact with:
67.35 to 67.25	1.33 to 1.43	Greyish buff stoneless sandy clay (cf. 67.93–67.45); sharp contact with:
67.25 to 66.80	1.43 to 1.88	Gravel of sub-angular chalk clasts and scattered flint clasts with sparse matrix passing down to well-rounded chalk clasts in sandy matrix
66.80 to 66.68	1.88 to 2.00	Void
66.68 to 65.68	2.00 to 3.00	Fine gravel of flint and chalk clasts in sandy matrix

Table D3: Lithostratigraphic description of borehole <BH4>

Depth (m OD)	Depth (m bgs)	Composition
69.13 to 69.02	0.00 to 0.11	Topsoil
69.02 to 67.49	0.11 to 1.64	Blocky chalk rubble
67.49 to 67.38	1.64 to 1.75	Compacted plant debris and pieces of roundwood
67.38 to 67.26	1.75 to 1.87	Blocky chalk rubble
67.26 to 67.13	1.87 to 2.00	Brownish grey gritty clayey silt
67.13 to 66.56	2.00 to 2.57	Void and coring debris
66.56 to 65.13	2.57 to 4.00	Fine gravel of chalk and flint in clayey chalky matrix becoming sandy and silty downward; chalk clasts mainly small (<10 mm) and well rounded

Table D4: Lithostratigraphic description of borehole <BH5>

Depth (m OD)	Depth (m bgs)	Composition
68.86 to 68.73	0.00 to 0.13	VOID
68.73 to 68.41	0.13 to 0.45	Chalk rubble (spoil)
68.41 to 68.15	0.45 to 0.71	VOID
68.15 to 68.11	0.71 to 0.75	Ag2 As1 Sh1 Ga+; dark brown organic clayey silt with a trace of sand. Diffuse contact in to:
68.11 to 67.56	0.75 to 1.30	Ag2 As1 Ga1 Gg+; grey sandy clayey silt with occasional gravel clasts. Some iron staining. Diffuse contact in to:
67.56 to 67.31	1.30 to 1.55	Ag2 As2 Gg+; grey silt and clay with rare gravel clasts. Sharp contact in to:
67.31 to 67.16	1.55 to 1.70	Ga2 Ag1 As1 Gg+; light grey clayey silty sand with rare gravel clasts
67.16 to 66.96	1.70 to 1.90	Gg2; Ga1 Ag1; white silty sandy gravel. Clasts mainly flint. Sharp contact in to:
66.96 to 66.91	1.90 to 1.95	Ag2 As2 Gg+; grey silt and clay with rare gravel clasts. Sharp contact in to:
66.91 to 66.86	1.95 to 2.00	Gg2; Ga1 Ag1; white silty sandy gravel. Clasts mainly flint
66.86 to 65.86	2.00 to 3.00	Ga2 Gg2; white sand and gravel. Clasts of flint and chalk

Table D5: Lithostratigraphic description of borehole <BH6>

Depth (m OD)	Depth (m bgs)	Composition
68.72 to 68.64	0.00 to 0.08	VOID
68.64 to 68.42	0.08 to 0.30	Ag2 As1 Sh1 Ga+; dark brown organic clayey silt with a trace of sand (topsoil). Diffuse contact in to:
68.42 to 68.22	0.30 to 0.50	Chalk rubble (spoil). Sharp contact in to:
68.22 to 67.27	0.50 to 1.45	Ag2 As1 Ga1 Gg+; grey sandy clayey silt with occasional gravel clasts of flint. Some iron staining. Diffuse contact in to:
67.27 to 66.82	1.45 to 1.90	Ga2 Ag1 As1 Gg+; light grey clayey silty sand with rare gravel clasts
66.82 to 66.72	1.90 to 2.00	Gg2 Ga1 Ag1; greenish grey sandy silty gravel with flint and chalk clasts
66.72 to 65.72	2.60 to 3.00	Gg3 Ga1 Ag+; greenish grey sandy gravel with a trace of silt. Clasts of chalk and flint

Table D6: Lithostratigraphic description of borehole <BH7>

Depth (m OD)	Depth (m bgs)	Composition
70.04 to 69.74	0.00 to 0.30	Ag2 As1 Sh1 Ga+; dark brown organic clayey silt with a trace of sand (topsoil). Sharp contact in to:
69.74 to 69.04	0.30 to 1.00	Chalk rubble (spoil)
69.04 to 68.04	1.00 to 2.00	Chalk rubble with redeposited Alluvium/Colluvium (spoil)
68.04 to 67.77	2.00 to 2.27	Ag2 As1 Sh1 Ga+; dark brown organic clayey silt with a trace of sand. Diffuse contact in to:
67.77 to 67.44	2.27 to 2.60	Ag2 As1 Ga1 Gg+; grey sandy clayey silt with occasional gravel clasts of flint and chalk. Some iron staining. Sharp contact in to:
67.44 to 67.24	2.60 to 2.80	Ag2 As2 Gg+; grey silt and clay with rare gravel clasts, including a possible flint flake. Sharp contact in to:
67.24 to 67.12	2.80 to 2.92	Ga2 Ag1 As1 Gg+; light grey clayey silty sand with rare gravel clasts. Sharp contact in to:
67.12 to 67.09	2.92 to 2.95	Ag2 As2; brown silt and clay. Sharp contact in to:
66.54 to 66.54	2.95 to 3.50	Gg2; Ga1 Ag1; white silty sandy gravel. Clasts mainly flint. Sharp contact in to:
66.54 to 66.29	3.50 to 3.75	Gg3 Ga1; greyish white sandy gravel with flint and chalk clasts. Diffuse contact in to:
66.29 to 66.04	3.75 to 4.00	Gg3 Ga1; orange sandy gravel with chalk and flint clasts

Table D7: Lithostratigraphic description of borehole <BH8>

Depth (m OD)	Depth (m bgs)	Composition
69.48 to 69.33	0.00 to 0.15	Ag2 As1 Sh1 Ga+; dark brown organic clayey silt with a trace of sand (topsoil). Sharp contact in to:
69.33 to 68.53	0.15 to 0.95	Chalk rubble (spoil)
68.53 to 68.48	0.05 to 1.00	Sh2 Ag1 As1; dark brown very organic silt and clay
68.48 to 68.12	1.00 to 1.36	Chalk rubble (spoil)
68.12 to 68.03	1.36 to 1.45	Sh2 Ag1 As1; dark brown very organic silt and clay. Contact obscured
68.03 to 67.91	1.45 to 1.57	Ag2 As1 Ga1 Gg+; grey sandy clayey silt with occasional gravel clasts. Some iron staining. Diffuse contact in to:
67.91 to 67.73	1.57 to 1.75	Ag3 As1 Dl+ Gg+; grey blue clayey silt with a trace of detrital wood and rare gravel clasts. Sharp contact in to:
67.73 to 67.48	1.75 to 2.00	Gg3 Ga1 Ag+; white sandy gravel with a trace of silt. Clasts of flint and chalk

Table D8: Lithostratigraphic description of borehole <BH9>

Depth (m OD)	Depth (m bgs)	Composition
69.52 to 69.40	0.00 to 0.12	Ag2 As1 Sh1 Ga+; dark brown organic clayey silt with a trace of sand (topsoil). Sharp contact in to:
69.40 to 68.30	0.12 to 1.22	Chalk rubble (spoil). Sharp contact in to:
68.30 to 68.07	1.22 to 1.45	Ag2 As1 Sh1 Ga+; dark brown organic clayey silt with a trace of sand. Contact obscured
68.07 to 67.81	1.45 to 1.71	Chalk rubble (spoil). Sharp contact in to:
67.81 to 67.43	1.71 to 2.09	Ag2 As1 Ga1 Dh+ Dl+; grey brown sandy clayey silt with a trace of detrital herbaceous material and a trace of detrital wood. One possible flint flake. Occasional Fragments of Mollusca. Sharp contact in to:
67.43 to 67.07	2.09 to 2.45	Ag2 As1 Ga1; green blue clayey sandy silt. Contact obscured
67.07 to 66.97	2.45 to 2.55	Ga3 Ag1; dark olive green silty sand. Sharp contact in to:
66.97 to 66.87	2.55 to 2.65	Ag2 As1 Ga1; green blue clayey sandy silt. Sharp contact in to:
66.87 to 66.52	2.65 to 3.00	Gg2 Ga1 Ag1; greyish white sandy silty gravel with chalk and flint clasts

Table D9: Lithostratigraphic description of borehole <BH10>

Depth (m OD)	Depth (m bgs)	Composition
69.29 to 69.19	0.00 to 0.10	VOID
69.19 to 69.03	0.10 to 0.26	Ag2 As1 Sh1 Ga+; dark brown organic clayey silt with a trace of sand (topsoil). Sharp contact in to:
69.03 to 68.57	0.26 to 0.72	Chalk rubble (spoil). Sharp contact in to:
68.57 to 68.47	0.72 to 0.82	Ag2 As1 Sh1 Ga+; dark brown organic clayey silt with a trace of sand
68.47 to 68.09	0.82 to 1.20	Chalk rubble (spoil). Sharp contact in to:
68.09 to 67.84	1.20 to 1.45	Ag2 As1 Ga1 Gg+; grey sandy clayey silt with occasional gravel clasts of flint. Some iron staining. Diffuse contact in to:
67.84 to 67.61	1.45 to 1.68	Ag2 As2 Gg+; grey silt and clay with rare gravel clasts. Sharp contact in to:
67.61 to 67.29	1.68 to 2.00	Gg2 Ga1 Ag1; greenish grey sandy silty gravel with flint and chalk clasts

Table D10: Lithostratigraphic description of borehole <BH11>

Depth (m OD)	Depth (m bgs)	Composition
68.60 to 68.35	0.00 to 0.25	Ag2 As1 Sh1 Ga+; dark brown organic clayey silt with a trace of sand (topsoil). Sharp contact in to:
68.35 to 67.97	0.25 to 0.63	Chalk rubble (spoil). Sharp contact in to:
67.97 to 67.45	0.63 to 1.15	Ag2 As1 Ga1 Gg+; grey sandy clayey silt with occasional gravel clasts of flint. Some iron staining. Diffuse contact in to:
67.45 to 67.15	1.15 to 1.45	Gg2 Ga1 Ag1; grey going in to orange sandy silty gravel. Contact obscured
67.15 to 67.00	1.45 to 1.60	Ga3 Ag1; grey silty sand. Diffuse contact in to:
67.00 to 66.75	1.60 to 1.85	Gg2 Ga1 Ag1; greenish grey sandy silty gravel with flint and chalk clasts. Sharp contact in to:
66.75 to 66.60	1.85 to 2.00	Gg3 Ga1; sandy gravel with large (>40 mm) flint clasts

Table D11: Lithostratigraphic description of borehole <BH12>

Depth (m OD)	Depth (m bgs)	Composition
68.86 to 68.76	0.00 to 0.10	VOID
68.76 to 68.56	0.10 to 0.30	Ag2 As1 Sh1 Ga+; dark brown organic clayey silt with a trace of sand (topsoil). Sharp contact in to:
68.56 to 68.31	0.30 to 0.55	Chalk rubble (spoil). Sharp contact in to:
68.31 to 68.26	0.55 to 0.60	Ag2 As1 Sh1 Ga+; dark brown organic clayey silt with a trace of sand. Diffuse contact in to:
68.26 to 67.30	0.60 to 1.56	Ag2 As1 Ga1 Gg+; grey sandy clayey silt with occasional flint clasts. Becoming very gravelly at base. Some iron staining. Diffuse contact in to:
67.30 to 66.86	1.56 to 2.00	Gg3 Ga1 Ag+; greenish grey sandy gravel with a trace of silt. Clasts of chalk and flint

Table D:12: Lithostratigraphic description of borehole <BH13>

Depth (m OD)	Depth (m bgs)	Composition
69.01 to 68.66	0.00 to 0.35	Dark brown soil debris
68.66 to 68.56	0.35 to 0.45	Clayey soil with chalk clasts
68.56 to 68.45	0.45 to 0.56	Blocky chalk
68.45 to 68.34	0.56 to 0.67	10YR3/4 dark yellowish brown; moderately sorted gritty stoneless silty clay; crumb structure; common root remains; scattered detrital plant remains; scattered broken mollusc shell; moderate acid reaction; well-marked transition to:
68.34 to 68.16	0.67 to 0.85	10YR3/3 dark brown; moderately to well-sorted slightly sandy stoneless silty clay; massive structure; scattered root and detrital plant remains; worm granules; scattered broken mollusc shell; moderate acid reaction; well-marked transition (with cluster of flint clasts) to:
68.16 to 67.71	0.85 to 1.30	10YR3/2 very dark greyish brown with 2.5YR4/6 red mottles passing down to 2.5Y3/2 very dark greyish brown with 2.5YR4/6 red mottles; well-sorted slightly sandy silty clay with scattered flint clasts (up to 30 mm); massive structure; small (up to 1 mm) particles of charcoal in upper part (down to c. 68.00 m OD); possible flint flake at 68.03 m OD; several pieces of burnt flint between 67.83 and 67.72 m OD; no acid reaction; sharp contact with:
67.71 to 67.62	1.30 to 1.39	5Y4/1 dark grey; well-sorted silty sand (fine to medium) with scattered flint clasts (up to 10 mm); massive structure; no acid reaction; sharp contact with:
67.62 to 67.07	1.39 to 1.94	Greenish grey to pale brown; clayey sandy gravel of flint and chalk clasts

Table D13: Lithostratigraphic description of borehole <BH14>

Depth (m OD)	Depth (m bgs)	Composition
68.78 to 68.20	0.00 to 0.58	10YR2/2 very dark brown passing down to 10YR3/2 dark greyish brown; poorly sorted gritty sandy silty clay with chalk and flint clasts (up to 15 mm); massive/crumby structure; scattered root remains; common detrital plant remains; worm granules; weak acid reaction; sharp contact with:
68.20 to 67.91	0.58 to 0.87	2.5Y5/2 greyish brown; well-sorted clayey silty fine to medium sand with scattered chalk clasts (up to 10 mm) in upper few cms; massive structure; scattered root and detrital plant remains; weak acid reaction; sharp contact (marked by 50 mm flint clast) to:
67.91 to 67.33	0.87 to 1.45	2.5Y4/3 olive brown passing down to 2.5Y4/1 dark greyish brown; poorly sorted sandy silty clay with flint clasts, small (10–15 mm) with cluster of larger; common root and detrital plant remains; common worm granules; broken and occasional complete mollusc shell; burnt flint at 67.79 m OD; moderate to strong acid reaction; sharp contact with:
67.33 to 66.78	1.45 to 2.00	Greyish green to pale brown; well-sorted slightly silty stoneless fine to medium sand; bedded; slight root penetration (<10 mm) from overlying unit; strong acid reaction

Table D14: Lithostratigraphic description of borehole <BH15>

Depth (m OD)	Depth (m bgs)	Composition
68.82 to 68.74	0.00 to 0.08	VOID
68.74 to 68.49	0.08 to 0.33	Ag2 As1 Sh1 Ga+; dark brown organic clayey silt with a trace of sand (topsoil). Sharp contact in to:
68.49 to 68.37	0.33 to 0.45	Chalk rubble (spoil). Sharp contact in to:
68.37 to 67.72	0.45 to 1.10	Ag2 As1 Ga1 Gg+; grey brown sandy clayey silt with occasional chalk and flint clasts. Some iron staining. Diffuse contact in to:
67.72 to 67.52	1.10 to 1.30	Ag2 As2 Gg+; grey silt and clay with rare gravel clasts. Sharp contact in to:
67.52 to 67.31	1.30 to 1.51	Ag2 As1 Ga1; greyish blue sandy clayey silt. Sharp contact in to:
67.31 to 67.17	1.51 to 1.65	Ga3 Ag1; grey silty sand. Sharp contact in to:
67.17 to 66.82	1.65 to 2.00	Gg2 Ga1 Ag1; greyish white silty sandy gravel

Table D15: Lithostratigraphic description of borehole <BH16>

Depth (m OD)	Depth (m bgs)	Composition
69.34 to 69.19	0.00 to 0.15	VOID
69.19 to 68.94	0.15 to 0.40	Ag2 As1 Sh1 Ga+; dark brown organic clayey silt with a trace of sand (topsoil). Sharp contact in to:
68.94 to 68.68	0.40 to 0.66	Chalk rubble (spoil). Sharp contact in to:
68.68 to 68.51	0.66 to 0.83	Ag2 As1 Sh1 Ga+; dark brown organic clayey silt with a trace of sand. Sharp contact in to:
68.51 to 67.34	0.83 to 2.00	Chalk rubble (spoil). Sharp contact in to:
67.34 to 66.34	2.00 to 3.00	Gg3 Ga1; sandy gravel. Clasts are flint and chalk

Table D16: Lithostratigraphic description of borehole <BH17>

Depth (m OD)	Depth (m bgs)	Composition
69.10 to 69.00	0.00 to 0.10	VOID
69.00 to 68.75	0.10 to 0.35	Ag2 As1 Sh1 Ga+; dark brown organic clayey silt with a trace of sand (topsoil). Sharp contact in to:
68.75 to 68.32	0.35 to 0.78	Chalk rubble (spoil). Sharp contact in to:
68.32 to 68.17	0.78 to 0.93	Ag2 As1 Sh1 Ga+; dark brown organic clayey silt with a trace of sand (topsoil). Sharp contact in to:
68.17 to 67.82	0.93 to 1.28	Chalk rubble (spoil). Sharp contact in to:
67.82 to 67.45	1.28 to 1.65	Sh2 Ag2 Th+; Humo. 3/4; dark reddish brown well-humified silty peat with a trace of herbaceous material. Seeds of buttercup and bogbean observed. Diffuse contact in to:
67.45 to 66.42	1.65 to 2.68	Ag2 As2 Dh+ Gg+; grey silt and clay with a trace of detrital herbaceous material and occasional gravel clasts. Some possible flint flakes recorded
66.42 to 66.10	2.68 to 3.00	Ag2 As1 Gg1 Dh+; grey clayey silt with gravel clasts and a trace of detrital herbaceous material. Some possible flint flakes recorded
66.10 to 65.50	3.00 to 3.60	Gg3 Ga1; orangey grey sandy gravel of chalk and flint. Sharp contact in to:
65.50 to 65.30	3.60 to 3.80	Gg3 Ga1; greyish white sandy gravel of chalk and flint. Sharp contact in to:
65.30 to 65.10	3.80 to 4.00	Chalk (bedrock)

Table D17: Lithostratigraphic description of borehole <BH18>

Depth (m OD)	Depth (m bgs)	Composition
68.61 to 68.34	0.00 to 0.27	Chalky rubble overlain by thin dark brown soil
68.34 to 68.33	0.27 to 0.28	Dark brown soil material
68.33 to 67.97	0.28 to 0.64	Chalky rubble
67.97 to 67.61	0.64 to 1.00	10YR3/3 dark brown; well-sorted stoneless peaty silt; massive and compact; common root and detrital plant remains; worm granules; broken mollusc shell; strong acid reaction; contact not seen
67.61 to 67.17	1.00 to 1.44	10YR2/2 very dark brown; peat – humified and compact above, paler and less compact below, no visible mineral content; sharp contact with:
67.17 to 67.04	1.44 to 1.57	10YR4/3 brown; very well-sorted stoneless silt; massive structure; common root remains; scattered detrital plant remains; worm granules; scattered whole and broken mollusc shell; strong acid reaction; sharp contact with:
67.04 to 66.91	1.57 to 1.70	10YR2/2 very dark brown; peat
66.91 to 66.85	1.70 to 1.76	10YR3/2 very dark greyish brown; very well-sorted peaty silt passing down to silt; massive structure; common root remains; scattered detrital plant remains; no acid reaction; sharp contact with:
66.85 to 65.89	1.76 to 2.72	10YR3/2 very dark brown; silty peat with scattered sand grains and granules of flint, becoming increasingly silty and clayey downward, scattered larger clasts of flint (up to 40 mm), including clusters at 66.66–66.61 m OD and 65.94–65.89 m OD; no acid reaction; well-marked transition to:
65.89 to 65.76	2.72 to 2.85	10YR3/3 dark brown; poorly sorted 'gravel' of flint clasts (mainly <20 mm, but 60 mm clast at base); weak acid reaction; sharp contact with:
65.76 to 65.61	2.85 to 3.00	Dark greyish green passing down to light grey speckled with dark green; well-sorted fine to medium sand; bedded; moderate acid reaction

Table D18: Lithostratigraphic description of borehole <BH19>

Depth (m OD)	Depth (m bgs)	Composition
68.37 to 68.21	0.00 to 0.16	VOID
68.21 to 68.01	0.16 to 0.36	Ag2 As1 Sh1 Ga+; dark brown organic clayey silt with a trace of sand (topsoil). Sharp contact in to:
68.01 to 67.75	0.36 to 0.62	Chalk rubble (spoil). Sharp contact in to:
67.75 to 67.42	0.62 to 0.95	Ag2 As2 Gg+; grey silt and clay with rare gravel clasts. Occasional Mollusca fragments. Sharp contact in to:
67.42 to 67.10	0.95 to 1.27	Sh2 Ag2; Th+; Humo. 3/4; dark reddish brown well-humified silty peat with a trace of herbaceous material. Sharp contact in to:
67.10 to 66.97	1.27 to 1.40	Ag2 As2; dark grey silt and clay. Contact obscured
66.97 to 66.75	1.40 to 1.62	Ag3 As1 Dh+; grey clayey silt with a trace of detrital herbaceous material and occasional Mollusca fragments. Diffuse contact in to:
66.75 to 66.02	1.62 to 2.35	Ag3 As1 Ga+ Dh+; grey clayey silt with a trace of detrital herbaceous material and sand. Frequent Mollusca fragments. Diffuse contact in to:
66.02 to 65.72	2.35 to 2.65	Ga2 Ag2; grey silt and sand. Sharp contact in to:
65.72 to 65.57	2.65 to 2.80	Gg2 Ag1 Ga1; greyish white sandy silty gravel. Diffuse contact in to:
65.57 to 65.37	2.80 to 3.00	Gg3 Ga1; sandy flint gravel

Table D19: Lithostratigraphic description of borehole <BH20>

Depth (m OD)	Depth (m bgs)	Composition
69.94 to 69.79	0.00 to 0.15	Ag2 As1 Sh1 Ga+; dark brown organic clayey silt with a trace of sand (topsoil). Sharp contact in to:
69.79 to 68.49	0.15 to 1.45	Chalk rubble (spoil). Sharp contact in to:
68.49 to 68.39	1.45 to 1.55	Ag2 As1 Sh1 Ga+; dark brown organic clayey silt with a trace of sand. Sharp contact in to:
68.39 to 67.94	1.55 to 2.00	Chalk rubble (spoil). Sharp contact in to:
67.94 to 67.42	2.00 to 2.52	Ag2 As2 Gg+; blue grey silt and clay with occasional gravel clasts. Sharp contact in to:
67.42 to 67.12	2.52 to 2.82	Ag2 As1 Ga1; greenish grey sandy clayey silt. Sharp contact in to:
67.12 to 66.94	2.82 to 3.00	Gg2 Ga1 Ag1; greenish grey silty sandy gravel. Clasts are chalk and flint
66.94 to 65.94	3.00 to 4.00	Gg2 Ga1 Ag1; greenish grey silty sandy gravel. Clasts are chalk and flint and larger than unit above

Table D20: Lithostratigraphic description of borehole <BH21>

Depth (m OD)	Depth (m bgs)	Composition
68.89 to 68.87	0.00 to 0.02	10YR2/2 very dark brown; poorly sorted gritty silty clay with flint particles (up to 5 mm); massive structure; common root and detrital plant remains; no acid reaction; contact not seen
68.87 to 67.49	0.02 to 1.40	10YR4/2 dark greyish brown; moderately sorted slightly gritty/sandy silty clay; with flint clasts (mainly <15 mm but up to 45 mm) and scattered small chalk clasts; massive structure; common root and detrital plant remains; worm granules (mainly below 68.00 m OD); scattered broken mollusc shell (mainly below 68.00 m OD); no acid reaction; well-marked transition to:
67.49 to 67.34	1.40 to 1.55	5Y4/2 olive grey; well-sorted slightly sandy silty clay with scattered sub-angular flint clasts (up to 40 mm); common root remains; scattered detrital plant remains; worm granules; strong acid reaction; very sharp contact with:

Depth (m OD)	Depth (m bgs)	Composition
67.34 to 67.16	1.55 to 1.73	Greyish green flecked with white; well-sorted slightly silty/clayey fine to medium sand with scattered sub-angular flint clasts (up to 35 mm); bedded; strong acid reaction; very sharp contact with:
67.16 to 66.12	1.73 to 1.77	10YR7/3 very pale brown; very well-sorted clayey silt; massive structure; very sharp contact with:
66.12 to 66.89	1.77 to 2.00	Greyish green flecked with white; well-sorted slightly clayey/silty fine to medium sand with beds of fine gravel of small (<25 mm) rounded chalk clasts; bedded; strong acid reaction (cf. 67.34–67.16)

Table D21: Lithostratigraphic description of borehole <BH22>

Depth (m OD)	Depth (m bgs)	Composition
68.80 to 68.62	0.00 to 0.28	Ga2 Ag2 Gs+; very dark greyish brown sandy silty topsoil. Rooting present, some flint at base. Inclusion of some calcareous material. Sharp contact in to:
68.62 to 68.34	0.28 to 0.46	Gs2 Ag1 Ga1; light grey chalk rubble (silt/sand sized), chalk size between 1 and 5 mm. Sharp contact in to:
68.34 to 68.24	0.46 to 0.56	As2 Ag1 Ga1; dark greyish brown silty sandy clay. Some iron mottling, small piece of flint and no evidence of charcoal. Diffuse contact in to:
68.24 to 68.20	0.56 to 0.60	As2 Ag1 Ga1; dark greyish brown sandy silty clay. Iron and charcoal presence, making up 25% of the unit. Sharp contact in to:
68.20 to 68.17	0.60 to 0.63	Gg4; flint horizon – single large piece of shattered flint. Sharp contact in to:
68.17 to 67.93	0.63 to 0.87	As2 Sh1 Ag1 Gg+; dark greyish brown organic silty clay with traces of gravel. Presence of shell, iron mottling, flint (up to 3 cm). Diffuse contact in to:
67.93 to 67.87	0.87 to 0.93	Gs1 Gg1 Sh1 As1; very dark greyish brown organic, sandy gravelly clay. More iron mottling and extensive charcoal evidence, some small pieces of flint (up to 5 mm). Diffuse contact in to:
67.87 to 67.74	0.93 to 1.06	As2 Ga1 Gs1 Gg+; dark greyish brown sand and clay with occasional gravel clasts. Charcoal and iron traces (though less than overlying unit), some flint clasts. Diffuse contact in to:
67.74 to 67.63	1.06 to 1.17	As2 Ga1 Ag1 Sh+; very dark grey sandy, silty clay with a trace of organic matter. Increase in iron and charcoal remains from overlying unit, some shell and calcareous material. Diffuse contact in to:
67.63 to 67.56	1.17 to 1.24	As2 Ga1 Ag1; brown silty sandy clay. Frequent charcoal and iron fragments, possible manganese staining. Sharp contact in to:
67.56 to 67.22	1.24 to 1.58	Ga1 Gs1 As1 Ag1; light yellowish brown silty, clayey sand. Extensive charcoal and iron mottling. Incorporation of calcareous rock, and some large flint, up to 3 cm wide. Sharp contact in to:
67.22 to 67.13	1.58 to 1.67	Gg4; flint gravel. Sharp contact in to:
67.13 to 67.04	1.67 to 1.76	Gs2 Ga1 Gg1; light olive brown gravelly sand. Clasts are mostly flint, some calcareous material. Diffuse contact in to:
67.04 to 66.96	1.76 to 1.84	Gg3 Gs1 Ga+; light olive brown sandy flint gravel. Diffuse contact in to:
66.96 to 66.80	1.84 to 2.00	Gg2 Gs2; pale olive gravel and coarse sand. Large clasts (up to 3 cm) of flint and chalk in green sand.

Table D22: Lithostratigraphic description of borehole <BH23>

Depth (m OD)	Depth (m bgs)	Composition
68.83 to 68.56	0.00 to 0.27	Dark soil
68.56 to 68.40	0.27 to 0.43	Chalk rubble
68.40 to 67.71	0.43 to 1.12	10YR3/4 dark yellowish brown with 2.5YR 4/6 red mottles passing down to 2.5Y4/2 dark greyish brown; moderately to poorly sorted gritty/sandy silty clay/clayey silt with flint clasts (up to 50 mm); massive structure; very scattered root and detrital plant remains; burnt flint present between 67.83 and 67.71 m OD; no acid reaction; sharp contact with:
67.71 to 67.25	1.12 to 1.58	2.5Y5/3 light olive brown with patchy iron and manganese staining; well-sorted slightly sandy clayey silt with scattered small (<15 mm) clasts of chalk in uppermost few cms; massive structure; scattered detrital plant remains; moderate acid reaction; sharp contact with:
67.25 to 66.83	1.58 to 2.00	Pale grey; poorly sorted slightly clayey/silty sandy gravel

Table D23: Lithostratigraphic description of borehole <BH24>

Depth (m OD)	Depth (m bgs)	Composition
70.64 to 70.38	0.00 to 0.26	VOID
70.38 to 70.24	0.26 to 0.40	Ag3 As1 Ga+ Gg+ Sh+; dark brown slightly organic clayey silt with traces of sand and gravel (topsoil). Diffuse contact in to:
70.24 to 69.04	0.40 to 1.60	As3 Ag1 Ga+ Gg+; orangey brown clayey silt with traces of sand and gravel (flint clasts). Diffuse contact in to:
69.04 to 68.37	1.60 to 2.27	As2 Ag1 Gg1; orangey brown gravelly silty clay
68.37 to 68.19	2.27 to 2.45	Weathered chalk bedrock. Diffuse contact in to:
68.19 to 67.64	2.45 to 3.00	Chalk bedrock

Table D24: Lithostratigraphic description of borehole <BH25>

Depth (m OD)	Depth (m bgs)	Composition
68.75 to 68.49	0.00 to 0.26	Void
68.49 to 68.31	0.26 to 0.44	10YR4/3 brown; slightly gritty moderately sorted silty clay with clasts up to 5 mm (mainly chalk) at base a 35 mm piece of ?road metal; crumby; common roots and root channels and detrital plant remains; worm granules; broken mollusc shell; strong acid reaction; sharp contact with:
68.31 to 68.23	0.44 to 0.52	10YR5/3–6/3 brown to pale brown; chalk rubble; sharp contact with:
68.23 to 67.88	0.57 to 0.87	10YR4/2 dark greyish brown; moderately to poorly sorted slightly gritty silty clay; massive; scattered root and detrital plant remains; strong acid reaction; very sharp contact with:
67.88 to 67.75	0.87 to 1.00	10YR2/2 very dark brown; peat; inclusion of material resembling 057–087 at 096
67.75 to 67.69	1.00 to 1.06	Void
67.69 to 66.75	1.06 to 2.00	10YR2/2 very dark brown; peat; a few very small (<1 mm) particles of flint, otherwise very little visible mineral content; a very small (c. 1 mm) piece of mollusc shell
66.75 to 66.55	2.00 to 2.20	Coring spoil; sharp steeply inclined contact at 020–030 between coring spoil and underlying peat
66.75 to 66.10	2.20 to 2.65	10YR2/2 very dark brown; peat with very scattered small (<5 mm) pieces of white flint; piece (10 mm) of burnt flint at 052; very sharp contact with:

Depth (m OD)	Depth (m bgs)	Composition
66.10 to 65.88	2.65 to 2.87	5Y7/2–6/2 light grey to light olive grey, becoming dull green in places; well-sorted slightly sandy silt with beds of well-sorted fine sand at 66–67, 72–75, 85–87; bedded; scattered detrital plant remains; well-marked transition to:
65.88 to 65.78	2.87 to 2.97	Poorly sorted clayey chalky sandy gravel with clasts of sub-angular flint up to 30 mm long dimension
65.78 to 65.75	2.97 to 3.00	Void

Table D25: Lithostratigraphic description of borehole <S2BH1>, Site 2

Depth (m OD)	Depth (m bgs)	Composition
69.30 to 69.17	0.00 to 0.13	7.5YR 3/2; Ag2 Ga1 Gg1; dark brown top soil, inclusion of roots and stems. Diffuse contact in to:
69.17 to 68.08	0.13 to 1.22	7.5YR 6/1; grey chalk rubble (some large pieces of chalk mixed with soil material). Sharp contact in to:
68.08 to 67.98	1.22 to 1.32	7.5YR 6/1; Ga1 Gs1 Gg2; grey sandy chalk. Diffuse contact in to:
67.98 to 67.45	1.32 to 1.85	Ag2 Th22; wet 'putty' chalk deposit mixed with peat running horizontally through core – either mixed in A303 construction, or borehole hit edge of a channel. Diffuse contact in to:
67.45 to 67.35	1.85 to 1.95	5YR 3/1; Th42 Sh2; very dark brown peat, very well-humified. Diffuse contact in to:
67.35 to 67.32	1.95 to 1.98	2.5 YR 2.5/1; As2 Ag2; black sticky organic layer containing macro/micro charcoal and burnt flint. Sharp contact in to:
67.32 to 67.29	1.98 to 2.01	As2 Ag2 Gg+; Gravel & chalk inclusion, sticky black organic layer containing macro/micro charcoal, and burnt flint. Diffuse contact in to:
67.29 to 67.25	2.01 to 2.05	7.5YR 2.5/1; Ag2 Gg2; black silt horizon with charcoal and flint inclusions. Diffuse contact in to:
67.25 to 67.08	2.05 to 2.22	7.5YR 3/1; As2 Ag2; very dark grey sticky black organic layer containing macro/micro charcoal. Diffuse contact in to:
67.08 to 66.74	2.22 to 2.56	Gley 1 6/10Y; Ag2 Gs1 Ga1 Tl+; greenish grey chalky grey silt with green/blue sand lens at 2.32–2.36 m bgs, some banding of greensand and chalk. Sharp contact in to:
66.74 to 66.58	2.56 to 2.72	5Y 7/1; light grey wet 'putty' chalk deposit, possible spoil from coring

Table D26: Lithostratigraphic description of borehole <S2BH2>, Site 2

Depth (m OD)	Depth (m bgs)	Composition
69.30 to 69.06	0.00 to 0.24	Void
69.06 to 68.95	0.24 to 0.35	7.5YR 3/2; Ag2 Ga1 Gg1; dark brown top soil, inclusion of roots and stems. Sharp contact in to:
68.95 to 67.97	0.35 to 1.33	7.5YR 6/1; grey chalk rubble (some large pieces of chalk mixed with soil material). Sharp contact in to:
67.97 to 67.88	1.33 to 1.42	7.5YR 3/2; Ag2 Ga1 Gg1; dark brown buried soil – potentially buried during road construction. Sharp contact in to:
67.88 to 67.57	1.42 to 1.73	7.5YR 4/2; Ag3 Ga1; brown soil, high amount of molluscan remains, some macrocharcoal and herbaceous material. Diffuse contact in to:
67.57 to 67.42	1.73 to 1.88	7.5YR 2.5/1; Th23 Tl21 Sh+; black moderately humified peat some root and leaf material evident. Diffuse contact in to:
67.42 to 67.38	1.88 to 1.92	10YR 2/2; Ag1 Sh2 Th41; very dark brown highly humified peat with some silt inclusions, some possible charcoal staining. Diffuse contact in to:

Depth (m OD)	Depth (m bgs)	Composition
67.38 to 67.18	1.92 to 2.12	7.5 YR 2/1; Th²3 Tl²1 Sh+; black Moderately humified 'crumbly' peat, similar to 1.64–1.68 m bgs. Diffuse contact in to:
67.18 to 67.10	2.12 to 2.20	2.5 YR 2.5/1; Ag2 As1 Gg1 Sh+; black sticky organic layer containing macro/micro charcoal and burnt flint. Diffuse contact in to:
67.10 to 67.00	2.20 to 2.30	5Y 2.5/1; Th³1 Tl³1 Sh2; black well-humified peat with some herbaceous material. Diffuse contact in to:
67.00 to 66.94	2.30 to 2.36	5Y 3/1; Ag2 Ga1 Tl¹1; very dark grey silty, possibly organic layer with molluscan remains and lenses of sand from underlying context – potential ground surface. Sharp contact in to:
66.94 to 66.82	2.36 to 2.48	Gley 1 6/10Y; Ag2 Ga1 Gs1 Tl+; greenish grey ligneous material within fine chalk with sand inclusions, highly calcareous when tested with weak acid (possible tufa marl). Sharp contact in to:
66.82 to 66.57	2.48 to 2.73	Ga2 Gs2; chalk and green sand mixed layer – Pleistocene greensands. Sharp contact in to:
66.57 to 66.30	2.73 to 3.00	5Y 6/2; Ga1 Gs2 Gg1; light olive grey fine chalk, large pieces of chalk, flint gravel, ligneous materials, greensand

Appendix D2: Isotopic determinations

Table D27: $\delta^{18}O$ determinations from the aurochs teeth at Blick Mead. BM 421, Mesial lobe

			run 1				run 2				
sample	ERJ	Weight mg	$\delta^{18}O$ VSMOW ‰	SD	RA	%CO3	weight mg	$\delta^{18}O$ VSMOW ‰	SD	RA	%CO3
BM421-1	52,70	2.941	23,2	0,21	23,4	6,7	0.54	22,2	0,16	22,4	6,8
BM421-2	50,90	2.927	23,5	0,16	23,3	6,6	1.72	22,6	0,11	22,2	6,6
BM421-3	48,57	2.935	23,0	0,30	23,8	5,2	1.70	21,9	0,15	22,9	6,7
BM421-4	46,63	2.848	25,0	0,26	23,6	4,8	1.73	24,2	0,11	23,1	6,8
BM421-5	43,93	3.076	22,9	0,18	24,2	5,0	1.72	23,8	0,09	23,9	6,8
BM421-6	41,74	2.739	24,7	0,07	23,7	4,7	1.72	24,4	0,13	23,7	7,0
BM421-7	40,00	2.884	23,6	0,16	24,6	5,3	1.82	23,6	0,07	24,3	6,9
BM421-8	37,85	2.878	25,4	0,16	24,3	5,2	1.60	24,8	0,10	24,1	7,1
BM421-9	35,54	2.889	23,9	0,12	24,3	5,2	1.75	23,8	0,09	24,1	7,0
BM421-10	32,96	2.739	23,7	0,18	23,5	4,8	1.72	23,9	0,05	23,7	6,7
BM421-11	30,22	2.896	22,8	0,27	23,3	4,3	1.56	23,4	0,06	23,6	6,5
BM421-12	28,34	2.665	23,4	0,28	23,2	4,0	1.76	23,7	0,07	23,4	6,1
BM421-13	26,06	2.616	23,4	0,18	23,6	5,0	1.57	23,2	0,10	23,7	7,0
BM421-14	24,12	2.671	24,1	0,14	23,8	4,8	1.81	24,3	0,08	23,6	6,6
BM421-15	22,54	2.722	24,0	0,08	23,9	4,4	**	**	**	**	**
BM421-16	19,76	2.940	23,8	0,15	23,6	4,9	1.73	23,3	0,07	23,6	6,4
BM421-17	18,03	2.626	23,2	0,17	23,2	4,7	1.75	23,1	0,07	23,0	6,9
BM421-18	15,59	2.718	22,6	0,12	23,1	5,0	1.61	22,6	0,10	23,2	6,7
BM421-19	13,44	2.791	23,8	0,29	22,8	4,9	1.72	23,7	0,07	22,9	6,9
BM421-20	11,31	2.731	22,3	0,14	22,8	5,1	1.42	22,4	0,10	22,8	6,9
BM421-21	9,17	2.674	22,6	0,19	22,4	5,9	1.65	22,3	0,06	22,4	7,5
BM421-22	7,01	2.936	22,4	0,15	22,5	5,9	1.69	22,5	0,07	22,5	8,0
BM421-23	4,45	2.803	22,7	0,10	22,7	5,4	1.78	22,5	0,06	22,7	7,5
BM421-24	2,70	2.580	22,9	0,15	22,8	6,2	1.57	23,0	0,12	22,7	8,2

Table D28: $\delta^{18}O$ determinations from the aurochs teeth at Blick Mead: BM 421, Middle lobe

sample	ERJ	run 1					run 2				
		Weight mg	$\delta^{18}O$ VSMOW ‰	SD	RA	%CO₃	weight mg	$\delta^{18}O$ VSMOW ‰	SD	RA	%CO₃
BM421-41	50,70	2.812	22,8	0,17	23,1	5,1	1.60	22,6	0,15	22,8	7,1
BM421-42	48,78	2.874	23,4	0,25	23,2	5,3	1.73	22,9	0,09	22,9	7,3
BM421-43	46,88	2.953	23,3	0,20	23,5	5,1	1.64	23,1	0,08	23,0	7,3
BM421-44	44,15	2.941	23,7	0,11	23,5	4,9	1.58	22,9	0,13	23,0	7,2
BM421-45	41,81	2.931	23,5	0,13	23,7	5,0	1.68	23,1	0,09	23,1	6,7
BM421-46	39,81	2.997	23,9	0,09	23,7	5,1	1.67	23,2	0,11	23,2	6,8
BM421-47	37,58	2.999	23,6	0,17	23,8	4,9	1.54	23,2	0,07	23,2	6,8
BM421-48	35,39	2.717	23,8	0,15	23,5	4,9	1.62	23,2	0,11	23,3	6,4
BM421-49	33,49	2.858	23,2	0,18	23,4	4,9	1.835	23,4	0,13	23,2	6,9
BM421-50	31,08	2.561	23,2	0,32	23,2	4,9	1.544	23,1	0,11	23,1	7,2
BM421-51	28,59	2.860	23,2	0,20	23,2	5,1	1.792	22,8	0,16	22,9	7,0
BM421-52	26,14	2.904	23,2	0,24	23,1	5,1	1,579	22,7	0,08	22,7	7,0
BM421-53	24,43	2.866	22,8	0,13	22,8	4,9	1.642	22,4	0,14	22,8	7,1
BM421-54	21,63	2.949	22,5	0,18	22,9	4,1	1.775	22,5	0,08	22,5	7,2
BM421-55	19,01	2.861	23,3	0,15	22,8	4,8	1.695	22,5	0,11	22,4	7,0
BM421-56	17,04	2.595	22,6	0,33	22,8	4,8	1.747	22,1	0,09	22,3	7,1
BM421-57	14,49	2.970	22,5	0,10	22,3	4,7	1.780	22,3	0,06	22,2	7,0
BM421-58	12,33	2.611	21,8	0,12	22,2	3,8	1.765	22,1	0,07	22,2	6,8
BM421-59	10,39	2.907	22,5	0,15	22,3	5,0	1.746	22,1	0,08	22,4	7,1
BM421-60	8,29	2.953	22,6	0,32	22,5	5,1	1.741	23,0	0,04	22,5	7,3
BM421-61	6,34	3.007	22,5	0,10	22,6	5,0	1.802	22,5	0,09	22,7	7,3
BM421-62	3,79	2.902	22,7	0,26	22,6	4,9	1.642	22,5	0,12	22,5	7,1
BM421-41	50,70	2.812	22,8	0,17	23,1	5,1	1.60	22,6	0,15	22,8	7,1
BM421-42	48,78	2.874	23,4	0,25	23,2	5,3	1.73	22,9	0,09	22,9	7,3

Table D29: $\delta^{18}O$ determinations from the aurochs teeth at Blick Mead: BM 422, Middle lobe

sample	ERJ	run 1					run 2				
		Weight mg	$\delta^{18}O$ VSMOW ‰	SD	RA	%CO₃	weight mg	$\delta^{18}O$ VSMOW ‰	SD	RA	%CO₃
BM422-1	28,45	2.651	24,0	0,37	23,2	4,7	1.643	23,5	0,10	23,5	6,8
BM422-2	25,35	2.808	22,3	0,15	23,3	4,9	1.737	23,6	0,03	23,4	7,0
BM422-3	23,03	2.697	23,7	0,25	22,8	5,0	1.535	23,3	0,05	23,5	7,1
BM422-4	20,64	2.945	22,3	0,19	23,2	5,1	1.555	23,8	0,10	23,4	7,2
BM422-5	18,06	2.729	23,7	0,17	23,3	4,9	1.761	23,3	0,15	23,5	7,1
BM422-6	16,19	2.752	23,9	0,21	23,4	4,9	1.612	23,3	0,11	23,3	7,2
BM422-7	13,55	2.784	22,6	0,06	23,3	3,3	1.814	23,2	0,09	23,2	7,4
BM422-8	11,51	2.650	23,3	0,17	23,0	5,4	1.662	23,1	0,15	23,1	7,3
BM422-9	8,67	2,732	23,2	0,05	23,1		1.627	23.0	0,10	22,9	7,4
BM422-10	6,19	2,700	22,8	0,06	22,8		1.659	22,6	0,11	22,7	7,5
BM422-11	3,12	2,968	22,4	0,07	22,6		1.791	22,5	0,13	22,5	7,7

ERJ = distance from the Enamel-Root Junction; RA = Running Average; ** = sample too small to complete run 2

AFTERWORDS

Tony Legge and the Blick Mead Project

– David Jacques

The recently discovered Mesolithic site at Blick Mead, about 2 km from Stonehenge and close to the town of Amesbury, must have been one of the last small projects Tony Legge encouraged and worked on. He continued to give advice and time to it until early in the New Year 2013.

At the time of Tony's first involvement with Blick Mead, in the spring of 2012, the project had been running on between £500 and £1,000 per year for six years, which just about paid for one long weekend dig per annum. Our excavations, partly out of necessity, have allowed people of talent, whatever their age or background, to self-organise, and as it happened Tony's grandson Tom had been part of a team that excavated a large cache of large animal bones in April 2012. We were not aware of Tom's relationship with Tony, but on the Saturday night Tom said who Tony was and that he was sure that he would be interested in the bones. I was only back at home for a day when Tony wrote and offered a meeting.

Within a few a minutes of being with him I was struck by what seemed to be Tony's unstoppable vitality – he was keenly enthusiastic about what we had found, and very practical about how we should manage things on site from there on. He took our meagre funding and 'no names' team in his stride and gave advice on how best to work in the oozy spring we were dealing with. In our second meeting he talked about how he could best support the research effort.

First, he offered to analyse all the bones we had found for free and write up the results for publication. Then he gently, but firmly suggested we use a particular design of water sieve to recover the most from the material in the spring, and then – knowing that we could not afford to buy such a sieve, gave me his own design plans so that we could make them ourselves. He also said he would come to the site and meet anyone who was sceptical about its archaeological worth.

One area where we have always been rich as a project is in the local support of the Amesbury community. I sent Tony's designs for our sieves to Amesbury resident Councillor Fred Westmoreland, who had been co-ordinating the town council's logistical support for our project since 2009. Fred quickly mobilised a number of Amesbury residents and businesses to support the making of 'Tony's' sieves and by the autumn of 2012 we were presented with three of them, made of stout oak, on site. These were donated gratis by Fred and Amesbury and serve today as an enduring symbol of the connection between the project, the town and Tony.

Thanks to this bridge established between town and gown, our next long weekend dig in October 2012 was able to really maximise the retrieval of artefacts. The sieves worked brilliantly in the tough conditions of the site and have continued to do so. At the time of writing we have found over 35,000 artefacts from Mesolithic contexts. Over 2,000 of these objects are from animal materials and from these eleven radiocarbon dates have been taken that show that people were visiting the site and feasting there for nearly four millennia from c. 7950 to 4050 BC. This is a unique sequence for the British Isles. It would not have been fully discovered without 'Tony's sieves' and his advice.

Tony and I continued to meet over the course of 2012. Each time he was open, practical, drily humorous and completely unbothered about reputation and standing – ideas, data and potential were what he was interested in. Like the best professors, he had great teaching skills, an ability to put you at your ease so that you were best able to give the best account of your ideas. When his analysis of the bones from the site revealed that we had found an unusually large percentage of aurochs in the assemblage (61%) he was particularly keen to discuss the significance of that and to explore any parallels. He liked it that some of our finds and the research were beginning to impact on the research agendas for the Stonehenge landscape.

In December 2012 Tony said he was struggling with his eyesight, but he still found the energy to nominate me for Cambridge University's Field Archaeologist in Residence post so that the project would benefit from the university's resources. His close interest in what we doing continued near to his death when he asked his daughter Karen, Tom's mother, to try and make sure that Peter Rowley-Conwy would get a chance to meet project team members at his funeral.

My short time of knowing Tony Legge probably charts a pattern of behaviour in him which others for a longer period would recognise. He was incredibly generous with his time. He was warm, full of energy and had the great teacher's trick of wearing a massive accumulation of knowledge lightly for other's benefit. You felt 'at home' with him. He made you feel at ease – always a thoughtful and generous quality. Tony transformed our project at Blick Mead in all respects because of all these characteristics. Our self-belief in what we were trying to do was greatly increased because of him. The project's reputation and standing was underscored by his approval. Our finds retrieval was greatly improved because of his ideas and care. Tony's presence lives on at the site, as we are sure it does in many others, because of his actions, thoughts and essential humanity.

This item is abridged from Chapter 6, 'Tony Legge and the Blick Mead Project', in *Economic Zooarchaeology: Studies in Hunting, Herding and Early Agriculture*, edited by Peter Rowley-Conwy, Dale Serjeantson and Paul Halstead, 2017.

AFTERWORDS

Community: The Contribution of Volunteers from Amesbury to the Blick Mead Project

– Gemma Allerton (Chair of Amesbury History Centre)

Amesbury residents are well used to the sight of archaeologists; there never goes more than a month when there is not a new opening in the ground full of people brandishing trowels. Amesbury parish is so rich with archaeology and with the high profile of Stonehenge residents will usually find they are watching a local dig on a TV programme. However, of all the archaeological digs locally, none has included the people of Amesbury like the Blick Mead one. In fact, the Blick Mead dig would not have even begun without the help of local people and their local knowledge; it was the knowledge of the local land custodian that first alerted archaeologists to the potential wealth of finds in the first place. Without Mike Clarke what lay under the ground there would have continued to be unknown.

In the early days the dig was a small affair, coming just one weekend a year and with very little funding; it relied upon volunteer activity and local goodwill in the form of time, funding and organisation of equipment. As the dig grew so did the workforce from Amesbury. These were people with no archaeological training and they were people from all backgrounds, all with different skills and different personalities. Each person found they belonged within the team and were able to help in many varied ways; there was a job for everyone. The small team organised itself, reacting to the events that were happening within the trench and quickly working out which jobs were priorities; they fashioned a production line which is still followed at the dig today.

Figure AW1: Gilly Clarke, Mike Clarke and Barry Bishop at Blick Mead. The terrace, and the future site of Trench 24, is in the background. Photograph courtesy of Tom Lyons.

Those local volunteers who were fit and able would be put to work with the hard labour jobs, digging out the initial trenches, pumping out the water, clearing the land ready for the archaeologists to do the fine excavation. Others would work the sieves; going through buckets and buckets of material from the trench and the spoil heap. That material was then handed to the volunteers who were cleaning and sorting the finds and the hardest job of all was going through the very small finds with tweezers and a magnifying glass. This meticulous work, together with the amount of volunteers that came forward, has meant that the soil has been worked through with immense precision and speed; all worked hard. The sieves captured large flint tools right down to the tiny microliths; the expert knowledge passed on to the volunteers meant that they relatively quickly became able to recognise what it was they were looking for. Each new volunteer that arrived at the dig would be greeted and shown around by another volunteer and one of the project officers and so the knowledge was passed on. A Mesolithic flint tool reference book by Roy Froom would be found on the table with a group of volunteers looking over it trying to identify what it was they had found. The volunteers had become so proud of the dig because it was their own heritage. The passion they had created a scenario of such attention to detail, that nothing was missed, every seed, every tiny piece of bone, every flint was examined closely. It is generally dirty, cold and hard work but the residents of Amesbury who volunteer find it exhilarating; for the first time they are involved in their landscape instead of reading about it in the news and the excitement of a 'good find' is shared by everyone. People have found themselves involved in the dig both practically and emotionally. After over ten years of volunteering, some of these volunteers are now experts in Blick Mead, they go out into the community and give talks on the subject and some have gone on to study the subject. Others have become confident in the archaeological dig setting and have taken on project managing tasks, often instructing newer volunteers at the site or taking groups on tours of the site.

Figure AW2: Amesbury Midwinter Solstice Lantern Parade to Blick Mead.
Photograph courtesy of David Cornelius-Reid.

There are many people from the local area who feel passionate about the dig and, whilst attending events connected to the dig such as the midwinter lantern parade, would also like to give their time but, due to their circumstances, for whatever reason, are unable to do so. These people have found other ways of helping and as well as practically, the people of Amesbury have helped the dig financially. Some residents have contributed directly to the cost of items such as Radiocarbon dates, others have contributed money towards the running of the dig annually. Grants have also come from organisations such as Amesbury Town Council and other organisations have been formed like the Amesbury Museum and Heritage Trust and the Amesbury Archaeology Fund to support the town's archaeology in a number of ways including paying for display cases for the items from the dig to be displayed.

Throughout the years, as each new problem arose, it is the people of Amesbury who come forward to solve it. It was recognised very early on that conventional sieve methods were not going to work, the waterlogged conditions meant that dry sieving was not an option so new sieves were made; sieves that perfectly fitted the circumstances of the Blick Mead dig. These sieves were made by residents in Amesbury and, since they were made, they have been maintained by the residents, stored year after year in Amesbury and are now being used, when not in use by the dig, as an educational tool in the Amesbury History Centre. Similarly, in the early days, there was no water pump for the trenches which were usually found under water, but as news of the dig grew, and the waterlogged conditions were known, a water pump was offered from a locally based company, which made the work much easier. Over the years the residents and businesses of Amesbury have donated diggers, generators, tents, buckets, trays, hundreds of rolls of kitchen roll, brushes, tables, chairs and a good deal of cakes. Businesses from Amesbury have also offered up many of their expert services; for example in 2015 it was arranged for an aerial photograph to be taken of the trench by the local photography section of the nearby airbase.

In 2012 Amesbury Town Council asked residents if they would like to see a purpose built building in Amesbury to showcase the finds of the Blick Mead dig (and to ultimately showcase the whole of Amesbury's heritage). The residents were thrilled about this idea; it was a chance to regenerate the town and fully become part of their landscape's story. The people of Amesbury agreed to a small increase in their council tax to pay for this building (by a 90% margin!), and in 2012 the first display of Blick Mead items went up for one Easter weekend in the building which would become the Amesbury History Centre. Then managed by the Amesbury Museum and Heritage Trust, this centre became the focal point of the dig, the place where the finds were brought, collated and fully cleaned ready for analysis. It was also this centre which organised the volunteer workforce and displayed all of the news headlines whenever they appeared and was a starting point for each day's work at the dig. The initial volunteers at the Blick Mead dig became the foundation members of the centre and most are still heavily involved.

The Amesbury History Centre together with the Amesbury Museum and Heritage Trust now work closely together each year to organise the team of volunteers for the dig. There is now a very long list of people who have been volunteering year after year and demand is so high to come and help that a rota must be made to ensure everyone gets a fair chance. In 2016 over a quarter of the people who worked at the dig were residents of Amesbury. It is also members from the Amesbury Museum and Heritage Trust who organise the health and safety of the site as well as facilitate any guests and press that come to the dig. This partnership has also seen the creation of an annual lantern parade which takes the people of Amesbury on a journey at the Winter Solstice through the beautiful landscape surrounding the Blick Mead dig, to celebrate the ancestral connection. The parade is a lasting effect of Blick Mead on Amesbury and showcases the local residents chance to show their connection with the site.

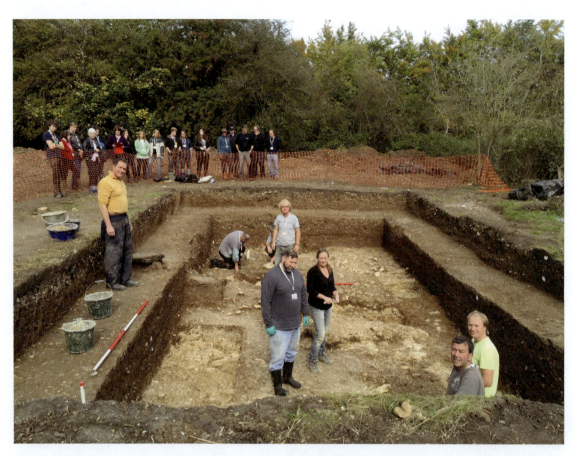

Figure AW3: Looking north over Trench 24 towards the end of the 2016 excavations. The chalk mound of the tree throw is clearly visible. L–R: John Gibbens, Mick Smith, David Jacques, Lance Russum (Polk State College), Vicky Ridgeway, Barry Bishop and Tom Lyons, with volunteers from Amesbury History Centre and elsewhere looking on. Photograph courtesy of Andy Rhind-Tutt.

Bibliography

Aaris-Sørensen, K. 1976. A Zoological Investigation of the Bone Material from Sværdborg I–1943. In *Sværdborg I, Excavations 1943–44*, ed. B. B. Henriksen, pp. 137–148. Copenhagen: Akademisk Forlag (Arkæologiske Studier III).

Aaris-Sørensen, K. 1980. Depauperation of the Mammalian Fauna of the Island of Zealand during the Atlantic Period. *Videnskabelige Meddelelser fra Dansk Naturhistorisk Forening* 142: 131–138.

Aaris-Sørensen, K. 1999. The Holocene History of the Scandinavian Aurochs (Bos primigenius Bojanus, 1827). In *Archäologie und Biologie des Auerochsen*, ed. G.-C. Weniger, pp. 49–57. Mettman: Neanderthal Museum (Wissenschaftliche Schriften des Neanderthal Museums 1).

Albarella, U. and Payne, S. 2005. Neolithic Pigs from Durrington Walls, Wiltshire, England: A Biometrical Database. *Journal of Archaeological Science* 32: 589–599.

Allen, M. J. 1994. 'Before Stonehenge'. In R. M. J. Cleal, K. E. Walker and R. Montague (eds), *Stonehenge in its Landscape: Twentieth-century Excavations*, pp. 55, 471–473. London: English Heritage Archaeological Report 10.

Allen, M. J. 1997. Environment and Land-Use: The Economic Development of the Communities who Built Stonehenge (an Economy to Support the Stones). *Proceedings of the British Academy* 92: 115–144.

Allen, M. J. and Bayliss, A. 1994. The Radio Dating Programme. In R. M. J. Cleal, K. E. Walker and R. Montague (eds), *Stonehenge in its Landscape: Twentieth-century Excavations*, pp. 511–535. London: English Heritage Archaeological Report 10.

Allen, M. J., Chan, B., Cleal, R., French, C., Marshall, P., Pollard, J., Pullen, R., Richards, C., Ruggles, C., Robinson, D. and Rylatt, J. 2016. Stonehenge's Avenue and 'Bluestonehenge'. *Antiquity* 90 (352): 991–1008, 999.

Allen, M. J. and Gardiner, J. 2002. A Sense of Time: Cultural Markers in the Mesolithic in Southern England? In B. David and M. Wilson (eds), *Inscribed Landscapes*, p. 149. Hawaii: University of Hawaii.

Ames, K. M. 2002. Going by boat. *Beyond Foraging and Collecting*, pp. 19–52. New York: Springer.

Anderberg, A.-L. 1994. *Atlas of Seeds: Part 4*. Uddevalla, Sweden: Swedish Museum of Natural History, Risbergs Trycheri AB.

Andrefsky, W. 1998. *Lithics: Macroscopic Approaches to Analysis*. Cambridge Manuals in Archaeology. Cambridge: Cambridge University Press.

Andrews, P. 1990. Owls, Caves and Fossils. London: The Natural History Museum.

Armour-Chelu, M. and Andrews, P. 1994. Some effects of bioturbation by earthworms (Oligochaeta) on Archaeological Sites. *Journal of Archaeological Science* 21 (4): 433–443.

Atkinson, T. C., Briffa, K. R. and Coope, G. R. 1987. Seasonal Temperatures in Britain During the Past 22,000 Years, Reconstructed Using Beetle Remains. *Nature* 325: 587–592.

Balasse, M. 2003. Determining Sheep Birth Seasonality by Analysis of Tooth Enamel Oxygen Isotope Ratios: The Late Stone Age Site of Kasteelberg (South Africa). *Journal of Archaeological Science* 30: 205–215.

Balasse, M., Ambrose, S., Smith, A. and Price, T. D. 2002. The Seasonal Mobility model for Prehistoric Herders in the South-Western Cape of South Africa Assessed by Isotopic Analysis of Sheep Tooth Enamel. *Journal of Archaeological Science* 29: 917–932.

Baldwin, E. 2013–2014. Stonehenge Hidden Landscapes Project 2014 Interim Geophysical Survey Report: Field Season 4 (2013–2014) for National Trust and English Heritage (Unpublished).

Barclay, A. 2014. Re-dating the Coneybury Anomaly and its implications for understanding the earliest Neolithic pottery from southern England. *PAST* 77: 11–13.

Barton, C. M., Olszewski, D. I. and Coinman, N. R. 1996. Beyond the Graver: Reconsidering Burin Function. *Journal of Field Archaeology* 23: 111–125.

Barton, R. N. E. 1989. Long Blade Technology in Southern Britain. In C. Bonsall (ed.), *The Mesolithic in Europe: Papers Presented at the Third International Symposium, Edinburgh 1985*. Edinburgh: John Donald Press, 264–271.

Barton, R. N. E. 1991. Technological Innovation and Continuity at the end of the Pleistocene in Britain. In R. N. E. Barton, A. J. Roberts and D. A. Roe (eds), *Late Glacial Settlement in Northern Europe: Human Adaptation and Environmental Change at the end of the Pleistocene*, pp. 234–245. Council for British Archaeology Research Report 77. York: Council for British Archaeology.

Barton, R. N. E. 1992. *Hengistbury Head Dorset Volume 2: The Late Upper Palaeolithic and Early Mesolithic sites*. Oxford University Committee for Archaeology Monograph 34. Oxford: Oxford University Committee for Archaeology.

Barton, R. N. E. 1998. Long Blade Technology and the Question of British Late Pleistocene/Early Holocene Lithic Assemblages. In N. Ashton, F. Healy and P. Pettitt (eds), *Stone Age Archaeology: Essays in Honour of John Wymer*, pp. 158–164. Oxbow Monograph 102: Lithics Studies Society Occasional Paper 6. Oxford: Oxbow Books.

Barton, R. N. E., Berridge, P. J., Walker, M. J. and Bevins, R. E. 1995. Persistent Places in the Mesolithic Landscape: An Example from the Black Mountain Uplands of South Wales. *Proceedings of the Pre-Historic Society* 61: 81–116, 81–82.

Barton, R. N. E. and Roberts, A. J. 2004. The Mesolithic Period in England: Current Perspectives and New Research. In A. Saville (ed.), *Mesolithic Scotland and its Neighbours. The Early Holocene Prehistory of Scotland, its British and Irish context, and some Northern European Perspectives*, pp. 339–358. Edinburgh: Society of Antiquaries of Scotland.

Bean, W. J. 1970. *Trees and Shrubs Hardy in the British Isles*. 8th edn. London: John Murray.

Bell, M. 1989. Environmental Conclusions. In P. Ashbee, M. Bell, and E. Proudfoot, *Wilsford Shaft: Excavations 1960–62*, pp. 128–133. England: Historic Buildings and Monuments Commission.

Bentley, R. and Knipper, C. 2005. Geographical Patterns in Biologically Available Strontium, Carbon and Oxygen Isotope Signatures in Prehistoric SW Germany. *Archaeometry* 47(3): 629–644.

Berggren, G. 1969. *Atlas of Seeds: Part 2*. Arlöv, Sweden: Swedish Museum of Natural History, Berlings.

Berggren, G. 1981. *Atlas of Seeds: Part 3*. Arlöv, Sweden: Swedish Museum of Natural History, Berlings.

Berridge, P. J. 1985. Mesolithic Sites in the Yarty Valley. *Proceedings of the Devon Archaeological Society* 43: 1–21.

Berridge, P. J. 1994. The Mesolithic Decorated and Other Pebble Artefacts: Synthesis. In H. Quinnell and M. R. Blockley, *Excavations at Rhuddlan, Clwyd: 1969–73 Mesolithic to Medieval*, pp. 115–131. Council for British Archaeology Research Report 95. York: Council for British Archaeology.

Binford, L. R. 1978. Dimensional analysis of behaviour: Learning from an Eskimo Hunting Stand. *American Antiquity* 43: 330–361.

Binford, L. R. 1978. *Nunamiut Ethnoarchaeology*. New York: Academic Press.

Bishop, B. J. 2008a. A Late Mesolithic Site at Woodthorpe Road, Guildford. *Surrey Archaeological Collections* 94: 125–157.

Bishop, B. J. 2008b. Mesolithic Occupation and Later Prehistoric Activity at Hillborough, Near Reculver. *Kent Archaeological Society eArchaeological Reports* <http://www.kentarchaeology.ac/archrep/Reculver01.pdf>.

Bishop, B. J. 2010. Lithics from the Evaluation and Excavation. In R. Atkins and A. Connor, *Farmers and Ironsmiths: Prehistoric, Roman and Anglo-Saxon settlement beside Brandon Road, Thetford, Norfolk*, pp. 35–39. East Anglian Archaeology 134.

Bishop, R. R., Church, M. J. and Rowley-Conwy, P. A. 2013. Seeds, Fruits and Nuts in the Scottish Mesolithic. *Proceedings of the Society of Antiquaries of Scotland* 143: 9–72.

Bocherons, H. and Drucker, D. 2003. Trophic Level Isotopic Enrichment of Carbon and Nitrogen in Bone Collagen: Case Studies from Recent and Ancient Terrestrial Ecosystems. *International Journal of Osteology* 13: 46–53.

Bowden, M. *Stonehenge Southern WHS Project: Vespasians Camp, Amesbury, Wiltshire: analytical earthwork survey*. Historic England Research Report 49/2016.

Bowden, M., Soutar, S., Field, D. and Barber, M. 2015. *The Stonehenge Landscape: Analysing the Stonehenge World Heritage Site*. Historic England. 108–109, 116.

Boyle, A., Dodd, A., Miles, D. and Mudd, A. 1995. *Two Oxfordshire Anglo-Saxon cemeteries: Berinsfield and Didcot*. Thames Valley Landscapes Monograph 8. Oxford: Oxford Archaeological Unit.

Bradbury, K. E. 2015. *An evaluation of the relationship between the distribution of tranchet axes and certain Mesolithic site types along the Salisbury Avon*. Unpublished MA dissertation, University of Buckingham.

Bradley, R. 2000. *An Archaeology of Natural Places*. London: Routledge.

Bradley, R. and Brown, A. 1992. Flint Artefacts. In J. Moore and D. Jennings, *Reading Business Park: a Bronze Age landscape*, pp. 89–93. Thames Valley Landscapes Monograph 1. Oxford: Oxford Archaeological Unit.

British Geological Survey. 1977. Geological Survey Ten Mile Map, South Sheet. 1:625 000 scale. 1st edn. Keyworth, Nottingham: British Geological Survey.

British Geological Survey. 2001. Solid Geology Map, UK South Sheet. 1:625 000 scale. 4th edn. Keyworth, Nottingham: British Geological Survey.

British Geological Survey. 2005. *Salisbury. England and Wales Sheet 298. Bedrock and Superficial Deposits*. 1:50 000 scale. Keyworth, Nottingham: British Geological Survey.

British Geological Survey. 2007. *Devizes. England and Wales Sheet 282. Bedrock Geology*. 1:50 000 scale. Keyworth, Nottingham: British Geological Survey.

British Geological Survey. 2010. *Salisbury. England and Wales Sheet 298. Bedrock Geology*. 1:50 000 scale. Keyworth, Nottingham: British Geological Survey.

Brittain, M. and Overton, N. 2013. The significance of others: A prehistory of rhythm and interspecies participation. *Society & Animals* 21 (2): 134–149.

Britton, K., Grimes, V., Dau, J. and Richards, M. 2009. Reconstructing Faunal Migrations Using Intra-Tooth Sampling and Strontium and Oxygen Isotope Analyses: A Case Study of Modern Caribou (Rangifer Tarandus Granti). *Journal of Archaeological Science* 36: 1163–1172.

Brown, A. 1991. Structured Deposition and Technological Change among the Flaked Stone Artefacts from Cranbourne Chase. In J. Barrett, R. Bradley and M. Hall (eds), *Papers on the Prehistoric Archaeology of Cranbourne Chase*, pp. 101–133. Oxbow Monograph 11. Oxford: Oxbow Books.

Brown, A. 1995. The Mesolithic and later flint artefacts. In T. G. Allen *et al.*, *Lithics and landscape: Archaeological discoveries on the Thames Water pipeline at Gatehampton Farm, Goring, Oxfordshire 1985–92*, pp. 65–84. Thames Valley Landscapes Monograph 7. Oxford: Oxford Archaeological Unit.

Brown, L. 2000. The regional ceramic sequence. In B. Cunliffe, *The Danebury Enmvirons Programme: The prehistory of a Wessex landscape. Vol. 1: Introduction*. Oxford Univ Comm Archaeol Monogr 48, pp. 79–124. Oxford: Oxford Archaeological Unit.

Brown, T. A., Nelson, D. E., Vogel, J. S. and Southon, J. R. 1988. Improved Collagen Extraction by Modified Longin Method. *Radiocarbon* 30: 171–177.

Buckley, M., Collins, M., Thomas-Oates, J. and Wilson, J. 2009. Species Identification by Analysis of Bone Collagen Using Matrix-assisted Laser Desorption/ionisation Time-of-flight Mass Spectrometry. *Rapid Communications in Mass Spectrometry* 23: 3843–3854.

Buckley, M., Whitcher Kansa, S., Howard, S., Campbell, S., Thomas-Oates, J. and Collins, M. 2010. Distinguishing Between Archaeological Sheep and Goat bones Using a Single Collagen Peptide. *Journal of Archaeological Science* 37: 13–20.

Buckley, V. (ed.). 1990. *Burnt Offerings: International Contributions to Burnt Mound Archaeology*. Dublin: Wordwell.

Budd, P., Montgomery, J., Barreiro, B. and Thomas, R. 2000. Differential Diagenesis of Strontium in Archaeological Human Dental Tissues. *Applied Geochemistry* 15 (5): 687–694.

Butler, C. 1998. A Mesolithic Site at Streat, East Sussex. *Council for British Archaeology Southeast Newsletter* 14: 4.

Camden, W. 1610. *Britiannia*. London: Bishop and Norton, 10.

Cappers, R. T. J., Bekker, R. M. and Jans, J. E. A. 2006. *Digital Seed Atlas of the Netherlands*. Groningen Archaeological Series 4. Netherlands: Barkhuis.

Charlton, S., Alexander, M., Collins, M., Milner, N., Mellars, P., O'connell, T., Stevens, R. and Craig, O. E. 2016. Finding Britain's Last Hunter-Gatherers: A New Biomolecular Approach to 'Unidentifiable' Bone Fragments Using Bone Collagen. *Journal of Archaeological Science* 73: 55–61.

Chenery, C., Pashley, V., Lamb, A., Sloane, H. and Evans, J. 2012. The Oxygen Isotope Relationship Between the Phosphate and Structural Carbonate Fractions of Human Bioapatite. *Rapid Communications in Mass Spectrometry* 26: 309–319.

Chippingdale, C. 2012. *Stonehenge Complete*. 4th edn. London: Thames and Hudson, 161.

Christie, P. M., Cornwall, I. W. and Brothwell, D. R. 1963. The Stonehenge Cursus. *WANHM* 58: 370–382.

Churchill, D. M. 1962. The Stratigraphy of the Mesolithic Sites III and V at Thatcham, Berkshire, England. *Proceedings of the Prehistoric Society* 13: 363–370.

Clark, J. G. D. 1934. Derivative Forms of the Petit Tranchet in Britain. *Archaeological Journal* 91: 32–58.

Clark, J. G. D. and Rankine, W. F. 1939. Excavations at Farnham, Surrey (1937–38): The Horsham Culture and the Question of Mesolithic dwellings. *Proceedings of the Prehistoric Society* 5: 61–118.

Cockburn, A. 2006. *Agile software development: The Cooperative Game*. London: Pearson Education.

Conneller, C. 2000. Fragmented Space? Hunter-Gather Landscapes of the Vale of Pickering. *Archaeological Review from Cambridge* 17 (1): 139–150.

Conneller, C. 2008. Lithic Technology and the C*haîne Opératoire*. In J. Pollard (ed.), *Prehistoric Britain*, pp. 160–176. Oxford: Blackwell.

Conneller, C., Milner, N., Taylor, B. and Taylor, M. 2012. Substantial Settlement in the European Early Mesolithic: New Research at Star Carr. *Antiquity* 86: 1004–1020.

Craig, O., Shillito, L-M., Albarella, U., Viner-Daniels, S., Chan, B., Cleal, R., Ixer, R., Jay, M., Marshall, P., Simmons, E., Wright, E. and Pearson, P. 2015. Fedding Stonehenge: Cuisine and consumption at the late Neolithic site of Durrington Walls. *Antiquity* 89: 1098.

Crittal, E. 1952. Andrews and Dury's Map of Wiltshire. 1773: A Reduced Facsimile. *Wiltshire Record Society* 8. Devizes.

Cummings, V. and Harris, O. 2011. Animals, people and places: The continuity of hunting and gathering practices across the Mesolithic–Neolithic transition in Britain. *European Journal of Archaeology* 14 (3): 365.

Cunliffe, B. 1976. Iron Age Sites in Central Southern England. Council for British Archaeology Research Report 16. York: Council for British Archaeology.

Cunliffe, B. 1984. Danebury: An Iron Age Hillfort in Hampshire. Vol. 2: The excavations 1969–1978. Council for British Archaeology Research Report 52. York: Council for British Archaeology.

Cunliffe, B. 1991. *Iron Age Communities in Britain*. 3rd edn. London: Routledge.

Cunliffe, B. 1995. Danebury: An Iron Age Hillfort in Hampshire. Vol. 6: A hillfort community in perspective. Council for British Archaeology Research Report 102. York: Council for British Archaeology.

Cunnington, M. E. 1929. *Woodhenge*. Devizes: George Simpson and Co.

Darling, W. G., Bath, A. H. and Talbot, J. C. 2003. The O & H Stable Isotopic Composition of Fresh Waters in the British Isles: 2, Surface Waters and Groundwater. *Hydrology and Earth System Sciences* 7: 183–195.

Darling, W. G. and Talbot, J. C. 2003. The O and H Stable Isotopic Composition of Fresh Waters in the British Isles: 1, Rainfall. *Hydrology and Earth System Sciences* 7: 163–181.

Darvill, T. 2006. *Stonehenge: The Biography of A Landscape*. Stroud: Tempus.

Davis, S. 1987. *The Archaeology of Animals*. Oxford: Routledge.

Degerbøl, M. 1933. *Danmarks Pattedyr i Fortiden i Sammenligning med recente Former*. Copenhagen: C. A. Reitzel (Videnskabelige Meddelelser fra Dansk Naturhistorisk Forening 96).

Degerbøl, M. and Fredskild, B. 1970. *The Urus (Bos primigenius Bojanus) and Neolithic domesticated cattle (Bos taurus domesticus Linné) in Denmark*. Copenhagen: Det Kongelige Dansk Videnskabernes Selskab (Biologiske Skrifter 17, 1).

Deniro, M. 1985. Postmortem Preservation and Alteration of In Vivo Bone Collagen Isotope Ratios in Relation to Palaeodietary Reconstruction. *Nature* 317: 806–809.

Dickinson, T. 1979. On the origin and chronology of the Early Anglo-Saxon disc brooch. In S. Chadwick Hawkes, D. Brown and J. Campbell (eds), *Anglo-Saxon Studies in Archaeology and History 1*, pp. 39–80. British Archaeological Reports, British Series 72. Oxford: BAR.

Dobberstein, R. C., Collins, M. J., Craig, O. E., Taylor, G., Penkman, K. E. H. and Ritz-Timme, S. 2009. Archaeological Collagen: Why Worry About Collagen Diagenesis?, *Archaeological and Anthropological Sciences* 1: 31–34.

Dolan, T. P. (ed.). 2006. A dictionary of Hiberno-English: The Irish use of English. Dublin: Gill Books, 215.

Donahue, R. E. 2002. Microwear Analysis. In J. Sidell, J. Cotton, L. Rayner and L. Wheller, *The Prehistory of Southwark and Lambeth*, pp. 81–88. Museum of London Archaeology Service Monograph 14. London/Swindon: Museum of London/English Heritage.

Donahue, R. E. and Burroni, D. B. 2004. Lithic Microwear Analysis and the Formation of Archaeological Assemblages. In E. A. Walker, F. Wenban-Smith and F. Healy, *Lithics in Action: Papers for the Conference Lithic Studies in the Year 2000*, pp. 140–148. Oxford: Oxbow Books.

Donovan, L. and Ehleringer, J. 1992. Contrasting Water-Use Patterns Among Size and Life-History Classes of a Semiarid Shrub. *Functional Ecology* 6: 482–488.

Edmonds, M. 1997. Taskscape, Technology and Tradition. *Analecta Praehistorica Leidensia* 29: 99–110.

Edmonds, M. 1999. *Ancestral Geographies of the Neolithic: landscape, monuments and memory*. London: Routledge.

Eerkens, J. 1998. Reliable and Maintainable Technologies: Artefact Standardization and the Early to Later Mesolithic Transition in Northern England. *Lithic Technology* 23 (1): 42–53.

Egging Dinwiddy, K. and Stoodley, N. 2016. *An Anglo-Saxon Cemetery at Collingbourne Ducis, Wiltshire*. Wessex Archaeology Report 37. Salisbury: Wessex Archaeology.

Elias, S. A. 2007. Beetle Records. In S. A. Elias (ed.), *Encyclopedia of Quaternary Science*, pp. 153–163. Oxford: Elsevier.

Ellaby, R. 1987. Upper Palaeolithic and Mesolithic. In J. Bird and D. G. Bird (eds), *The Archaeology of Surrey to 1540*, pp. 53–69. Guildford: Surrey Archaeological Society.

Ellaby, R. 2004. Food for Thought: A Late Mesolithic site at Charlwood, Surrey. In J. Cotton and D. Field (eds), *Towards a New Stone Age: Aspects of the Neolithic in south-east England*, pp. 12–23. Council for British Archaeology Research Report 137. York: Council for British Archaeology.

Ellis, C. J., Allen, M. J., Gardner, J., Harding, P., Ingram, C., Powell, A. and Scaife, R. G. 2003. An early Mesolithic seasonal hunting site in the Kennett Valley southern England. *Proceedings of the Prehistoric Society* 69: 107–135.

English Heritage. 2008. Geophysical Survey in Archaeological Field Evaluation. Research and Professional Service Guideline No. 1. 2nd edn. Swindon: English Heritage.

Evans, C., Pollard, J. and Knight, M. 1999. Life in the Woods: Tree Throws, 'Settlement' and Forest Cognition. *Oxford Journal of Archaeology* 18 (3): 241–254.

Evans, J. G. 2004. Texture and Asymmetry in Later Prehistoric Lithics, and their Relevance to Environmental Archaeology. In R. Cleal and J. Pollard (eds), *Monuments and Material Culture: Papers in honour of an Avebury Archaeologist: Isobel Smith*, pp. 215–224. Salisbury: Hobnob Press.

Evans, J. G., Montgomery, J., Wildman, G. and Boulton, N. 2010. Spatial variations in Biosphere Sr-87/Sr-86 in Britain. *Journal of the Geological Society* 167 (1): 1–4.

Evans, J. G. and Smith, I. F. 1983. Excavations at Cherhill, North Wiltshire 1967 (with contributions by T. Darvill, C. Grigson and M. W. Pitts). *Proceedings of the Prehistoric Society* 49: 43–117.

Every, R. and Mepham, L. 2008. Pottery. In C. Ellis and A. Powell with J. W. Hawkes, *An Iron Age Settlement Outside Battlesbury Hillfort, Warminster, and sites along the Southern Range Road*, pp. 50–65. Wessex Archaeology Report 22. Salisbury: Wessex Archaeology.

Fernández-Jalvo, Y. and Andrews, P. 2016. *Atlas of Taphonomic Identifications. 1001+ Images of Fossil and Recent Mammal Bone Modification*. Dordrecht: Springer, 359.

Fernández-Jalvo, Y., Andrews, P., Denys, C., Sesé, C., Stoetzel, E., Marin-Monfort, D. and Pesquero, D. 2016. Taphonomy for Taxonomists: Implications of Predation in Small Mammal Studies. *Quaternary Science Reviews* 139: 138–157.

Fernández-Jalvo, Y., Sanchez-Chillon, B., Andrews, P., Fernandez-Lopez, S. and Alcala Martinez, L. 2002. Morphological Taphonomic Transformations of Fossil Bones in Continental Environments, and Repercussions on their Chemical Composition. *Archaeometry* 44 (3): 353–361.

Field, D. 1989. Tranchet Axes and Thames Picks: Mesolithic Core Tools from the West London Thames. *Transactions of the London and Middlesex Archaeological Society* 40: 1–26.

Fielding, D. C. 1966. The identification of skulls of the two British species of *Apodemus*. *Journal of Zoology* 150 (4): 498–500.

Finlay, N. 2000b. Microliths in the Making. In R. Young (ed.), *Mesolithic Lifeways: Current research from Britain and Ireland*, pp. 23–31. Leicester Archaeology Monographs 7. Leicester: School Of Archaeological Studies, University Of Leicester.

Finlayson, B., Finlay, N. and Mithen, S. 1996. Mesolithic Chipped Stone Assemblages: Descriptive and Analytical Procedures Used by the Southern Hebrides Mesolithic Project, pp. 252–268. In A. J. Pollard and A. Morrison (eds), *The Early Prehistory of Scotland*. Edinburgh: Edinburgh University Press.

French, C., Scaife, R. G., Allen, M. J., Parker-Pearson, M., Pollard, J., Richards, C., Thomas, J. and Welham, K. 2012. Durrington Walls to West Amesbury: A Major Transformation of the Holocene Landscape. *The Antiquaries Journal* 92: 1–36, 30.

Fricke, H. and O'neil, J. 1995. Inter- and Intra-Tooth Variation in the Oxygen Isotope Composition of Mammalian Tooth Enamel Phosphate: Implications for Palaeoclimatological and Palaeobiological Research. *Palaeogeography, Palaeoclimatology, Palaeoecology* 126: 91–99.

Froom, F. R. 1971. Investigations into the Mesolithic around Hungerford, pp. 2–3. Group 9 CBA Newsletter 1.

Froom, F. R. 1972. A Mesolithic Site at Wawcott Kintbury. *Berkshire Archaeological Journal* 66: 23–44.

Froom, F. R. 1976. *Wawcott III: a Stratified Mesolithic Succession*. British Archaeological Reports 27. Oxford: BAR.

Froom, F. R. 2012. *The Mesolithic of the Kennett Valley*. Oxford: Oxbow.

Fuglestvedt, I. 2011. Humans, material culture and landscape: Outline to an understanding of developments in worldviews on the Scandinavia Peninsula, ca. 10,000–4500 BP. *Structured worlds: the archaeology of Hunter-Gatherer thought and action*, pp. 32–53. Sheffield: Equinox Publishing.

Gaffney, C., Gaffney, V., Neubauer, W., Baldwin, E., Chapman, H., Garwood, P., Moulden, H., Sparrow, T., Bates, R., Löcker, K. and Hinterleitner, A. 2012. The Stonehenge Hidden Landscapes Project. *Archaeological Prospection* 19 (2): 147–155.

Gingell, C. J. and Morris, E. 2000. Pottery. In A. J. Lawson, *Potterne 1982–5: Animal husbandry in later prehistoric Wiltshire*, pp. 136–178. Wessex Archaeology Report 17. Salisbury: Wessex Archaeology.

Gonjor, H. W. 1993. Behavioural Principles of Animal Handling and Transport. In T. Grandin (ed.), *Livestock Handling and Transport*, pp. 16–17. Wallingford: CAB International.

Goodman, D. 2013. *GPR-Slice v6.0 GPR Imaging Software – User's Manual* (Geophysical Archaeometry Laboratory Inc.).

Grace, R. 1992. Use Wear Analysis. In F. Healey, M. Heaton and S. J. Lobb, Excavations of a Mesolithic Site at Thatcham, Berkshire, pp. 53–63. *Proceedings of the Prehistoric Society* 58: 41–76.

Grant, A. 1982. The Use of Tooth Wear as a Guide to the Age of Domestic Ungulates. In B. Wilson, C. Grigson and S. Payne, *Ageing and Sexing Animal Bones from Archaeological Sites*, pp. 91–108. British Archaeological Reports, British Series 109. Oxford: BAR.

Grayson, D. K. 1984. *Quantitative Zooarchaeology*. New York: Academic Press.

Green, H. S. 1980. *The Flint Arrowheads of the British Isles: A detailed study of material from England and Wales with comparanda from Scotland and Ireland: Part I*. British Archaeological Reports, British Series 75. Oxford: BAR.

Griffiths, S. 2014. Points in Time: The Mesolithic–Neolithic Transition and the Chronology of Late Rod Microliths in Britain. *Oxford Journal of Archaeology* 33 (3).

Gutowski, A., Foerster, J. and Schaumburg, J. 2004. The Use of Benthic Algae, Excluding Diatoms and Charales, for the Assessment of the Ecological Status of Running Fresh Waters: A Case History from Germany. *Oceanological and Hydrological Studies* 33 (2): 3–15.

Harding, P. 1981. The Comparative Analysis of Four Stratified Flint Assemblages and a Knapping Cluster. In J. Richards, *The Stonehenge Environs Project*, p. 220. English Heritage.

Harding, P. 2000. A Mesolithic Site at Rock Common, Washington, West Sussex. *Sussex Archaeological Collections* 138: 29–48.

Harvey, G. 2005. *Animism: Respecting the living world*. Adelaide, Australia: Wakefield Press, 18.

Hather, J. G. 1993. *An Archaeobotanical Guide to Root and Tuber Identification. Volume 1: Europe and South West Asia*. Oxford: Oxbow Books.

Hather, J. G. and Mason, S. L. R. 2002. Introduction: Some Issues in the Archaeobotany of Hunter-Gatherers. In *Hunter-Gatherer Archaeobotany: Perspectives from the northern temperate zone*. London: Institute of Archaeology, University College London.

Haynes, S. 2012. The reinterpretation of a prehistoric landscape in the 18th century. How far did the presence of prehistoric earthworks at Amesbury Abbey, and in the surrounding landscape, influence the 1738 design of Charles Bridgeman? Unpublished MA dissertation, University of East Anglia.

Healy, F., Heaton, M. and Lobb, S. 1992. Excavations of a Mesolithic site at Thatcham, Berkshire. *Proceedings of the Prehistoric Society* 58: 41–76.

Heaton, T. 1999. Spatial, Species, and Temporal Variations in the 13C/12C ratios of C3 plants: Implications for Palaeodiet Studies. *Journal of Archaeological Science* 26: 637–649.

Higgs, E. 1959. Excavations at a Mesolithic Site at Downton, near Salisbury, Wiltshire. *Proceedings of the Prehistoric Society* 25: 209–232.

Hilts, C. 2017. Caught Knapping: Revealing the secrets of Blick Mead's Mesolithic Toolmakers. *Current Archaeology* 325: 52–54.

Hodder, I. 2012. Entangled: An Archaeology of the Relationships between Humans and Things. Malden, MA: Wiley-Blackwell.

Hodder, M. A. and Barfield, L. H. (eds). 1991. *Burnt Mounds and Hot Stone Technology: Papers from the 2nd International Burnt Mound Conference, Sandwell, 12–14 October 1990*. Sandwell: Sandwell Metropolitan Borough Council.

Holst, D. 2010. Hazelnut Economy of Early Holocene Hunter-Gatherers: A Case Study from Mesolithic Duvensee, Northern Germany. *Journal of Archaeological Science* 37: 2871–2880.

Hooper, W. 1933. The Pygmy Flint Industries of Surrey. *Surrey Archaeological Collections* 41: 50–78.

Hunter-Mann, K. 1999. Excavations at Vespasian's Camp Iron Age Hillfort. *WANHM* 92: 39–51.

Hurcombe, L. 2007. Plant Processing for Cordage and Textiles using Serrated Flint Edges: New Chaînes Operatoires suggested by Ethnographic, Archaeological and Experimental Evidence for Bast Fibre Processing. In V. Beugnier and P. Crombé (eds), *Plant processing form a prehistoric and ethnographic perspective/Préhistoire et ethnographie du travail des plantes: Proceedings of a workshop at Ghent University (Belgium) November 28, 2006*, pp. 41–66. British Archaeological Reports, International Series 1718. Oxford: BAR.

Ingold, T. 1993. The Temporality of the Landscape. *World Archaeology: Conceptions of Time and Ancient Society* 25 (2): 152–174.

Jacobi, R. M. 1976. Britain Inside and Outside Mesolithic Europe. *Proceedings of the Prehistoric Society* 42: 67–84.

Jacobi, R. M. 1978. The Mesolithic of Sussex. In P. L. Drewett (ed.), *Archaeology in Sussex to AD 1500*, pp. 15–22. Council for British Archaeology Research Report 29. York: Council for British Archaeology.

Jacobi, R. M. 1980. The Early Holocene Settlement of Wales. In J. A. Taylor (ed.), *Culture and Environment in Prehistoric Wales*, pp. 131–206. British Archaeological Reports, British Series 76. Oxford: BAR.

Jacobi, R. M. 1981. The Last Hunters in Hampshire. In S. J. Shennan and R. T. Schadla-Hall (eds), *The Archaeology of Hampshire from the Palaeolithic to the Industrial Revolution*. Hampshire Filed Club and Archaeological Society. Monograph 1: Figs 7 and 18, pp. 10–25.

Jacobi, R. M. 1987. Misanthropic Miscellany: Musings on British Early Flandrian Archaeology and Other Flights of Fancy. In P. Rowley-Conwy, M. Zvelebil and H. P. Blackholm (eds), *Mesolithic Northwest Europe: Recent trends*, pp. 163–168. Sheffield: Department of Archaeology and Prehistory, University of Sheffield.

Jacobi, R. M., Martingell, H. E. and Huggins, P. J. 1978. A Mesolithic Industry from Hill Wood, High Beach, Epping Forest. *Essex Archaeology and History* 10: 206–219.

Jacomet, S. 2006. *Identification of cereal remains from archaeological* sites. 2nd edn. Unpublished manuscript. Archaeobotany laboratory, IPAS, Basel University.

Jacques, D. 2015. 'Early Britons: Have we underestimated our ancestors?' *BBC* <http://www.bbc.co.uk/news/science-environment-33963372>.

Jacques, D. 2017. Tony Legge and the Blick Mead Project. In P. Rowley-Conwy, D. Serjeantson and P. Halstead (eds), *Economic Zooarchaeology: Studies in Hunting, Herding and Early Agriculture*, pp. 24–25. Oxford: Oxbow Books.

Jacques, D., Bishop, B., Lyons, T. and Phillips. 2017. About Time for the Mesolithic near Stonehenge: New Perspectives from Trench 24 at Blick Mead, Vespasian's Camp, Amesbury. In D. Boric, D. Antonovic *et al.* (eds), *Foragers in Europe and Beyond* (papers presented at the 9th international conference on the Mesolithic in Europe MESO 2015). Oxford: Oxbow Books.

Jacques, D., Lyons, T. and Phillips, T. 2014. Return to Blick Mead. *Current Archaeology Magazine* 293: 24–29.

Jacques, D. and Phillips, T. 2014. Mesolithic Settlement near Stonehenge: Excavations at Blick Mead, Vespasian's Camp, Amesbury. *Wiltshire Archaeological and Natural History Magazine* 107: 7–27.

Jacques, D., Phillips, T. and Clarke, M. 2010. A Reassessment of the importance of Vespasian's Camp in the Stonehenge Landscape. *PAST* 66: 11–13.

Jenkyns, H., Galef, A. and Corfield, R. 1993. Carbon-and Oxygen-Isotope Stratigraphy of the English Chalk and Italian Scaglia and its Palaeoclimatic Significance. *Geology Magazine* 131 (1): 1–34.

Jones, D. G. 1989. *Metallogenic Models and Exploration Criteria for Buried Carbonate-Hosted Ore Deposits: A Multidisciplinary Study in Eastern England*, ed. J. A. Plant and D. G. Jones. Keyworth, Nottingham: British Geological Society, 1989; London: The Institution of Mining and Metallurgy.

Jones, P. 2013. *A Mesolithic 'Persistent Place' at North Park Farm, Bletchingley, Surrey*. SpoilHeap Publications Monograph 8. Woking: SpoilHeap Publications.

Juel Jensen, H. 1994. *Flint tools and plant working: hidden traces of Stone Age technology. A use wear study of some Danish Mesolithic and TRB implements*. Aarhus: Aarhus University Press.

King, J. 1962. Report on Animal Bones. In J. Wymer and J. King, Excavations at the Maglemosian sites at Thatcham, Berkshire, England, pp. 355–361. *Proceedings of the Prehistoric Society* 28: 329–361.

Klooss, S., Fischer, E., Out, W. and Kirleis, W. 2016. Charred Root Tubers of Lesser Celandine (Ficaria verna HUDS.). In: Plant Macro Remain Assemblages from Northern, Central and Western Europe. *Quaternary International* 404A: 25–42.

Kufel-Diakowska, B. 2011. The Hamburgian Zinken Perforators and Burins – Flint Tools as Evidence of Antler Working. In J. Baron and B. Kufel-Diakowska (eds), *Written in Bones: Studies on technological and social contexts of past faunal skeletal remains*, pp. 233–240. Wrocław, Poland: Uniwersytet Wrocławski Instytut Archeologii.

Kuhn, S. L. 1994. A Formal Approach to the Design and Assembly of Mobile Toolkits. *American Antiquity* 59 (3): 426–442.

Lacaille, A. D. 1942. Scottish Micro-Burins. *Proceedings of the Society of Antiquaries of Scotland* 76: 103–119.

Lamdin-Whymark, H. 2008. The residue of ritualised action: Neolithic depositional practices in the Middle Thames Valley. British Archaeological Reports, British Series 466. Oxford: BAR.

Lawson, A. J. 2007. *Chalkland: an Archaeology of Stonehenge and its Region*. Salisbury: Hobnob Press.

Leary, J., Branch, N. and Bishop, B. J. 2005. 10,000 Years in the Life of the River Wandle: Excavations at the former Vinamul site, Butter Hill, Wallington. *Surrey Archaeological Collections* 92: 1–28.

Leduc, C. 2014. New Mesolithic Hunting Evidence from Bone Injuries at Danish Maglemosian sites: Lundby Mose and Mullerup (Sjælland). *International Journal of Osteology* 24: 476–491.

Leduc, C. and Verjux, C. 2014. Mesolithic Occupation patterns at Auneau 'Le Parc du Château' (Eure-et-Loire – France): Contribution to Zooarchaeological Analysis from Two Main Pits to the Understanding of Type and Length of Occupation. *Journal of Archaeological Science* 47: 39–52.

Leeds, E. T. 1945. The distribution of the Angles and Saxons archaeologically considered. *Archaeologia* 91: 1–106.

Legge, A. J. 2014. 'Mammal Remains'. In D. Jacques and T. Phillips, Mesolithic Settlement near Stonehenge: Excavations at Blick Mead, Vespasian's Camp, Amesbury. *Wiltshire Archaeological and Natural History Magazine* 107: 17–20.

Legge, A. J. and Rowley-Conwy, P. A. 1988. *Star Carr Revisited: A Re-analysis of the Large Mammals*. London: Centre for Extra-Mural Studies, Birkbeck College, University of London.

Leivers, M. and Dinwiddy, K. E. 2015. *Excavation of a multi-period site at Herne Bay, Kent*. Wessex Archaeology Ref. 60694: <http://www.kentarchaeology.org.uk/10/034.pdf>.

Leivers, M. and Moore, C. 2008. *Archaeology on the A303 Stonehenge Improvement*. Salisbury: Wessex Archaeology for Highways Agency.

Levi Sala, I. 1992. Functional Analysis and Post-Depositional Alterations of Microdenticulates. In R. N. E. Barton, *Hengistbury Head, Dorset Volume 2: The Late Upper Palaeolithic and Early Mesolithic Sites*, pp. 238–247. Oxford University Committee for Archaeology Monograph 34. Oxford: Oxford University Committee for Archaeology.

Lewis, J. S. C. and Rackham, J. 2011. Three Ways Wharf, Uxbridge: A Late-Glacial and Early Holocene hunter-gatherer site in the Colne Valley. Mola Monograph 51. London: Museum of London Archaeology.

Lewis, J. S. C. and Walsh, K. 2004. Perry Oaks – Neolithic Inhabitation of a West London Landscape. In J. Cotton and D. Field (eds), *Towards a New Stone Age: Aspects of the Neolithic in south-east England*, pp. 105–109. Council for British Archaeology Research Report 137. York: Council for British Archaeology.

Linford, P. 1995. *Report on Geophysical survey at Vespasian's Camp*. London: English Heritage <http://www.eng-h.gov.uk/reports/vespasians/>.

Longin, R. 1971. New Method of Collagen Extraction for Radiocarbon Dating. *Nature* 230: 241–242.

Lund, J. 2010. At the water's edge. In M. O. H. Carver, A. Sanmark and S. Semple (eds), *Signals of belief in early England: Anglo-Saxon paganism revisited*, pp. 49–66. Oxford: Oxbow Books.

Lyman, R. L. 1994. *Vertebrate Taphonomy*. Cambridge: Cambridge University Press.

McFadyen, L. 2008. Temporary Spaces in the Mesolithic and Neolithic: Understanding Landscapes. In J. Pollard (ed.), *Prehistoric Britain*, pp. 121–134. Oxford: Blackwell.

McFadyen, L. 2009. Landscape. In C. Conneller and G. Warren (eds), *Mesolithic Britain and Ireland: New approaches*, reprint of 2006 edn, pp. 121–138. Stroud: The History Press.

Maltby, M. 1986. Animal bones from the Coneybury Anomaly. Report to Historic Buildings and Monuments Commission.

Marean, C. 1991. Measuring the post-depositional destruction of bone in archaeological assemblages. *Journal of Archaeological Science* 18: 677–694.

Maroo, S. and Yalden, D. W. 2000. The Mesolithic mammal fauna of Great Britain. *Mammal Review* 30: 243–248.

Marshall, F. and Pilgram, T. 1993. NISP vs. MNI in quantification of body-part representation. *Society for American Archaeology* 58 (2): 261–269.

Marshall, S. 2013. Silbury Springs. *British Archaeology* 131: 24–27.

Medina, M. E., Teta, P. and Rivero, D. 2012. Burning damage and small-mammal human consumption in Quebrada del Real 1 (Cordoba, Argentina): An experimental approach. *Journal of Archaeological Science* 39: 737–743.

Mellars, P. 1976. Settlement Patterns and Industrial Variability in the British Mesolithic. In G. Sieveking, I. H. Longworth and K. E. Wilson (eds), *Problems in Economic and Social Archaeology*, pp. 375–399. London: Duckworth.

Mellars, P. 2009. Moonshine over Star Carr: Post Processualism, Mesolithic Myths and Archaeological Realities. *Antiquity* 83: 507.

Mellars, P. and Dark, P. 1998. Star Carr in Context: New archaeological and palaeoecological investigations at the Early Mesolithic site of Starr Carr, North Yorkshire. Cambridge: McDonald Institute for Archaeological Research.

Mellars, P. and Reinhardt, S. C. 1978. Patterns of Mesolithic Land-use in Southern England: A Geological Perspective. In P. Mellars (ed.), *The Early PostGlacial Settlement of Northern Europe*, pp. 241–293. London: Duckworth.

Milner, N. 2009. Subsistence. In C. Conneller and G. Warren (eds), *Mesolithic Britain and Ireland: New approaches*, reprint of 2006 edn, pp. 60–82. Stroud: The History Press.

Mitchell, F. J. G. 2005. How Open Were European Primeval Forests? Hypothesis Testing Using Palaeoecological Data. *Journal of Ecology* 93: 168–177.

Mithen, S., Finlay, N., Carruthers, W., Carter, S. and Ashmore, P. 2001. Plant Use in the Mesolithic: Evidence from Staosnaig, Isle of Colonsay, Scotland. *Journal of Archaeological Science* 28 (3): 223–234.

Montgomery, J. 2010. Passports from the past: Investigating human dispersals using strontium isotope analysis of tooth enamel. *Annals of Human Biology* 37: 325–346.

Montgomery, W. I. 1975. On the Relationship Between Sub-Fossil and Recent British Water Voles. *Mammal Review* 5 (1): 23–29.

Moore, C. N. and Rowlands, M. 1972. *Bronze Age Metalwork in Salisbury Museum*. Salisbury: Salisbury and South Wiltshire Museum Occas Pub.

Moore, P. D., Webb, J. A. and Collinson, M. E. 1991. *Pollen Analysis*. Oxford: Blackwell Scientific.

Moran, C. 2012. *Moranthology*. London: Ebury Press, 247.

Mortimer, R. N., Gallagher, L. T., Geldered, J. T., Moore, I. R., Brooks, R. and Farrant, A. R. In Press. Stonehenge – a unique Late Cretaceous phosphatic chalk geology: Implications for sea-level, climate and tectonics and

impact on engineering and archaeology. *Proceedings of the Geologists' Association* <http://dx.doi.org/10.1016/j.pgeola.2017.02.003>.

Müller, W., Fricke, H., Halliday, A., Mcculloch, M. and Wartho, J. 2003. Origin and migration of the Alpine Iceman. *Science* 302: 862–866.

Myers, A. M. 1987. All Shot To Pieces? Inter-Assemblage Variability, Lithic Analysis and Mesolithic Assemblage 'Types': Some Preliminary Observations. In A. G. Brown and M. R. Edmonds (eds), *Lithic Analysis and Later British Prehistory: Some problems and approaches*, pp. 137–153. British Archaeological Reports, British Series 162. Oxford: BAR.

Myers, A. M. 1989. Lithics, Risk and Change in the Mesolithic. In I. Brooks and P. Phillips, *Breaking the Stony Silence: papers from the Sheffield Lithics Conference 1988*, pp. 131–160. British Archaeological Reports, British Series 213. Oxford: BAR.

National Institute of Agricultural Botany. 2004. *Seed Identification Handbook: Agriculture, Horticulture and Weeds*, 2nd edn. Cambridge: NIAB.

Nielsen-Marsh, C. M. and Hedges, R. E. M. 2000. Patterns of Diagenesis in Bone I: The Effects of Site Environments. *Journal of Archaeological Science* 27: 1139–1150.

Norfolk Museums Service. 1977. *Bronze Age Metalwork in Norwich Castle Museum*, 2nd edn. Norwich: Norfolk Museums Service.

Nunez, M. and Okkonen, J. 2005. Humanizing of North Ostrobotnian landscapes during the 4th and 3rd millennia BC. *Journal of Nordic Archaeological Science* 15: 25–28.

Oakley, K. P., Rankine, W. F. and Lowther, A. W. G. 1939. *A Survey of the Prehistory of the Farnham District*. Guildford: Surrey Archaeological Society.

O'Connor, T. 2000. *The Archaeology of Animal Bones*. Stroud: Sutton Publishing Limited.

Odell, G. H. 1981. The Morphological Express At Function Junction: Searching For Meaning In Lithic Tool Types. *Journal of Anthropological Research* 37: 319–342.

O'Kelly, M. J. 1954. Excavations and Experiments in Ancient Irish Cooking-places. *Journal of the Royal Society of Antiquaries of Ireland* 84: 105–155.

Ong, W. J. 1982. *Orality and Literacy: The Technologizing of the Word*. London: Psychology Press.

Overton, N. J. 2016. More than Skin Deep: Reconsidering Isolated Remains of 'Fur-Bearing Species' in the British and European Mesolithic. *Cambridge Archaeological Journal* 26 (4): 561–578.

Parfitt, S. A. 2014. The Small Vertebrate Remains. In D. Jacques and T. Phillips, Mesolithic Settlement near Stonehenge: Excavations at Blick Mead, Vespasian's Camp, Amesbury. *Wiltshire Archaeological and Natural History Magazine* 107: 20–22.

Parker Pearson, M. 2012. *Stonehenge: Exploring the Greatest Stone Age Mystery*. London: Simon and Schuster.

Parker Pearson, M., Chamberlain, A., Jay, M., Marshall, P., Pollard, J., Richards, C., Thomas, J., Tilley, C. and Welham, K. 2009. Who was buried at Stonehenge? *Antiquity* 83 (319): 28.

Parker Pearson, M., Pollard, J., Richards, C., Thomas, J. and Welham, K. 2015. *Stonehenge. Making Sense of a Prehistoric Mystery*. York: Council for British Archaeology, 4, 43.

Pavao, V. 1998. Structural Density Assays of Leporid Skeletal Elements with Implications for Taphonomic, Actualistic and Archaeological Research. *Journal of Archaeological Science* 26: 53–66.

Pelcin, A. 1997. The Effect of Indentor Type on Flake Attributes: Evidence from a Controlled Experiment. *Journal of Archaeological Science* 24: 613–621.

Pelegrin, J. 2000. Les techniques de débitage laminaire au Tardiglaciaire: critères de diagnose et quelques réflexions. In *L'Europe Centrale et Septentriole au Tardiglaciare*, pp. 73–86. Mémoires du Musée de Préhistoire d'Ile de France 7.

Pitts, M. W. 1983. Procurement and Use of Flint and Chert. In J. G. Evans and I. F. Smith, Excavations at Cherhill, North Wiltshire 1967, pp. 72–84. *Proceedings of the Prehistoric Society* 49: 43–117.

Pitts, M. W. and Jacobi, R. M. 1979. Some Aspects of Change in Flaked Stone Industries of the Mesolithic and Neolithic in Southern Britain. *Journal of Archaeological Science* 6: 163–177.

Pollard, J. 2000. Ancestral Places in the Mesolithic Landscape. *Archaeological Review from Cambridge* 17 (1): 123–138.

Price, T. D., Burton, J. H. and Bentley, R. A. 2002. The Characterization of Biologically Available Strontium Isotope Ratios for the Study of Prehistoric Migration. *Archaeometry* 44: 117–135.

Pryor, F. 2016. *Stonehenge*. London: Head of Zeus, 198.

Rackham, J. and Pipe, A. 2011. Faunal Remains. In J. C. S. Lewis and J. Rackham (eds), *Three Ways Wharf, Uxbridge. A Late glacial and Early Holocene Hunter-Gatherer Site in the Colne Valley*, pp. 104–138. Mola Monograph 51. London: Museum of London.

Rankine, W. F. 1936. A Mesolithic Site at Farnham. *Surrey Archaeological Collections* 44: 25–46.

Rankine, W. F. 1938. Tranchet Axes of Southwestern Surrey. *Surrey Archaeological Collections* 46: 98–113.

Rankine, W. F. 1946. Some Remarkable Flints from West Surrey Mesolithic Sites. *Surrey Archaeological Collections* 49: 6–19.

Rankine, W. F. 1952. A Mesolithic Chipping Floor at the Warren, Oakhanger, Selborne, Hants. *Proceedings of the Prehistoric Society* 18: 21–35.

Reid, C. 1903. *The Geology of the Country around Salisbury (Explanation of Sheet 298). Memoir of the Geological Survey. England and Wales* 77. London: H. M. S. O.

Reille, M. 1992. *Pollen et spores d'Europe et d'Afrique du Nord*. Marseille: Laboratoire de botanique historique et Palynologie.

Reynier, M. J. 1998. Early Mesolithic Settlement in England and Wales: Some Preliminary Observations. In N. Ashton, F. Healy and P. Pettit (eds), *Stone Age Archaeology: Essays in honour of John Wymer*, pp. 174–184. Oxbow Monograph 102 / Lithic Studies Society Occasional Paper 6. Oxford: Oxbow Books.

Reynier, M. J. 2000. Thatcham Revisited: Spatial and Stratigraphic Analyses of Two Sub-Assemblages from Site III and its Implications for Early Mesolithic Typo-Chronology in Britain. In R. Young (ed.), *Mesolithic Lifeways: Current research from Britain and Ireland*, pp. 33–46. Leicester: School of Archaeological Studies.

Reynolds, F. 2012. Totemism and food taboos in the Early Neolithic: A feast of roe deer at the Coneybury 'Anamoly', Wiltshire. In H. Anderson-Whymark and J. Thomas (eds), *Regional perspectives on Neolithic pit deposition: Beyond the mundane*, pp. 13–14. Oxford: Oxbow Books.

Richards, J. 1991. *English Heritage Book of Stonehenge*. London: English Heritage.

Richter, J. 1982. Faunal Remains from Ulkestrup Lyng Øst a hunter dwelling place. In K. Andersen, S. Jørgensen and J. Richer, *Maglemose hytterne ved Ulkestrup Lyng* (eds), pp. 141–177. Copenhagen: H. J. Lynge and Son.

Richter, J. 2005. Selective Hunting of Pine Marten, *Martes martes*, in late Mesolithic Denmark. *Journal of Archaeological Science* 32: 1223–1231.

Richter, J. and Noe-Nygaard, N. 2003. A Late Mesolithic Hunting Station at Agernæs, Fyn, Denmark. *Acta Archaeologica* 74: 1–64.

Ritchie, C., Gron, K. and Price, T. D. 2013. Flexibility and Diversity in Subsistence During the Late Mesolithic: Faunal Evidence from Asnæs Havnemark. *Danish Journal of Archaeology* 2 (1): 45–64.

Roberts, N. 2014. *The Holocene*, 3rd edn. Hoboken, NJ: Wiley-Blackwell.

Robles, J., Arroyo-Cabrales, J., Johnson, E., Allen, B. and Izquierdo, G. 2002. Blue Bone Analyses as a Contribution to the Study of Bone Taphonomy in San Josecito Cave, Nuevo Leon, Mexico. *Journal of Cave and Karst Studies* 64 (2): 145–149.

Rogers, B., Gröcke, D. R., Gron, K., Montgomery, J., Rowley-Conwy, P. and Jacques, D. 2017. *Stable Isotope Analysis of the Blick Mead Dog: A Proxy for the Dietary Reconstruction of Mesolithic Hunter-Gatherers* <https://www.dur.ac.uk/resources/archaeology/pdfs/BlickMeadDogToothPoster.pdf>.

Romaniuk, A. A., Shepard, A. N., Clarke, D. V., Sheridan, A. J., Fraser, S., Bartosiewicz, L., Herman, J. S. 2016. Rodents: Food or pests in Neolithic Orkney. *Royal Society Open Science* 3 (10) <http://dx.doi.org/10.1098/ros/160514>.

Rosenlund, K. 1979. Knoglematerialet fra Bopladsen Lundby II. In B. B. Henriksen (ed.), *Lundby-holmen*, pp. 128–134. Copenhagen: H. J. Lynge and Son.

Rosvold, J., Herfindal, I., Andersen, R. and Hufthammer, A. K. 2014. Long-term Morphological Changes in the Skeleton of Red Deer (Artiodactyla, Cervidae) at its northern periphery. *Journal of Mammalogy* 95 (3): 626–637.

Rots, V. and Plisson, H. 2014. Projectiles and the Abuse of the Use-wear Method in a Search for Impact. *Journal of Archaeological Science* 48: 154–165.

Rowley-Conwy, P. 2013. North of the Frontier: Early Domestic Animals in Northern Europe. In S. Colledge, J. Conolly, K. Dobney, K. Manning and S. Shennan (eds), *The Origins and Spread of Domestic Animals in Southwest Asia and Europe*, pp. 283–311. Walnut Creek, CA: Left Coast Press.

Rowley-Conwy, P. A., Albarella, U. and Dobney, K. 2011. Distinguishing Wild Boar from Domestic Pigs in Prehistory: A Review of Approaches and Recent Results. *Journal of World Prehistory* 1: 25.

Rowley-Conwy, P., Albarella, U. and Dobney, K. 2012. Distinguishing Wild Boar from Domestic Pigs in Prehistory: A Review of Approaches and Recent Published Results. *Journal of World Prehistory* 25: 1–44.

Rowley-Conwy, P. and Owen, A. C. 2011. Grooved Ware feasting in Yorkshire: Late Neolithic animal consumption at Rudston Wold. *Oxford Journal of Archaeology* 30: 325–367.

Saunders, D. 2015. An assessment of the evidence for hunting strategies involving large animals within the pre-Stonehenge ritual landscape during the Mesolithic. Unpublished MA dissertation, University of Buckingham.

Saville, A. 1981a. Honey Hill, Elkington: A Northamptonshire Mesolithic site. *Northamptonshire Archaeology* 16: 1–13.

Saville, A. 1981b. Mesolithic Industries in Central England: An exploratory investigation using microlith typology. *Archaeological Journal* 138: 40–71.

Sell, P. D. 1994. Ranunculus ficaria L. sensu lato. *Watsonia* 20: 41–50.

Semple, S. 2010. In the open air. In M. O. H. Carver, A. Sanmark and S. Semple (eds), *Signals of belief in early England: Anglo-Saxon paganism revisited*, pp. 21–48. Oxford: Oxbow Books.

Serjeantson, D. 2011. *Review of animal remains from the Neolithic and Early Bronze Age of Southern Britain*. London: English Heritage, 261.

Serjeantson, D. 2014. Survey of animal remains from southern Britain finds no evidence for continuity from the Mesolithic period. *Environmental Archaeology* 19 (3): 256–262.

Sharma, S., Joachimski, M., Tobschall, H., Singh, I., Tewari, D. and Tewarid, R. 2004. Oxygen isotopes of bovid teeth as archives of paleoclimatic variations in archaeological deposits of the Ganga plain, India. *Quaternary Research* 62: 19–28.

Sheath, R. G. and Sherwood, A. R. 2011. Phylum Rhodophyta (Red Algae). In D. M. John, B. A. Whitton and A. J. Brook. *The Freshwater Algal Flora of the British Isles: An Identification Guide to Freshwater and Terrestrial Algae*, pp. 159–180. Cambridge: Cambridge University Press.

Sheperd, W. 1972. *Flint. Its Origins, Properties and Uses*. London: Faber and Faber.

Silver, I. 1969. The ageing of domestic animals. In D. Brothwell and E. Higgs (eds), *Science in Archaeology*, pp. 283–302. London: Thames and Hudson.

Simić, S. 2008. New Finding of Species *Hildenbrandia rivularis* (Liebmann) J. Agardh 1851 (Rhodophyta) in Serbia. *Biotechnology and Biotechnological Equipment* 22 (4): 973–976.

Sjögren, K.-G., Price, T. D. and Ahlström, T. 2009. Megaliths and mobility in south-western Sweden: Investigating relationships between a local society and its neighbours using strontium isotopes. *Journal of Archaeological Science* 28: 85–101.

Smith, C. 1992. *Late Stone Age Hunters of the British Isles*. London: Routledge.

Smith, K. 1977. The Excavation of Winklebury Camp, Basingstoke, Hampshire. *Proceedings of the Prehistoric Society* 43: 31–129.

Soil Survey of England and Wales. 1983. Soils of England and Wales, Sheet 5 South West England.

Sonani, R. R., Rastogi, R. P., Patel, R. and Madamwar, D. 2016. Recent advances in production, purification and applications of phycobiliproteins. *World Journal of Biological Chemistry* 7 (1): 100–109.

Spielmann, K. A. 2002. Feasting, Craft Specialisation, and the Ritual Mode of Production in Small Scale Societies. *American Anthropologist* 104 (1): 195–207.

Sponheimer, M. 1999. *Isotopic ecology of the Makapansgat Limeworks fauna*. PhD dissertation, Rutgers University, The State University of New Jersey.

Stace, C. 2005. *New Flora of the British Isles*. Cambridge: Cambridge University Press.

Starmach, K. 1969. Growth of thalli and reproduction of the red alga *Hildenbrandia rivularis* (Liebm.) J. AG. *ACTA Societatis Botanicorum Poloniae* 38: 523–533.

Stewart, J. R. M., Allen, R. B., Jones, A. K. G., Penkman, K. E. H. and Collins, M. J. 2013. ZooMS: Making eggshell visible in the archaeological record. *Journal of Archaeological Science* 40: 1797–1804.

Stonehenge Hidden Landscapes Project 2014. Interim Geophysical Survey Report: Field Season 4 (2013–2014). Unpublished report for National Trust and English Heritage.

Storck, P. L. and Spiess, A. E. 1994. The significance of new faunal identifications attributed to an early paleoindian (Gainey Complex) occupation at the Udora Site, Ontario, Canada. *American Antiquity* 59: 121–142.

Strohalm, M., Kavan, D., Novák, P., Volnỳ, M. and Havlíćek, V. 2010. mMass 3: A cross-platform software environment for precise analysis of mass spectrometric data. *Analytical Chemistry* 82: 4648–4651.

Sykes, N. and Curl, J. 2010. The Rabbit. In T. O'connor and N. Sykes (eds), *Extinctions and Invasions: A Social History of British Fauna*, pp. 116–126. Oxford: Windgather.

Taçon, P. S. C. 1991. The Power of Stone: Symbolic aspects of stone use and tool development in western Arnhem Land, Australia. *Antiquity* 65: 192–207.

Tallantire, P. A. 2002. The early-Holocene spread of hazel (*Corylus avellana* L.) in Europe north and west of the Alps: An ecological hypothesis. *The Holocene* 12 (1): 81–96

Taylor, K. and Markham, B. 1978. *Ranunculus ficaria* L. (*Ficaria verna* Huds; *F. ranunculoides* Moench). *Journal of Ecology* 66: 1011–1031.

Teegen, W.-R. 1999. *Studien zu dem kaiserzeitlichen Quellopferfund von Bad Pyrmont, Ergänzungsbände zum RGA* 20. Berlin and New York: De Gruyter.

Thomas, J. S., Parker-Pearson, M., Pollard, J., Richards, C., Tilley, C. and Welham, K. 2009. The Date of the Greater Stonehenge Cursus. *Antiquity* 83: 44.

Timby, J. 2000. The pottery. In M. Fulford and J. Timby, *Late Iron Age and Roman Silchester: Excavations on the site of the Forum-Basilica 1977, 1980–86*, Britannia Monograph 15, pp. 180–312. London: Society for the Promotion of Roman Studies.

Tornero, C., Bălăşescu, A., Ughetto-Monfrin, J., Voinea, V. and Balasse, M. 2013. Seasonality and season of birth in early Eneolithic sheep from Cheia (Romania): Methodological advances and implications for animal economy, *Journal of Archaeological Science* 40: 4039–4055.

Torrence, R. 1989. Retooling: Towards a behavioural theory of stone tools. In R. Torrence (ed.), *Time, Energy and Stone Tools*. New Directions in Archaeology, pp. 57–66. Cambridge: Cambridge University Press.

Towers, J., Jay, M., Mainland, I., Nehlich, O. and Montgomery, J. 2011. A calf for all seasons? The potential of stable isotope analysis to investigate prehistoric husbandry practices. *Journal of Archaeological Science* 38: 1858–1868.

Towers, J., Montgomery, J., Evans, J., Jay, M. and Parker Pearson, M. 2010. An investigation of the origins of cattle and aurochs deposited in the Early Bronze Age barrows at Gayhurst and Irthlingborough. *Journal of Archaeological Science*, 37: 508–515.

Tringham, R., Cooper, G., Odell, G., Voytek, B. and Whitman, A. 1974. Experimentation in the Formation of Edge Damage: A new approach to lithic analysis, *Journal of Field Archaeology* 1: 171–196.

Turner, D. J. 1965. Carshalton: Orchard Hill. *Surrey Archaeological Society Bulletin* 12.

Van Vuure, C. 2005. *Retracing the Aurochs*. Sofia: Pensoft.

Van Wijngaarden-Bakker, J. H. 1974. The animal remains from the Beaker settlement at Newgrange, Co. Meath: First report. *Proceedings of the Royal Irish Academy section C* 74: 313–383.

Vatcher, G. and Vatcher, F. de M. 1973. Three post-holes in Stonehenge car park. *WANHM* 68: 57–63.

von den Driesch, A. 1976. *A Guide to the Measurement of Animal Bones from Archaeological Sites*. Massachusetts: Peabody Museum Press, Harvard University.

Waddington, C., Bailey, G., Bayliss, A., Boomer, I., Milner, N., Pedersen, K., Shiel, R. and Stevenson, T. 2003. A Mesolithic Settlement Site at Howick, Northumberland: A Preliminary Report. *Antiquity* 77: 11.

Wainwright, G. J. 1971. Durrington Walls: Excavations 1966–1968. *Reports of the Society of Antiquaries of London* 24. Dorking.

Wainwright, G. J. 1979. *Gussage All Saints: An Iron Age settlement in Dorset*. Department of the Environment, Archaeological Reports No.10. London: Department of the Environment.

Wang, Y. and Cerling, T. 1994. A model of fossil tooth and bone diagenesis: implications for paleodiet reconstruction from stable isotopes. *Palaeogeography, Palaeoclimatology, Palaeoecology* 107: 281–289.

Warren, G. 2009. Technology. In C. Conneller and G. Warren (eds), *Mesolithic Britain and Ireland: New approaches*, reprint of 2006 edn, pp. 13–24. Stroud: The History Press.

Welker, F., Soressi, M., Rendu, W., Hublin, J.-J. and Collins, M. 2015. Using ZooMS to identify fragmentary bone from the Late Middle/Early Upper Palaeolithic sequence of Les Cottés, France. *Journal of Archaeological Science* 54: 279–286.

Welker, F., Hajdinjak, M., Talamo, S., Jaouen, K., Dannemann, M., David, F., Julien, M., Meyer, M., Kelsoc, J., Barnes, I., Brace, S., Kamminga, P., Fischer, R., Kessler, B. M., Stewart, J. R., Pääbo, S., Collins, M. J. and Hublin, J.-J. 2016. Palaeoproteomic evidence identifies archaic hominins associated with the Châtelperronian at the Grotte du Renne. *PNAS* 113 (40): 11162–11167.

Wessex Archaeology: Time Team. 2001. Beach's Barn, Netheravon, Wiltshire: Finds assessment report, unpubl report for Videotext Communications, ref 44633.

Wessex Archaeology. 2012. Appendix 7: Stonehenge and Avebury Revised Research Framework (Draft). Unpublished English Heritage Consultation Document.

White, J. 1995. *Forest and Woodland Trees in Britain*. Oxford: Oxford University Press.

Whitehead, P. and Edmunds, M. 2012. Palaeohydrology of the Kennet, Swallowhead Spring and the siting of Silbury Hill. *English Heritage Report Series* 12: 1–35.

Whitehouse, N. J. and Smith D. N. 2010. How fragmented was the British Holocene wildwood? Perspectives on the 'Vera' grazing debate from the fossil beetle record. *Quaternary Science Reviews* 29: 539–553.

Whittle, A., Bayliss, A., Healey, F. and Allen, M. J. 2010. *Gathering Time – Dating the early Neolithic enclosures of South Britain and Ireland*. Oxford: Oxbow.

Wicks, K. and Mithen, S. 2014. The impact of the abrupt 8.2 ka cold event on the Mesolithic population of western Scotland: A Bayesian chronological analysis using 'activity events' as a population proxy. *Journal of Archaeological Science* 45: 240–269, 255.

Woodman, P. C. 2001. Mesolithic middens from famine to feasting. *Archaeology Ireland* 15 (3): 32–35.

Woolhouse, T., Crummy, N., Percival, S. and Tingle, M. 2008. A Late Bronze Age hoard and Early Iron Age boundary at Lodge Farm, Costessey. Unpublished Report.

Wright, E. and Viner-Daniels, S. 2015. Geographical variation in the size and shape of the European aurochs (*Bos primigenius*). *Journal of Archaeological Science* 54: 8–22.

Wymer, J. J. 1962. Excavations at the Maglemosian sites at Thatcham, Berkshire, England. *Proceedings of the Prehistoric Society* 28: 329–361.

Yalden, D. W. 1983. Yellow-necked mice (*Apodemus flavicollis*) in archaeological contexts. *Bulletin of the Peakland Archaeological Society* 33: 24–29.

Zazzo, A., Balasse, M. and Patterson, W. 2005. High-resolution $\delta^{13}C$ intratooth profiles in bovine enamel: Implications for mineralization pattern and isotopic attenuation. *Geochimica et Cosmochimica Acta* 69: 3631–3642.

Żelezna-Wieczorek, J. and Ziutkiewicz, M. 2008. *Hildenbrandia rivularis* (Rhodophyta) in Central Poland. *Acta Societatis Botanicorum Poloniae* 77: 71–77.

Documents

Bodleian Library, Oxford

MS Gough Drawings a3*, folio 32, Charles Bridgeman's plan of Amesbury Abbey.

Wiltshire and Swindon History Centre, Chippenham

WRO 283/6 – 1741 Queensberry Estate Records.
WRO 283/6 4 – 1741 Queensberry Estate Records.
WRO 283/219 – 1824 Antrobus Estate Records.
WRO 944/1 – 1726 Flitcroft Survey.
WRO 944/2 – 1726 Flitcroft Survey.
WRO 944/3 – 1771 Queensberry Estate Records.
WSA 776/1122 Note about water meadows at Countess Farm, c. 1790; correspondence and papers of Christopher Ingram, tenant of Countess Farm.

Index

A303 19, 50, 61, 169, 179
 late 1960s widening 10, 23, 178, 181
 road construction dumping 26, 69, 175
adze *see* axe
alkaline leeching 155
Allerton, Gemma 10, 217
Alps 144
Alton Priors 125
Ames, K. M. 161
Amesbury 12, 35
 Abbey 4, 6, 187
 Archaeology Fund 219
 Heritage Trust 219
 History Centre 217, 219–220
 Lantern Parade 218–219
 Museum 12, 159, 219
 Town Council 10, 12, 221
amicability 14
Ancient Monuments Laboratory 179
Anglo-Saxon 160
 disc brooch 199, 201–202
animal bones 19, 21, 76
animism 163, 166–167
Antrobus family 4, 9
Archaeological Surveys Ltd 179
arrow shafts 107
arrowhead, ripple-flaked oblique 28, 116, 119, 161
 transverse 26, 74, 78, 89–93, 113
Asnæs Havnemark 135
Atlantic *see* Mesolithic, Late
Aubrey Holes 168
Auneau 135
aurochs 19, 127–152, 163–164
 minimum number of individuals 129, 134
 Polish 145
 teeth 17, 127–152, 168
Avon, River 4, 35, 60, 153
Avon House 37, 51
axe, tranchet 28, 161
 transverse 107, 118, 120

Baldwin, Eamonn 178
Battlesbury Bowl 178, 200
BBC
 Flying Archaeologist 12
 Horizon 13
Beach's Barn 200
Beacon Hill 164

Beaker 134
Bell, Martin
Binford, L. R. 161
bird 134
Birmingham, University of 179
Bishop, Barry 22, 27, 217
Bletchingley 115
Blick Mead
 base camp 135
 borehole survey 35–66
 cobbles 27, 113, 176
 colluvium 116
 cooking 74–76
 deposit modelling 39–40, 48–49
 dwelling structures 118
 feasting 162–163
 geoarchaeological context 35–36
 hearth 118
 homebase 32, 114, 135, 146, 161, 164
 landscaping 35, 68, 175
 lynchet 7, 37, 175, 178
 macro-assemblage 78
 Made Ground 35, 51, 61, 181
 medieval 17, 35, 61, 177
 micro-debitage 78, 81–82
 natural environment 64
 Neolithic 28
 peat 51
 pit 118
 pond 160
 posthole 118
 project leadership 13–14
 retooling 95
 sarsen 27
 sieves 11
 small vertebrates 153–158
 spring 22, 122–125, 138
 temporality 32–33
 terrace 17
 tree throw 26–30, 65–66, 117, 162
 Trench 1 74
 Trench 2 26
 Trench 6 23
 Trench 11 26
 Trench 14 8, 11
 Trench 18 177
 Trench 19 12, 40, 52, 67, 193–200
 Trench 22 19–21, 40, 52, 72

Trench 23 26, 73–74
Trench 24 14, 26, 32, 64, 115–119
Trenches 1–14 173–177
Trenches 22 and 23 10, 11, 32, 67
volunteers 12, 217–219
water-meadows 50
boar 133, 135, 151
boats 161
Bos primigenius see aurochs
Boscombe Down 164
Bourne Mill Spring 115
Bowden, Mark 7
Bradbury, Keith 120–121
Bradford, University of 120, 137, 138
Bradley, Richard 159
Bridgeman, Charles 5–6
Bristol Avon, River 114
British Geological Survey 35–37
Bromilow, Julie 1, 14
Bronze Age 60–67, 73–74, 77, 113
 Early 137
 Middle 177
Broomhill 162
Brown, Tony 22, 160
Buckingham, University of 11
burins 92, 116
butchery 130

Camden, William 4
Carshalton 113, 115
cattle, domestic 130, 168
cereal 63
chaîne opératoire 78, 119
Charlton, Sophy 149–152
Charlwood 100, 107
Cherhill 114, 136, 162
Christie, P. M. 166
Clarke, Gilly 217
Clarke, Mike 8, 14, 18, 125, 159, 217
cobbled surface 26
Coneybury 4, 164–167
Conneller, C. 162–163
copper alloy knife 199
Cornelius-Reed family 4
Countess Farm 6–8, 160
Cow Down 114

Danebury 178, 201
Davies, Cate 24
'Deepcar' type 96
deer
 red 130–135, 151, 168
 roe 128, 133, 135
denticulates 92
Devensian, Late 60
diagenesis 143–144, 152
Dickinson, T. 201–202
dog 134, 163

Doggerland 144
Donahue, Randolph 120–121
Donaldson, Kerry 187
Downton 85, 114, 161
Durham University 130, 137
Durrington Walls 4, 28, 61–63, 116, 133
Dury and Andrews' map 7–8

earth resistance survey 187–188, 192
East Anglia 77
elk 132, 151
Ellaby, R. 100
English Heritage 7
Ertebølle culture 135
Essex 77
Eton Rowing Course 120
Evans, J. G. 89

Farnham 112, 115, 162
faunal assemblage 127–152
Field, David 7
Finlay, N. 94
fish 155
flakes and blades
 crested 81
 decortication 80–81
 platform rejuvenation 81–82
 routine reduction 82
Flamborough Head 116
flint
 blades 91, 106, 116
 borers 104
 burnt 21–28, 32, 49–50, 72–75, 116–117
 cores 83–84
 debitage 112
 fossil 117
 knapping 27, 89, 113, 115, 120
 magenta 122–125
 notches 104
 piercers 104–105
 recorticated 69–70, 73, 76
 scrapers 104–107
 serrates 106
 striking platforms 84–89
 struck 21–32, 71–72, 117
Flitcroft Survey 4
Froom, Roy 218

Gaffney, Vince 12
Garlick, Vicky 128, 130
Gatehampton Farm 120
Gayhurst 137
geoarchaeological deposit modelling 60
geophysical survey 177, 187–188, 190, 192
goat 134
Golden Ball Hill 114
Gröcke, Darren R. 127–149
Gron, Kurt 127–152

ground-penetrating radar 7, 19, 160, 179–180
Guilfoyle-Pink, Malcolm 13, 67
Gussage All Saints 200

Half Borough Field 6
Hampshire 96
Hayward, Reverend 4, 6
hazel 65
Henge enclosures 28, 116
Hengistbury Head 106
Herne Bay 120
Heywood Farm 114
Highways England 161
Hildenbrandia rivularis 123–125, 128, 161
Hodding, John 7, 8
Holocene 60, 63–64, 65
 Early 32, 144, 156, 160
 Thermal Optimum 153
Homes, Kerry and John 17
'Honey Hill' 96, 102
'Horsham'
 industry 102–104
 point 96, 161
Howick 33
Humber estuary 144
hunter-gatherers 153
hunting grounds 164
Hydropunctaria rheitzophila 125

Ingram, Christopher 7, 8, 160
insect analysis 37
Iron Age 4, 74, 178
 Early 174
 pottery 199–200
Irthlingborough 137–141, 144–145
IsoAnalytical 138
isotopic analysis 136–152, 163, 203–213
 carbon 139, 142
 oxygen 139, 141, 143
 strontium 138, 143

James, Nick 8
John, David 12, 122–123, 160
Jones, D. 121

Kennett Valley 102
Kent 77
Kettlebury 102
King Barrow Ridge 4, 164–165

Lake 164
landscape history 4
laser scanning 179–181, 184
Late Glacial industries 80
Lawson, Andrew 201
Legge, Tony 10, 127, 215–216
lesser celandine 65, 66
Levick, Emily 35

lithostratigraphy 32, 60, 203–213
'Long Blade' industries 91
Longford, Catherine 65
Ludwig Boltzmann Institute 179
Lundby 136

McComish, Dave 7
McFadyen, Lesley 114
Maglemosian culture 135
magnetometry 179, 187–191
Maltas, Tom 15, 65–66
marten 155–158
Massif Central 144
Mepham, Lorraine 174, 175, 199–200
Mesolithic 1, 60–61, 63
 Early 96
 faunal remains 17
 first monuments 164
 flints 9, 17, 19, 69
 Late 1, 100, 102
 Middle 96
 societies 78
 tool types 24
Mesolithic–Neolithic transition 159, 165
mice 154–156
Micraster 117
micro-burins 89, 93–95, 104
 Krukowski 94
micro-debitage 78, 81–83, 103, 115, 117
micro-denticulates *see* flint, serrates
microliths 27, 94–106
 rods 100
 slate 100–102
 typology 80, 95
microwear analysis 120
Montgomery, Janet 127–149
Moran, Caitlin 162
Mullerup 130

Natural History Museum 124, 154
Neolithic 67, 165
 society 1
 Late 60–64, 74, 83–85, 91, 113, 116
New York Times 12
Newgrange 134
Nunamiut 135

O'Kelly, M. J. 74
Oakhanger 114
Oliver's Hill Field 114
Open University 10, 121, 179
Ordnance Survey 35, 159, 179, 190

Palaeolithic 91, 104
Palaeozoic 121
Parfitt, Simon A. 153–158, 193
'persistent place' 1, 127, 159
Phillips, Tom 10

pig 133
pike 162
plant macrofossil analysis 37, 48, 52
plant processing 106
pollen analysis 37, 47–48
Potterne 201
pottery
 Early Iron Age 173, 175
 Iron Age 178
 medieval 173

QinetiQ 12, 178
Quaternary 68, 74, 179
Queensberry 4, 6

rabbit 134
radiocarbon dates 1, 203–213
Rhind-Tutt, Andy 159
Ringkloster 135–136
River's Brook 114
RockWorks 40
Rogers, Bryony 127–152
Romano-British 202
Rowley-Conwy, Peter 127–149, 163

Sabin, David 189–194
Salisbury Plain 4, 9, 77, 169
salmon 162
San Josecito Cave 128
sandstone slab 76–77, 107–112
sarsen 27, 76, 162
Saunders, David 166
Schuster, Jörn 201–202
Scottish Universities Environmental Research Centre 48
Seaford Chalk Formation 35, 125, 179
sheep 134
Sheffield, University of 65
'Silchester ware' 201
slate 76–77, 121, 161
Sling, the 6, 7, 8, 19
Smith, Mick 12, 153
Southwark 106
Spielmann, K. A. 163
Star Carr 33, 102, 107, 130, 135, 157
Stonehenge 127, 163, 167
 Avenue 4, 28, 116
 bluestones 168
 Bottom 164
 ditch 168
 Greater Cursus 164, 166
 Hidden Landscapes Project 7, 19, 160
 knoll 28, 164, 165, 168, 169
 landscape 1, 160
 ritual landscape 1, 119, 159, 169

Stonehenge and Avebury Revised Research Framework 113
Stonehenge Riverside Project 166
Summerlands Farm 114
Surrey 96, 115
Sussex 96

Thanet Sand 77
Thatcham 33, 106, 113–114, 135, 157
Three Ways Wharf 133, 135, 155
toad 162
totemism 166–167
Tremadoc slate 121–122
trout 162

Ulkestrup Lyng Øst 135

Veal, Robyn 120
vertebrae 155
Vespasian's Camp 1, 4, 159, 179
 chalk hill 78
 landscaping 9
 north-western rampart 178
 vallum 178
 walkover survey 178
vole molars 154–155

Walden Spring 125
Wall's Field 4–6
Wandle, River 113
Wawcott 100, 114, 161
Weald 96, 102, 162
Webb, Peter 121–122
Wessex Archaeology 164
West Amesbury 6, 8, 61–63
West Amesbury Henge 4, 29, 116, 125, 161
West Kennet Barrow 125
White, Joshua 127
Wickham-Jones, Caroline 27
Wilsford Shaft 63
Wiltshire 102, 114, 118
Wiltshire Archaeological Society 4
Wisconsin-Madison, University of 138
wolf 134
Woodbridge Road 82, 107
Woodhenge 28, 116
Woolson Hill 5

XRF analysis 121–122

York, University of 150

Zealand, island of 135
'zinken' 104–106
zooarchaeological analysis 127–152
ZooMS 128, 132, 150, 152

STUDIES IN THE BRITISH MESOLITHIC AND NEOLITHIC

Series Editors
David Jacques and Graeme Davis

Studies in the British Mesolithic and Neolithic presents the results of fieldwork and excavation as well as works of interpretation from all perspectives on the British Neolithic revolution. Archaeological methodology is augmented where appropriate with interdisciplinary techniques, reflecting contemporary practice in the discipline. Throughout the emphasis is on work which makes new contributions to the debate about the transition between hunter gatherer and farming cultures during this pivotal stage in British prehistory.

The series supports the archaeological community both in providing an appropriate forum for research reports as well as supporting interpretative work including cross-disciplinary research. It takes its inspiration from the work of the University of Buckingham's excavations at Blick Mead in the Stonehenge World Heritage Site.

Studies in the British Mesolithic and Neolithic is based at the Humanities Research Institute, University of Buckingham.

Volume 1 Blick Mead: Exploring the 'First Place' in the Stonehenge Landscape.
 David Jacques, Tom Phillips and Tom Lyons
 260 pages. 2018. 978-1-78707-096-7.